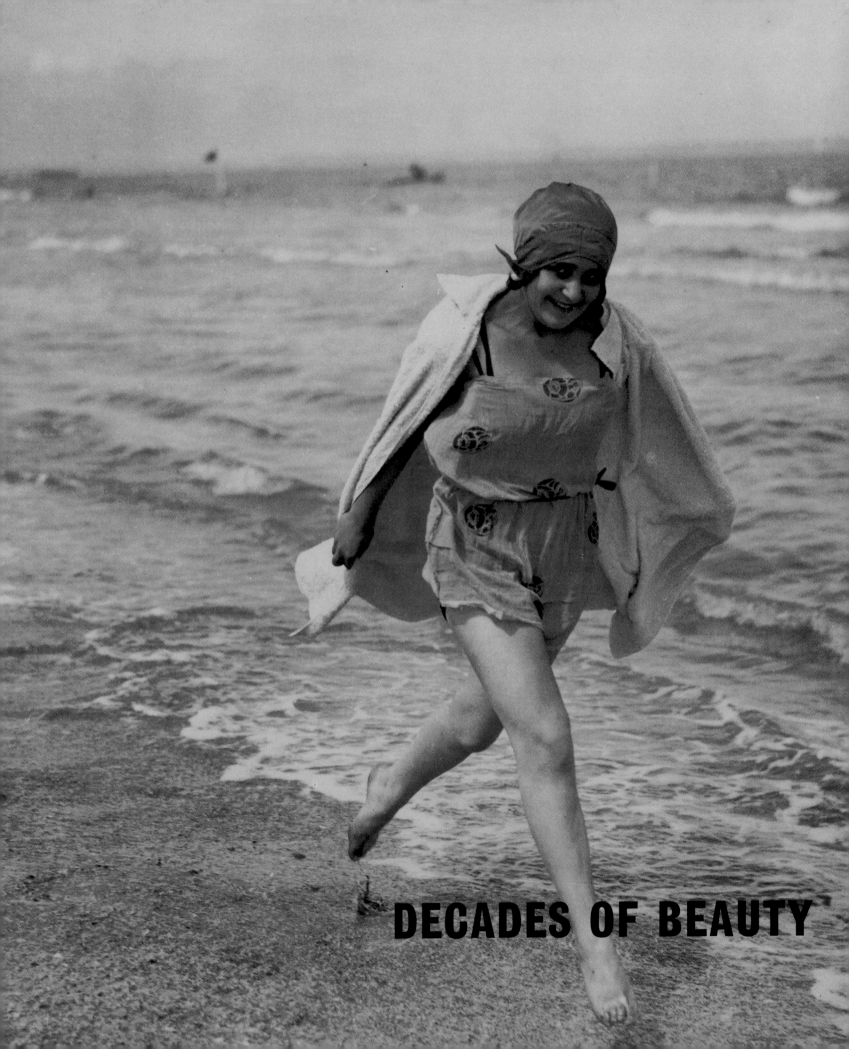

DECADES OF BEAUTY

Publishing Director: Laura Bamford **Executive Editor:** Mike Evans **Editor:** Humaira Husain **Production Controller:** Julie Hadingham **Picture Research:** Jenny Faithfull **Art Director:** Keith Martin **Design:** Ben Barrett **Mac Operator:** Peter Burt First published in 1998 by Hamlyn, an imprint of Octopus Publishing Group Ltd.

Copyright © 1998 Octopus Publishing Group Ltd.

132 West 31st Street, New York NY 10001

Library of Congress Cataloging-in-Publication Data is available on request from Facts On File, Inc. ISBN 0-8160-3920-8

Facts On File books are available at special discounts when purchased in bulk quantities for businesses, associations, institutions or sales promotions. Please call our Special Sales Department in New York at 212/967-8800 or 800/322-8755.

You can find Facts On File on the World Wide Web at http://www.factsonfile.com.

Printed and bound in China.

10 9 8 7 6 5 4 3

CONTENTS

LIFE & TIMES FACES IN VOGUE FILM & MEDIA FASHION HAIR & HATS

Introduction

The Western ideal of beauty has changed regularly and radically through the last 100 years and there are many reasons for this: world events and developments in technology and shifting priorities are obvious ones, coupled with changes in society often triggered by economics and the need to create new markets. Also, every so often appears a rare genius, making something happen out of the blue, capturing the imagination to such an extent that we realize it was inevitable, so perfectly it sums up the spirit of the age. Perceptions of beauty have changed radically from the last century with various ideals oscillating back and forth.

This is the story of the development of markets, the creative genius of hundreds of designers and manufacturers and the gradual sophistication of the media and their audience, of the technological advances of the 20th century and the people who bought and sold them, of society and its concerns.

In times of hardship, fashion and beauty are often the first to be affected, and yet are sorely needed symbols of morale. Women have held the fort in troubled times: nursing the sick and doing men's work in the First World War; as intelligence and defense personnel in the Second; munitions workers in both; and even as front-line troops in the Gulf War. Increasingly, women have competed on a professional basis with men, and these war-driven experiences were to influence how women dressed generally, and the way designers and manufacturers saw them. The forces of fashion affected the fashion of the forces, and vice versa.

Clothes, makeup and hair all reflect change in society, acting as barometers of our expectations. Skirt lengths are said to move up in good economic times and down in bad. The shifting erogenous zone, a concept of fashion historian James Laver, says each age emphasizes a different facial and body part. However, it is the whole look of each decade that enables us to reassess 20th-century beauty.

It is the story of the emancipation of women. For instance, women donning male attire for work. Though shocking at first, the sexual connotations of this were later exploited in films, filtering through to fashion. The ideal became youthful, sporty, boyish or natural, in contrast to the full-blown matronly Edwardian look. Dior once said "As far as fashion is concerned there are two ages, girlhood and womanhood." Mothers may have the cash, but daughters have the cultural cachet.

Today fashion has become its own history book as designers like Vivienne Westwood and John Galliano take past styles and put a new twist to them. The industry continually refers to trends, and there is a dynamic at work allowing media, advertisers, designers and artists to feed off each other to satisfy the public's appetite for novelty.

Couture is increasingly street-led and more trends originate from subculture and street style. Gwen Stefani (the singer with 90s band No Doubt) has a marcel wave, a sequin on her forehead, midriff-baring tanktop, fatigues, sneakers and 30s makeup—red lips and black eyebrow pencil. It is a strong image, from everywhere and nowhere. "Classic," since the 20s, indicates something timeless and special: a Cartier watch, 501s, Chanel No. 5, a Hermès Kelly bag, sneakers or a Louise Brooks bob. In today's consumer mentality, these are appreciated in a way incomprehensible to previous centuries. As with many of the old fashion houses, Worth, the first prominent fashion purveyor since Rose Bertin, couturier to Marie Antoinette, has long gone, but its scent Je Reviens remains a legacy in itself.

Hollywood glamour has been paramount, as many trends began with the power of celluloid. Film is a huge market for the beautiful, sometimes dictating to the fashion industry who is and who isn't.

Weddings symbolize the zenith of looking good for millions of women, yet historically only the elite had wedding dresses. The business really grew in the 50s and now, despite informal celebrity weddings since the 60s, and fewer traditional church nuptials, vast amounts are being spent in the ritual of tying the knot.

Women's identity comes from experience or background, and choice and interest is expressed through image. Previous taboos are broken about what they may buy themselves, buying their own scent, flowers, diamonds and cosmetic surgery with impunity. Hair

has also established images, changing for practical reasons, sheer defiance of the norm and morale-boosting. And the principle of looking after oneself has returned, rather than a moral code that frowns upon vanity. Few dress to show status, but aspirations, preferences or beliefs. We can control what we want people to see of our age and philosophy. Diana, Princess of Wales, rarely dressed as a "Royal," presenting a relaxed image of a wealthy, modern woman—apace with the times and breaking the mold.

Clothing and morality are also linked; when underwear becomes outerwear, bounds of acceptability are challenged. Away from the beach or outside the boudoir, a bikini or lingerie can look ridiculous, such are the confines of occasion. Another function of fashion is to challenge, react, copy and move on. Old looks lie low for an average of seven years before reappearing for reappraisal.

Technology has benefited skin care and clothes with cheap, easy-care fabrics, better cosmetics, hair products and advances in science. Knowledge is power, and decisions about diet, exercise and well-being ultimately affect appearance. Ethics replace religion and morals; companies have re-thought production methods in reaction to concern about animal welfare for instance, changing both style and advertising. The media is increasingly more accessible, it and its users more sophisticated. Pluralistic images appear, often with a sense of irony and humor. And those images are now often controlled by women, for women and about women.

On the eve not only of a new century but millennium, we have come full circle. Chanel, originator of costume jewelry makes real jewelry; therapies and treatments favored are often traditional rather than high-tech; makeup comes in no-nonsense packaging as if prescribed; and makeup artists receive their due, as in the days of Max Factor and other pioneers. There is both an elite and mass market. Individualism is here to stay. Almost every image is borrowed from yesterday. Each idea takes seconds to germinate, days to put into practice, weeks to last and, once over, put into posterity as history. The more we value it, the more it says about us.

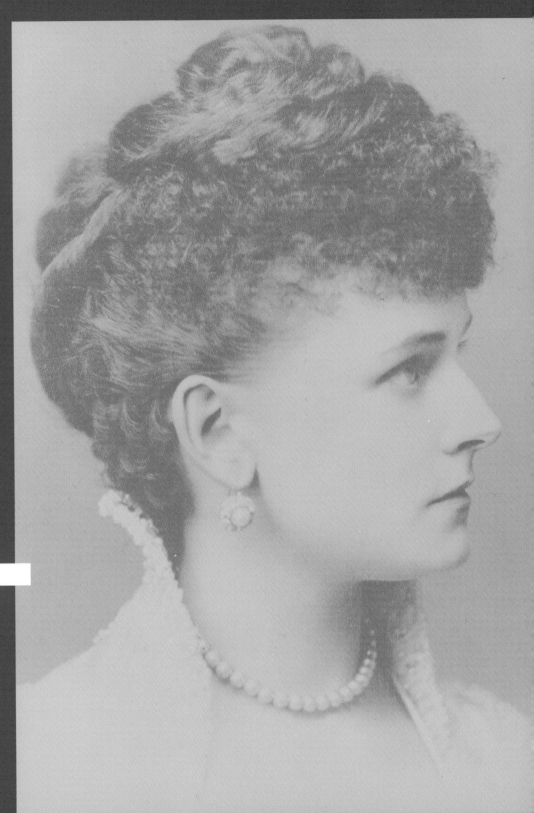

1890-
1899

AS QUEEN VICTORIA'S
REIGN DREW TO A
CLOSE THE BELLE
ÉPOQUE WAS REACHING
ITS HEIGHT. LIFE WAS
AS STABLE AS COULD BE
IMAGINED, BUT THE
SIGNS OF CHANGE WERE
ON EVERY HORIZON

These were the sunset days of the Gilded Age and the dawn of a new century. Everyone expected changes, but no one could have imagined the enormity or the speed at which the face of Western civilization would be altered. Looking back, the conventions and social mores of the time are almost the complete opposite of ours today. Despite the term the "Gay Nineties," denoting a golden age of Gaiety Girls and Stage Door Johnnies who drank champagne from the slippers of their inamoratas, these were the waning years of the Victorian moral order. The sense of individuality that we promote today would have been completely out of sync with the rigid social conventions of the time. During the Victorian era the ordinary individual was secondary to the overall order of things. Class and seniority were considered good enough reasons in themselves to command respect, and while beauty and fashion had always been of importance, they were originated by one's betters, to be imitated according to age and social station.

These were the days of the Belle Époque. For some, they were days of opulence. For others, engaged in ill-compensated toil, the growth and prosperity that characterized the era were illusory.

In America, the rich looked to Europe for refinement, art and fashion, and those who could afford it made frequent trips to trawl for art treasures and for clothes from the pioneer of modern couture Charles Worth. America was going through a grand process of urbanization, and New York, being closest to Europe, was the principal city. In New York it was the era of the 400, the *crème de la crème* of New York. It included characters like the legendary Mrs. Stuyvesant Fish, who would enter a party wearing a floor length double row of pearls with a huge pigeon's blood ruby on the end and kick it across the floor just to demonstrate her enormous wealth.

Other members of this elite included the August Belmonts and the famous Vanderbilts. They all visited the fashionable Rhode Island resort of Newport and knew everything about each other. In February 1897 the Bradley Martins threw a party at the Waldorf Hotel at a cost of $368,200, attended by guests wearing costumes costing up to $10,000, while thousands of unemployed poor roamed the streets of neighboring districts. This "high society" had liveried servants and lived in palaces, but were surrounded by untold deprivation. Just a few streets from fashionable Fifth Avenue, there was a shanty town that stretched about 60 blocks or more.

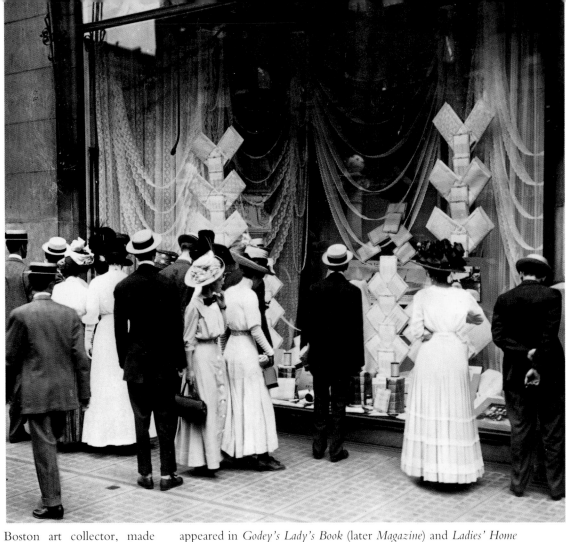

right: Marshall Field's Department store launched a new age in shopping.

left, above: Interior designer Elsie de Wolfe at home in New York, 1896.

below: The Belle Époque was a time of relaxed prosperity for the upper classes.

Isabella Stewart Gardner, the Boston art collector, made Bernard Berenson famous, through her fostering his talent and bankrolling him, in order to buy the best art in the world. She was a little *de trop* for the Boston Brahmins as she was a keen customer of Mr. Worth and an even more zealous supporter of the Boston Red Sox. She bequeathed her home full of art to become one of the most atmospheric museums in the US.

The 90s were also the days of the Buccaneers, the young ladies from America who came to stalk their male prey on the grouse moors of Britain. As long as there was a decent size castle attached to a bankrupt peer looking for an injection of new blood and new money, huge inheritance could be traded for a prestigious title.

Although there was a large and burgeoning middle class in both the US and Europe that was beginning to develop and then subdivide, people were continuing to come to the cities. For the working class, conditions were appalling. Jacob Riis published his book *How the Other Half Lives* in 1890. During the next 20 years a few privileged women did much to improve conditions in the slums and establish schools.

In America, there was as yet no real distribution structure for home produced luxury goods. Although the first department store in the world, Marshall Field, had opened in Chicago, most people throughout the land bought everything from dry goods stores, and in smaller communities where customers were usually known to the shopkeeper, often on credit. Women either bought their clothes from stores, or made their own from the paper patterns that appeared in *Godey's Lady's Book* (later *Magazine*) and *Ladies' Home Journal*. Charles Worth also had a lucrative pattern business.

In Britain the economy was prospering, enjoying the double advantage of an established world empire and an industrial market that continued to diversify. There was a full quota of middle-class buyers and, as they became more prosperous, women were targeted for sales. Traditionally, middle-class married women in Britain had been used to a certain amount of economic power, and the freedom to use it for luxury goods—within the moral bounds of the time—so the advertisers concentrated on their tried and trusted methods.

Other women were joining their consumer ranks, as more were employed as office workers, shop assistants and teachers in the huge number of schools being established. Working-class women had always worked of course, and many petit bourgeois wives had known the considerable hardship of having a job to do in the family business, as well as having to manage all the housework and childcare themselves with little or no help.

Despite the machine age being at full throttle, there were artisans making beautiful objects and luxury goods at cheap labor rates. The Victorian love of decoration, as in the arts and crafts movement, is due in part to this. And whereas ideals of beauty had previously been set by the social elite, there was now a need for these criteria to take into account the new individual consumer, and for the ideal to change regularly in order to create new markets.

1990-
1980-
1970-
1960-
1950-
1940-
1930-
1920-
1910-
1900-
1890-

COSMETICS **BODY SHAPE & UNDERWEAR** **WORK & PLAY**

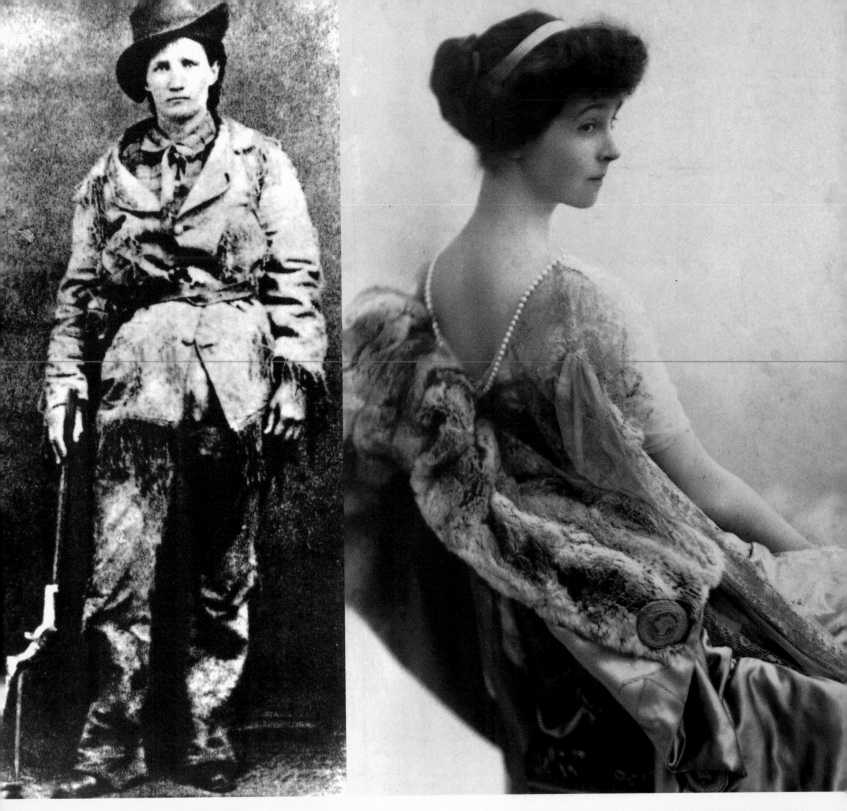

CALAMITY JANE

was a hard-gambling, heavy-drinking, tough-fighting frontier woman, famous for her affair with "Wild Bill" Hickock, but not notably concerned with feminine style, contrary to her portrayal by Doris Day in the 1953 movie.

CONSUELO VANDERBILT

was one of the rich young American women who married into the British aristocracy. Duchess of Marlborough, she was famed for her beauty, as captured in photographs and portraits painted by the likes of John Singer Sargent.

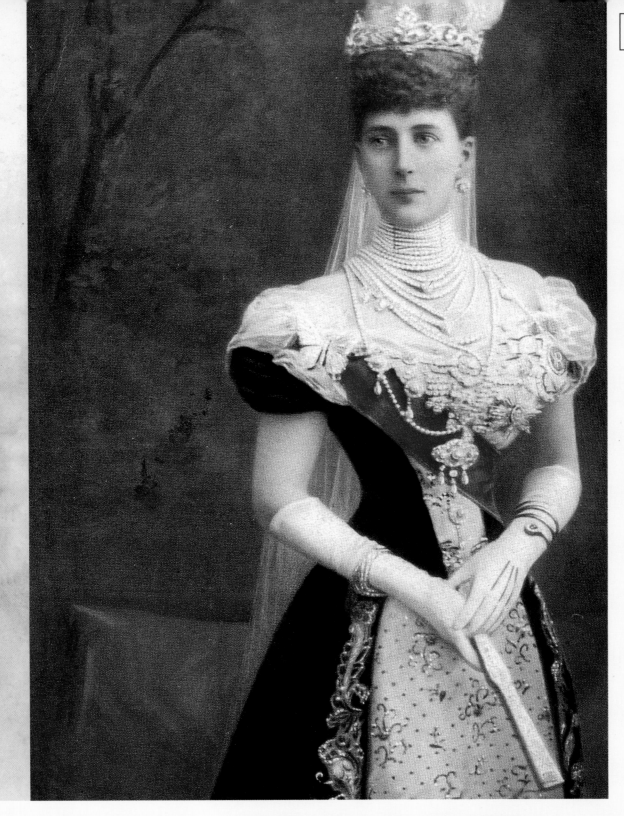

1990-
1980-
1970-
1960-
1950-
1940-
1930-
1920-
1910-
1900-
1890-

PRINCESS ALEXANDRA

epitomized the feminine ideal of the 1890s. The Danish-born beauty was always protected fiercely by Edward VII, despite his peccadilloes. Her portrayal, usually in state dress, was a benchmark for cultivated fashions of the era.

COSMETICS BODY SHAPE & UNDERWEAR WORK & PLAY

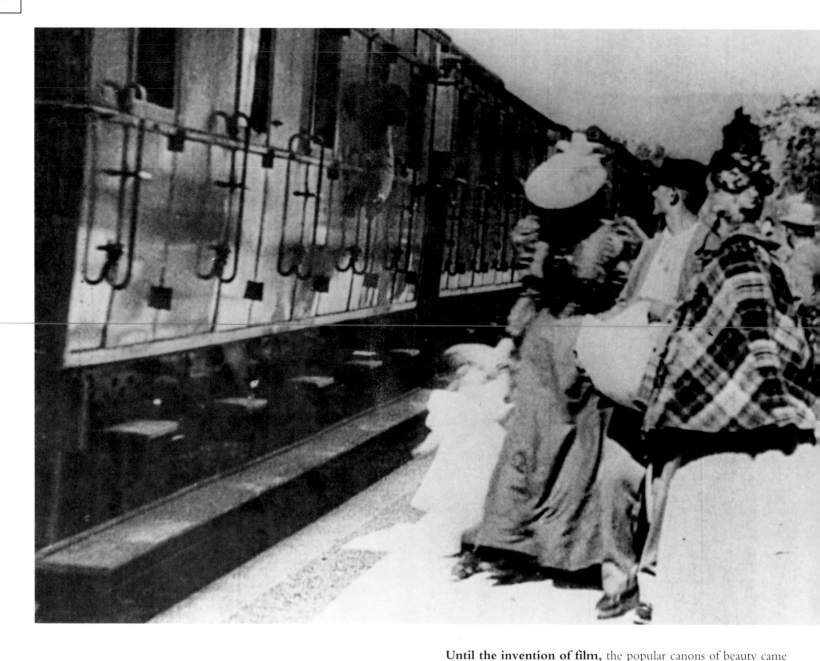

Until the invention of film, the popular canons of beauty came from the world of the stage and music hall. In the British society magazine *The Tatler,* pictures were published of aristocratic women and their families, usually accompanied by sycophantic, groveling captions. Permission to use such pictures was not granted lightly, the women knew they were very influential—they were the stylistic trend-setters simply because of who they were. Gradually, female performers from the theater and music hall began to appear on the pages, anxious to flaunt their new wealth and position. The actresses were dressed by couturiers as soon as they became famous, as they had a public image to think of. The magazine features thereby did unofficial PR work for the designers.

Actress Lily Langtry wore black in honor of her dead brother on virtually every occasion, until, finally, one day, when she had attained some success, she appeared in white velvet and people climbed on chairs just to catch a glimpse of her. Mourning could obviously help a poor girl's clothes go a long way.

Tastes in beauty were constantly under debate and liable to change according to the whims of a fickle public. Lily Langtry was not considered a great beauty by American standards; they thought her nose was too large. However, the favored nose shape according to *Godey's* in 1887 changed from small to long, while *Harper's Bazaar* pronounced that Grecian noses were now the most beautiful—though many of the great beauties of the age did not have regular features or looks that the popular culture of the day valued. With the arrival and establishment of film, the criteria of beauty were to change greatly. Obviously, to be at all successful in pictures one had to be very photogenic, to have good bone structure, but it was also important to fit in with the look of the time. Up to that point, the ideal was merely to look childlike, unspoilt and as though one had a warm, agreeable personality.

The technological evolution of film came at the same time as the arrival of the industrial developments in printing, which made it possible to publish and market illustrated books, magazines and newspapers on a large scale. It meant a double impact on a mass audience that acquired visual literacy at the same time many of them were learning to read prose. Words and pictures working together as storytelling devices took many of their explanatory methods from the magic lantern and peepshows, as well as actual visual jokes from the music hall.

In this way, the language of film was invented, and audiences marveled at how the passing of time and change of setting could be indicated through simple symbolism. As the medium became more sophisticated, it was possible to make people think that they were privy to the innermost thoughts of a character through montage, dream balloons and such, and even convey the illusion of a flashback in time.

The first films by the pioneering Lumière brothers show a train pulling into a station, a baby having breakfast and the Lumière factory workers leaving for lunch. *L'Arroseur Arrose,* one of the next films by Lumière, takes the old gag of the boy stepping onto the garden hose every time the gardener tries to use it. When the gardener picks it up to look down the hose, the boy unleashes a torrent of water that sprays the man in the face. The film goes one step ahead of the joke though, and the boy is shown later, being punished for his naughtiness.

In the late 90s, films like *Grandma's Reading Glass, The Kiss* and *Fatima* were not purely representational. They used montage to create drama and tension, and a new idea called point-of-view. By cutting from a distressed face to an awful scene, one gets the idea that the person is witnessing that scene. The eternal language of film became increasingly flexible and fluent.

There were further discoveries made during this time about lighting and design, but for most audiences, it was fascinating enough merely to see moving figures, let alone the technical tricks that were an integral part of film from the start. Radical changes in entertainment were not only novel in a technical sense, but they altered the way people perceived stories, through visual imagery—including beauty—and all in a very short period of time.

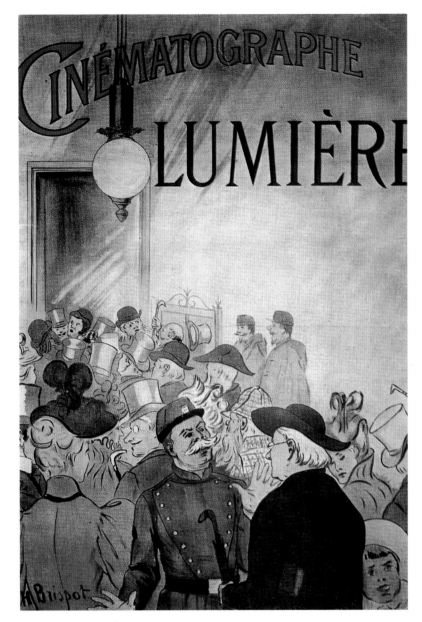

above: The French Lumière Brothers were highly instrumental in the advancement of the cinema.

left: A shot from the Lumière film depicting a train pulling into a station.

1890- 1900- 1910- 1920- 1930- 1940- 1950- 1960- 1970- 1980- 1990-

It is quite hard for us to imagine now that seniority and class were the prime basis of social respect, and therefore dowagers and matrons were probably the major movers on the fashion buying scene. They had a certain amount of money and freedom, and so enjoyed more choice than the single woman.

Like everything else at this time, there was a strict stratification of dress according to status, and women in general were used to quite a limited palette of colors—which was even more severely limited whenever a death in the family occurred. Mourning and half mourning were sensitive subjects to deal with, according to your relationship to the deceased, and if you were a young widow you wore black for a long while after, in order to keep potential suitors at bay and your reputation intact.

Charles Worth still reigned supreme in the world of fashion, and in *Harper's Bazaar* his lush clothes in velvets, rich with embroidery, symbolized wealth and luxury. They appealed to the rich, since they highlighted their position. The decade started with the last remains of the bustle, which developed into the hourglass shape with its huge sleeves and wide skirts making the waist look tinier than ever. Mid-decade, the sleeve became so enormous that it flopped and the S shape began to take hold. Bodices were high, and even the neck contained strict boning to make the chin jut out. The skirt was narrowed to outline the curve of the hip created by the corset, but became longer in the back.

Tailored suits also appeared, appealing to independent women and particularly women involved in philanthropic social work, so they became a sort of uniform for the enlightened. The new American college girl (an increasingly common type at this point) and working girls could buy these "tailor-mades" ready-made in the United States. Shirts and skirts were also quite a common sight, in part due to the success of the the Gibson Girl, the character created by fashion illustrator Charles Dana Gibson in 1890. With her hair piled into a chignon or tucked under a big hat, a starched blouse and flowing skirt, she represented the very trendiest ideal of fashion.

Jewelry was all real. For royalty, it would be by Fabergé or Cartier; for the rich, Castellani brothers; and for the intellectuals of the day, Arts and Crafts. Louis-François Cartier was close to Empress Eugénie and also Charles Worth, which brought the firm innumerable noteworthy connections. Lalique was also a big name. Family jewelry was of course always highly regarded, but the real Victorian taste was for rose-cut stones, which would very soon become old-fashioned. Tiaras were popular, and special advice columns were published in women's magazines about how to dress with them. Again, the mourning period required extra special consideration, and mourning jewelry with the loved one's hair in it was still a cherished idea.

above: A portrait of a fashionable young lady from the 1890s.

right, above: A fashion plate shows designs of huge sleeves and tiny waists.

right, below: Jewelry from the Tiffany catalog, 1890.

far right: Ensembles for walking, from the *Delineator*, December 1899.

Worth

Worth was still going as a fashion house, as was Jays and Redfern, which had been court dressmaker to Queen Victoria and Princess Alexandra. Originally a draper in Cowes, Worth achieved notoriety through Lily Langtry, and at one stage was so successful, that he had branches in London, Paris, New York and Chicago. He designed the 1916 women's Red Cross uniform, which was only minimally altered in World War II, and was very influential in the area of mourning clothes

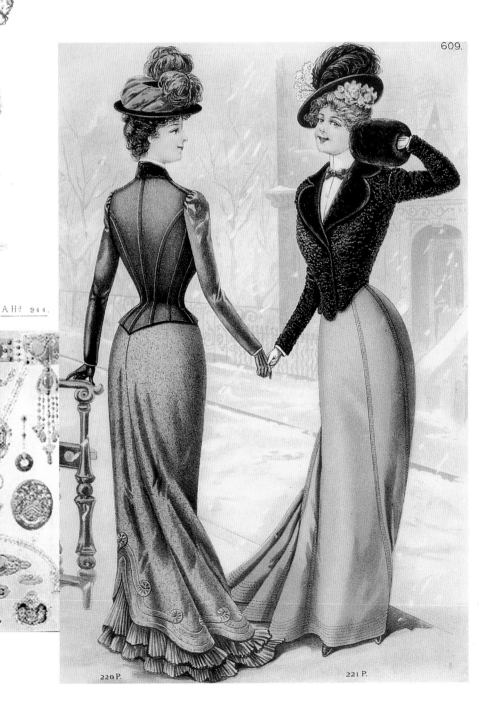

1990-
1980-
1970-
1960-
1950-
1940-
1930-
1920-
1910-
1900-
1890-

COSMETICS **BODY SHAPE & UNDERWEAR** **WORK & PLAY**

This Headdress is formed with two of U. & A.'s 21 - Tresses, and 21 - Fringe. Entire Headdress from £6 6s.

THE POMPADOUR, from 25 -

THE PARAGON, 21 - Natural Curling Fringes, not affected by the damp or sea air. Price from 15 - each.

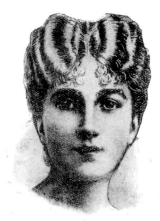

Coverings for thin partings ; perfect copies of nature. From £2 12s. 6d.

TRICHOBAMMA, a Fragrant Extract for imparting vitality to weak or falling Hair. In Bottles, 5/6, 7/6, and 12/6.

Our New Coil on Patent Handle Frame, from 35 complete.

The New Butterfly Fringe, especially designed for Ladies whose hair is thin on temples. Price 21 -

AURICOMUS FLUID, for Golden Hair, 2/6, 5/6, and 12 6 per bottle.

Rouleaux Curls, mounted on Comb forming pretty Headdress where lightness is required. Price from 15 6.

The Victorian woman's hair was her crowning glory, although, in reality, it was most likely to be in terrible condition. The use of irons was relentless, and the hair became seriously damaged, singed and like wool. Women never cut their hair except in the case of serious illness, but it must have come out in handfuls and quite often smelled scorched. French hairdresser Marcel Grateau had recently introduced his famous wave, which was achieved by applying hot tongs to produce a curl rather than a crimp. Done at intervals over the head, the hair would assume the look of moiré, or watered silk. It proved immensely popular, and the look was current in various guises right up to the late 1930s.

Curly hair was meant to indicate a sweeter temperament, while straight-haired girls were considered diffident or even awkward. Fortunately, false hair was used copiously and without apology. However, there were set ideas on how blondes and dark-haired women should style their locks. A woman's hair was profoundly important to the overall effect she was able to make. Reaching the age when the hair could be put up was a rite of passage in her life, and often there were several interim stages, where a plait would be loosely put up with a ribbon, to signify the coming event.

Dyes, not surprisingly, were abhorrent to Victorian sensibilities, but even so there are several accounts of women who did use them. While a commercially produced dye was considered beyond the pale, beauty authorities advocated the use of rust, herbs and the most putrid homemade tinctures to be applied to the head. Gray hair was considered very attractive, particularly if premature, since it was felt to make the woman look younger and softer. Hair powders were very popular for evening, as were "beauty spot" patches.

The fashion at the beginning of the decade was for a tight, frizzy little head. This gradually loosened into more swept up styles with a larger overall effect, to make the neck appear longer, more fragile and less able to support the weight. The change of shape coincided exactly with the change of clothing shape and the gradual change to floppy, floaty styles of dress, and the more relaxed, colorful climate anticipating the start of a new century.

Hats were extravagant, often with huge numbers of feathers. There were scare stories even then about the impending extinction of birds, due to millinery crazes. Sailor-type hats, flowerpot shapes and little pert straws were all sought after until the 1900s when millinery went really mad in size, decoration and veils. Dimensions on the whole matched the clothes—narrow, upright and overstuffed.

left: Hats were large and extravagant, highlighting a delicate neck and shoulders.

above: An advertisement for hairpieces from Unwin & Albert of Regent Street.

right: Many women curled their hair, as it portrayed a sweeter temperament.

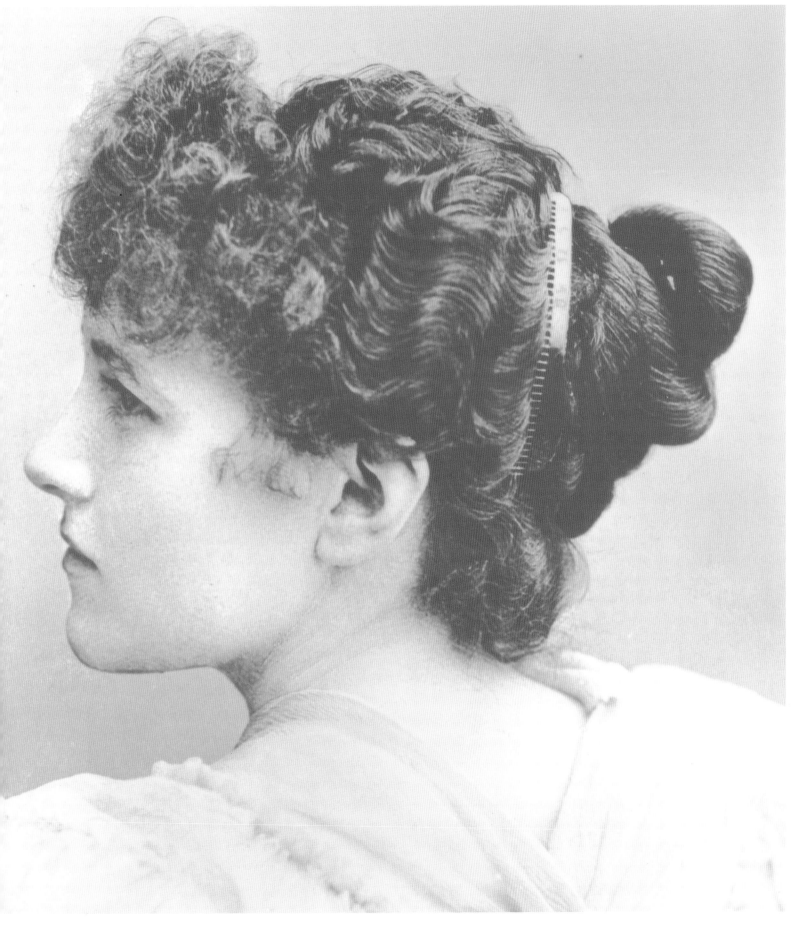

1990-
1980-
1970-
1960-
1950-
1940-
1930-
1920-
1910-
1900-
1890-

COSMETICS **BODY SHAPE & UNDERWEAR** **WORK & PLAY**

right: The so-called natural look of the 1890s was often brought about through hours of hard work.

below: Guerlain's Jicky shocked Victorian sensibilities with its unusual smell of sandalwood and tonka bean.

Due to the closely held moral dictum of the Victorians, the idea of cosmetics was frowned upon, but cologne and preparations from the dressmaker had long been considered acceptable, provided they were for the health and not vanity. This "medicinal" approach, a familiar refrain throughout the next hundred years, has its roots in this moral reasoning. Beauty therapists in the 1990s wear white coats and see clients in consulting rooms, assuming the mantle of physicians telling us to look after ourselves; if we do as they say, we are not vain, but health-conscious. As the history of cosmetics continues, women become gradually less reticent about the pleasure they get from adorning their natural beauty, but in the 1890s it was justified as not being seen as slovenly, as a "slattern."

In 1896, English critic Max Beerbohm published *Defence of Cosmetics*. With a feeling for the *fin-de-siècle* impatience for change, he wrote:

> For behold! The Victorian era comes to an end. . . . Are men not rattling the dice box and ladies dipping their fingers in the rouge pot? . . . No longer is a lady of fashion blamed if, to escape the outrageous persecution of time, she fly for sanctuary to the toilet-table; and if a damsel, prying in her mirror, be sure that with brush and pigment she can trick herself into more charm, we are not

angry. Indeed why should we ever have been? Surely it is laudable, this wish to make fair the ugly and overtop fairness, and no wonder that within the last five years, the trade of the makers of cosmetics has increased immoderately—twenty-fold, so one of these makers has said to me. It was not only morally wayward to try to conceal rather than highlight what God gave you, Beerbohm and others refer to it as "trickery."

It could be risky to buy commercial beauty products, you never really knew what they contained. Makeup had been applied for centuries before the Victorians, but was made with corrosive, caustic and poisonous substances. Reputation was paramount for a company, and because discretion was all, the customer could be a victim with very little recourse. There are even stories of customers of early beauty parlors around this time being blackmailed! Women were generally advised to pay as much as they could afford for makeup, to ensure quality.

Home remedies were considered the answer, because, not only would they improve your looks, it was also a "dainty and satisfying reward," as if by working at it the home brewer would somehow be morally better and a little more deserving of the right to wear it. Looking at the constituents of some of these recipes, it was in fact completely foolhardy—it was like giving a chemistry set to the unschooled. Recipes required such ingredients as alcohol, mercury, glycerine, borax and bleach.

The other risk of DIY was embarrassment. Most of these whiteners and unguents were as thick as modern face packs, and you simply could not afford to change your facial expression, or all would be lost! The colors were rudimentary, so women who did wear these products probably ended up looking like a lot of grim, bruised clowns, afraid to say a word in case the chalk paste cracked like plaster all over their face!

Harriet Hubbard Ayer—independent woman and divorcée, bought a face cream prescription on one of her trips to Paris in 1886. A consummate saleswoman, she convinced her next husband to back her in business promoting this cream, which she claimed was used by Juliette Récamier, a leader of French fashion in the first half of the century. She even wrote a fake testimonial supposedly by the long-deceased Mme Récamier. Ayer also became one of the most authoritative beauty journalists of the age. About whiteners, she warned that "a sweet and modest woman should be careful to an extreme degree in using artificial expedients during the daytime. The manifestly made-up woman is too atrocious a blot on the landscape to even discuss. At night, for the home dinner as well as for opera and ball, the artificial light makes it possible for a woman literally to put on her war paint." The fabulously wealthy Mrs.

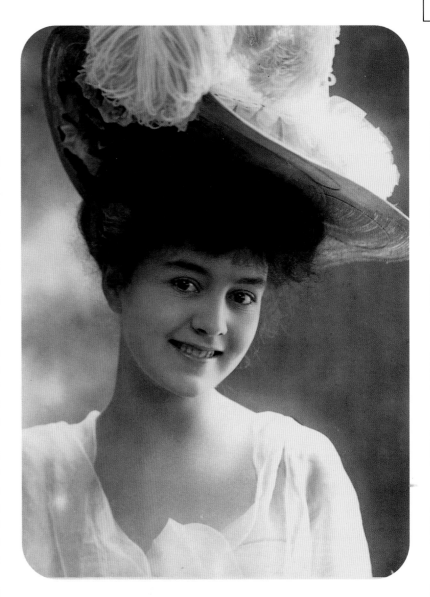

Stuyvesant Fish was well known for her tolerance towards young girls who wore whiteners to her parties. Strictly, she should have sent them home, but didn't. No one was going to argue with her!

Harriet Hubbard Ayer, in her book *My Lady's Dressing Room by Baroness Blanche A Staffe* "translated by Mrs Hubbard Ayer," says "A woman who is indifferent on regarding her own appearance cannot hope to preserve the admiration of her husband. On these points a man loves to be deceived and he is right. What is life, what is love without illusion?" Her faith in the sisterhood is feint to say the least; however, since she goes on to say "It is always another woman who first tells a man that her sister uses artificial colour or stains her hair." and later, "It is the plain, unadorned and weary, and too natural a woman whose husband invariably falls a victim to the wiles of a Delilah or succumbs to the artificial charms of a Jezebel. The very man who will almost fall in a fit at the sight of toilet powder in his wife's dressing room, will break her heart and waste his substance in the worship of a peroxide or regenerator Titian-red blonde."

Rouge was inconceivable, even though there were still men around from the dandy days who wore it with asperity. The beauty "authorities" were unanimous—people never know when to stop with it! Nevertheless, for the determined there were recipes with beetroot, strawberry juice, carmine and cochineal, all found in the kitchen. Cream rouge could be bought commercially, available in little balls of silk or gauze on a stick of ivory or wood, which one dipped in water or alcohol and applied to the face.

The secret and devious practice of making up was not confined to the face. The décolleté low neckline was of prime importance, and many women powdered and "shaded" the bosom. Skin care techniques were plentiful for this area, too, since the bloom on this part of the skin was as important as the face. Veins were accentuated, by painting them in blue to make the skin look more delicate.

The New York Hospital had been practicing plastic surgery since 1826, and in Europe experiments had been taking place since the 18th century. More and more doctors were now pioneering the science, and there was considerable interest in the correction of ill-shaped noses and deformities.

Hygiene at the time was poor, and scents were much used to mask odor. Many of the scent companies had been established in the 1700s, like Yardley and Lenthéric, the latter running an extremely risqué advertising campaign in the 90s of a woman in her petticoats, ankles showing at her dressing table, hair down. Guerlain was popular, too, because it was used by Empress Eugénie. Their Jicky, introduced in 1889, was quite a shocking change from the flowery Victorian scents people were used to, as it contained the unusual ingredients of fern, tonka bean and sandalwood. Worth also sold fragrances, as a complement to his clothes.

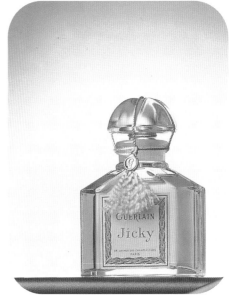

1890- 1900- 1910- 1920- 1930- 1940- 1950- 1960- 1970- 1980- 1990-

COSMETICS **BODY SHAPE & UNDERWEAR** **WORK & PLAY**

right: Being squeezed into corsets was no easy task, often needing two pairs of hands.

below: Advertising for ladies' outfits.

bottom: A medical advice journal shows the difference between a well-corseted and badly corseted waist.

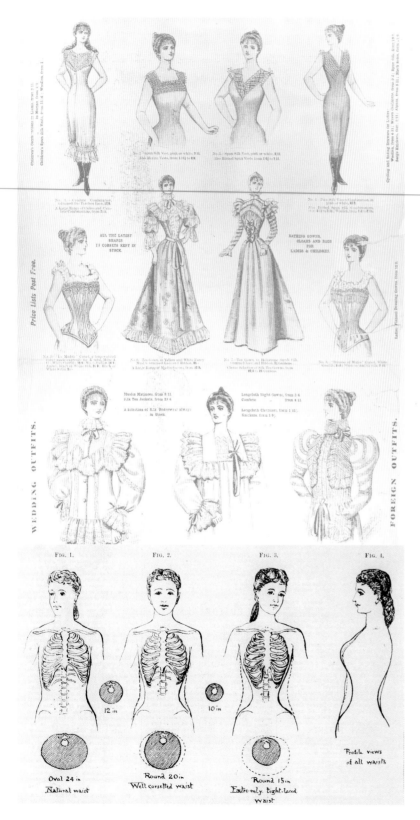

The last vestiges of the bustle remained into the 90s, to be replaced by the hourglass figure, but by the end of the decade, the S shape silhouette was everywhere. Crinoline, used since earlier in the century, had created an important protected space to symbolize the vulnerability of womanhood, while Victorian man remained a dark, thin, authoritarian figure. Now it was left to the corset alone to emphasize the fragility of woman and to accentuate her physique in a painful and deformed-looking manner. It pushed the chest up and out, while flattening the thorax and pushing it down and under. It prevented her doing very much physically: it was the role of well-off Victorian woman to appear to be pale and languishing, as the muse, not the artist.

In the 1880s the intellectual movement had taken the loose and flowing Grecian robe as their preferred garb, and women had worn loose and flowing garments as respite from the corset when alone together. This idea was to be promoted shortly by Lucile and Poiret, but for the moment women remained trussed up and suffocated in the name of propriety.

The bosom was low and heavy, with no cleavage, and was likely to be heavily bolstered, with ruffles over the breasts sewn onto the corset, or even a pneumatic bust! The high neck and leg o'mutton sleeves were for daywear. For evening, off the shoulder numbers with two sets of straps—on the shoulder and off—highlighted this desirable bulk over the bust. It was balanced by the same shaped whaleboning on the bottom as the top, a large padded posterior and plenty of petticoats.

The wearing of a corset had considerable moral connotations. To forsake it was to "let yourself go," in the truest sense. It really would not be excusable unless one was in the advanced stages of pregnancy, in which case it was not possible to allow oneself to be seen, even at home. To be straitlaced is quite literally to be upstanding and morally invincible.

Breast piercing was a short-lived trend that defies belief in view of the strict morality of the times. Tiny gold or jeweled rings were fixed on nipples, said to improve the bustline, make it curvier and produce a pleasant sensation brushing against fabrics. It is strange to think of those very uptight matrons hiding such secrets.

The Victorian preoccupation with ankles persisted, and the only way to see them in the open was to go to the music hall. The most popular beauty of the era was the music hall star Lillian Russell:

"She was a voluptuous beauty, there was plenty of her to see. We liked that. Our tastes were not thin or ethereal."

Lillian Russell had a reputation for the amount she ate, and by the end of her career she was huge, but it didn't worry her beloved audience. They preferred a bit of *avoirdupois* in those days, and a thin woman was considered mean and sour, while the curvaceous girls were the good marriage prospects, supposedly having the sweetest nature and good humor.

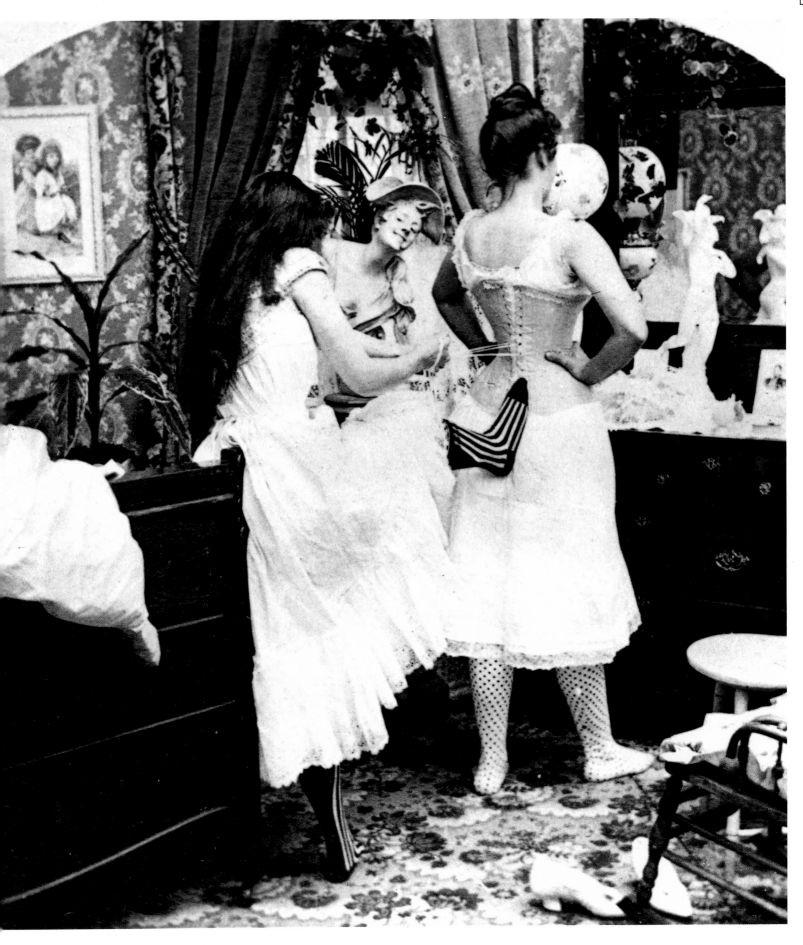

1990-
1980-
1970-
1960-
1950-
1940-
1930-
1920-
1910-
1900-
1890-

COSMETICS **BODY SHAPE & UNDERWEAR** WORK & PLAY

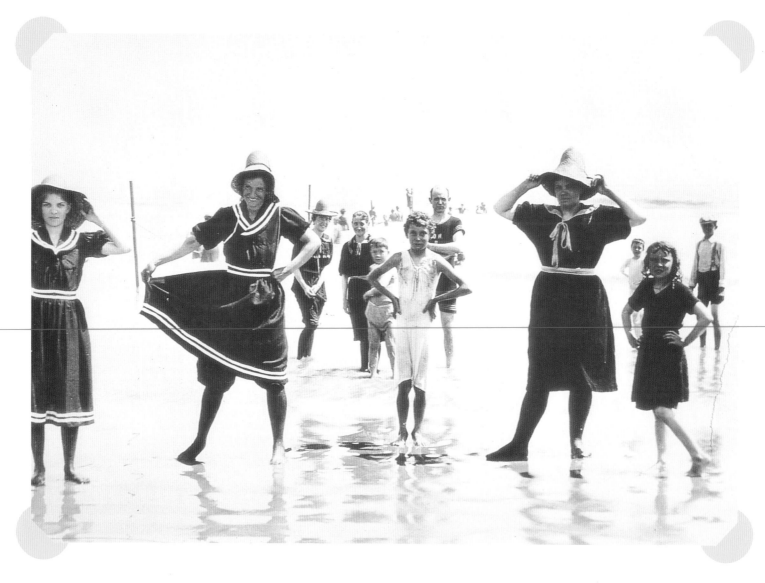

The industrial society had been creating great prosperity for many. These nouveaux riches and middle-class people wanted not only the best goods, but new activities to occupy their new leisure time. These activities would ideally afford them the opportunities to pose and parade endlessly and show their new social profile. For the young, it meant that meetings were possible with people outside the home and the ballroom. For women, particularly women who worked or wanted to be active physically and intellectually, it was quite literally liberation.

The difficulty though, for women, was what to wear. In the UK and Europe, the norm was an adaptation of whatever men wore for the particular sport, yet still giving an impression of fragility and helplessness. In America, the approach was much more forthright from the beginning. Girls favored tailored suits worn a bit shorter than the norm, worn over trousers, boots and maybe a cape in the winter, or shirts and blouses and bodices tucked inside the waistband of the skirt to form the S shape. Some decoration of lace or white embroidery was usual. These were called lingerie dresses, and were worn by everyone at the posh resorts, regardless of age.

Women had been climbing and crossing glaciers for a couple of decades in long skirts and even crinolines, in normal shoes or boots and thin silk stockings—an amazing feat in itself before one even thinks that they were laced into impossibly tight corsets. Then by the 90s the bicycle had really caught on and presented quite a dilemma about what to wear. It was felt that something practical was needed, since the chain could be dirty and stain the clothes, but Amelia Bloomer's invention of the divided skirt was originally scorned for its boldness and inelegance. In the 1890s, Viscountess Harburton set up the National Dress Society to try to bring women's sports clothes into line with men's, and get it made acceptable for all sports, and by the second half of the decade, the divided skirt was accepted as the alternative and worn with a jacket. It was difficult to sit on a bicycle in the S shape corset so, on health grounds of course, a woolen one was advocated, the first in a long line of special sports underwear requiring different fabrics for the ease of breathing. Many women could not afford all these accoutrements and many pictures show them wearing a simple white blouse and dark skirt. All sorts of girls and women found a new freedom in bicycle riding, and even took vacations on them.

In Britain, girls began to enjoy croquet and tennis, in private, of course. Women had felt it necessary to play in bustles during the 80s, but now, although the bustle was no longer fashionable, a long

trailing skirt was the uniform, along with the blouses with huge voluminous sleeves and the usual tight corsets. In addition, a straw hat would be worn with elaborate decoration of flowers or feathers. Obviously, in such an outfit, physical exertion would be minimal, but this was the idea, since any real spirit of competition was most undesirable. Later in the decade, attempts were made to bring the costume more in line with the male equivalent; the boater, for example, was taken up with enthusiasm and, later, it was commonplace for women to wear a coat, skirt and man's straw hat. If the dress for tennis was an adaptation of summer garden party dress, the clothing for golf was the same as ordinary country clothing, that is to say, heavy tweeds, a heavy coat and huge cap. In 1897, there was a real competitive ladies' hockey game, the Ladies Golf Union was founded, and *Punch* pictured the "New Woman."

Bathing became popular, as many of the new rich bought villas by the sea, and in America, summered at the chic resorts. Costumes had changed little in 30 years, consisting of a plain one-piece dress with very short sleeves and even a low neck, although usually it went from the neck to the throat. This had trousers or knicker-bockers underneath. Laced-up ghillie shoes were worn, and a mob cap or knotted handkerchief over the head. Despite efforts to differentiate the clothes worn for bathing from other clothes, the corsets and stockings remained the done thing. These suits were made of serge and wool, to keep bathers warm in the cold sea! Victorian bathing was still, of course, strictly segregated by sex, and women would change in a bathing hut, or even a bathing machine, which was a hut on wheels, pulled by a donkey, which rolled down into the water itself to preserve the occupant's modesty.

Riding clothes were the only sports clothes to resist any change. This was because the woman's riding habit had already caused quite a stir in the 1700s. Women had fought to wear this form of man's dress, with its modesty "apron" added, and the women who wore it at that time behaved accordingly by swaggering and strutting around everywhere they went. Side saddle still prevailed, but taking into account that hunting was (and is) a class-conscious sport, it was probably a secret accolade to those who were newly advanced socially to join the local hunt, to be able to wear such a traditional and conservative costume.

The automobile, even today the ultimate status symbol and arbiter of modernity, was another occupation requiring an invention of suitable attire. The hats of the time were anchored on by large all-encompassing veils, which helped to keep out the grit and dust of the roads. Even special coats and blankets were designed to preserve warmth and comfort in a relatively confined space that was, nevertheless, exposed to all elements. Goggles were yet another necessity, swiftly adopted for practical rather than aesthetic reasons.

Thorstein Veblen coined the phrase "conspicuous consumption" in 1899, in his book *The Theory of the Leisure Class,* to explain how people must display their wealth and leisure. Hotels and restaurants became popular, vacations and summer houses were quite common, and the Grand Tour for Americans was the mark of class and money. Within the next hundred years, all these things would be within the grasp of almost everyone.

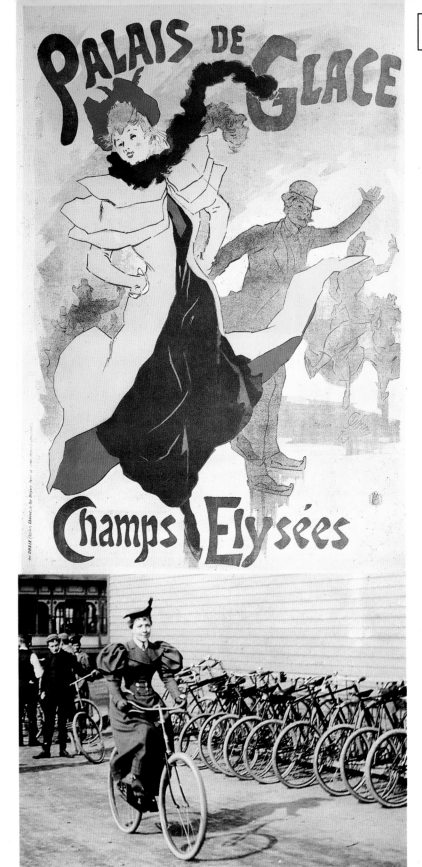

1990-
1980-
1970-
1960-
1950-
1940-
1930-
1920-
1910-
1900-
1890-

top: A Parisian ice-skating poster by Jules Cheret.

above: Cycling became hugely popular among young girls during the 1890s.

left: Bathers in Santa Monica, California.

COSMETICS **BODY SHAPE & UNDERWEAR** **WORK & PLAY**

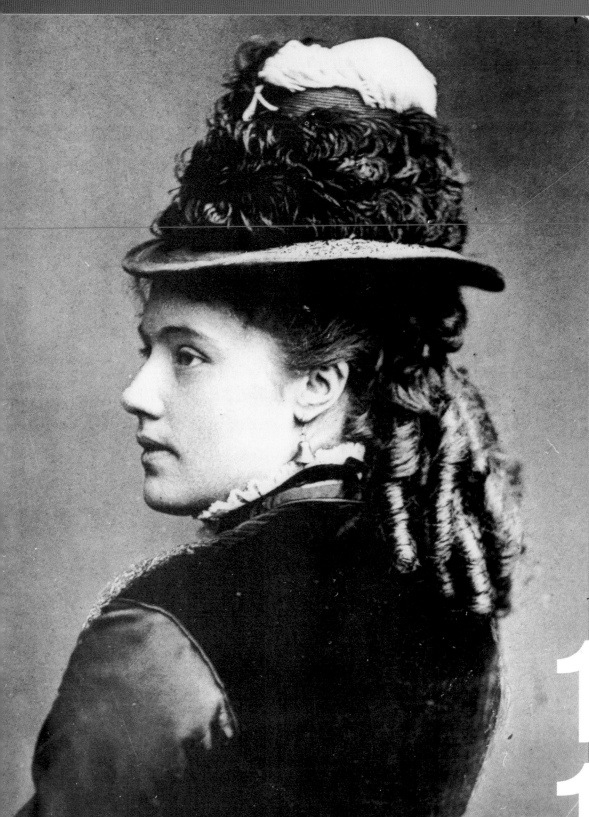

The invention of radio by Marconi

Impressionist painting at its peak

W.L. Judson invents the zip fastener

Art Nouveau first appears in Europe

The first American football game
played in the US

Queen Victoria's Diamond Jubilee

The War of the Worlds by HG Wells

Opening of the Paris Métro

Four-wheel car constructed by
Karl Benz

Radium discovered by Pierre and
Marie Curie

Introduction of the first automatic
telephone switchboard

1890
-1899

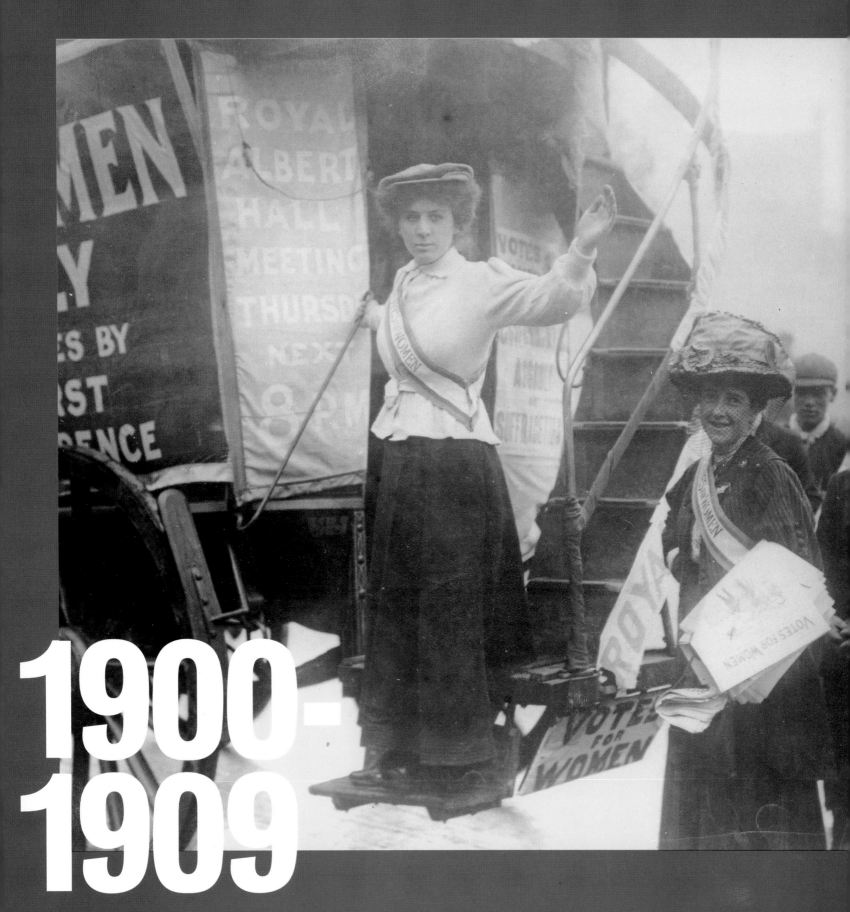

1900–1909

By the time Queen Victoria died in 1901, there was a craving for change for the new century, and it is significant that the birth of modernism occurred at precisely this time. Yet seen in historical and fashion terms, the 1900s are still part of the Belle Époque. The first decade of the 20th century was a very feminine and graceful period, which, despite its very ornate visual style, has a lot in common with the 18th century.

Paris was very much a catalyst at this time, since the world of art was taking over from literature as the chief expression of the times and the new ideas were concentrated in the French capital. Likewise Paris was being redecorated with Art Nouveau architecture, including public buildings from Métro stations to pissoirs, a style also appearing in the South of France, most notably in hotels like the Negresco in Nice. In New York, tall buildings, soon to be dubbed "skyscrapers," were the showpieces for the new era. The Flat Iron Building on Fifth Avenue was the first, along with a whole new district around it.

The Ritz hotel opened in London, signifying a new way of life that was evolving away from the strictures of Victorian values. People were now adhering to the new principles of conspicuous consumption with enthusiasm, and there came with it, as it widened, a competitive element. People were entertaining themselves and each other socially, outside the home, and in doing so welcomed any opportunity to see and be seen.

The World's Fair was held in Paris in 1900, and everyone who might be interested in what was happening went there to see the marvelous new styles and developments. It was a point of reference for all contemporary cultural events, where the *haute monde* met the *beau monde*. It was an important time for art. Klimt and Mucha helped to establish a definitive style for the age, while the Cubist movement led by Picasso and Braque was at an embryo stage. The whole period was rich with ideas and debate.

In other areas this awareness of new possibilities was awakening too. Einstein's first paper on relativity was published, and Freud and Jung were making waves with their studies in psychoanalysis and sexual repression, challenging traditional social attitudes irrevocably. The unenlightened were startled by the thought that women were sexually functioning beings too.

Night work by women was internationally forbidden at this time. The stricture gave rise to the phrase "ladies of the night," implying that the only females who were earning a living after the hours of darkness were those following the "oldest profession."

Elinor Glyn, sister of the famous dress designer Lucile, had her own great talent for fiction, and by writing her personal history, *Three Weeks,* produced the sensational novel of the age. The plot featured an "ugly duckling" heroine who is ostracized for her plain looks, but nevertheless had a happy ending. This went against the popular literary conventions of the period, in which the Edwardians preferred to sentimentalize childhood rather than to address the real issues, particularly on what were seen as such sensitive matters.

The suffragists became increasingly vocal, with many women joining the cause. It was not until the next decade that their demands would be addressed, and even then often out of necessity.

> **THE EDWARDIAN ERA SAW A RELAXATION IN MANNERS AND STYLE. THERE WERE NEW IDEAS IN THE AIR, AND WOMEN WERE BECOMING MORE NATURAL, MORE ASSERTIVE AND MORE INDEPENDENT**

LIFE & TIMES FACES IN VOGUE FILM & MEDIA FASHION HAIR & HATS

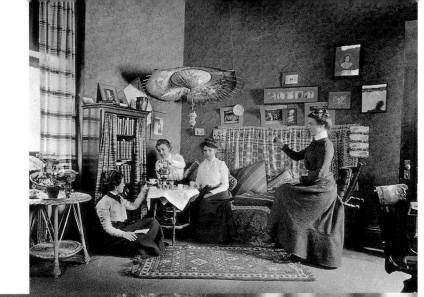

right: Female students in a dorm, 1900.

left: The Ritz Hotel, London, 1906.

below: Women at work, US, 1908.

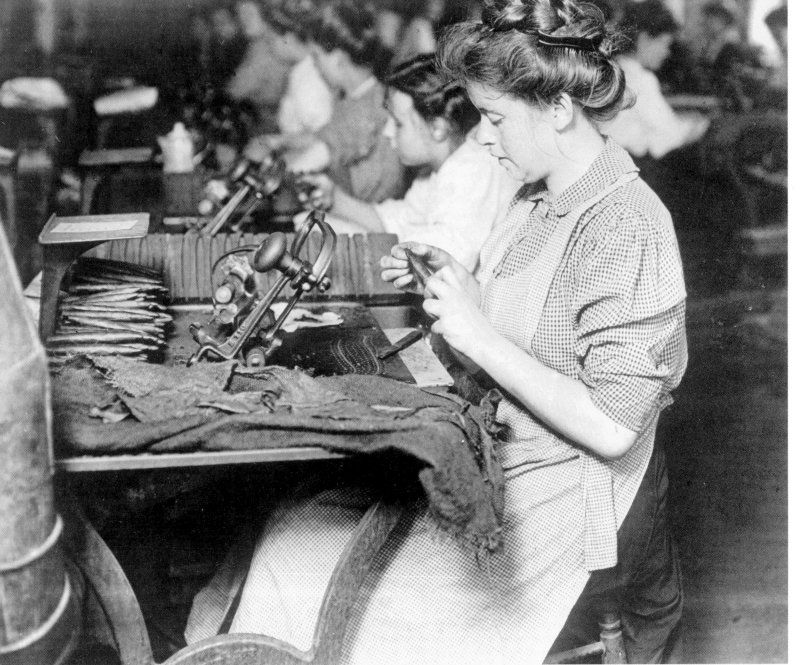

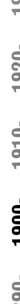

1990-
1980-
1970-
1960-
1950-
1940-
1930-
1920-
1910-
1900-
1890-

COSMETICS BODY SHAPE & UNDERWEAR WORK & PLAY

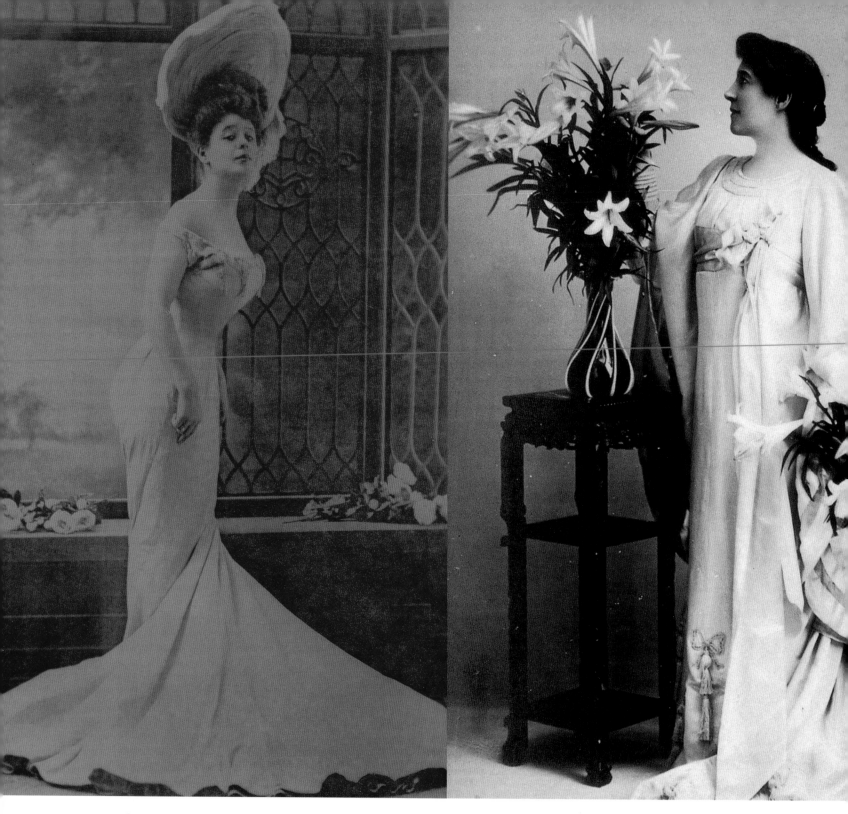

CAMILLE CLIFFORD

first appeared on the London stage in 1904, and rose to fame in Britain as the personification of the Gibson Girl. A legendary beauty with candy-box good looks and sweet nature, she was revered by press and public alike.

LILLIE LANGTRY

or Jersey Lily, as she was known, was one of the great loves in the life of Edward VII, and the public felt the same way. Her creamy blonde looks made her the biggest star of the day, hysteria breaking out when she appeared in public.

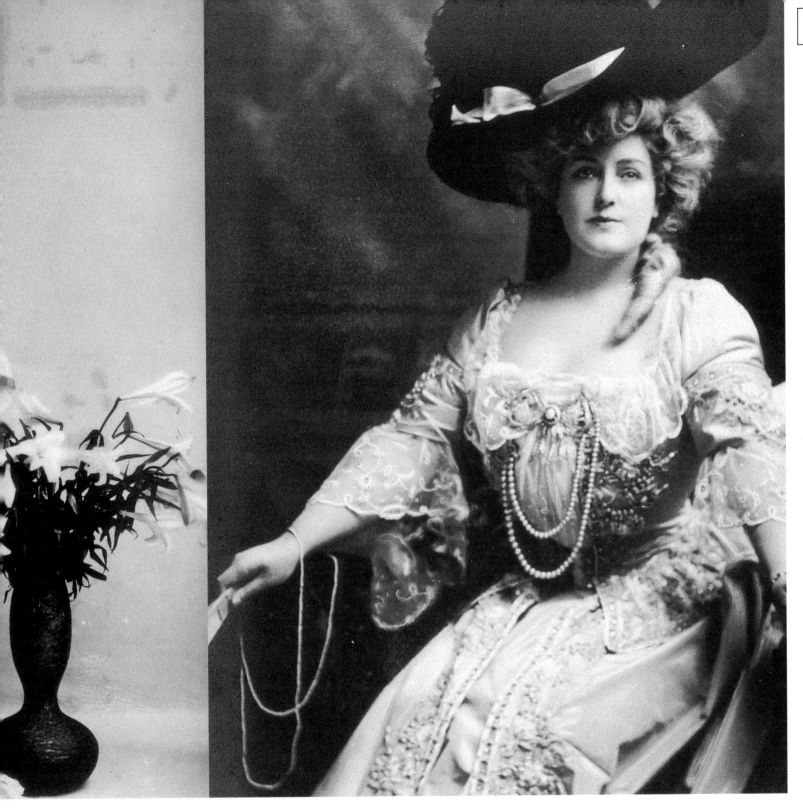

1990-
1980-
1970-
1960-
1950-
1940-
1930-
1920-
1910-
1900-
1890-

LILLIAN RUSSELL

was another favorite performer on the British music hall stage. Her ample proportions—"she was a voluptuous beauty, there was plenty of her to see"—reflected a public taste for well-built women rather than sylphlike waifs.

left: Gibson Girl, her strong, sporty physique and idealized beauty became a national obsession in America.

right: *The Delineator*, one of a number of women's magazines of the time.

THE DELINEATOR
A MAGAZINE FOR WOMEN
NOVEMBER 1909

The film world at this time was most concerned with marketing distribution rights and consolidation. Hollywood had begun to establish itself as a center because it was a convenient place to film. Most filming was done out of doors because of the need for maximum light; in this respect the climate of Southern California was perfect. Likewise it offered good locations for the fast-developing genres of action movies, particularly westerns. In 1907 the famous Lumière brothers invented color photography, bringing even more possibilities to the world of photography and film.

In Europe, the Pathé company soon came to dominate anything to do with film, manufacturing equipment for the industry, after acquiring rights to Edison's patent. The Gaumont organization got the rest, including film rights. In America, similar competition and consolidation was in progress, and the first production companies like Biograph were formed.

The development of film and its language can be seen clearly in the films of Edwin Porter; *The Great Train Robbery,* starring the popular Gish sisters, and *The Kleptomaniac,* a humorous little picture, are where it all began to get interesting. The famous *Le Voyage dans la Lune* (A Trip to the Moon) by Méliès demonstrated some of the possibilities in the special-effects department, and it is watched with wonder and affection even by today's more sophisticated audiences.

Colliers magazine had a "personality" who transcended all these films. The Gibson Girl, whose personification in Britain was the US actress Camille Clifford, and in America, Irene Langhorne, was a cartoon character created by the artist Charles Dana Gibson (who had married Langhorne in 1895). From 1890 to 1910 he used her to satirize the conventions of society with this emancipated image of woman. She was an active sportswoman and an enthusiastic driver who overwhelmed any man she was depicted with, by use of her beauty and sporting, competitive nature. The apex of contemporary grace, her clothes set the fashion for skirts and embroidered shirts in America. She won hearts through her vigor and energy in sport and irresistible modesty in any social situation. She was so popular that wallpaper featuring her face was manufactured for bachelors. The wit and economy of the pictures, with their high style was, and is, irresistible even when Gibson takes on the lower end of the social scale and the other stereotypes like "the old roue," and themes such as the parochial parents visit their showgirl daughter and the servant caught imitating the mistress.

The idea of photography was still less fashionable than portraiture. Society painters were doing a roaring trade. Philip de Laszlo, John Singer Sargent and Sir John Lavery were in their heyday. However that, like so many things, was about to change. *Vogue* was founded in 1892 and bought by Condé Nast in 1909. During the 1900s, 1910s and 1920s fashion was photographed, but it was felt that the medium was inferior to drawing. The drawings in magazines like *Femina* have the people participating in lifelike situations in real settings, portraying endless activities, such as the various types of *le footing*—walking—in town, in woods, at the resort and so on. They project a huge range of minutely differing activities, even "How to dress our baby nurses." London's *Daily Mirror* was very different from its image today, featuring *Country Life*-style pictures of young girls about to be married, which were very popular. *Punch,* as always, was influential in its satirical representation of modern issues.

Despite its growing popularity, cinema was still a novelty; it had yet to change lives. The female film addicts were not a known force until the 20s, and stage stars underrated the medium. There were so many new, marvelous theaters, hotels and opera houses that the grand social occasions still took place "live." There was a stigma attached to any variant on this, and many imagined that the enemy of civilization was the phonograph. But it was the bioscope, the early film projector, which would influence people's lives—fashion and beauty included—more than anyone could have imagined.

COSMETICS **BODY SHAPE & UNDERWEAR** **WORK & PLAY**

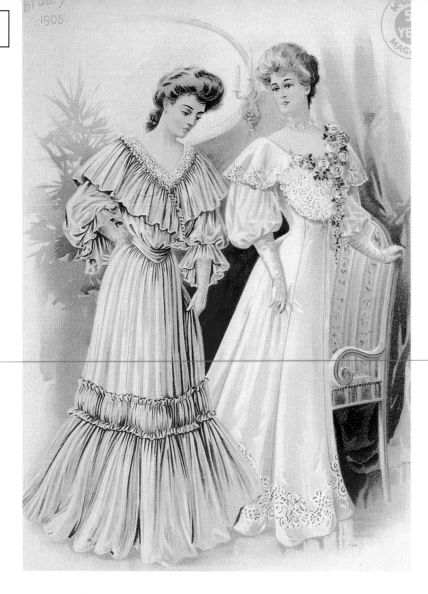

The fashions of the age were ultra-feminine, subtly different from those of the previous decade, in that everything was much looser and more graceful, and the clothes are characterized by a full-blown look. All the glamour, quite literally, went to the head, with the new looser hairstyles and heavy ornate hats.

The silhouette is much more floppy and the ideal was the mature woman. Young girls and single women were still confined to the simple, limited palette of light colors with little decoration until after marriage. "Tailor-mades" (suits) were much admired on both sides of the Atlantic and steadily gained in popularity. The suit jacket is noticeably longer in this decade than in the 1890s, and the skirt is straighter, but the mannish shape was quite clearly the new direction to take.

The S shape was in full swing at the beginning of the 1900s, but in 1908 Poiret introduced the new Empire line, and gradually the tortured corset shape, which reached its height in 1906, was finally laid to rest. With this new shape, there was to be a new approach to pattern and color, and things would never again be the same for the couture world.

Doucet was one of the foremost designers of the time. His clients were the great Réjane, who did publicity for him, and Liane de Pougy. Sarah Bernhardt wore his creations and he had a high profile, due to his instinct for the fashion of the time. He did not, however, survive the acid test of appealing to young women, since his style did not have the pure essence that the modern customers required. He bought the house of Doeuillet, another derivative artist, who survived principally on his publicity in the *Gazette du Bon Ton*. This publication charged its contributors, but for most it was a wise investment, but not enough to sustain them through the sea changes to come. Drecoll, another of these prewar dinosaur houses is one of the best examples of the over-elaborate and fussily detailed styles that did not make it into the modern age; although the clothes were greatly admired in their time, they were not classic.

A Mrs. Gordon, who wrote the *Gentlewoman's Book of Dress*, 1895, spoke for many when she declared about the aesthetic movement, that a dress for them was "a sack tied around the waist with string, with string and two smaller sacks for sleeves. Their hats are modelled on cabbage leaves." Yet these were now the height of fashion for everyone. Liberty of London was to pick up on this trend for "robes," as they were disparagingly called at first. It created its own style based on the aesthetes' ideas for dress with a modern twist, and their reputation was to last a long time abroad on the basis of this style of "arts and crafts" in clothes.

In 1908 Poiret and Lucile both claimed invention of the round neckline, and Lucile said she invented the Peter Pan collar. Both styles had actually appeared in store catalogs before either designer featured them. The V neck and the Glad neck, when women stopped wearing little modesty squares in the neckline, were also gaining popularity. But the influence of Poiret was growing, and fashion was soon to change irrevocably.

Thorstein Veblen in his *Theory of the Leisure Class* has a chapter on "Dress as an Expression of Pecuniary Culture." He talks about French heels, elaborate bonnets skirts, long hair and corsets, but not furs, which to any dress historian is a puzzle, because the 1900s were a time when fur came into mainstream fashion and, once there, dominated the scene regardless of season or purpose. Its one main function was to signify wealth. Other theorists have said it provided reassurance against lack of love. Whatever underlying social theory, the fact is that furs were worn as trimming, as stoles and, of course, as that hallmark Edwardian item, the wrap.

At the 1900 Paris Exposition, Mme Paquin featured newer items like teagowns and fur coats. One coat used 300 skins, cutting took 100 hours and 1,000 hours' skilled sewing. Now furs appeared regularly in collections. Doucet was one of first to use them as if they were fabric. Paquin usually featured a fur muff in her collection, even in summer; the heads and tails were especially featured in this era, as never before.

For glamour, it was definitely fur this decade that was hard to beat; Sarah Bernhardt dressed in fur-trimmed dresses and opulent fur coats in her open carriage, Réjane had a stuffed tiger and Elinor Glyn inspired the famous verse—

"Would you like to sin
with Elinor Glyn
On a tiger skin?"

For most men, the answer was yes.

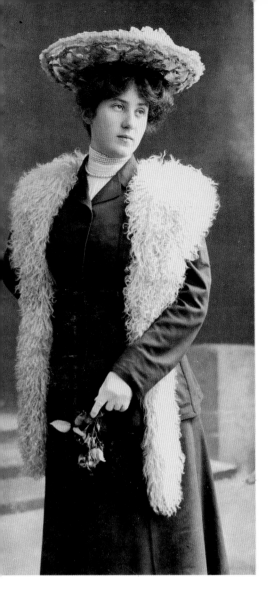

above: A fashion-conscious young lady from 1905.

left: Illustration from *McCall's Sewing Patterns*, February 1905.

Callot Soeurs

Callot Soeurs made luxurious clothes. Run by three sisters, the eldest of whom, Mme. Gérber was the principal personality. Their clothes were the most feminine of the time, they were the first to have lamé evening dresses and lace blouses with tailored suits. Inspired by the 18th-century painter Fragonard, they accessorized dresses with little Marie Antoinette aprons and furbelows, which, although not to our purist modern taste, are delicate and beautiful, ideal for the concern of the prewar fashion plate.

Lucile

Lucile, born Lucy Sutherland, was a colorful and inventive designer, claiming responsibility for the abandonment of the corset as well as the invention of lingerie and the bra. The sworn enemy of Paul Poiret, she was actually a real innovator, in that she was one of the first to introduce the teagown as a genuine fashion item, which she called a *deshabille*. This was quickly parodied in the music hall song "Isabelle in her Dishabel." These teagowns were now fashion proper, not just caftans for the afternoon women's only tea parties. She was also the first to make use of real live parading mannequins, and gave her creations lovely names. She later became Lady Duff-Gordon and had a business briefly in New York, before her retirement shortly after the *Titanic* disaster, of which she and her husband were survivors.

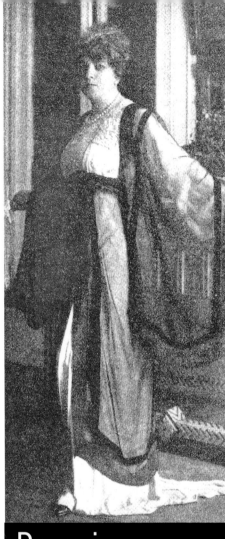

Paquin

Mme. Paquin, as she was usually known, was the first female couturier after Rose Bertin. She took her mannequins to events such as the races and opera, a brilliant public relations move for her company. She was the chairman of the fashion sector of the Paris Exposition. Her approach was a combination of the pragmatic and the intellectual, and she is seen by many as the original forerunner of both Jeanne Lanvin and Chanel. She sent her clothes to America, where she had a keen following, and also designed costumes for Paul Iribe and Léon Bakst.

1990-
1980-
1970-
1960-
1950-
1940-
1930-
1920-
1910-
1900-
1890-

COSMETICS BODY SHAPE & UNDERWEAR WORK & PLAY

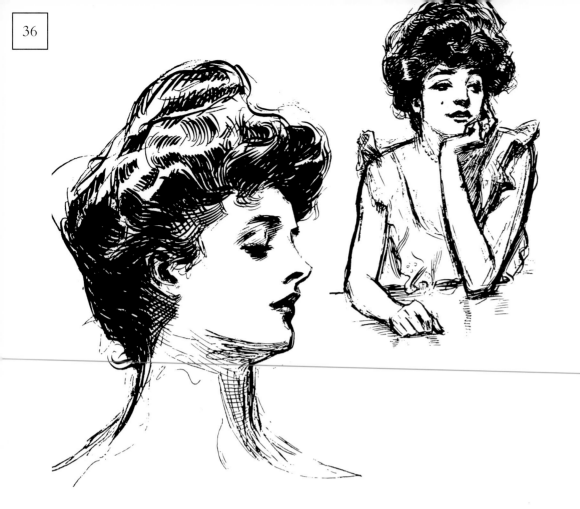

Fashions in hair, once established, changed little this decade. The main trend was for less frizzy, more full styles. The head looked enormous with the opulent coiffure and huge hats of the day. This Pompadour style, made popular by the Gibson Girl, was worn by almost everyone. The large waves and swept-up elegance was varied only in the amounts of fake hair added and the size of the pads over which the hair was laid, in order to achieve the necessary amount of height for the top-heavy style.

Decorations of combs, often with engravings, shells or even precious stones came in and out of fashion, while flowers were always popular. Fringes were additions that many liked to think about, but the main shape stayed rigidly the same.

Coronation styles were endlessly discussed in British magazines. How to wear one's tiara and how to care for the hair were some of the major preoccupations. Brushing the hair was an essential ritual in hair care, and glossy, shiny hair was washed more frequently than in any previous age.

The new penchant for baths and showers made this much easier to do. Bathrooms came in with the Edwardians, different taps labeled "sitz" and "plunge," complicated shower arrangements, or even separate showers. Bathrooms were huge, and modern fittings ran to heated towel rails, tooth-mug holders and frosted glass.

Gray and white hair were still in vogue, and the use of dyes was less widespread than it had been previously. A comb impregnated with color was used to enhance eyelashes or moustaches for men. It was later presented in crayon form and then as a cream. It was most popular with women and calls to mind Hair Mascara from Christian Dior in the 1990s. More popular was the first permanent wave from Karl Nessler in New York, who used the name Nestle. It took up to 12 hours and it was very expensive. Before, women had used irons and tongs or tied their hair in rags.

False pieces were advertised and back-combing was a means of making the soft fullness that had become so desirable. A column-like neck was essential for the style of the times, and hats become huge and heavy to accentuate it even more. Necklines started to be lower and décolleté for evening became more evident too, in order to achieve this contrast between the heavy head and the fragile neck almost incapable of supporting it. Little cotton squares were put in dresses to preserve modesty, but were removable. For the evening, plumes and bandeaux with feathers and jewels were ornate and very noticeable. The height of the ornament was accentuated by the depth of the décolleté.

Hats were not only larger than ever, but more elaborately trimmed, and were worn with an extreme forward tilt. A special *cache-pigne* was devised to hide the gap between the hair and the hat. The boater was still a great favorite, but the newest thing was the addition of huge veils over hats for motoring, for practical and aesthetic purposes. Hats got so enormous that extra-long hatpins were made with special butts for use in public places. They were so large that eyes were in real danger. Tall crowned hats finally came in after several tries, but the main shape was the cornucopia of flowers and bows that came low and wide over the eyes.

Mode 1909!!!

above: *An American Girl in France,* by Harrison Fisher, 1900s.

left: A young girl models an elaborate large hat, 1909.

far left: The Gibson Girl—the perfect example of style.

1990-

1980-

1970-

1960-

1950-

1940-

1930-

1920-

1910-

1900-

1890-

4

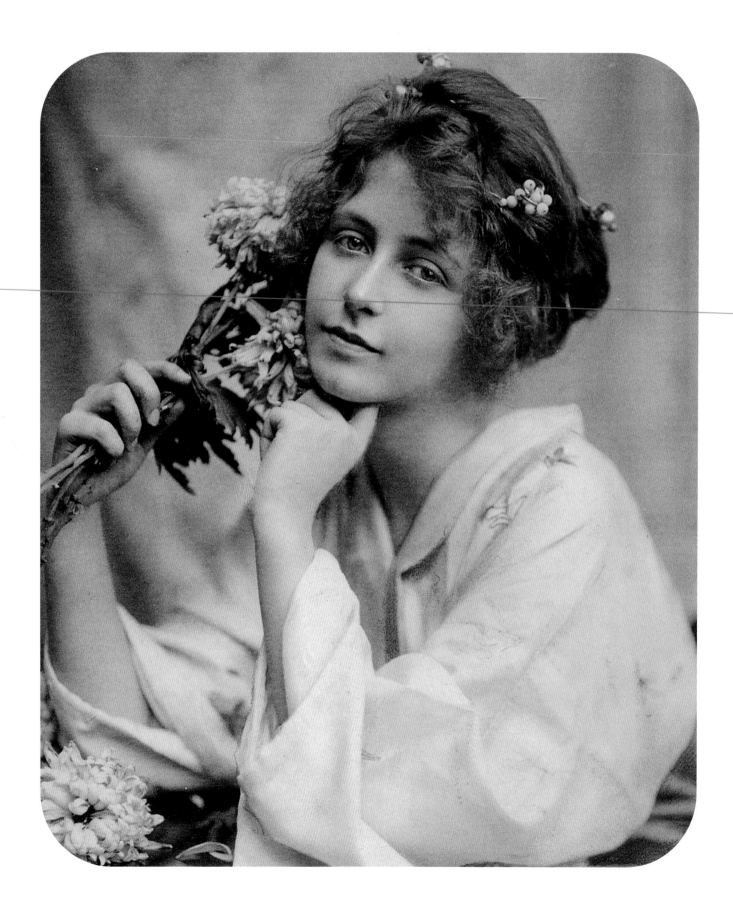

left: Despite a widening use of cosmetics, the natural look was still favored.

right: A detail from an advertisment for Dr. Lennox's Arsenic Wafers, 1901.

The beauty business was still concerned with liquid whiteners and creams at this stage. This tinting was now more acceptable; the combination with techniques of dainty coloring tricks was part of a woman's repertoire admired by others. They worked in a wider palette of color now: brown, yellow or purple diluted with talcum powder. Highlighting veins with watercolor was still a trick favored by many, since the pale, delicate translucent skin of the Victorians was the one everyone desired.

Commercial cosmetics of the age were products such as Vienna Face Wash, which was re-created in the 1980s by The Body Shop, and Blanc de Perles for a whitener. Japanese rice powder was another whitening agent, probably one of the least harmful. Cecil Beaton recollected that all women of his youth had the same deathly white powdered faces and sweet pea–colored clothing.

Rouge de Théâtre was the product now used for reddening the cheeks, its acceptability gradually strengthening. Birch balsam was used for covering pockmarks, more common then because there were no cures for smallpox and less serious ailments that left scars. Grecian water was a highly prized beauty commodity, as was liquid makeup when it appeared as powder substitute. It was hard to dry and took forever. Papier Poudre was the big seller to camouflage shine. It is still sold at The Body Shop today and is ever popular with the current obssession with matte skin.

All sorts of nail polishing pastes were on sale, but with no color as yet. There were also all manner of nonspecific hair removers and skin food, and rouge paste and the new talcum powders were very much in vogue. Arsenic preparations were said to be the answer for pimples, freckles, wrinkles, blackheads and a red face or sallow skin. There were pencils for lips and brows, and bust enhancers.

François Coty was becoming active in the world of cosmetics. When he went to a Paris store to demonstrate his new scent, he was refused permission to open it. He smashed the bottle on the way out, delighting everyone and demonstrating that he was not to be put down by the system, and went on to found one of the most influential and successful cosmetics empires in history.

Harriet Hubbard Ayer steadily churned out wonder treatments with great regularity. She had shrewdly gauged the public's hunger for "receipts from the nobility" and her La Belle Cocotte, an anti-wrinkle face cream, was a hit. There was nothing subtle in Mrs. Ayer's salesmanship, but it worked. Her main rival, however, a Mme. Leclaire, specialized in a confidential approach. She sold her "special recipes lost in the French Revolution" from her Fifth Avenue salon in an atmosphere of stagy conspiracy with the client, promising secrecy at all times.

In 1909, a new idea was put into practice by Selfridges. They were the first shop to display cosmetics, where the customer could experiment and play with colors. Powders, lip salve and rouge were attractively collected on the counter, whereas previously, they had been hidden under it and one had to ask specifically for them. At the same time, department stores became important not just for their wares but as a place to be seen. This was a decade of endless posing and parading. Being seen buying the latest ribbons and silks was a great opportunity, and these shops had an important social function that was to widen as time went on.

1990-
1980-
1970-
1960-
1950-
1940-
1930-
1920-
1910-
1900-
1890-

THE "SPECIALITÉ CORSET"

IS A DREAM OF COMFORT.

Thorstein Veblen, writing in 1899 in his *Theory of Leisure Class,* comments that "the corset was worn to suppress vitality, but to gain in cachet." The competitive element is always noticeable to him and he goes on to say that fashion is the obvious area for this to be most telling. However, now it was active in the unseen areas too.

With the end of the Victorian ethos, fine silk and other fabrics superceded cotton underclothes, and there was a certain amount of snobbery about this. Quality of fabric and splendor of decoration was all-important. The Edwardian age was a great one for lingerie. Eroticism was now possible, and the ankle was emphasized heartily with frills and flounces in profusion. Petticoats and underskirts were also plentiful. Suggestion, rather than definitive statement, was the real drive behind it all, and the cascade around the ankle meant that it was supposed to be seen in a sort of "accidentally-on-purpose" way. That little bit of leg was more thrilling than nudity will ever be!

The new corsets were smaller and straight at the front. The curves of the bosom were much more important than the hip. The new straight front corset showed increasing concern for health and fitness, but it meant that the bust had to be worn low, because,

being lifted from beneath, it wasn't possible to achieve any more uplift. So, women were "bow-fronted" with no cleavage visible. It was meant to be big and buxom, and all sorts of enhancements were available: pads, shapemakers to insert and frills starched and sticking out. Overhanging the waist, the Edwardian bust was the complete opposite of the uplift we desire today.

Lingerie was considered very daring, and silks and lace overtook the lawn, linen and cotton of the Victorian days. Underpants are barely recognizable to us as such, since they were just two long pieces, joined only at the back of the waist. Tiny tucks and detail at the back waistline and masses of lace and ribbons were the style, with legs very wide.

Lingerie was not cheap, but petticoats were extravagant. Clearly snobbery was rife; those who wore flannelette were "below the salt" and the underwear designed for sport didn't catch on, except among those truly dedicated to their health—it was patronizingly described as being "very worthy." The health cult had started, but followed only by cranks and the avant-garde. At this time, even children were corseted, it was meant to be good for them. These

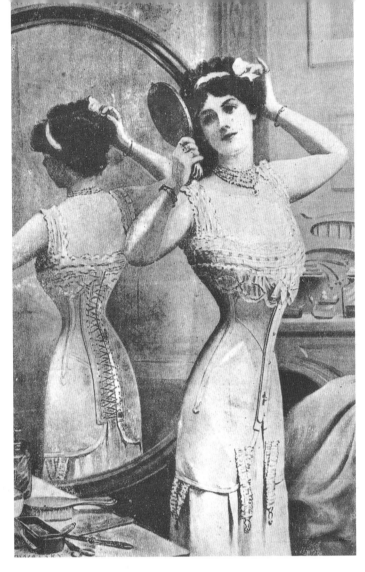

above and left: Corset manufacturers constantly tried to stress the comfort of their garments.

came back again. She then claimed to be the inventor of both silk stockings and the bra.

Lingerie was also promoted for those who were not as well-off as her customers; many people got hold of the shapes and then had them embroidered and made by a "little seamstress." However, for some, this was not good enough. Flora Klickmann in *Girl's Own Paper* and *Women's Magazine* wrote "The girl who will don badly machined, ready-made underwear, gaudily trimmed with cheap imitation lace, and garnished with bows of papery ribbon, is not only wasting her money in buying such garments, but is actually pandering to dishonesty, and encouraging herself to tolerate and condone what is false and bad—hopelessly bad.

The girl who takes a pleasure in making her own things (if she has the time) as nicely as can be made (whether by machine or by hand), putting fine, even feather stitching and such-like work into them instead of 'cheap and nasty' imitation lace and ribbon, is fostering a love of truth and sincerity, as well as cultivating a sense of beauty and fitness."

The ostensible morality of the time meant that women must be covered from throat to instep, yet it was glaringly contradicted by the strong hourglass silhouette. Woman was temptation, so social taboos must be upheld to stop the animal male getting at the weak, vulnerable female. Sexual morality was at the core of the morality of society, yet fashion was dictated by the *grandes cocottes,* or elite courtesans, of Paris. Paradoxically, too, fashion emphasized the shape of older women, thereby favoring them for the last time in living memory.

To be alone with a man could have disastrous consequences on a young girl. It was called "getting into a scrape." Minutes alone with a wolfish male might give people ideas about you. But in reality, very little could happen as the underwear was so cumbersome and there were so many layers, that it would take a considerable effort to reveal any body part at all. First you wore combinations, an undershirt and panties in one, with a back "trapdoor," then came the corset and/or stays, fastened with metal clips down the front. The back laced up to make the slender waist everyone wanted. Then, silk pads were attached to the hips and underarms, to create those voluptuous curves, and a camisole or petticoat bodice went over that. Then came a chemise buttoning down the front, gathered at the waist and trimmed with lace around the neck and on its puffed sleeves. The underpants buttoned at the waist or tied with tapes. Silk stockings were held up with garters or suspenders clipped to the corset. Finally, a petticoat of lawn or silk was laid on the floor in a circle, the lady stepped into it and tied it around her waist. The dress went on over all that, even in summer, and a stiffened belt with a clasp was worn and pinned up in back if a shirt and skirt were worn, so there would never be a gap between the two. Hat, gloves and buttoned boots and an umbrella finished the ensemble. It would be impossible to leave the house without a hat.

Brooches, earrings and a watch pinned to the bosom were the necessary characteristic adornments of the era. Several necklaces could be worn with a low-cut gown. One needed a bag and parasol in the daytime, and fan and flowers at night, as well as a warm wrap,

health corsets were the forerunners of the liberty bodice, which became the new alternative for children's underwear, and then of course it was followed by the undershirt. It is interesting to see that adult clothing has come to resemble children's clothing more and more this century. Even our underwear has come to imitate it.

Mrs. Eric Pritchard, in her book *The Cult of Chiffon,* said proudly then, "The corset of today is at its best, it is the most hygienic and beautiful little garment produced, chiefly because there is hardly anything to it." It may have been smaller, but it was still cumbersome and heavily stifling.

Lucile claimed to have started the passion for lingerie. "I was particularly anxious to have a department for beautiful underclothes, as I hated the idea of my creations being worn over the ugly nun's veiling or linen-cum-Swiss embroidery, which was really all the virtuous woman of those days permitted herself. . . . So I started making underclothes as delicate as cobwebs and as beautifully tinted as flowers, and half the women in London flocked to see them." She goes on to say that although everyone wanted them, they couldn't face it at first, but took them away in brown paper packaging and

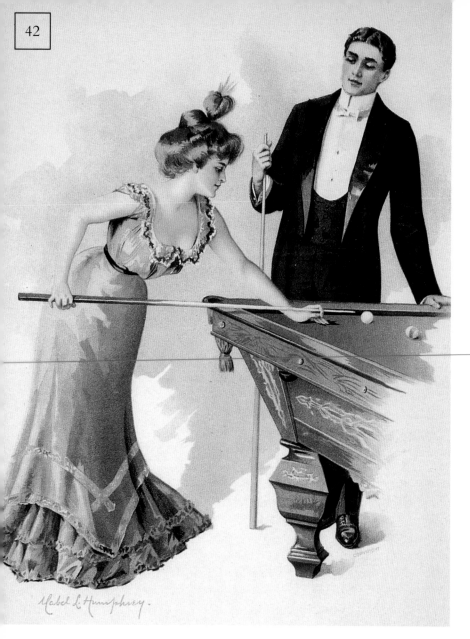

The profusion of new educational establishments for girls meant that the craze for female sports gathered more and more momentum. Sports was now an accepted and established way of meeting the opposite sex. Skiing, golf, tennis and even roller skating to music were all very popular pastimes. The Gibson Girl had a huge amount of influence, and as a result these sports were taken up with great fervor. But the car was the really modern thing to have.

The companies of Ford and Rolls-Royce were established, and 23,000 cars were registered in 1903 with a speed limit of 20 mph. In 1901, 15,000 cars were bought. In 1913, some 338,000 were bought, and they came with about 12 spare tires! Furs worn for motoring were becoming increasingly popular. Sable had started to overtake chinchilla for fashion, but for car use, lynx, opossum and fox were ditched for goat, bear, racoon, wolf and even sheep.

There was still no proper sports outfit suitable for most activities, apart from motoring. Although sometimes bloomers peeked out from beneath knee-length skirts, for women-only activities. With the full quota of petticoats and corsets, the bicycle was especially successful, because shoes with heels could be worn. Better guarded bicycle chains meant knickerbockers were not needed, so one could be elegant and cut a dashing figure without looking freakish or unfeminine.

Spectator sports became more popular as communications grew better, and the photography and film that reported them more sophisticated. In Britain, the annual Oxford and Cambridge boat race was so newsworthy that every child wore a blue ribbon of the appropriate hue to indicate their preferred team. But the horseraces were the prime place to be, particularly at Longchamps and Chantilly in France, and at Ascot.

The 1908 Olympics took place in London, and a group of girl gymnasts from Denmark were discussed ad nauseam. They could not win any medals or points, but their appearance made a huge impression on the general public.

"I Wonder Who's Kissing Her Now," "By The Light of the Silvery Moon" and "Temptation Rag" were the hit songs. Novelty dances like the cakewalk and turkey trot were short-lived crazes, and for those who could afford it, dancing to the phonograph became a hugely popular pastime, to the chagrin of the older generation who disliked its new-fangled connotations.

Card games were often played in mixed parties, and afternoon tea and "at home" occasions were everyday distractions. Tea parties, garden parties and enormous picnics were all things the Edwardians loved. There was an element of social duty attached to visiting people, and this had an etiquette all its own.

And for the English debutantes, presentation at court was a must—"coming out" was a big event in their lives, until it was phased out in the 1960s.

Biarritz was the top resort for the fashionable set, where one could expect to find the king and many members of the English court. There were numerous English clubs and a library there. Bournemouth and Rottingdean were the leading resort destinations in England. In America, the top resort was Newport, Rhode Island.

Ouida (Marie Louise De La Ramée) was among the most popular fiction writers with women, her romantic novels (45 in all) full of dashing heroes and brave deeds, and set in a fashionable world far removed from reality. Ladies Home Journal magazine was the leading ladies journal of the day—many hours would be spent discussing its pronouncements on beauty, life and morality.

above: Fashions were as important as the event itself. At the races, 1907.

left: An early auto-carriage, 1908.

far left: The playful atmosphere of sports was the perfect excuse for some flirting.

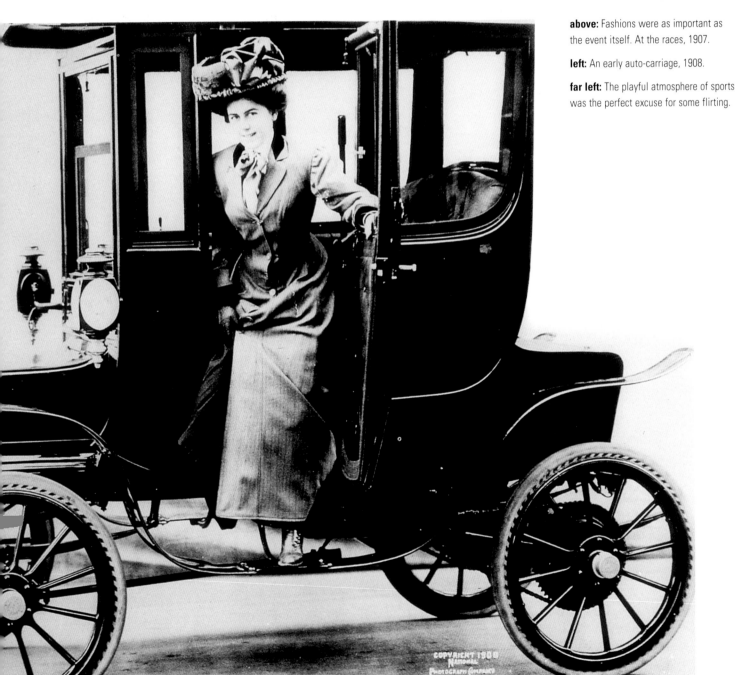

1990-
1980-
1970-
1960-
1950-
1940-
1930-
1920-
1910-
1900-
1890-

COSMETICS BODY SHAPE & UNDERWEAR **WORK & PLAY**

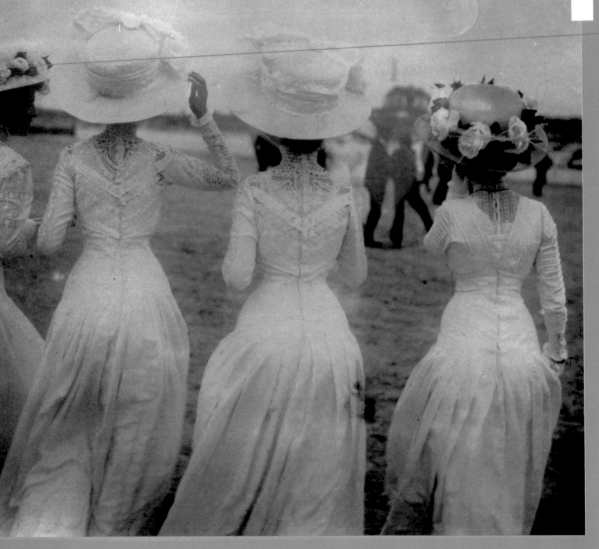

1900 -1909

President William McKinley assassinated

Queen Victoria dies, 1901

First radio message from US to UK

Wright brothers make first powered flight in heavier-than-air machine

Einstein publishes first papers on relativity

Emmeline Pankhurst founds National Women's Social and Political Union

Underground subway system opened in New York City

Olympics held in London 1908

Tour de France bicycle race established

1910-1919

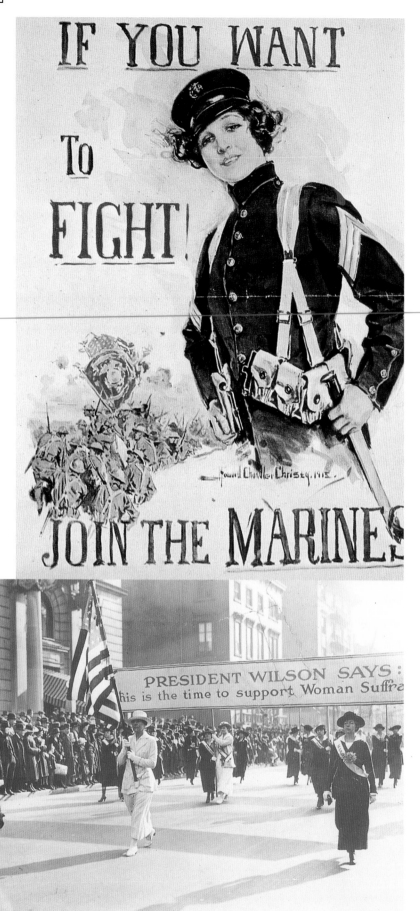

IF YOU WANT TO FIGHT! JOIN THE MARINES

PRESIDENT WILSON SAYS: his is the time to support Woman Suffr...

The First World War dominated the years 1910–1919; it was a decade quite uniquely split in two with pre- and postwar societies being radically different. The first half was characterized by the death of King Edward VII and although Edwardian society had brought with it some very definite changes, socially things were much the same as before. For those with money, the Belle Époque was still the status quo. But the war brought changes to everyone, since few were spared the grief of the loss of a family member or untouched by some other experience of its effects. Much social change occurred suddenly rather than gradually, and after the cataclysmic conflict it was impossible to imagine that things would return to what they had been before.

During the war, reminders of the severity of the situation, even of the most superficial nature, were everywhere. Theaters put up notices that evening wear was "optional but unnecessary," and women left their jewels behind to show sympathy with the communal sacrifice that characterized the times. Much of the change was forced on a previously rigid society. No sooner had suffragist riots in London's Whitehall been debated and generally mocked, than British women were looked to for help, to hold the fort and also feed and nurse the sick and wounded. Volunteer work suddenly became chic in America, Britain and even nearer the battle front in Europe, with a newly caring upper echelon. Social barriers began to erode as women from all classes got involved in some aspects of the war effort, and this was bound to have a tremendous effect in their private and social lives. Before the war, women's interests were bound to the home, but experiencing philanthropic work (plus the cause of the suffragists) meant that their perspective was suddenly much wider.

One of the consequences of war work was that lots of women having experienced independence did not wish to join the ranks of domestic servants—or indeed domestic housewives—again. Women were given the vote in 1920, and for the women of this generation life would never be the same again.

The United States of America had become the powerhouse economy of the world. The vast waves of immigration that had characterized the first decade of the century helped forge it into the greatest industrial nation on earth. At the end of World War I the

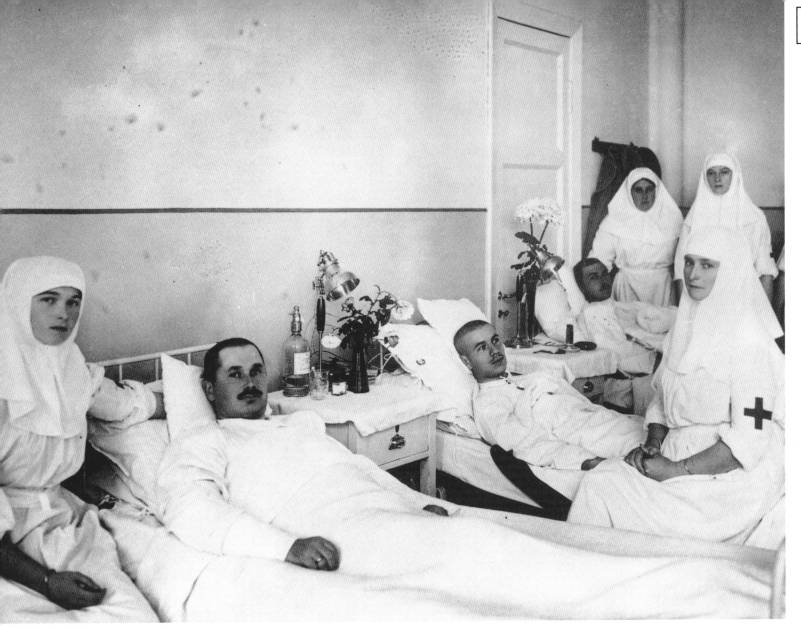

way was clear for American expansion, upward and outward, with skyscraper cities that reached to the sky and sprawling suburbs that were to define the growing pattern of 20th-century life. The "American influence" on European culture was growing, largely through the burgeoning popular medium of the movies, and again this set a trend that was to continue worldwide through the decades that followed.

There were other challenges to the intellectual status quo. The work in psychoanalysis of Freud and Jung was to both shock and irrevocably change attitudes to taboos, social-sexual repression and so on. And in 1917 the October Revolution in Russia put all of Western society on "red alert."

While intellectuals all over the world discussed the pros and cons of the communist system being created in the new Soviet Union, the defense mechanisms of capitalism began to flex their muscles in response with a crackdown on union activity in much of American industry, and similar knee-jerk reactions to labor unrest elsewhere.

Where, despite their newly won emancipation, were working women to fit in the new scheme of things?

above: Members of the Russian royal family nurse soldiers during the war. The czarina is seated on the right.

left: Suffragists march in support of women's suffrage in New York, 1917.

top left: A World War I recruitment poster appealing for women to join the Marines.

COSMETICS **BODY SHAPE & UNDERWEAR** **WORK & PLAY**

LILLIAN GISH

was known as "The First Lady of the Silent Screen." Her fragile beauty hid an emotional depth that would burst forth in the most powerful way, a style ideally suited to the melodramas of her director/mentor, the great D.W. Griffith.

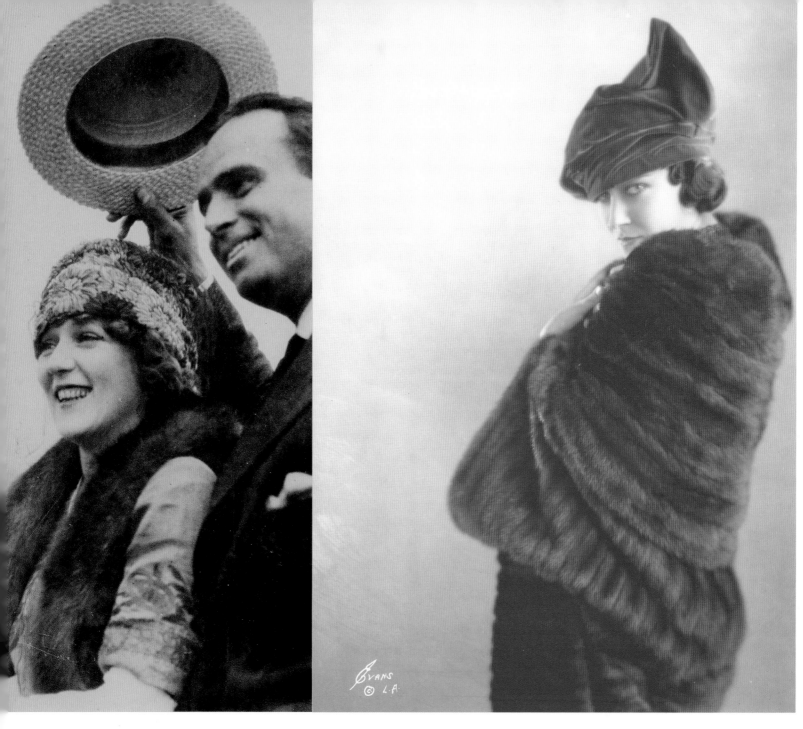

1990-
1980-
1970-
1960-
1950-
1940-
1930-
1920-
1910-
1900-
1890-

MARY PICKFORD

captivated audiences as "America's Sweetheart" with her little-girl charm. An astute businesswoman, she founded United Artists with D.W. Griffith, Charlie Chaplin and Douglas Fairbanks, who she married (above) in 1920.

GLORIA SWANSON

graduated from the Mack Sennett Keystone company, where she starred in romantic comedies, to superstardom with Cecil B. DeMille. Her clothes adorned the fashion magazines, and to millions she was glamour personified.

COSMETICS BODY SHAPE & UNDERWEAR WORK & PLAY

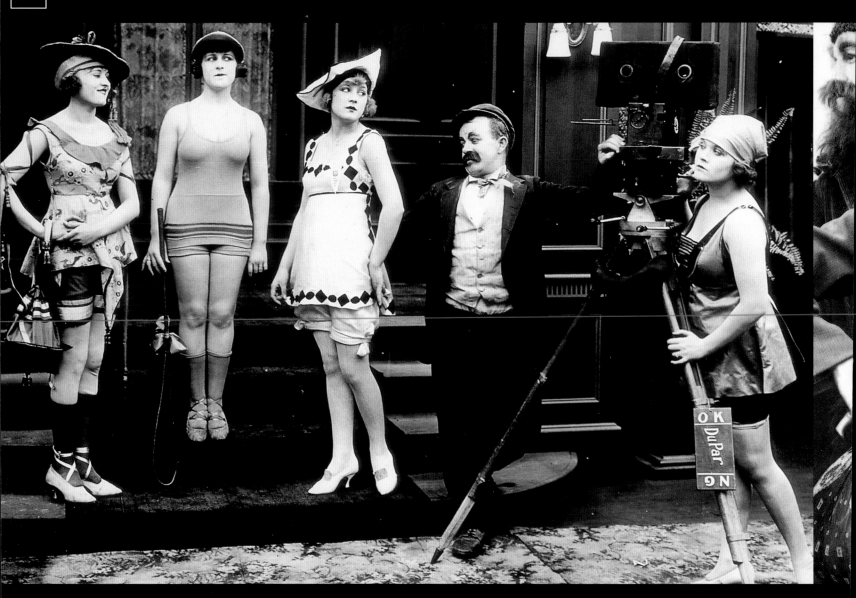

Film was now out of its infancy and enjoying its first golden era, that of the silent screen. These were pioneering times in the world of film, and the major theories and principles of film narrative were developed during this period. The developments and innovations were staggering and touched audiences directly. They were thrilled and entertained with ever more exciting plots, realistic settings and sophisticated techniques. The impact of this new style of narrative, achievable through montage, or juxtaposition of filmed images, used to alter time and point of view, changed the way many writers and artists did their work. D.W. Griffith was not only more technically sophisticated than any other director of the time, his films had a populist edge that produced the first true blockbusters. He re-created ancient civilizations in *Intolerance* with huge sets and legions of extras. His *Birth of a Nation,* although marred by racist dipictions of African Americans, is still a must for any student of film, but to American audiences at the time was a devastating experience, dealing with relatively recent history and the emotive subject of the Civil War. His *Broken Blossoms,* about a neglected child in Limehouse, London was highly sensational stuff to the sentimental

audiences of the day, while the complexity of the biblical plots of *Judith of Bethulia* was unprecedented in silent film.

By 1912, five million Americans were visiting the cinema daily The excitement of each new production brought bigger and more eager audiences every day. Charlie Chaplin was making films, his tragi-comic "little man" becoming an icon for the times, and Mack Sennett was directing some of the best comic films of the day with his trademark slapstick pie-in-the-face plots that introduced such character actors as Fatty Arbuckle, Ben Turpin and Chester Conklin—and of course the Keystone Kops.

In European cinema, the German Ernst Lubitsch was working in comedies and historical dramas with Pola Negri, and Sweden's Victor Sjöström was making sophisticated dramas like *The Outlaw and His Wife* before moving to Hollywood.

Film was quickly becoming a recognized genre of the arts, not least because its popular position meant that it was experienced by more people than straight art or literature ever was. Also, because it was a fusion of other disciplines, it became an important influence on those art forms, which could often no longer express themselves

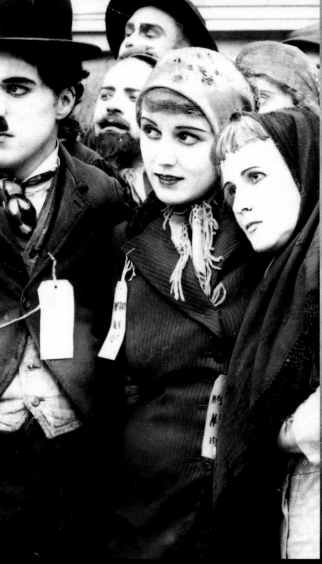

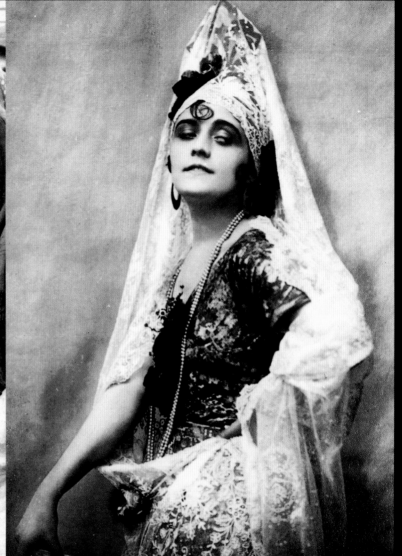

POLA NEGRI

began her film career in her native Poland before moving to Germany to work with Ernst Lubitsch. Reputedly of Gypsy origin, her exotic image led to Hollywood stardom in the 20s, an affair with Rudolph Valentino, and marriages to a count and a prince.

as previously, after the horrific events of the decade.

The influence of war and film can be clearly seen in post-war painting and literature. The fragmentation and experimentation in representational art, and also in poetry, reveal a sort of "editing" and change of form, not unlike the techniques of the cinema.

Vogue magazine had previously only been available in its original American version, but, with the war, it was felt that the British would benefit from their own edition as it was taking too long to get over the Atlantic. The main photographers working for *Vogue* were the best of the day; Hoppe, Hugh Cecil and Bertram Park all took pictures for *Vogue* and other magazines, as well as doing their own private work.

There was a short-lived fashion for society women to dress up as

left: Mack Sennett's famous Bathing Beauties pose for the camera.

center: Edna Purviance—her vulnerable femininity made her perfect for the emotive plots of Charlie Chaplin.

The fashions of this period are the missing link between the Belle Époque and the start of modern fashion as we know it and, as one would expect, it went in fits and starts. The logic of the change is seen clearly in terms of the political and cultural events of the time. The oscillations of fashion were quite irrelevant to most people before the war; certainly those who worked in its sweatshops were not concerned with the styles. Conditions were so appalling for female factory workers in England that there would be a Parliamentary enquiry eventually.

However, during and after the war, changes occurred for reasons of practicality and necessity. Many women experienced a newly won independence, so more people were participating in the fashion game, frivolous and fussy styles giving way to modern, less status-oriented styles. The excesses of the Belle Époque were out of tune with the times, and modern machine-made clothes were required to last longer for the majority of buyers.

The corset, as symbol of incarceration of womankind, might have been shed in the name of style by the customers of Poiret and Lucile, but the entrenched ideas about women that went with the corset would have to be dislodged gradually, and it would take something really major to do it. The war did change many attitudes and probably convinced women that they could do more, and deserved more freedom. Once they had convinced themselves, the changes came quite speedily. The clothes worn by military personnel and civilian working women never made it to the fashion magazines, but the jaunty look and sporty attitude of these "mannish" clothes did have an impact. These factors, together with the mood of severity and "playing it down" (not wearing jewels at the opera) and the new short hair, signified changes that had occurred and more to come.

Before the war, there was a preoccupation with the exotic. Paul Poiret, dubbed the "Pasha of Paris," introduced a style of dress influenced heavily by the Ballets Russes, which visited the city in 1909. From this moment on, the whole of European fashion looked as though it could have been designed for a production by Léon Bakst. There was a total explosion of color and the emphasis of the waist and hips of the hourglass silhouette was to move. From this moment on, the waistline crept up to below the bust, creating a new "Empire line" and the hem rose slightly accordingly. The train disappeared, and the line of the dress becomes fragmented, with a straight skirt and a detail around the middle being the important feature.

All these clothes appeared in a shocking and bright new palette of rich and sumptuous Eastern color, even stockings changed from dreary Victorian black to red and gold. Poiret influenced the whole fashion landscape so that pattern became a dominant element of it. He commissioned Raoul Dufy and Georges Lepape and Paul Iribe to design exotic fabrics for his creations, and Perugia, the famous shoemakers, created a range of beautiful Eastern-style jeweled slippers for maximum impact. Every detail was perfect, even the heels were different and based on historical precedent. This richness of pattern was particularly suited to the simpler draped styles, and the new evening coats, basically simple wraps, became working surfaces on which the designers could introduce more and more opulence.

Poiret worked in fur for these designs, too. The Edwardian love of fur continued throughout this decade as an indicator of status. It appeared as lingerie trimmings, nightwear, hats and bags, and even summer dresses and rose-trimmed hats. This would seem to our modern sensibilities to be in very bad taste, and after the war was indicative of the excess to be purified, but at this stage it was considered the apex of style. Fur was very much part of the new orientalism so much in vogue. The influence of ballet producer Sergey Diaghilev was so strong that every woman wanted a bit of Eastern glamour. The fur coat had a huge stand-up collar, reaching right down to the waist and fastened with a huge clasp, with the shape of the coat kept simple. This made it a much cheaper garment to produce. The favorite furs of the day were musquash, and the new marten and zibeline so beloved of Doucet.

Many of the *haute monde* and intellectual women experimented with evening pajamas and trousers, which worn with turbans and feathers seemed very exotic indeed. However, no sooner had they been liberated than Poiret decreed that his new creation, the hobble skirt, should predominate, so women had to suddenly learn to walk like geishas. This new inhibition cannot have been popular with the wearers, who probably accepted it in the name of style. However, despite the tales of bus steps being altered to accommodate the vagaries of fashion, the Catholic Church refused absolution to those who donned it. This was the beginning of the end for Poiret, since after the war his dictates were too extreme, too fussy for the mood of the time, and women declined his pagoda-hip designs and crinolines—he was soon abandoned for the forward thinking ideas of Lanvin and Chanel.

World War I put a stop to fashion, and for a while uniform and utilitarian wear dominated. Couture continued until after the war on a smaller scale and then the San Francisco exhibition allowed Paris couture to be shown in the US again. Now, though, there were American companies that were ready to compete with the great couturiers, either with their own designs or by copying the very designs they encouraged.

In Britain, an embryonic ready-to-wear industry had to think of ways to proceed. The textile companies had relied on selling huge quantities of fabric, and now that idea was obsolete. At first, they tried little items like aprons and mantles or cloaks, anything that could be made without attaching them to any particular styles, so that they had a modicum of protection against the fast changes that occurred in the world of fashion. Their dreams were to be answered shortly, when all throughout the next decade fashion would be dictated by one simple shape, and technology was to provide cheap, easy-care fabrics for them to work with.

World War I put Chanel's ideas into practice, since simplicity was now the essence of fashion. Many sports garments, such as sweaters and skirts, were being worn every day. After the war, many did try to go back to the way things were, but it was too late. It seemed most women wanted to be more active. They had breached the codes, cast off all the extra weight of clothing, and healthy living and the body were the focus for a new youthful image.

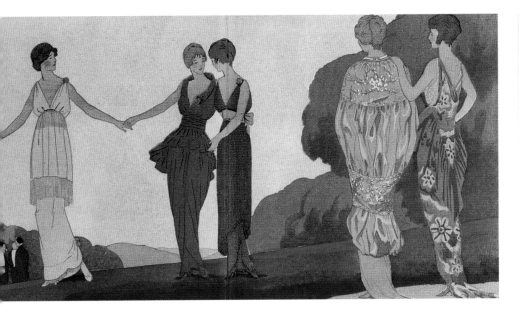

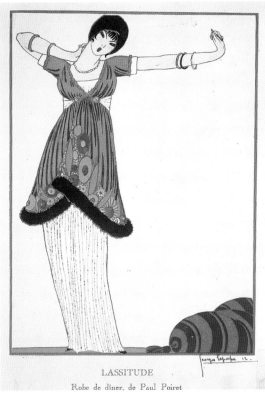

LASSITUDE
Robe de dîner, de Paul Poiret

above: Evening dress by Paul Poiret, 1912.

left: Contemporary designs, Doeuillet 1914.

1990-
1980-
1970-
1960-
1950-
1940-
1930-
1920-
1910-
1900-
1890-

Erté

Erté, adopted name of Romain de Tirtoff (1892–1990), the famous designer of stage costumes, was very prolific over two decades. The clothes of the 10s and 20s were theatrical. The exotic, elongated and extravagant designs that were his forte suited this climate well. Employed by Paul Poiret in 1913–14, he designed ballet costumes for Diaghilev, covers for *Harpers Bazaar*, costumes for Josephine Baker and sets for the Folies-Bergère and Ziegfeld Follies in Paris and New York.

Lanvin

Jeanne Lanvin, the eldest of 11 children of a journalist, started off by making clothes for her daughter. The enterprise grew into a children's clothing business of some note and later she crossed into women's couture. Her fashion is characterized by its extreme discretion and restraint, although the shapes of her pajamas and Zouave trouser skirts and capes show an often lyrical interpretation of world styles. Her fashion house was to retain its supremacy into the 1930s, and she represented France at the 1939 World's Fair. Her success was based on her innate understanding of social protocol (her daughter did, after all, become the comtesse de Polignac), and her finesse and taste for decoration. Stitching, sequins and embroidery all have their place and function, to catch the light, to accentuate structure, but always appear in a way that show thought and restraint. The signature shape she most loved was the full skirt, which updates historical dressmaking in an age of sports clothes, and demonstrates her genius. Her scents, Arpège and My Sin are classics.

Fortuny

Mariano Fortuny, the Spanish painter and self-styled inventor, was born into a well-to-do family and flirted with inventions for theater lighting, photography and theater design, for which he wrote theories, until he was taken with the clothes of Alma-Tadema, Lord Leighton and Liberty, and the Art Nouveau movement. He considered his clothes to be inventions and patented his pleating methods and his dyes made from vegetable extracts in 1909. His clothes, with their glamorous batwing sleeves, were in silk and silk velvet with wonderful stenciled designs, he himself creating the dyes, printing the velvet, making the blocks and pattern designs. Hems were weighted with Venetian glass or beautiful wooden beads. The famous Delphos dress was based on classic Greek examples, and other inspirations included ethnic Indian, Japanese, Turkish and North African costumes. He much admired the painter Carpaccio and, fittingly, worked and died in Venice. The latter-day successors to his style are the duo Charles and Patricia Lester in Britain, and Mary McFadden in the US.

COSMETICS **BODY SHAPE & UNDERWEAR** **WORK & PLAY**

above: Short hair and elaborate head-bands—the ideal look of the years 1910–19.

left: Vernon and Irene Castle—they made frequent, much publicized trips to England, where they were feted by high society and theater people alike.

right: Paul Poiret's glamorous coat and exotic turban-like hat for the theater were typical of the popular styles of the day.

During this decade hair was as much a symbol of womens' place in society as was the corset, and became a very controversial issue. Less padding and fake hair became the norm in the light of the new pure Empire line silhouette for clothes. The height of the previous decades' hairstyles did not set well with the dimensions of the new more classically influenced shapes, and the higher waist required a new repertoire of styles. As the decade progressed, more women found themselves in military or quasi-military uniform, and this was to influence fashion significantly until the 1920s.

Many women got their hair cut for reasons of practicality, while doing war work in the factories, but, at the same time, women occupied a saintly and vulnerable position in popular culture and "Madonna" hair was the idealized image cherished in the minds of the men who went to war. The penchant for society women to be pictured as nuns only heightened this illusion. This was the sort of role traditionally expected from women of the elite. The fact that women from all backgrounds were participating in nursing, and all manner of jobs vacated by men—and quite often enjoying it— made the role of gender a confusing and often awkward subject for everyone.

"Curtain" hair was the natural development from the two poles of style. The hair was parted through the center and looped over a decorative band of some sort. This was a compromise essentially between long and short. For the evening, these bands were adorned with feathers or jewels, and the hair was looped low at the sides and put back in a loose bun or roll. This wearing of the band low on the forehead was echoed in the wearing of hats, which were now worn in the home with afternoon dresses. This anticipated the trends of the 20s, when fringes and hats came low down the face, and for years it seemed the forehead would never be seen again.

Henna was in keeping with the new Eastern-style fashions, and many women experimented with it rather than risking the primitive chemical dyes of the day. The fascination for the secrets of the harem, which had been so frowned upon by the Victorians, held new significance for the women influenced by the likes of Poiret, Isadora Duncan and the theater.

Short hair wasn't just taken up by those who worked. It was seen as chic and adopted as a style statement by many young women. Irene Castle, the dazzlingly beautiful young American half of the famous dance duo Irene and Vernon Castle, cut her lustrous locks before an operation and was imitated by a couple of hundred people in the first week of it being reported, and a couple of thousand within a fortnight. There was increasing pressure to make the choice of long or short.

Short hair won the day, though, since short hair also seemed to be appropriate in these times of grief. It was a traditional expression of grief, and after the war it was as though everyone wanted to express both their collective grief and emancipation simultaneously. After the war, the rush to get "the chop" was accelerated by the images of the movie stars and the common desire for modernity. The flappers finalized the issue, and before long those who resisted the change were the exception rather than the rule.

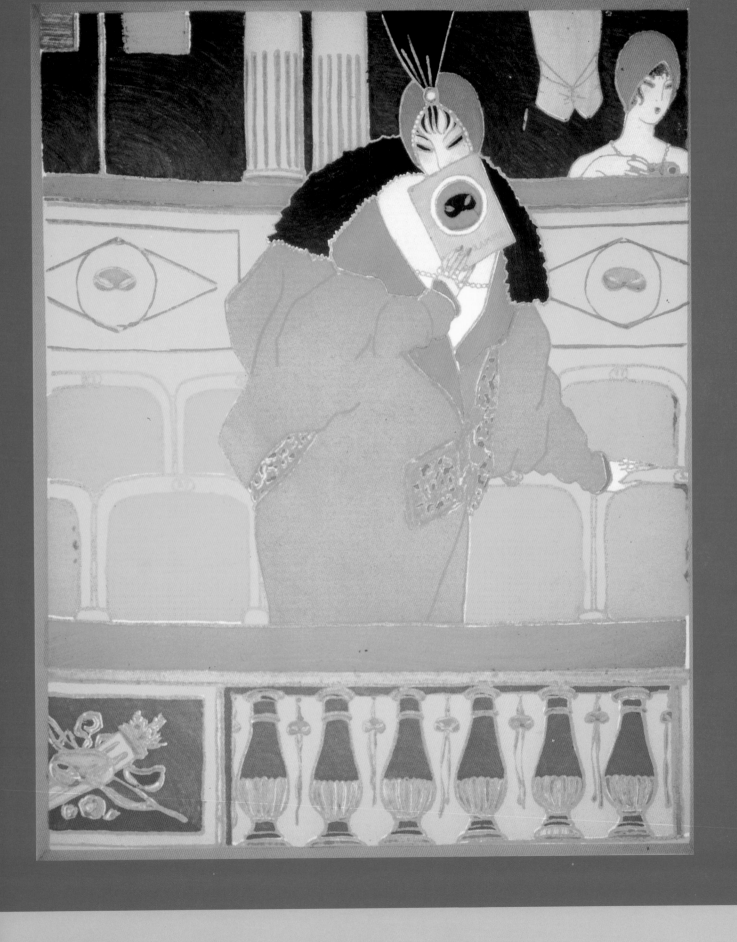

1890- 1900- **1910-** 1920- 1930- 1940- 1950- 1960- 1970- 1980- 1990-

COSMETICS BODY SHAPE & UNDERWEAR WORK & PLAY

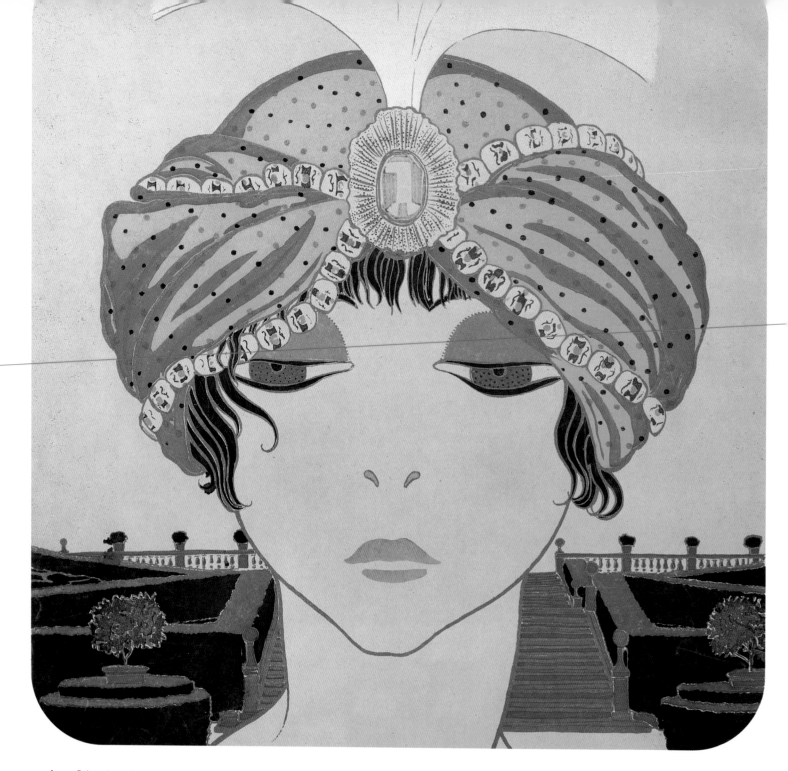

above: Poiret glamorized and exoticized cosmetics in his fashion plates. Soon the rest of the world would catch on—here we see the precursor of the cupid's bow mouth and heavy eyes of the 20s.

Society's gradual acceptance of makeup was largely suspended during the war years. Whereas prewar society went along with the theatrical look that characterized the new fashions of Poiret, who like Chanel was interested in marketing his own scents and potions himself, the prevailing mood from 1914 to 1918 was that one should heed the pleas for patriotic spending and forgo the use of cosmetics in favor of more practical necessities. A little rouge was permitted in modest application, and that was about it.

Creams were once again marketed for traditional health reasons, and even the indefatigable Harriet Hubbard Ayer was writing for Cheseborough-Ponds, promoting the use of Vaseline on health grounds. In fact, so ubiquitous was the use of Vaseline, that few of

its users realized it was a tradename! During the war, the typical upper-class female had thick, unplucked eyebrows, a lick of Vaseline and the usual pale skin, although the first tans did make their appearance at this time. Papier poudre was still much in demand, but the heavy white powders of the Edwardian days were now seen as inappropriate.

The house of Cyclax was founded. One of the foremost companies of the era, it is still successful today. Pears soap was used by "nice" girls, while very "fast" women (or simply poor ones) used Phul-Nana and Shem-el Nessim. Lavender water or refined cologne were the only scents that most women were prepared to use before the war.

Plastic surgeons advertised corrections of scrawny necks, ugly noses and ears or lips, unhealthy complexions, saggy cheeks, even problematic scowls, all "without detention indoors." Frederick Kolle, who wrote the foremost book on the subject at the time, dedicates a chapter to the history of plastic surgery and another to the modern equipment: a certain table, another trolley, a skylight, incinerator and several types of catgut for stitching. He then advises "thorough washing of the hands" and the enthusiastic pioneer was away! Kolle guides the reader step by step through the various stages of injecting the face with paraffin to fill it out, or even worse procedures. It seems as though he expected anybody to have a try, and they probably did! Another often advertised treatment was electrical stimulation of the blood, for a whole variety of ailments. It, too, was presumably carried out by virtually anyone.

During World War I, amidst the horrendous carnage, great strides were made in cosmetic and plastic surgery, and real surgeons of repute were able to learn a lot more about burns and the healing methods of the skin. The hospital at East Grinstead was the center of progress in this field, together with hospitals in America pioneering research and development worldwide.

François Coty was one of the great personalities of the decade. He entered the world of cosmetics after seeing the World's Fair of Paris in 1900. He was a Corsican, possessing the romantic spirit of an artist but using it like the born salesman that he was. He believed that if you invented a lovely scent and sold it in a beautiful bottle at a reasonable price, you couldn't go wrong. He proved the sense in this over and over again—and although he had bottles designed by the great artists of the times such as Lalique, his prices were extremely reasonable. He earned the reputation of genius, and his company is still founded on the original principles, having lasted for years without a blemish. His packaging was second to none, even on cosmetics like powder and lipstick, and he was the first to introduce the concept of a range of goods, all in any one particular fragrance. The best known fragrances from Coty are Le Muguet, from 1910, and the later L'Aimant and Complice.

At this time, Max Factor was still working as a wigmaker to the Russian court, but was about to go to America to seek his fortune. In 1908, Helena Rubinstein came to England from Australia to establish her beauty salon and cosmetics business, specializing in skin products, and two years later Elizabeth Arden opened her salon in New York—the beauty world as we know it was just beginning.

Elizabeth Arden

Elizabeth Arden was one of the new breed of businesswomen in the cosmetics industry. She opened her first salon in 1910 and soon became a household name the world over.

1990-
1980-
1970-
1960-
1950-
1940-
1930-
1920-
1910-
1900-
1890-

COSMETICS **BODY SHAPE & UNDERWEAR** **WORK & PLAY**

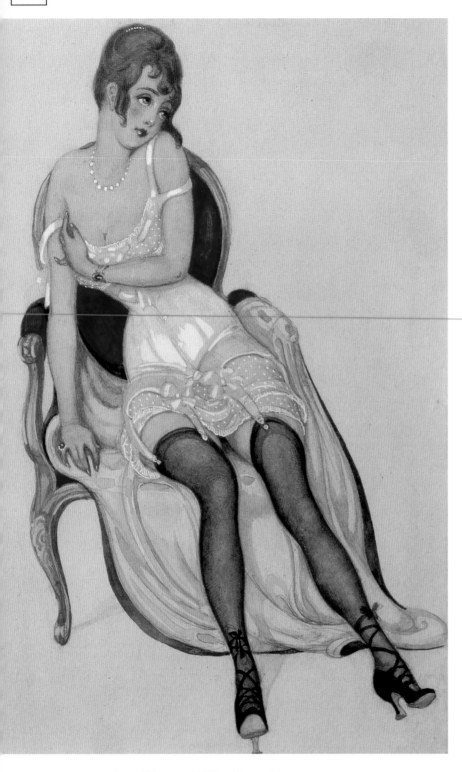

above: Underwear of 1917, as illustrated by Gerda Wegener.

right: An early patent for the new brassiere—November 1914.

Facsimile of original brassière patent.

The body shape was almost universally the "barrel and tunic" combination introduced by Lucile and then Poiret until the war, when the military influence dominated clothes until 1918. Then sporty, modern looking clothes came into their own. Sweaters were worn with simple skirts, with the prototype for the 1920s' chemise taking over evening wear.

The world of dance had a profound influence on the shape of the fashions of this decade, first with the abandonment of the corset by Isadora Duncan and then with the universal preference among new designers for the Eastern shapes and Empire lines of Poiret and Lanvin, which began after the famous visit of the Ballets Russes to Paris. That and the influence of dancer Irene Castle, who helped popularize contemporary dances like the Bunny Hop and the Tango, meant that freedom of movement was now of paramount importance, and the sight of the ankle was inevitable.

Rationing had its own beneficial effect on the general shape of things, since women shed some of the padding of flesh as well as corsets, and the silhouette of the age became more girlish and young. The flattened shape of the 20s began to develop in the underwear of the age. Corsets were no longer structured, but concentrated instead on a binding effect, since they had little or no

1,115,674.

M. P. JACOB.
BRASSIÈRE.
APPLICATION FILED FEB. 12, 1914.

Patented Nov. 3, 1914.
2 SHEETS—SHEET 1.

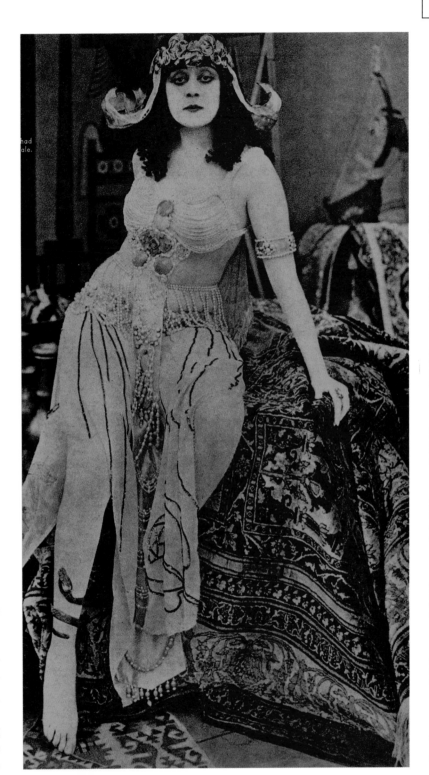

elasticity. They were mostly satin or broche and had suspenders sewn on. The Hollywood star Theda Bara was the cause of great consternation in society, not to mention the underwear industry, since she was usually portrayed in revealing outfits that seemed to be worn with little or no means of support, but with a few strategically placed sequins or flowers that just about preserved her modesty. Men and women alike were scandalized, but the women were probably deeply envious too.

Just as they shed their corsets, women had to put up with being hobbled. The hobble skirt, which narrowed severely between the knee and ankle and only allowed the briefest of steps, was a short-lived trend since women had become used to very practical clothing during the war that allowed them freedom of movement.

Underwear stayed slimmer, and didn't require lacing, but little thought was given to its design. Open and closed underpants were popular, and the divided leg was introduced after the war. The bra was said to have been invented by Caresse Crosby, who improvised, with the help of her French maid, by using two handkerchiefs and a long ribbon, in 1912. It first caught on in France, then in America, but Caresse got no credit. The new petticoats were lighter and used less lace in order to keep the hips fashionably slim.

THEDA BARA

was billed as a woman of mystic powers, born in the Sahara Desert (actually Cincinnati), her name an anagram of "Arab Death." She wore indigo makeup, which emphasized her death-like pallor, rode in a white limousine attended by "Nubian slaves," and received the ever-attentive press in an incense-heavy room while stroking her pet serpent! The original vamp, her more than 40 roles included Madame Du Barry, Salome and Cleopatra.

COSMETICS **BODY SHAPE & UNDERWEAR** WORK & PLAY

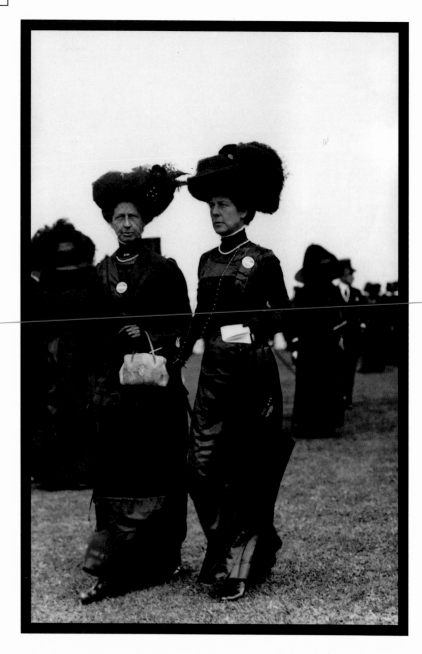

parade to be made up of uniformed women from all war groups. The suffragists, usually characterized as battle-axes in "temperance" suits, in fact campaigned in plain white dresses to show martyrdom to the cause, carrying simple bunches of red roses—the suffragists included 400 such women. The procession marched for two and a half hours, and then a crowd of 60,000 heard Lloyd George speak. The result was fantastic. By 1916, 50,00 women were working in and around Woolwich Arsenal, where no females had worked previously, and by 1917, 700,000 women were active making munitions. Their "uniform" consisted of peg-top trousers, considered necessary because of the dangers involved in the job, and a blouse, but the women added all sorts of scarves and accessories for fashion. Unlike in many other factories, there was a strong spirit of camaraderie, and the ranks included and transcended the whole class structure. Women also worked as lamplighters, trash collectors, tram drivers and conductors, chimney sweeps, postwomen and on the railways, all but bus conductresses disappearing after the war.

American women made significant contributions to the US war effort—according to the Women's Overseas League, 161 American women lost their lives doing so. The US Army Nurse Corps was established in 1901, the Navy Nurse Corps in 1908. During the war, the Marines also decided to open its ranks to women. Nearly 13,000 women served in the Navy and Marine Corps on equal status with their male counterparts.

Women were also hired as independent contractors to work as telephone operators, translators and in other capacities. The Women in Industry Service Bureau was created as civilian women increasingly replaced men in farms, mines, mills and factories.

Many women office workers copied the Gibson look because it was both fashionable and practical. Technical training manuals encouraged what a later age called "dressing for success"; this meant clothing with the look of efficiency—clean lines, no frills, neither too "feminine" (fluffy or frilly) nor too "masculine" (heavy tweeds and worsteds). A black skirt and a white shirtwaist matched in look the sober, no-nonsense lines of the secretary's typewriter.

The most famous uniform of WWI was that of the Red Cross. Known to many as the "proudest badge," it first appeared in the Franco-Prussian War and was very similar to the regular servant's uniform. As Vera Brittain witnessed in her book *Testament of Youth*, many people thought that a job with the Red Cross was merely for the sake of public relations and that one was needed to hold the

The ideas of Isadora Duncan and the world of ballet and dance made their impact on fashion with as much force as the trend for real sports clothes, but the acid test for most of the decade, from 1914 to 1918, came when women sought practical clothes to wear for their war work. These clothes, the uniforms of the farm girls and the bus conductresses, did not hit the fashion pages, but they profoundly influenced them. Women also got the idea that they were capable of doing more, while the competitive spirit of sport was being rapidly instilled into them in the increasing number of girls' schools being established at the time. Finally, as in the Second World War, women were generally fitter, due to care in eating and the increased amount of activity in their lives.

When the government of the day realized that they would need women to replace the men who had been serving in the back areas, Britain's minister of munitions, Lloyd George, asked suffragist leader Mrs. Pankhurst for her help. The government supplied £2,000 for a

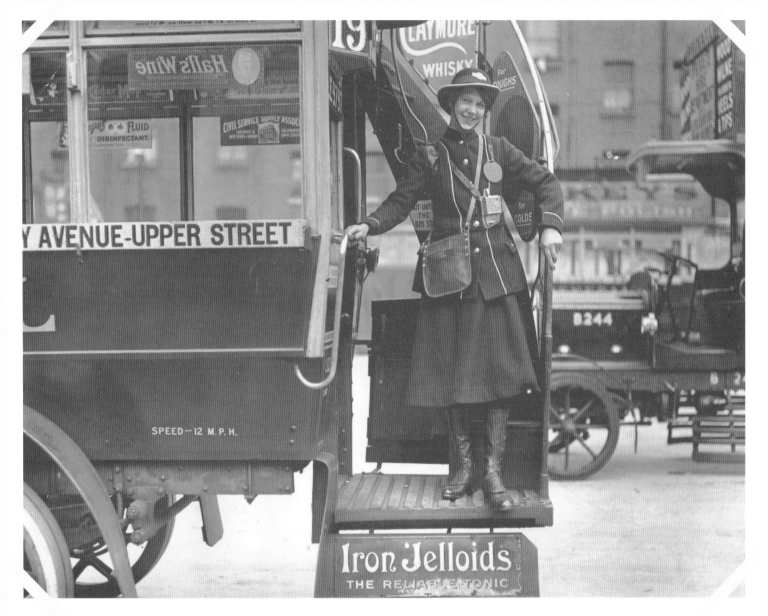

above: A cheerful conductress poses in 1917.
left: The famous Black Ascot of 1910.

hand of effete young soldiers, but the reality involved terrible conditions, hostility from trained nurses, bad pay and untold horror. The uniform was really a hard-earned privilege. The police force also admitted women now, another job requiring real dedication.

Another area of dress affected by the Great War was mourning dress. During the Victorian era it had been strictly observed, and indeed Queen Victoria herself spent so long in mourning clothes that it was difficult for anyone to do otherwise themselves.

Mourning was very pronounced in this decade too. The death of Edward VII came a few weeks before Ascot, so the famous Black Ascot of 1910 was imbedded in the childhood memories of many (including Cecil Beaton, who used the idea for his stunning race-course sequence in the 1964 film *My Fair Lady*). The designer Mme Paquin lost her husband around this date too, so she made black and white dominant over other colors for at least a year. However, during the war family losses were so frequent that one

would have been in a permanent state of mourning if conventions had not been considerably slackened. The dominance of black gave way to gray and even mauve, and the usual jet mourning jewelry, which had been further taken up at the death of Queen Victoria, was replaced by diamonds and pearls. These had been most hopefully advertised by the Parisian Diamond Company of Bond Street, the day after the death of the king. Although the practice of the wearing of widow's weeds continued into the 30s, it was gradually more influenced by fashion and practicality.

Sport continued to grow in importance, and the motor car showed its superior virtues over the horse and carriage. Cars and ambulances had most definitely proved their worth during the war. The world had changed and everybody knew it.

COSMETICS BODY SHAPE & UNDERWEAR WORK & PLAY

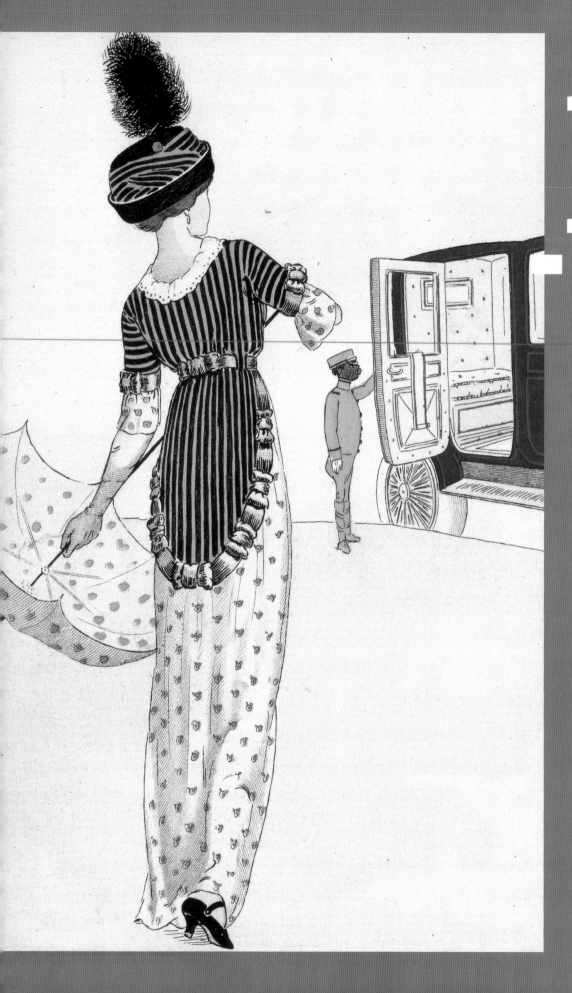

1910 -1919

World War I

Rasputin murdered

The Russian Revolution

Woodrow Wilson elected
President of the US

Death of Edward VII

Suffragist riots

The sinking of the "unsinkable"
Titanic

Lawrence of Arabia leads Arabs
against the Turks

Cézanne, Picasso and cubism

Charlie Chaplin makes his film debut

Amundsen reaches the South Pole

First plastics developed

Conveyor belt assembly introduced by
Henry Ford

1920-
1929

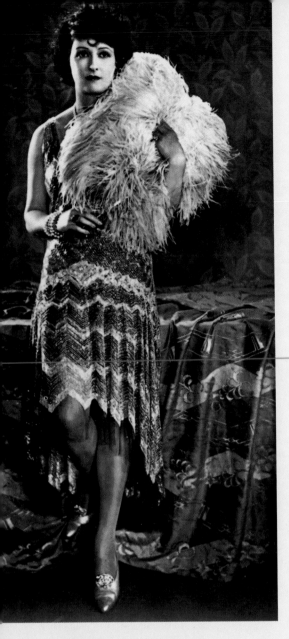

above: Short hair and short skirts, the 1920s was the age of the flapper.

right: A litho by fashion illustrator Georges Barbier called *Farewell,* 1920.

below: Fun, fun, fun: a Charleston endurance test in a nightclub, 1926.

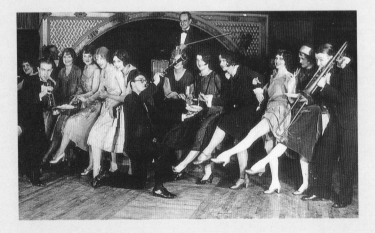

After the wholesale slaughter of young men in the First World War, feelings of futility and mass sorrow gave way to the notion that if you had youth, you must make the most of it. Jazz became a craze almost overnight, the motor car accelerated the speed of life, and the whole world seemed to want to party. This was the landscape of Evelyn Waugh's *Vile Bodies* and F. Scott Fitzgerald's *The Last Tycoon*. So many young people had been wiped out that the 1920s marked the start of a completely new order, and many historians cite it as the true beginning of the 20th century.

In the aftermath of war, for women much had changed. In both America and England, they now had the vote. With so many young men dead or disfigured, lots of women thought that they would never marry, either because they had lost a love or that "the one meant for me had been killed."

Women had done much to keep things going while the men had been away, working in munitions factories, doing men's work as bus conductors and farm laborers, keeping the country fed or nursing the sick. Many girls born into domestic service were now finding that they were given a wider choice of options and, for these women, nothing was ever going to be the same.

This was the age of the flapper (coined in Germany, the word was "backfisch"), which aptly sums up the fast and reckless nature of the new girls. They were exactly like young fish, quicksilver, shimmying around everywhere, and hard to keep hold of! Living fast was their motto, defying every convention, putting on makeup in public, smoking—often with a long cigarette holder, which was too, too shocking—but their real hallmark was the short cut of their hair. They had freedom and more independence, so why not live? Indeed, it has been suggested that many were acting out a devil-may-care lifestyle on behalf of those young men who could not.

Women were relieved of many traditional burdens in this era. There were new domestic labor-saving devices, the dominance of the automobile over the horse-drawn carriage was final, and as a result of this, many women spent more time away from the home. New easy-care fabrics were invented so the tyranny of household chores was lessening. The gramophone was widely available, radio stations were established, and many people even had telephones.

The new fashions took women out of corsets, representing a physical freedom enjoyed for the first time in hundreds of years.

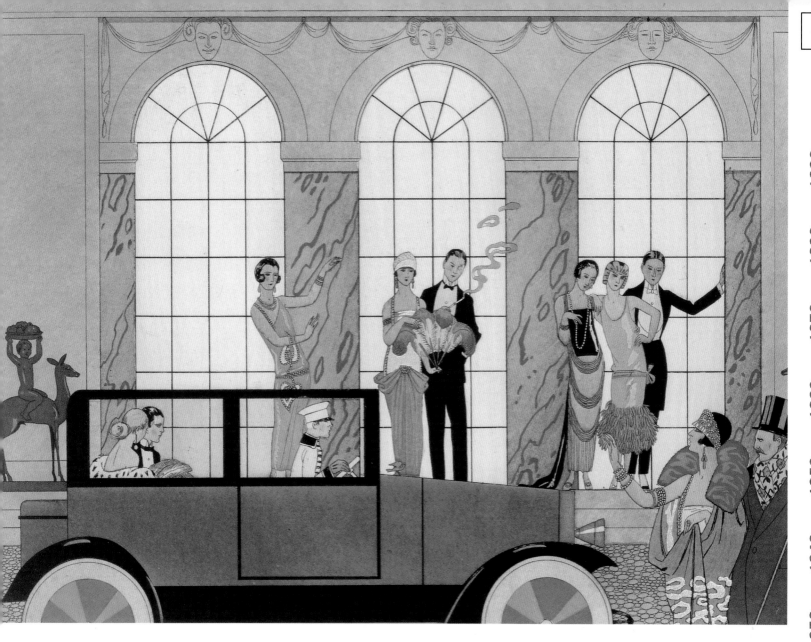

1990-
1980-
1970-
1960-
1950-
1940-
1930-
1920-
1910-
1900-
1890-

This was not only a physical advance, but it was deeply symbolic. Marie Stopes had well established her work educating women regarding contraception and so, for the first time ever, women had access to some sort of birth control and therefore more control over their own bodies and lives than ever before.

Apart from women getting the vote in America, the Mann Act was passed, an attempt to put a halt to white slavery, while the Women's Temperance League, carrying much of the female vote, helped establish Prohibition. The United States got its first taste of Communist paranoia too, with the Russian Revolution, ten days that truly shook the world.

In literature, F. Scott Fitzgerald was writing *The Great Gatsby,* and African-American writers Ralph Ellison and Richard Wright were launching their careers. At the same time T.S. Eliot and Ezra Pound were changing the face of poetry.

Undoubtedly the single biggest influence on art—both popular and "highbrow"—was the cinema and the attendant techniques of telling stories on film, which heralded a new era of experimentation by writers, photographers and directors.

This was the famous Jazz Age and the clubs and shows featured Afro-American jazz (and its close musical relatives) with previously unheard of rhythms and seemingly cacophonous instruments. The wild scenes in places like Harlem's Cotton Club, and cabaret lounges as far flung as London and Paris, can only be imagined. With Prohibition in the US, and clubs in London often unlicensed, drinks were often served in tea cups, with police raids sending guests scampering out of back exits, adding to the fun and craziness of it all. American slang became the craze in smart society across the English-speaking world, and the topic that engaged most people seemed to be the most recent memorable party and its guests, rather than any serious talk of current events on the political scene.

Despite the endless round of parties, most ordinary people were deprived in the 20s, it was an era of hunger marches and breadlines, and when in 1926 British workers called a general strike, the middle and upper classes were reminded that life was not fun-filled for everyone. Black Friday, or the Stock Market Crash of Friday, October 24, 1929, was when life changed irrevocably for many of the rich and privileged, as well as those born into poverty.

COSMETICS **BODY SHAPE & UNDERWEAR** **WORK & PLAY**

JOSEPHINE BAKER

thrilled sophisticated clubgoers with her manic dancing,
outrageous costumes and exotic image. From Harlem
clubs and Broadway shows she became a legend in the
Paris music halls, the highest paid entertainer in Europe.

LIFE & TIMES FACES IN VOGUE FILM & MEDIA FASHION HAIR & HATS

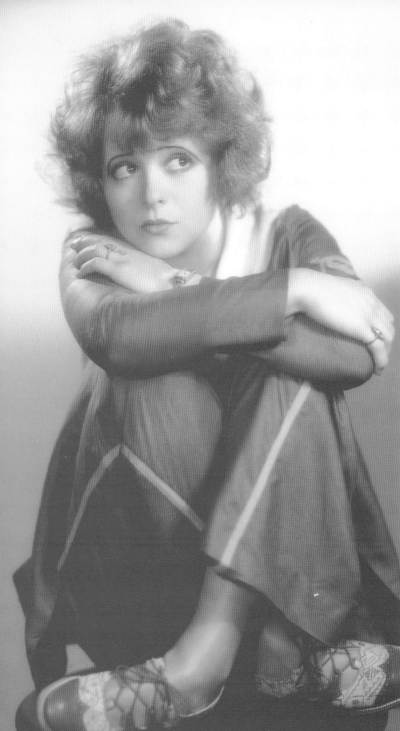

1990-
1980-
1970-
1960-
1950-
1940-
1930-
1920-
1910-
1900-
1890-

LOUISE BROOKS

whose regular features, impeccable bone structure and boyish bob heralded a new criteria for beauty. Strikingly photogenic, she progressed from light flapper roles to tougher parts in Hollywood and later Germany.

CLARA BOW

the original "It" girl, her image was carefully molded by the Hollywood publicity machine as the ultimate symbol of the Roaring Twenties flapper, whose bobbed hair, cupid bow lips and sparkling eyes came to represent the era.

COSMETICS BODY SHAPE & UNDERWEAR WORK & PLAY

above: A cover from March 1922 of *Femina*, a popular fashion review that ran from 1901 until 1956, and featured many noted artists and illustrators

right: *Gazette du Bon Ton* was an arts and fashion magazine founded in 1912. In 1925 it was bought by Condé Nast and merged with *Vogue*. Shown here is an illustration of an evening dress by Worth, 1921.

LE PARAVENT ROUGE
ROBE DU SOIR, DE WORTH

gloria swanson

1990-
1980-
1970-
1960-
1950-
1940-
1930-
1920-
1910-
1900-
1890-

Movies were now a very well-established medium for news and entertainment, but people were still enthralled by the simplest plots and effects. The immediacy and depth of feeling in their reactions was a joy to filmmakers. From the basic slapstick of Mack Sennett to the humor-with-tears of Charlie Chaplin's comedies, directors could plug into a range of emotions in their audiences that was unprecedented in popular art. Despite the melodramatic acting styles, through the magical language of celluloid a new culture was being created. The suspension of disbelief, requiring a conspiratorial mentality in the theater, was already taken for granted. The array of arresting images of the enormous number of film artists in the 20s, really did change the way we look at the world.

That is why so many of the revolutionary art movements of the period turned to film, it was like the pop music of the time, it was immediate, new and radical, and there were endless possibilities with audiences sitting there waiting to be amazed. Expressionism gave us Fritz Lang, whose *Dr. Mabuse* and *Metropolis* presented a jagged, terrifying future, and the *Cabinet of Dr. Caligari* (on which Lang collaborated) presenting a world, like an expressionist painting, where all the horizontal ground and vertical planes were crooked, as if a bizarre, nursery rhyme reality had taken over.

Surrealism gave us *Un Chien Andalou* and *L'Age d'Or,* both the work of Luis Buñuel and Salvador Dalí, in which extraordinary images are juxtaposed so potently that even now the films are strangely disturbing. Other European films like F.W. Murnau's *Sunrise,* Erich von Stroheim's *Greed* and Dziga Vertov's *Man with a Movie Camera* (in which the idea of the spontaneous roving camera is shown as deceptive) meant that audiences were quite spoilt. *The Last Laugh, Kuhle Wampe* and *Pandora's Box* (with Louise Brooks) were other groundbreaking feature films. And Eisenstein's *Battleship Potemkin,* a true classic of Soviet Russian cinema, still tops many critics' polls as the greatest film ever made.

The John Ford film *The Iron Horse* brought the West to life, like a living Remington painting, while *The Jazz Singer* (1927) brought sound to the screen, and for many the event of the decade, Garbo speaks! Fortunately, she passed the sound test with flying colors, unlike many actors and actresses whose vocal performances were so bad they stayed in the can or were dubbed—a scenario that proved the inspiration for the 1952 film about 20s' films, *Singin' in the Rain.* Like with many of the archetypal fashions of the 20s, most stars of the silent screen were unsaleable when things changed irrevocably at the end of the decade.

The favorite magazines of the decade were *Vogue, Harpers* and *Life*. For them, Man Ray and Edward Steichen changed the face of fashion photography, bringing the principles of modern art and invention to it. These pictures were not merely static society portraits for posterity, but concentrated on the figure as an object, and a desirable one at that. Women wanted to look like Modigliani or Brancusi figures, or even tribal art "stick people." Exoticism played a major part in the public taste in the 1920s, and after Howard Carter opened the tomb of Tutankhamun, there was a mania for Egyptian things. So beauty leaned to the exotic; like Gloria Swanson, Theda Bara and Pola Negri, girls wanted to be different in a similar way.

Eric, the leading illustrator on the *Gazette du Bon Ton,* was able to exaggerate the elongated thin body shape to the ultimate, and show the figure as a vibrant extension of the fabrics he depicted in his colorful drawings and advertising. Mainbocher had discovered him, and his drawings elegantly epitomize the age as well as showing the clothes as they were. Benito, the other brilliant fashion artist of the time, achieved an almost abstract feel to the flapper pictures he created for *Vogue* covers. In his pictures lies the very essence of the modern woman of the time.

In magazines and radio, the advertisers were working overtime, talking to urban and rural audiences alike, selling them the same cosmetics and cars. They told them to spend money on "the good life," to increase their comfort and if necessary, to rely on installment buying in order to enjoy today what they could pay for tomorrow. The self-esteem that would come of it depended on easy terms and steady income. It was all to change suddenly, and the tone of the next decade was very different indeed.

COSMETICS **BODY SHAPE & UNDERWEAR** **WORK & PLAY**

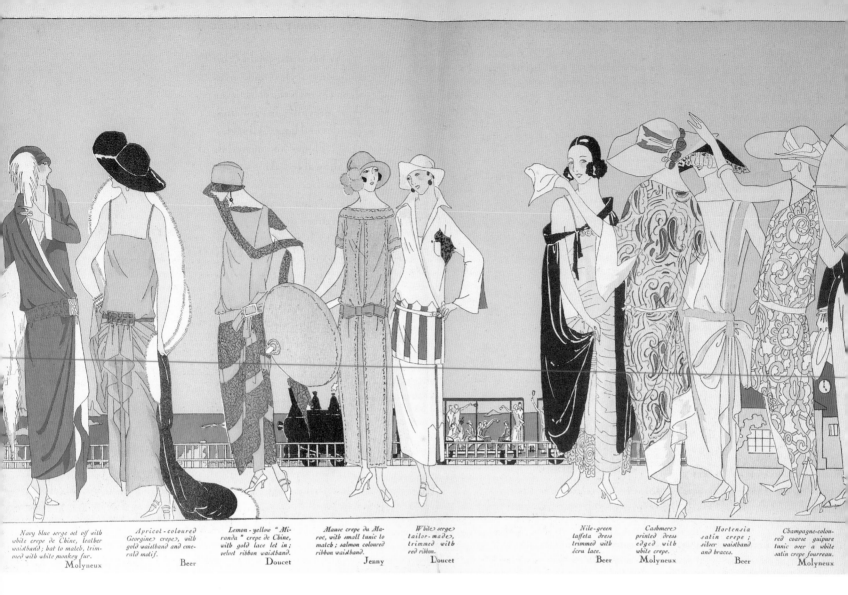

In one fell swoop, the corset was cast aside and in came the chemise. The typical dress had a tank top and low waist, and legs were uncovered for the first time in modern history, the suggestion of nudity being heightened by the use of diaphanous fabrics and little adornment. Beading was also used, in order to emphasize the see-through materials and to catch the light, and placed at strategic positions to emphasise the risqué nature of the outfit. This simple, skimpy shape appears to dominate the dress scene all through the decade, but in fact it was really like a crescendo, leading up to its dominance around the mid-20s and then trailing off quite literally, with the jagged hemlines with useless trains and uneven frills towards the 1930s, where it anticipates the fluidity in fashion that characterized the next decade.

Rayon, or artificial silk as it was called, was a real novelty, within the price range of practically everyone. It made life easier in terms of washing and wearing and, with the simplicity of the chemise shape, which was really a variation on the swimming suit, it is difficult to overstate the real change in women's fashion. The accent was well and truly on youth from this moment on and the sporty, boyish good looks with full makeup transformed the received ideas about beauty irrevocably.

Around this time, the demise of French fashion in the US was really obvious and the home market started to flourish. Department stores would order a small number of clothes from Paris, furnishing the in-house teams with the general outline ideas, adding to them and making them their own. This system was immensely popular with the predominantly middle-class customers, who really just wanted the idea of Paris without the hefty price tag.

The cloche hat dominated the whole of the 20s and for some women, the 1930s too, but it sums up this decade because pulled right down over the eyes, it could not be worn without the short hair characteristic of the time. The same goes for the Louis heel (a pump with a heel like that worn by the French king), tapered in mid-section before flaring out at the bottom, and the Mary Jane ankle-strap button shoe.

NANCY CUNARD was the exponent of a look in which fashionable society took on trends inspired by jazz and Afro-American culture. She typified the 20s' look—the rake-thin silhouette, like an African art figure with armfuls of huge ivory bracelets, leopard prints and kohl-rimmed eyes. She created a look that has run on and on, and is still current at the end of the century.

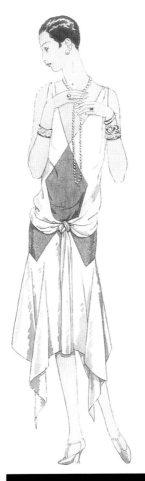

left: A contemporary illustration depicting and describing creations by Molyneux, Beer, Doucet and Jenny.

Vionnet

Madeleine Vionnet, inventor of the bias cut, displayed a technical genius that not only liberated the female form, but accentuated it through brilliant drapery. It was said that "she confronted fabric and figure directly, without preconceptions." She alone in the 1920s succeeded in freeing the body while at the same time showing it to be female.

Chanel

Coco Chanel's influence permeates the 20th century like a lingering scent, omnipresent now even 30 some years after her death. As Dior put it "With a black pullover and ten rows of pearls she revolutionized fashion." Originally set up in business by her lover, Boy Capel, she established the "poor girl" look, of jersey sports clothes in neutral colors, bright and plentiful costume jewelry, and the famous flat two-tone pumps. Altogether it was the perfect clothing for women liberated from the corset, and many more were freed under her influence. Her clothes not only transcended class barriers of the time, but they carried the wearer through day into night. Chanel herself had a wonderful life with several monumental love affairs, including one with the duke of Westminster. When he gave her ostentatious and expensive jewelry, she wore it alongside her costume junk and carried it off to grand effect.

Delaunay

Sonia Delaunay embodies the hand-in-glove relationship between fashion and art in the 1920s. Her graphic cubist/vorticist patterns were perfectly suited to the square-cut shape of the 20s, and the colors were in tune with art deco interiors. It is no wonder women were satirically compared to tower blocks in this period, tall and thin and square, in fact you could even see the windows!

Patou

Jean Patou understood women and also the simplicity that was required during this age. He humorously presented the scents in his boutique on a cocktail cabinet to be mixed up like drinks. His scents have endured, the principal one, Joy, reveling in the reputation of being the "costliest scent in the world," and launched in the year of the Wall Street crash. His clothes were feminine and sporty, and risqué in a quiet way. He was the first designer to use his monogram as a design element, and the first to introduce accessories to complement the clothes.

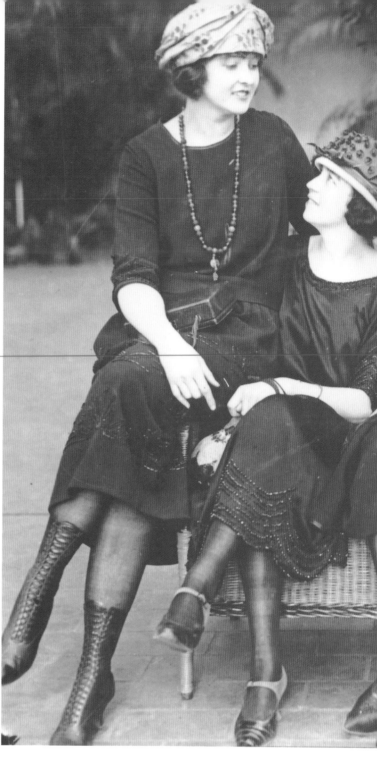

above: A variety of bobs and cloches from 1924.

ANITA LOOS

was best known for her humourous 1925 novel *Gentlemen Prefer Blondes*, but was also a major screenwriter in the silent era. A tiny birdlike figure and cheeky urchin looks were perfectly complemented by her "little boy" hairstyle.

the names were fun, like the Moana, influenced by the Jazz world, and the Chesterfield, the name of a man's coat style.

At its height, the new short hair was worn by everyone except matrons and dowagers, but, due to the persistence of nagging doubts, hairdressers made wigs in both short and long styles so that women could be assured some peace of mind. As the decade wore on, these became ever more elaborate and inventive, their being increasingly influenced by films. Hairpieces—postiches—were also promoted, to accommodate the growing number of women toward the 1930s who, tired of the extremely short styles, wanted a longer bob and could just put their hair in a tiny ponytail and cover it with a fake knot. These wearers, though, did not have the same pride in their cunning as the women of the 1890s or the 1960s. They really did not want people to realize their ingenuity. It is easy to imagine that, with all the haircutting going on, the supply of real hair was plentiful, and wigs and falls were better than ever before.

Dyeing became immensely popular during this era, with henna in particular. In the old days, it was considered "one of the secrets of the harem, and better to stay there, my dear" but now, like all other forbidden fruit, it was being sampled with great gusto. Peroxide, which was also felt to be scandalous, was now being experimented with, although with far less success, since many dyes were quite dangerous and people were frequently poisoned by them. It did not, however, lessen the demand. Women were, evidently, inured to suffering in the name of beauty.

Bobs and haircuts had amusing names, and generally the mood of hairdressing was playful and exciting, although actress Mary Pickford, the darling of America, had a harder time of it than most. She agonized in public for years before the inevitable shearing. How could Rebecca of Sunnybrook farm, little ringletted girl next door, become a modern woman and retain her warm place in the hearts of her public? How could she at the ripe age of thirty-something go around like a little girl? She did cut her hair, and her public was famously unforgiving. How similar it must have been for many girls and wives who did it to please themselves, and in doing so incited the rage of their nearest and dearest.

The first primitive perms made their appearance during this time and were an exciting development for everyone. Barbers had been making money out of cutting shingles (a hairstyle characterized by the hair being cut progressively shorter as it approaches the nape of the neck) for women, and now the dressing of hair was becoming slightly more feminine. But a lot of the time hair was hidden under turbans, cloches or sports caps, so it was largely immaterial what it looked like as long as it was short.

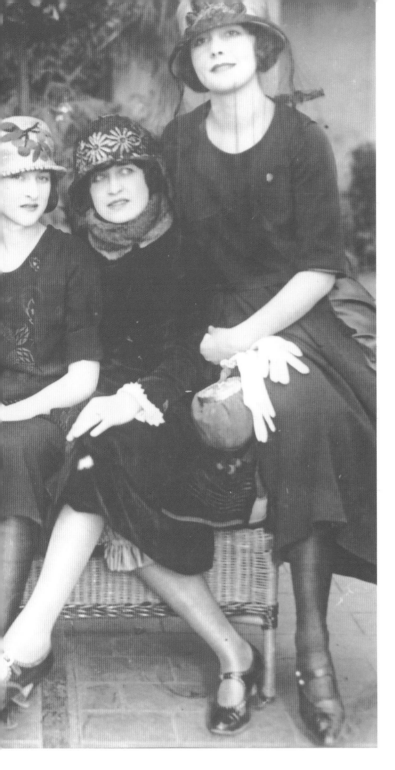

The single most popular hairstyle of the 20s was the Eton crop, after decades of ironing, frizzing, piling, pinning and basically torturing hair, women began to see the sense in shearing their locks. It was, for most people, a very emotive issue. For centuries, hair had been a woman's crowning glory and to dispense with the most sacred symbol of femininity was not something you rushed into lightly, despite appearances. Throughout the decade, when people were taking the plunge every day, rumors abounded about how the bob was going out of style. This was the dilemma. What if long hair made a comeback? Would one be left feeling a freak? And how could one be truly modern with long hair? It really did not fit the dimensions of the new styles and the emphasis on modernity. Even

COSMETICS **BODY SHAPE & UNDERWEAR** **WORK & PLAY**

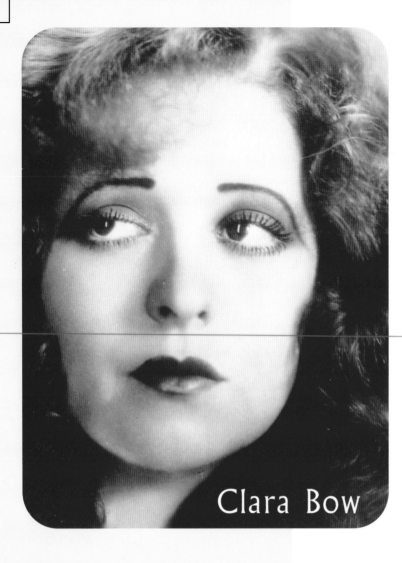

Clara Bow

left: Chanel No. 5 was one of the most popular scents of the 20s. This illustration by Sem perfectly portrays Chanel's love of simplicity in both the clothes and the shape of the bottle.

The widening use of cosmetics can be attributed to the fact that women finally felt the necessary self-assuredness to wear them, and the use of the new twist-up lipstick was the hallmark of the flapper. Not only was it considered terribly chic to wear it, but it was adequately outré a gesture to be seen applying it in public. The ritual of "making up" with lipstick and a powder compact became a fashionable activity in itself.

The heavy kohl-rimmed eyes and cupid's bow mouth came directly from the wild crazed-looking actresses of Hollywood, and suddenly every girl wanted to look like Clara Bow the "It" girl, "It" being sex-appeal, though they couldn't say it then. Film actresses of the 20s looked exotic, symbolized modernity and did outrageous things like wearing nail polish, so colored nails became a craze. The only problem was that most nail varnish had no staying power, despite an exciting array of colors.

The aristocratic role models from before the war were overtaken now by personalities from the world of film. Everyone felt close and familiar with these actors and actresses, the publicity about them was unprecedented and the cinema was a cheap and regular form of entertainment for all sections of the public. The thousands at Rudolph Valentino's funeral proved that fan culture was a force to be reckoned with.

Girls were using heavy makeup under the growing influence of the film stars of the day, and Max Factor was one of the chief people responsible for this. He was utterly dedicated to his craft and worked day and night on an idea in order to make it succeed. In the 20s he developed a makeup especially suitable for film rather than stage. He helped the heartthrob Rudolph Valentino with his need for darker greasepaint than most actors, giving him a lovely natural complexion rather than the ghostly, unflattering one that had hitherto been his lot.

As far as actresses went, he took over the total appearance of people like Gloria Swanson, Pola Negri, Garbo and the major stars of the day. He introduced a radical approach, color harmony, which told women of their color group; this, of course, meant he could sell powder, lipstick and rouge all at once. The stars had different color changing rooms, an idea that was later taken up by fashion shops. Max Factor's society line of makeup was doing very well as a result of the publicity he received for his help to the stars and the subtlety

of the images he created for them. The release of publicity photographs of Max Factor with the stars, in earnest discussion about beauty products, was a shrewd move and it was to remain a tradition up to the 70s, so greatly did the public clamor to know the truth behind the scenes.

Makeup was financially within the reach of many more people as it became cheaper and cheaper. The manufacturers were looking increasingly for a mass market, so as well as presenting their goods as chic and of high quality, they were also now advertised to a much wider public. Increased attention was also paid to packaging in this new competitive market.

Elizabeth Arden—like others—chose Bond Street in London for her salon with a factory behind it. By 1925, the company grossed £20 million per year, which shows the capacity for sales in the era. Max Factor managed to organize nationwide distribution for his Color Harmony range of makeup in the US, and export was humming by the 1930s. Women were literally clamoring for good cosmetics regardless of class.

Skincare and makeup were beginning to be heavily promoted. Elizabeth Arden, Helena Rubinstein and Dorothy Gray were all manufacturing foundations that took a while to dry and were worn with powder. Often sticky and difficult to apply, they now had to accommodate the new demands for makeup to also be compatible with a tan.

Brush-on mascara and eye pencil were later developments, but kohl was used enthusiastically by the filmgoers and young, whereas, before the war, it was enthused over as one of the "secrets of the harem." Jazz singers became popular in the more broad-minded atmosphere of France, and the French adored the style of Josephine Baker. Black beauty was thought chic and daring, but although the first beauty column to deal with advice for black women was French, it was *The Queen* magazine that reported that Josephine Baker was known to use white of egg to put a glossy sheen on her hair, and used white pencil on her eyelids.

Jean Patou invented suntan oil in 1927, called Chaldée after the woman of legendary beauty with a golden complexion. Designing bathing suits as well, along with Coco Chanel he helped popularize the whole culture of sunbathing. Ambre Solaire sun tan oil was also introduced; sales were huge and it became the leading brand name.

Max Factor

A young Joan Crawford, an up-and-coming new film actress in the late 20s, being attended to at the Factor salon by **Max Factor** himself.

1890- 1900- 1910- 1920- 1930- 1940- 1950- 1960- 1970- 1980- 1990-

COSMETICS　　　**BODY SHAPE & UNDERWEAR**　　　**WORK & PLAY**

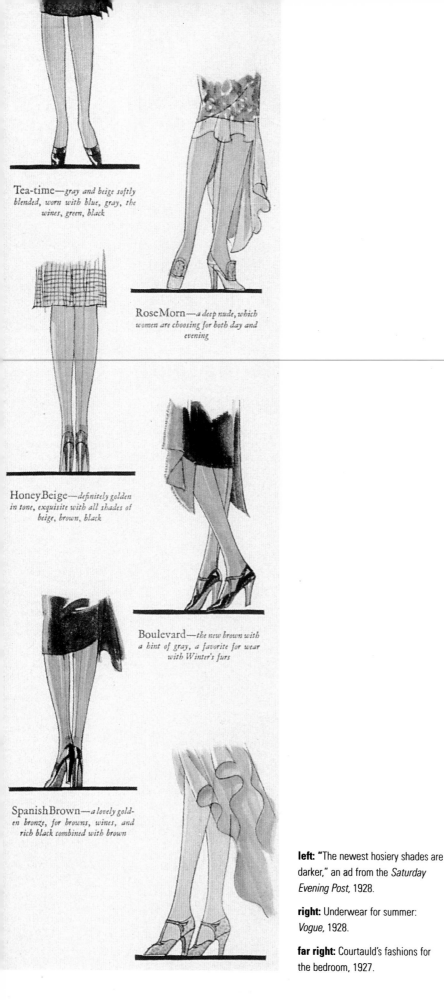

Tea-time—*gray and beige softly blended, worn with blue, gray, the wines, green, black*

RoseMorn—*a deep nude, which women are choosing for both day and evening*

HoneyBeige—*definitely golden in tone, exquisite with all shades of beige, brown, black*

Boulevard—*the new brown with a hint of gray, a favorite for wear with Winter's furs*

SpanishBrown—*a lovely golden bronze, for browns, wines, and rich black combined with brown*

left: "The newest hosiery shades are darker," an ad from the *Saturday Evening Post*, 1928.

right: Underwear for summer: *Vogue*, 1928.

far right: Courtauld's fashions for the bedroom, 1927.

The body shape of the 20s was quite clearly revolutionary. Not only did fashion decree that women should stop squashing their intestines and support their breasts from above rather than below after centuries, but all decoration and clutter was cleared from the silhouette. It was the greatest change that had occurred in a hundred years, women wanted to look as flat as boards, and even bound their bodies in an attempt to look wraithlike and shapeless. It wasn't just a political change, it was practical. Dancers like Josephine Baker and Florence Mills and the Blackbirds were inciting everyone to do the Charleston and the Black Bottom, and life was moving to a very different rhythm. Geometric shapes were beginning to appear on fabrics, and Sonia Delaunay created patchwork coats to symbolize the Jazz Age. Flowers and femininity were definitely out.

Other art movements were also influencing fashion, notably Futurism, notorious for its hatred of females and associated shapes, and cubism, vorticism, expressionism and even Dada, as well as all manner of surrealist fantasy-based ideas. Women had to be tall and thin, in fact Madeleine Vionnet wouldn't see anyone who was short or ugly! Chanel introduced "Lingerie touches," contrasting strips of color, and everyone imitated them, further emphasizing the lightness of dress and absence of man-made constraints.

Instead of corsets, women wore tight, boneless, elastic girdles to flatten the form and neaten the silhouette, but the fastest flappers were wont to ditch these in the hat check at the dances they attended and roll down their stockings. Underwear was chemise-like to go with the clothes, and with both open and closed directoire drawers very much in vogue, a glimpse of stocking wouldn't be all Cole Porter could hope for. As Dorothy Parker said "Brevity is the soul of lingerie." The main effect was that with little or no support, bras had special side lacings to anchor down the bust, and despite a primitive sizing system being introduced in the 20s, the cup sizing of the breast was not acknowledged until the 30s.

The rayon revolution brought with it a change in stockings, too. The new rayon ones were much cheaper than silk and obviously more sexy and desirable than lisle, but they were less durable and incredibly shiny; girls, therefore, spent an inordinate amount of time powdering their legs before going out.

Women were generally more self-assured due to the vote, and the proven point that they could be independent. Although *Vogue* showed maternity clothes for the first time, this was not the emancipation women wanted. The emphasis was universally on the tomboy, even cat-like, quality of womanhood, moving faster, dressed in quicksilver clothes and shimmying around. They were most definitely traveling light.

The image was very feminine and feline. The Gibson Girl kittens had turned into tigresses. They were very likely to be hungry ones, since the boyish body shape of the age required rigorous dieting, if not starvation, and exercise was absolutely crucial to the look. Patou, Chanel and Vionnet all opened sports shops to capitalize on the demand for the right clothes for the job, and René Lacoste, the tennis star nicknamed "The Crocodile" because of his ferocious court style, wore Patou's "crocodile" shirt with both men and women in mind.

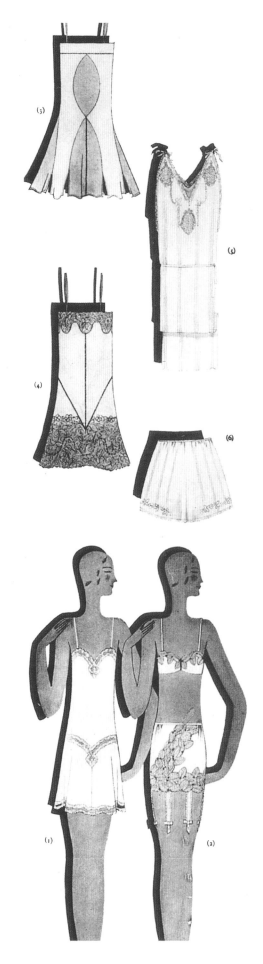

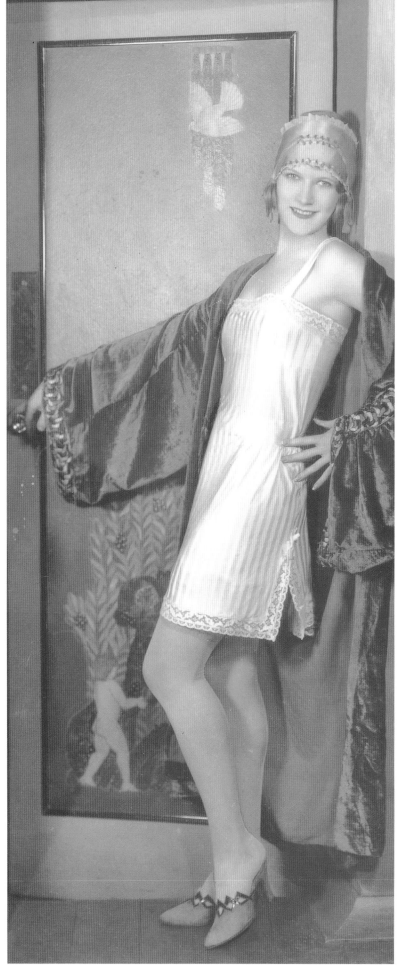

1890-
1900-
1910-
1920-
1930-
1940-
1950-
1960-
1970-
1980-
1990-

COSMETICS **BODY SHAPE & UNDERWEAR** **WORK & PLAY**

For most women, leisure was still a strictly limited phenomenon. Certainly, to spend one's leisure time outside in the elements was unheard of for the majority. But the 1920s signaled a shift of emphasis; with the liberation from corsets and with sports clothes in the couture houses, sporting activity was becoming more accessible.

Chanel decreed the desirability of the suntan, reasoning that it signified leisure and health and, since most factory and office work took place by definition indoors, it was now time to get to the resorts and bronze oneself. Of course, the designers had already got the message, and all along the waterfront at Cannes, Chanel, Molyneux, Lanvin and others had opened exclusive boutiques to entice the ladies away from the beach and into their clothes.

Tweeds were *de rigueur* as were any English sports clothes, during this *alfresco* chapter in fashion history. Golf was particularly popular, since argyle sweaters or long line twin sets and golf shoes (and if possible a spaniel with an English name, like Bob or Mac!) were thought particularly chic. Driving clothes and skiing gear were also now addressed by designers. However, the sports clothes that really sum up the 20s are the swimsuit and the tennis outfit. The one-piece swimsuit was a variation on a man's, with horizontal stripes, and you had to be in tip-top condition in order to even contemplate it. Long, wide trousers also came in the late 20s with

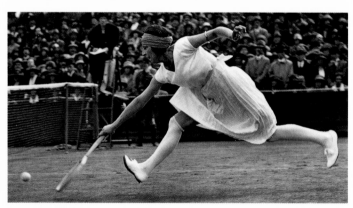

SUZANNE LENGLEN

whose eight-year run as Wimbledon women's champion was matched by her impact on fashion, dispensing with the blouse, tie and long skirts of the tennis courts in favor of loose-fitting dresses, sleeveless cardigans and bright colored headbands.

huge hats and espadrilles, anticipating the key looks of the 30s. Tiny shorts and vests were also popular with a small abbreviated rubber cloche with sporty stripes and a thin belt.

Jean Patou designed the first pair of women's tennis shorts exclusively for Suzanne Lenglen, but on the whole the usual shaped dress with pleated skirt was quite suitable for the game, perhaps a variation being a blouse and skirt. The fineness of stockings of the period made it useless to try to wear them for sport, but no one abandoned them till the 30s, so they just added socks.

Shorts were accepted clothing for cycling, and normal clothing was worn for skating, needing no real adaptation with the new short skirt. The Le Mans 24-hour race was born, and cars and motoring were of growing importance for men and women in the 20s, with gloves and outfits specially designed. However, women drivers were often lampooned as tearaways, evading their duties at home.

Dancing was, quite literally, a craze. The influence of Josephine Baker was phenomenal since no one had seen anything like her. She was said to dance like she was possessed and so did her devotees. Dances like the Charleston swept the world as jazz-influenced music invaded the home with the gramophone and radio, and dance halls and ballrooms boomed with live bands playing the music. Louis Armstrong, Duke Ellington and other jazz names injected popular culture with brand-new rhythms, while from Tin Pan Alley came catchy new songs with cool, understated lyrics—"I can't give you anything but love, baby."

Women were constantly trying to lose weight, and apart from dieting they took cures, and even went to health spas like Champneys, which had just opened. Sport became an absolute obsession and to be anything but tall, thin and staggeringly rich was really quite unattractive, despite the song lyrics. Women competed in the Olympics, and the future was acknowledged to be in the hands of youth—though teenagers had yet to be invented! The 1920s were like the 1960s in that they were prosperous, full of hope, and the fashion of the time was oriented that way.

It was clear during this decade that women were starting, at last, to realize that beauty was not so much a duty as an expression of their personality and a personal pleasure—not a sin, but a function of being smart, socially and intellectually, and a function or signifier of class and independence.

Shopping was a real hobby, the department stores gave ordinary women the opportunity to be seen, and were often even thought of as fertile ground for discovering potential stars. This was largely because Greta Garbo was a shop assistant, then she modeled hats and the rest is history. This storyline was to be used in the movies themselves time and time again, and many girls must have felt that working in a store was a big step on the way to possible stardom.

Cocktails made their debut and despite Prohibition, they became quite an institution and way of life for many. The Oscar ceremony was instigated at Grauman's Chinese Theatre, and the *New Yorker* was published for the first time—the beginning of two more very important American cultural institutions.

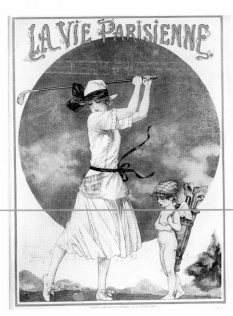

above: The young girl in this photograph perfectly portrays the youthful, sporty image desired in the 1920s.

left: Women and sports were ubiquitous in the 20s: a cover of *La Vie Parisienne*, 1922.

1990-
1980-
1970-
1960-
1950-
1940-
1930-
1920-
1910-
1900-
1890-

COSMETICS BODY SHAPE & UNDERWEAR **WORK & PLAY**

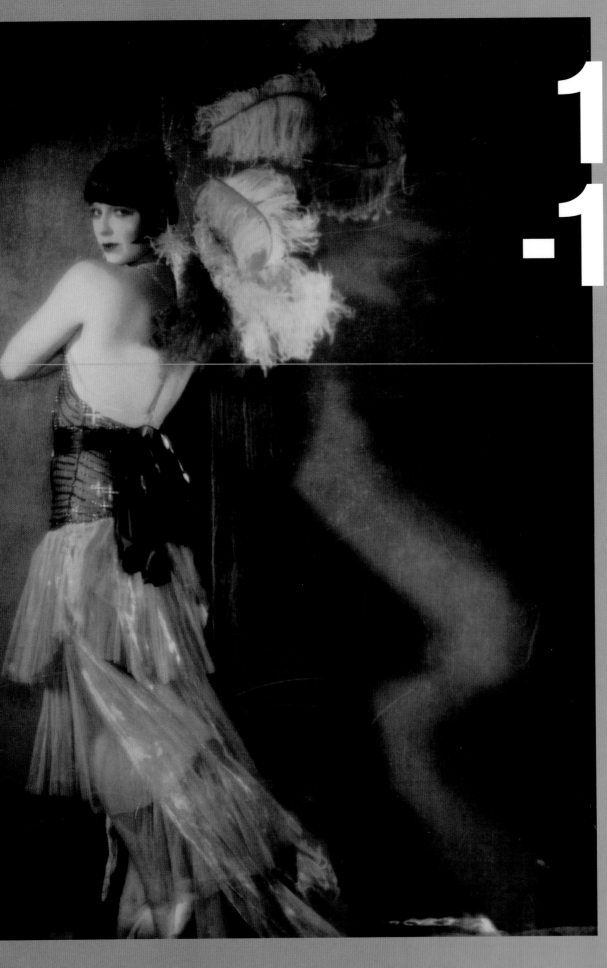

1920 -1929

Prohibition in the United States

League of Nations established

Calvin Coolidge elected US President

Gramophone records electrically recorded for the first time

The tomb of Tutankhamun discovered

Flight of the first helicopter

US immigration limited for first time

Photographs transmitted across the Atlantic by wireless technology

Hitler's *Mein Kampf* published

Television invented by John Logie Baird

Alexander Fleming's discovery of penicillin

Lindbergh makes first solo flight from New York to Paris

The Black Friday Wall Street crash

St. Valentine's Day Massacre in Chicago gang warfare

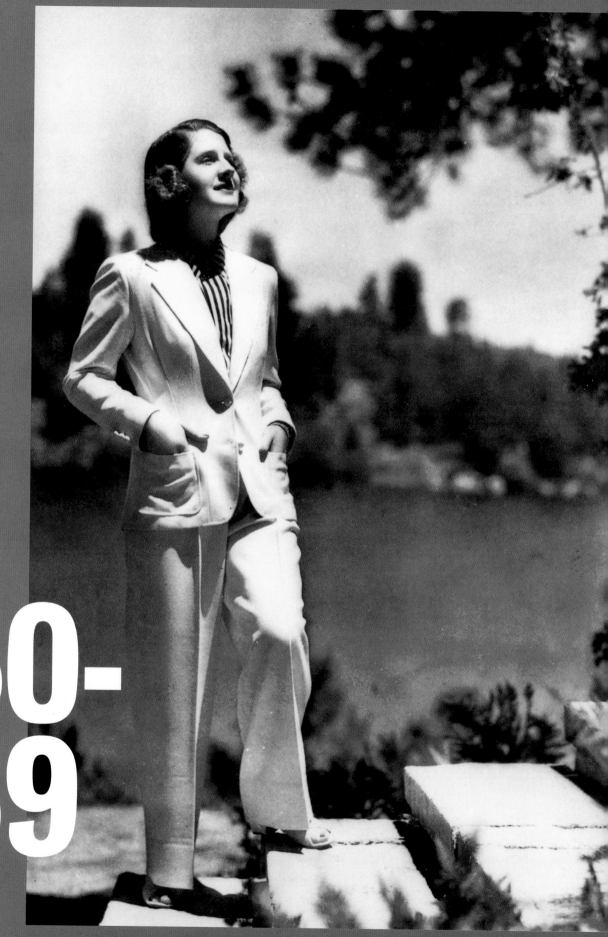

1930-1939

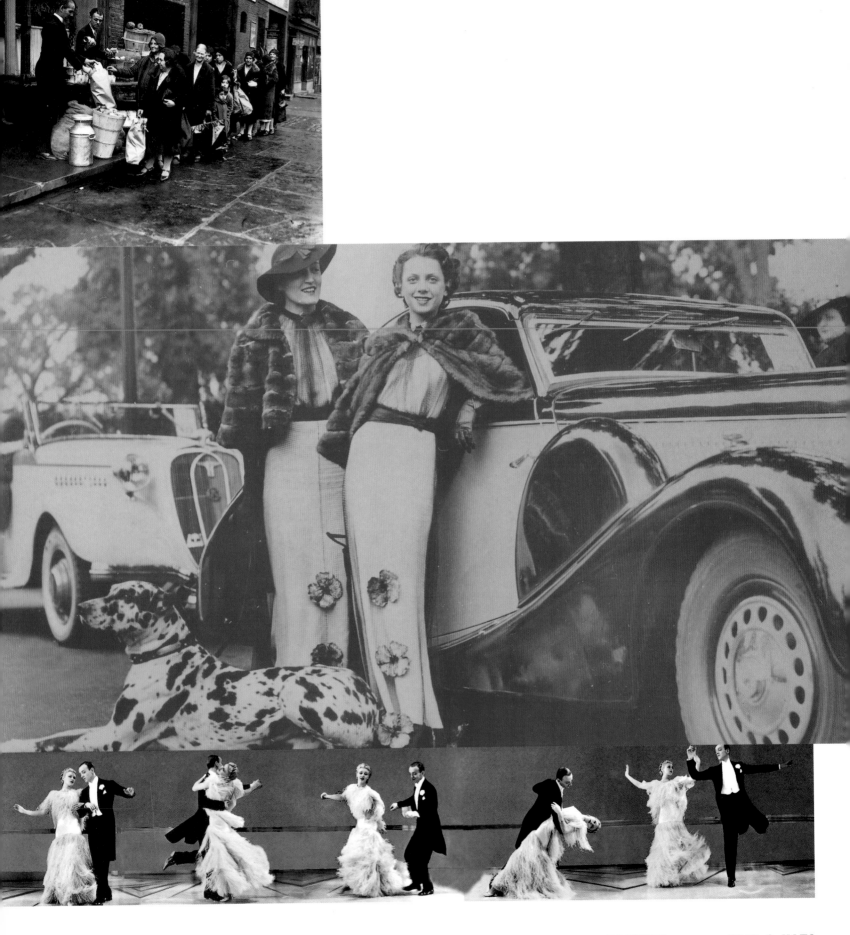

LIFE & TIMES FACES IN VOGUE FILM & MEDIA FASHION HAIR & HATS

After the hedonistic, racy 20s, the 30s seem an altogether cooler, quieter decade. Images of the silver screen sirens and the cool, light interiors were deceptive, however, for not very far beneath the surface of the gloss and glitter were the harsh realities of deprivation and political dissent. The depression in America brought turmoil and hardship to the poor, and to many formerly well-off after the Wall Street crash of 1929. The divide between rich and poor was to become wider than ever, and in the heartlands of America whole families were displaced, forced to move in the search for work. The New Deal came not a moment too soon for most Americans. In Britain, too, there were similar problems, and the decade was characterized by hunger marches, breadlines and general despair.

Many idealists became interested in communism as a solution to the problems of Western society, with lots of young intellectuals inspired to fight for the International Brigade in the Spanish Civil War. In Germany, Hitler's growing popularity soon swept him to power, capitalizing on the economic problems made worse in the aftermath of the punitive peace agreed after the Great War. All over there was a mounting sense of drama and foreboding, as the skies darkened once again on the international political scene

Not surprisingly, people took solace in the escapist world of the cinema, where the world created by Hollywood and European filmmakers usually came with a happy ending. The glamorous stories on the silver screen carried on as if all was well in the world at large; they were full of optimistic plots, plenty of singing and dancing, and lots of comedy. Anything to take your mind off your troubles, if you had the money for a seat—and most people did, the cinema being the most affordable of mass entertainments.

For the rich, it was often as if none of this was happening, social problems barely touched the lives of the real socialites, who took it in their stride when the noise of the hunger marchers interrupted their enjoyment momentarily. The super rich were still taking their holidays in the Mediterranean to get a tan, doing the Season, and flocking to Berlin, which had become both the avant-garde and pleasure capital of Europe. In other words, the party was still in full swing for those who could last it out. Sometimes belt-tightening was hinted at, but the prospect of it in the future only inspired more fun and spontaneity in the present.

The abdication of Britain's King Edward VIII came as a shock and demoralization to the establishment, and many found it simply incomprehensible that a man could give up his royal duty for a woman like Wallis Simpson, an American divorcée. King Edward had been a playboy, a real trend-setter, and his reign was eagerly anticipated as likely to be very glamorous. The shock of such a gesture caused sadness and disappointment among traditionalists, but others saw it in a more romantic light, that he should give up so much for the woman he loved.

Britain's constitutional crisis was soon put into dramatic perspective by the outbreak of war in Europe. Women were once again called upon to step into the breech, becoming farm laborers, munitions factory workers, nurses, as well as taking over male jobs unconnected with the war effort. In more specialized fields, women played their part in intelligence work and even espionage!

THE THIRTIES WERE AN ERA OF EXTREMES IN WEALTH AND POVERTY. THE RICH ENJOYED A LIFE OF LUXURY AND FASHION, WHICH FOR THE POOR WAS MERELY AN ESCAPIST FANTASY VIA THE MAGIC OF THE SILVER SCREEN

left, above: Depression breadline—handing out food to the poor, New York.

center: Two ladies in France pose with luxurious furs and shiny automobiles, June 1937.

bottom: Hollywood's glamorous Fred Astaire and Ginger Rogers dance the night away in *Top Hat*.

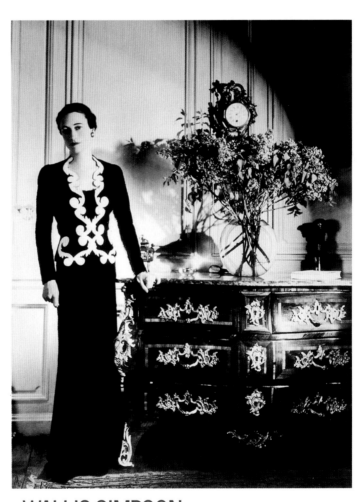

WALLIS SIMPSON

Wallis Simpson was, for many, an enigma. Described by Cecil Beaton as an "ugly child who has woken up to find that she is beautiful" her best features were her wraithlike figure and her almost neurotic neatness and discipline, which suited the look of the day. Dressed invariably in her favorite designer, Mainbocher, a fellow American living in Paris, and with more than a penchant for Cartier panthers and square cut emeralds, she was ideally suited to her time. She and the uncrowned king remained devoted to each other until his death, and she was finally allowed to be laid to rest beside him at Frogmore.

1990- 1980- 1970- 1960- 1950- 1940- **1930-** 1920- 1910- 1900- 1890-

GRETA GARBO

led a life shrouded in mystery, even to many who knew her.
With a Swedish accent, sculpted features and enigmatic
image, to a clamoring public she was the ultimate in
aloofness and cool, before the phrase was even invented.

LIFE & TIMES **FACES IN VOGUE** FILM & MEDIA FASHION HAIR & HATS

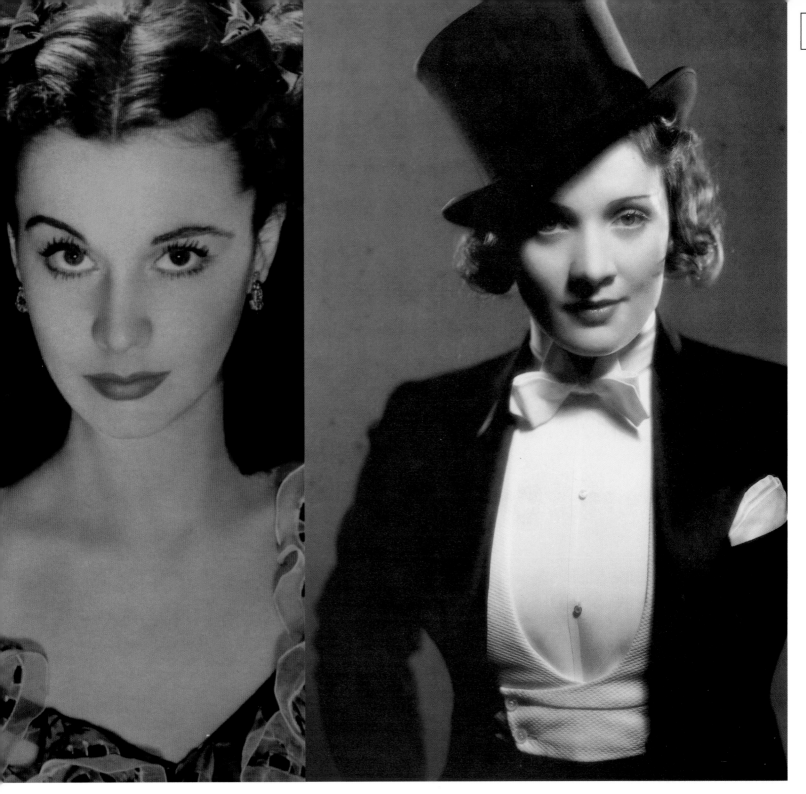

1990-
1980-
1970-
1960-
1950-
1940-
1930-
1920-
1910-
1900-
1890-

VIVIEN LEIGH

was the archetypal English rose when she hit Hollywood in 1939 with her role as Scarlett O'Hara in *Gone With the Wind*. A small frame and delicate looks confirmed her reputation as one of the perfect beauties of the cinema.

MARLENE DIETRICH

created her top-hat-and-tails stereotype in *The Blue Angel* (1930), which almost eclipsed a great classical beauty that shone in films from the 20s to 70s, but helped perpetuate the Dietrich icon as modern legend and myth.

COSMETICS BODY SHAPE & UNDERWEAR WORK & PLAY

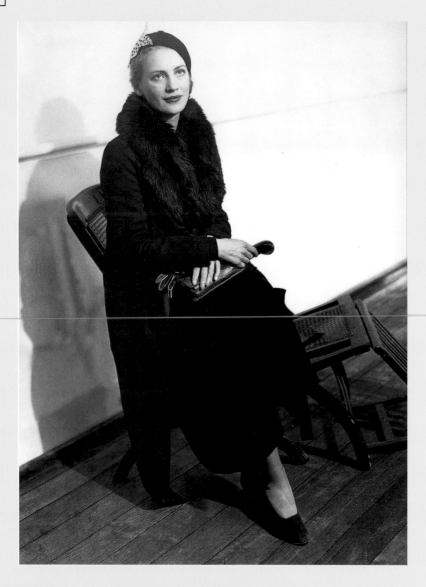

LEE MILLER

Lee Miller was an American photographer who worked for all the best magazines and became the official photographer for *Vogue* during the Second World War. Well-acquainted with all the surrealists and Pablo Picasso, she was married to the English surrealist painter Roland Penrose. She was stunningly beautiful and could easily have been a professional model, but her legacy is certainly more interesting as it is.

right: Judy Garland played the young Dorothy in MGM's 1939 classic, *The Wizard of Oz.*

Hollywood provided dream material for ordinary people during these difficult times. Comedy teams such as The Marx Brothers were hugely popular, while musicals like *Top Hat* and *42nd Street* provided a diet of sheer escapism. Optimistic American-dream themes, like being discovered by talent scouts or beating the high school heartthrob in the game of love, were repeated over and over again with Judy Garland and other Hollywood "girls next door."

Stella Dallas, featuring Barbara Stanwyck, was all about 30s' fashion. The moral was if she didn't change her vulgar style, she would be left behind. It reflects the standardization of fashion during the period, and how the fussy designers were being ditched.

There were some real thought-provoking classics, like *All Quiet on the Western Front*, *Stagecoach,* and ever-popular gangster films with Edward G. Robinson and James Cagney, but principally Hollywood was the dream factory, the purveyors of romance and glamour for people the world over to forget the humdrum and take the celluloid pathway to fantasyland. The high camp of *The Blue Angel* and the risqué comedy of *It Happened One Night* (for those who wanted to know that Clark Gable didn't wear an undershirt), was infinitely preferable to anything remotely serious.

Ziegfeld Follies, *Gold Diggers of 1935* and similar big musicals with kaleidoscope dance sequences (the greatest being choreographed and directed by Busby Berkeley) and full-on glamour were the favorite themes. Other Berkeley musical titles that captured the imagination of the world included *Stage Struck*, *Hollywood Hotel*, *Ziegfeld Girl* and *Broadway Serenade*. Ultimately, in 1939, *The Wizard of Oz* was an instant classic, totally escapist and viewed fondly today.

In nonmusical films, period costume was all the rage; after the demise of the very definitive fashions of the 20s, this too was a form of escapism in the drearier-looking 30s. Costume dramas, (many of the swashbuckling variety), were spectacular hits worldwide.

After the revolution of the talkies, Technicolor arrived at the end of the decade with *Gone With the Wind* and other blockbusters, and films became imbued with even more fantastic possibilities. The build up to *Gone With the Wind* was phenomenal, the search for a Scarlett O'Hara making headlines as it went on. Hollywood was now an established town, with mansions and thriving businesses and a seemingly endless source of people who wanted to make it in the movies. The casting couch was well worn by all accounts, and film was the greatest single source of employment for the beautiful and not-so-beautiful people. In fact, Hollywood could and did dictate who was beautiful and who was not. The influx of British talent, which had exposed virtually everyone who was anyone in the British stage and screen, finally produced Vivien Leigh. A popular choice, she was little known elsewhere in America, and being one of the great beauties of her age, she was eminently suitable as the beautiful but shallow and scheming Scarlett.

Films were a powerful force all over Europe, so powerful, in fact, that the final unification of Italy came about, linguistically at least, by means of Mussolini's "white telephone" films, so called because of the luxurious settings and glamorous actors. Governments in Italy and Germany were investing heavily in film, since the medium was recognized as a potent medium of propaganda, and the

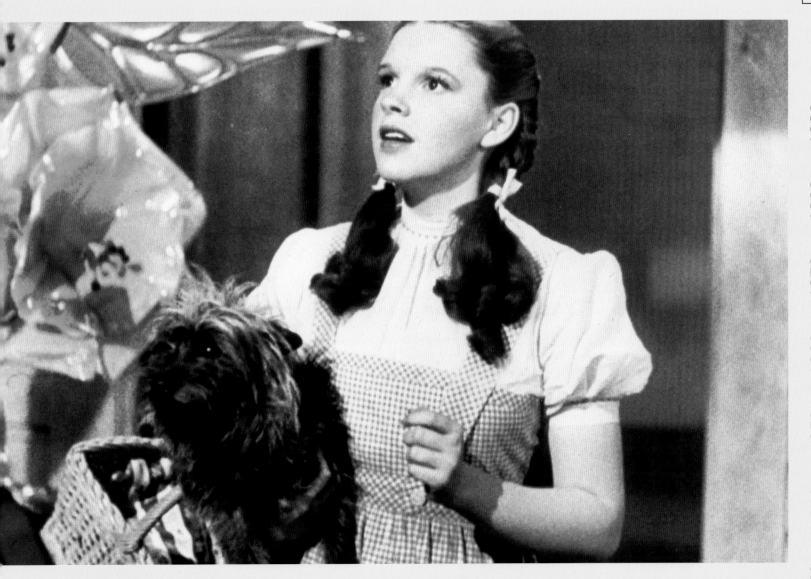

success of Cinecitta in Rome is the legacy of this policy. The power of film in this way would prove of more sinister potential as time went on.

The surrealist movement continued to make its presence felt with its exhibitions and films, and the endless publicity received by Salvador Dalí in particular. It was very fashionable to include quasi-surrealist imagery in photo sessions, and Cecil Beaton in particular photographed socialite Diana Cooper and the Maharani of Kapurthala, among others, in surrealist landscapes. The influence of Surrealism was everywhere suddenly, in film, photography and clothes, and even at the lavish society parties of the 30s, the themes were at work.

The photographers of the age, Beaton, Horst, Hoyningen-Heune, Steichen and Man Ray (adopted name of Emmanuel Rudnitsky) took endless pictures of models lounging, smoking, or wearing trousers and sweaters with ropes of jewels, in subtle light, in cool, empty interiors, or in elaborate period settings. These and of course the elaborate settings created by set designer Oliver Messel for grand society parties and opera, were ideal for photography. Unreal, magical landscapes far away from the dreary concerns of the

real world, became the style for the decade. A mood was created in which the suggestion of subconscious emotions, pensive and strange, were the keynotes.

The coverage of Oliver Messel's sets in chic magazines, for the opera and grand society balls like the one at Osterley held by Lady Jersey, his collaborations with the likes of Cecil Beaton and Horst, meant that his influence on the images of the time was enormous. Socialites clamored to have their picture taken in this lavish, vaguely eccentric, atmosphere of the times.

And as well as surrealist and fantasy settings, the spare, cool, modern interior was a recurrent theme, suiting the styles of Horst and Man Ray—who managed to instil an intimacy in photographs not seen before. Steichen captured similar contemplative moods, often picturing a woman seated at her dressing table from behind, to accentuate the back as the feature of the era. Beaton was more of a stately portraitist, the indeterminacy of the settings heightening the drama of the "historical moment." There were also fads for Regency furniture in pictures, while anything at all Victorian was considered amusing, objects from that period being deliberately utilized for their "humorous" value.

COSMETICS **BODY SHAPE & UNDERWEAR** **WORK & PLAY**

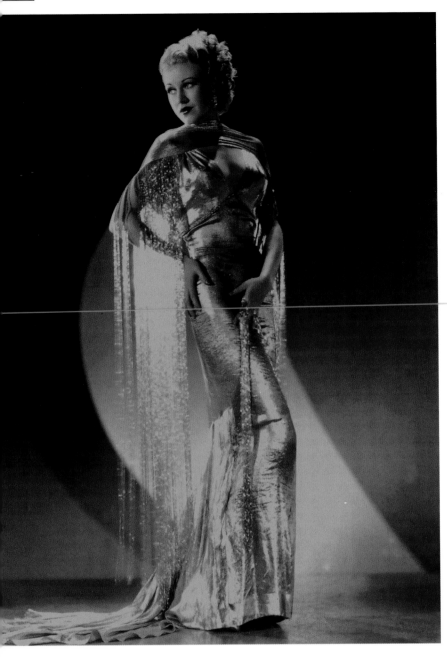

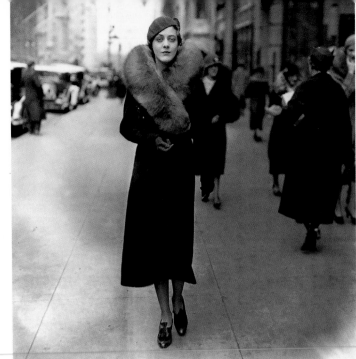

The style of the 30s was magical and painted with a light touch. The world of film heavily influenced the world of fashion and beauty more than ever, the clothes looking even more sumptuous and incandescent. Cut on the bias, the evening clothes of the time possessed a fluidity that was perfect for the lights and movement of the cinema. The dance films of Fred Astaire and Ginger Rogers in particular were the perfect medium for the shimmering, floating styles in these black-and-white movies.

The films had a huge influence on trends, and because of the censorship limitations imposed by the Hays Office, designers had to be careful about revealing too much; so evening clothes were often made with a bare back, the bare back achieving a sexy look without being too controversial or showing much cleavage. The designers who worked in film, notably Travis Banton, Howard Greer and Adrian, were also very influential. Women had begun to imitate the

stars in earnest now, and yet economics for many demanded longevity; they needed clothes suitable for most occasions. Despite the mania for witty hats this decade, the cloche was to be the uniform for most ordinary people until the war years, when, to raise morale, they were made in every shape and from any materials. Late in the decade, there were crazes for Tyrolean hats, the fez and various nautical styles. Berets, turbans and snoods anticipated the big-selling styles of the 40s when fashion resumed after the war and throughout the decade, and period hats were reinterpreted from any time in the past, particularly medieval.

In such strained times, status symbols were everything. Furs with broad shoulders and small wraps or fox were enviable, but silver fox was *the* status symbol for evening. Jewelry was simple and modern-looking. Stones were mostly square-cut and Cartier was the first jeweler to mix stones (outside state jewelry), for their famous panthers and the favorite "service stripe" bracelets.

Films helped cement the new concept of a total image for a woman, and until the war, the sense of fashion was more feminine and standardized. Shapes were mostly classic, but more interestingly made than the 20s' chemise. Whereas few fashion designers stood out in the 20s, so uniform were the ideas, now the truly innovative could be recognized clearly. Printing techniques, vastly improved in the 20s, were superlative now, clothes draped and detailed, and yet the female form was highlighted more closely than ever. A sensuous female feel was sharply interrupted by the economies forced on the clothing industry by the war office, but the look was to return at the end of the next decade. By the late 30s, Hollywood, Balenciaga, Vionnet in Paris and Hartnell in England, had all paid tribute to the bustle, putting it in suit peplums and running a riot of ingenuity with hats based on the extravagance of the 1890s, so that the feel was luxurious, light, and almost Winterhalter for the 20th century. Women started to imitate the stars' total image. Mae West had been harking back to the Belle Époque in her evening wear throughout the 30s and "poured in" was a phrase coined in the 30s, just for her.

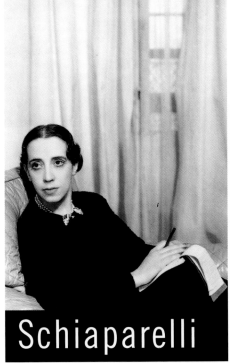

Schiaparelli

Elsa Schiaparelli founded a fashion house that was noteworthy for its connections with the avant-garde artists of the day. Schiap, as she called herself, made the most of her friendships with various surrealists (including Jean Cocteau) and based many of her witty ideas on their principles and images. The "shoe" hat, the inkpot complete with feather quill, and even the mutton chop, the *trompe l'oeil* bow sweater dress with the full length lobster evening gown and "vegetable" costume jewelry, always made light of fashion, always pushed the jokey aspect of things to the limit. Her "desk suit" had drawer pulls on the pocket flaps. She invented "shocking pink," her perfume Shocking being the most outrageous of aromatics, said to smell like a woman's sexual odor, and in a bottle made according to dress measurements sent to her by Mae West. She used diamanté on lapels and tailoring details, and enjoyed great success among sophisticated, intellectual clients. She had collections *pour la ville*, *pour le nuit* and *pour le sport*. "Never fit the dress to the body, but train the body to fit the dress" she said in *Shocking Life*, her autobiography.

Grès

Madame Alix Grès had a very strong personal style. She had wanted to be a sculptor, but, due to lack of funds, she ended up making toiles for fashion houses before establishing her own house as Alix Barton. Her simple, pleated dresses were like Fortuny, but timeless. She reopened during the Occupation, now calling herself Grès. Her dresses, made of jersey, fitted straight onto the body with no pattern and little cutting, just like sculpture. Cabochard is her signature scent—meaning obstinate.

Molyneux

Captain Edward Molyneux was around for a long time on the fashion scene, having started with Lucile and continuing after the war, until he finished in 1950, almost blind. He was such a purist that the streamlined liquidity of 30s fashion shows his truly great strengths. His ensembles really were pared down elegance, with the simplest of dressmaking details and colors. He made clothes that could readily be combined with other clothes to befit another occasion. He favored navy and black for evening dresses and sportswear alike. For evening, he invented the hallmarks of 30s' glamour—the white satin slip with silver fox, white crepe, soft velvet in neutral colors. He designed for Gertrude Lawrence in *Private Lives* and specialized in evening pajamas. He loved beading and embroidery with stunning imagery, and from time to time even slipped in the odd joke, such as a set of buttons in the shape of cigarette butts.

Mainbocher

Mainbocher was the favorite designer of Wallis Simpson, his slim, streamlined designs perfectly showed off her main asset, her slim figure. The first US designer in Paris, born Main Rousseau Bocher, he used the device of the bolero, often to highlight the 30s flatness and curve of the body. He also adored using the bias cut. He moved to New York and opened a house there in 1940. His mentors were Vionnet, Louise Boulanger and Augusta Bernard. He designed the uniform for the American Red Cross and discovered Hoyningen-Heune and Eric when he was the editor of French *Vogue*. He successfully reestablished himself in America during the Second World War.

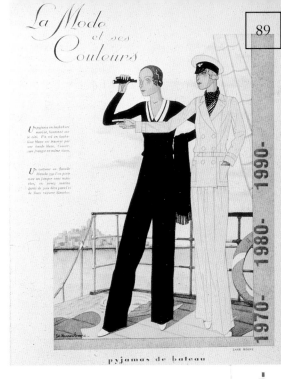

above: Elegant 1930s fashions for sailing.

opposite page, right: Sumptuous fur was a potent status symbol in the 30s.

left: Ginger Rogers in a shimmering evening creation.

1990-
1980-
1970-
1960-
1950-
1940-
1930-
1920-
1910-
1900-
1890-

right: Glistening and perfectly set: hair-styles of the 30s from the 1939 film *The Women*.

below right: An example of the sleek, sculptured hair of the day.

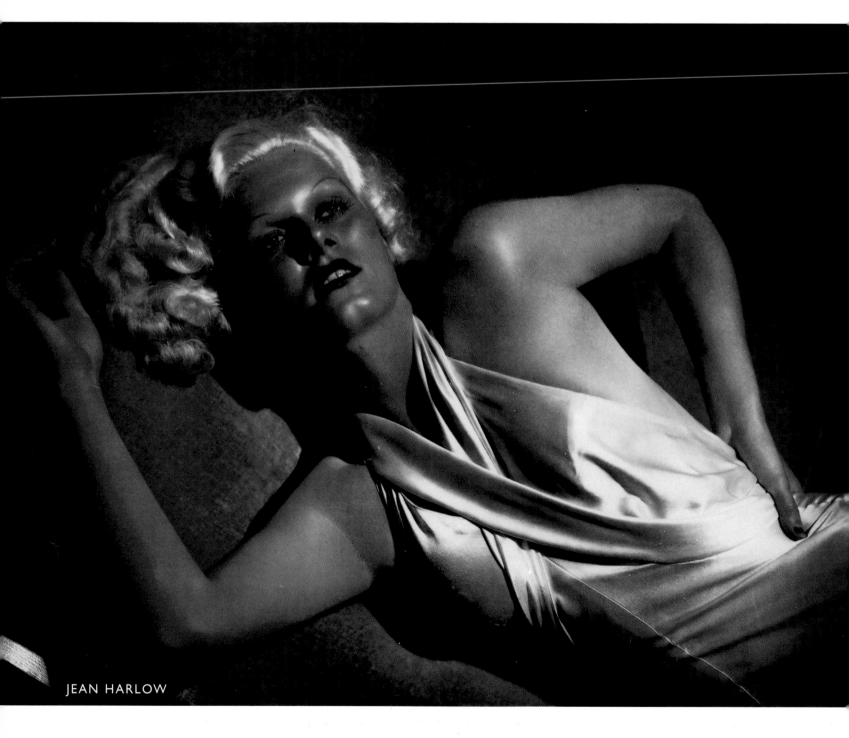

JEAN HARLOW

The 30s were notable for bringing relief from the tyranny of the shingle and the crop. The more subtle sensuality of the clothes demanded a new dawn, and not only did hair get slightly longer, but a slight curl was permitted too. The forehead reappeared after a decade of being hidden by fringe, hat and turban, and hair was more textural looking in that the styles to come were more sculptural, with waves and grooves, features which suited the clothes of the time, and also the lighting of photography.

The hair color of the decade was definitely platinum blonde. It caught the movie lights, and had a sheen and luster that perfectly complemented the oyster and cream colors favored in evening wear. Diamond or crystal decorations were used to create a fantasy feeling. Film stars Anny Ondra, Anna May Wong and English actress Jill Esmond, wife of Laurence Olivier, helped popularize these short, sculptural styles. Their best exponent was Antoine, who commuted regularly between Paris and New York—where he showed his skills in public at Saks Fifth Avenue department store.

Writing about hair in the 30s, contemporary beauty journalists enthused about every new style that came along; the Eton crop was forsaken for the shingle, which led to the bingle and finally the mingle! Each tiny deviation from the previous look was greeted with utter delirium, and when the bob evolved from the simple shape to the page boy and ultimately into the peek-a-boo style characterized by Veronica Lake toward the 40s, it was copied in near hysteria by hundreds of thousands of girls. Eventually Lake cut her hair in deference to the number of accidents experienced by her followers working in factories, getting their hair caught in machinery.

The marcel wave made a popular comeback, its effect was easily achievable and also the alternatives for permanent waving were increased by several different methods, using steam and vapor with Pelleray irons, water waving pin curls, permanent waves using the Eugene steaming method, the McDonnell and also the Nestlé vapor.

The postiche continued to be useful to women growing out their hair, but now, as a result of the trend for dressing up in period costume, these became more and more elaborate and wildly colored—dressing the hair to match the clothes was all the rage.

Dyes were also popular, henna and bleach being the most common choice, and hairdressers began offering various treatments. An authoritative hairdressers' manual of the period told its readers how to carry out perms and cuts, as well as giving advice on items as diverse as nutrition, blood disorders, using electric reducers, steam cabinets, light treatments, movie makeup and singeing. It also contained advice on hygiene, how to treat chemical burns, and even how to calculate different voltages for travel abroad.

Marlene Dietrich was one of the most charismatic and stunning-looking stars of the silver screen. She understood perfectly how to be photographed with the correct lighting, and she wore clips around her hairline to lift her face. She also enjoyed the personal touch of Max Factor himself, who put gold dust in her hair to make it look truly lustrous. At $60 an ounce, she needed at least half an ounce a day, and he would stay behind after the star had left to sweep up any excess off the floor!

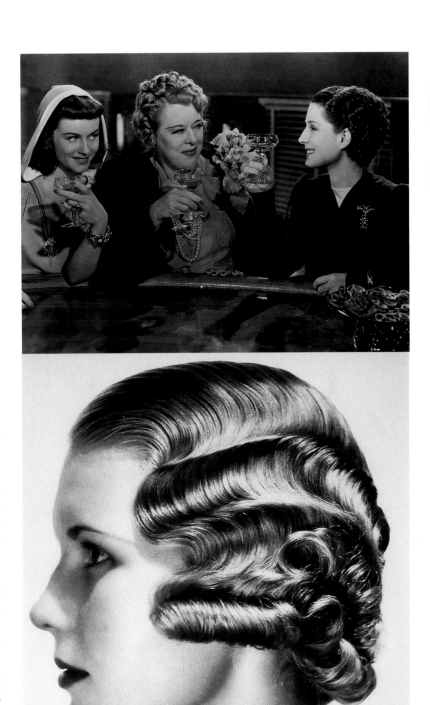

1890- 1900- 1910- 1920- **1930-** 1940- 1950- 1960- 1970- 1980- 1990-

COSMETICS　　　**BODY SHAPE & UNDERWEAR**　　　**WORK & PLAY**

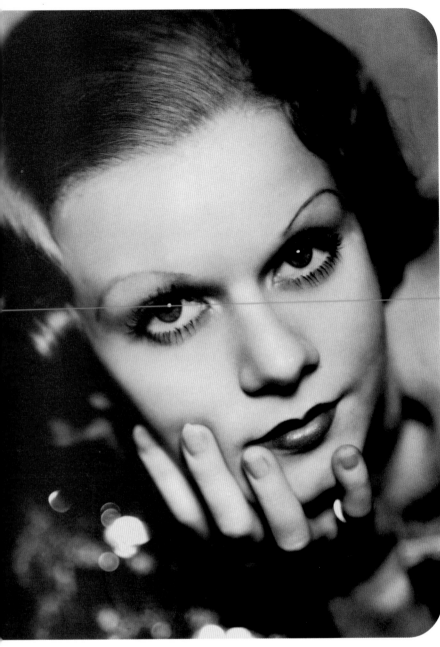

JEAN HARLOW

was the original platinum blonde, in fact one of her first starring vehicles was called *Platinum Blonde*. After purely sexpot parts, she developed a flair for comedy while retaining the bombshell look that made her a superstar.

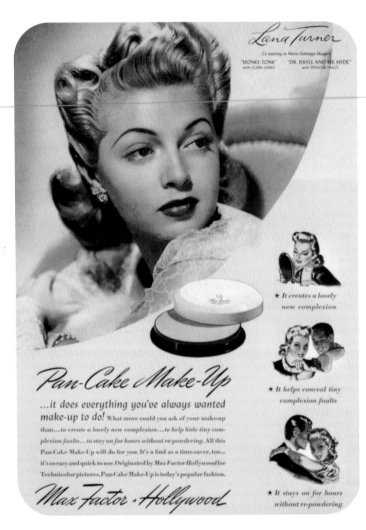

above: Max Factor's breakthrough Pan-Cake makeup as advertised by the beautiful Lana Turner.

right: Maureen O'Sullivan promotes Max Factor's makeup blender.

Cosmetics in the 30s became much more sophisticated and widely used. Women everywhere devoured the ideas from Hollywood, and emulated as far as possible the sultry silver screen style of the likes of Garbo, Dietrich and Carole Lombard.

A good maquillage was not only acceptable but *de rigueur*, and for the first time there were products and looks that were truly "must haves." Germaine Monteil and Revlon were two newcomers to the beauty world. Monteil was famous for getting the idea of makeup across to the middle-class women of America, and paving the way for the modern woman of today, both as consumer of makeup and business role model. In 1935 she took the lead from Lanvin and Chanel and introduced makeup and skincare products. They included face powders and lipstick, including her famous Chinese Red. She taught women her personal principle that "beauty is not a gift, it is a habit" and helped establish the modern beauty routine with her "Preview Combination Set" containing cleansing cream, day cream, night cream, powder and lipstick. Revlon came to fame, when its founders, Charles and Joseph Revson, and the chemist "L," Charles Lachman, were the first to commercialize nail enamel. Previously it had not stayed on the nails, but they developed a manufacturing process using pigments instead of dyes, and then introduced the concept of seasonal fashion colors for nails. Then at the end of the decade, they went on to present matching nail and lip colors.

The older names in beauty were keeping up with the times, too. Houbigant brought out an enameled triple vanity compact with rouge, powder and lipstick; Yardley produced new compacts for rouge and a new combination cream; and Coty, special clear nail varnish. Maybelline brought out a new mascara and Terri had a large range, including a Bakelite cased lipstick and vanity cases to fit the new chic. Dorothy Gray and Tangee also had popular products, while other new ranges included Clairol, Almay and Wella.

Manufacturers large and small jostled for premier position, and literally hundreds of new products were launched in all price ranges, with great attention paid to details of packaging for compacts and lipsticks. Coty, Gala, Guerlain and Chesebrough-Ponds all opened factories in London's new art deco industrial area on the Great West Road. Products were increasingly sold in chemist shops and the ubiquitous Woolworth's. Britain's Boots came up with their new cosmetic line, No. 7, in 1935. Things were very, very different from Harriet Hubbard Ayer's challenge to the received ideas of 30 years before.

Elizabeth Arden opened her home as a health spa, Maine Chance in Maine, in addition to the famous Red Door salons, and another in Arizona shortly afterwards. Elizabeth Arden was already a generic term used for "beauty salon." She also brought out a new set of six lipsticks called a lipstick wardrobe, each in a different colored case. Later she introduced matching cream rouge and cream eyeshadows to coordinate with the Color Harmony principle she claims to have invented, which meant that you were supposed to complement the colour of your clothes. She added to this prolific period with the introduction of Blue Grass, the hugely successful scent, and continued a horsy theme with eight-hour cream, originally made for horses' legs. Both still sell widely today.

Helena Rubinstein and Dorothy Gray, both established at the same time as Arden, were still in their stride too, producing new products and keeping up with the arrivistes in the beauty world.

With all the press coverage of the movie stars, Max Factor did not disappoint with his Pan-Cake makeup, while his two special gimmicks for the 30s were the "beauty calibrator" and the "kissing machine." The calibrator looked like some medieval instrument of torture to measure beauty, and the kissing machine measured the pressure of the lips and gave an imprint of the mouth and its shape, the idea being that you could then even up the smile.

The makeup of the 30s was often made in outrageous colors; the heiress Barbara Hutton, for instance, wore black nail polish, orange lipstick and green eyeshadow and was considered incredibly chic. Color was often wild and experimental, much like the 90s revival of the 1970s. And through much of the 30s, Berlin was the trend capital of Europe, highly influential in colors and style.

1990-
1980-
1970-
1960-
1950-
1940-
1930-
1920-
1910-
1900-
1890-

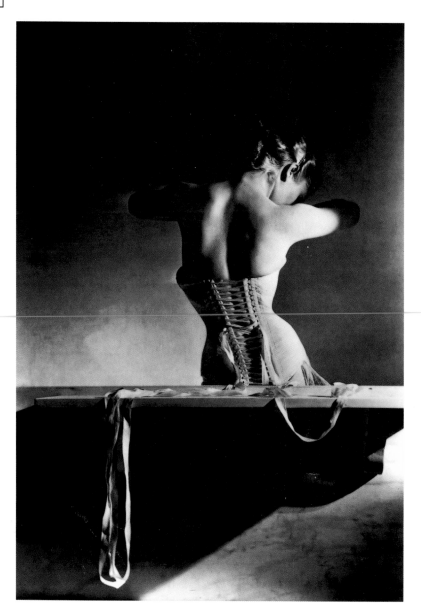

The strict, flat figure desirable in the 20s was softened considerably in the 30s. The clothes appeared to float near the body, skimming it here and there, rather than actually defining the body shape. For these clothes and fabrics, the minimum amount of rigging was needed, and with the back being uncovered for sport and evening wear, bras could not be worn at all.

This was problematic for anyone with a bust. The bust was very much accentuated with fabric, but no actual cleavage was visible—reflecting the "moral" constraints imposed on the cinema images of the day. The waist was nipped in and the loins and bottom were on display, with the tight bias cut over that area. Despite curves being fashionable again, comfort was now a basic requirement.

For most daywear, corselettes were ideal, since there was no visible line, and the smoothness of the fabrics could be shown to perfection. For trousers this hardly mattered, although the panty girdle and the "roll-on" were introduced in the mid-30s. But there was still the problem of garters, unless women dispensed with stockings for sport and resort wear, which is exactly what they did. The underwear of the 30s was otherwise French drawers (awkward for cyclists wearing shorts), and bras much like the ones worn today, except that they were fabric with a lot of elastic at the back. Padding came in along with the wired bra in 1935, and special padded bra slips were sold, for ultimate smoothness.

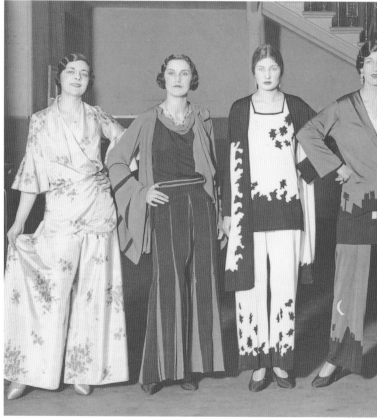

1990-
1980-
1970-
1960-
1950-
1940-
1930-
1920-
1910-
1900-
1890-

In the 1930s Warners acknowledged the breast again when they introduced cup sizes. An element of control in underwear came back and the corset began to make a comeback in a less tyrannical and more elastic form towards the end of the decade.

There was something definitely tacitly sexual about this, as Horst's famous picture of Mainbocher's corset shows. However, the development of new fabrics meant that there were now finer elastics that could be used with fine lace, voile, lace and even satin and silk. The heavy elastic panels and the broche and cotton "passion-killers" could now be dispensed with. The predominant color was a very characteristic shade of pink, with black occasionally, or gorgeous printing from time to time. At the end of the decade, spiral boning was introduced, making it much easier to bend and move, and zip fasteners overtook hooks and eyes, making it faster and easier to dress and undress.

The 30s were a time of serious sex appeal as opposed to the exotic and bizarre flavors of the 20s, where shock value counted for more. The smoldering, pressure-cooker looks of the stars were dampened a bit by the rules of the Hays Office, which was the guardian of public morals as far as the American cinema was concerned, and any pictures of couples in bed meant pajamas for both. Ironically, this—and Noel Coward—did much to popularize pajamas both as lounge wear and bed attire.

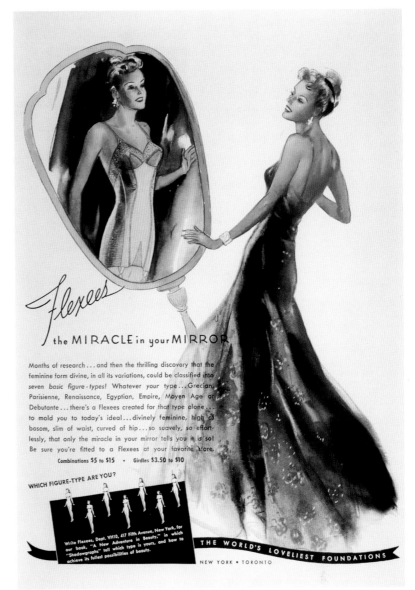

Flexees

the MIRACLE in your MIRROR

Months of research...and then the thrilling discovery that the feminine form divine, in all its variations, could be classified into seven basic figure-types! Whatever your type...Grecian, Parisienne, Renaissance, Egyptian, Empire, Moyen Age or Debutante...there's a Flexees created for that type alone... to mold you to today's ideal...divinely feminine, high of bosom, slim of waist, curved of hip...so suavely, so effortlessly, that only the miracle in your mirror tells you it is so! Be sure you're fitted to a Flexees at your favorite store.

Combinations $5 to $15 • Girdles $3.50 to $10

WHICH FIGURE-TYPE ARE YOU?

Write Flexees, Dept. VH10, 417 Fifth Avenue, New York, for our book, "A New Adventure in Beauty," in which our "Shadowgraphs" tell which type is yours, and how to achieve its fullest possibilities of beauty.

THE WORLD'S LOVELIEST FOUNDATIONS

NEW YORK • TORONTO

above: An advertisement for Flexees corsets from *Harpers Bazaar*, 1939.

left: Cocktail and pajama suits from an artificial silk exhibition in London, 1939.

far left: Horst's famous picture of Mainbocher's corset endowed the garment with an incredibly sexy aura. The image was revived in the 1990s by pop queen Madonna in one of her videos.

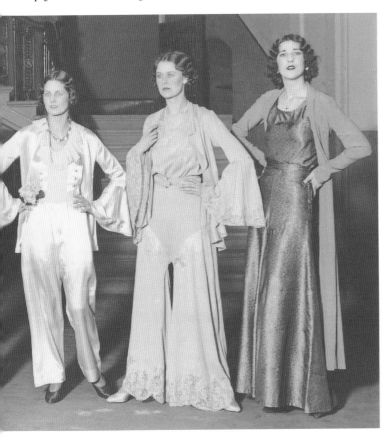

COSMETICS **BODY SHAPE & UNDERWEAR** **WORK & PLAY**

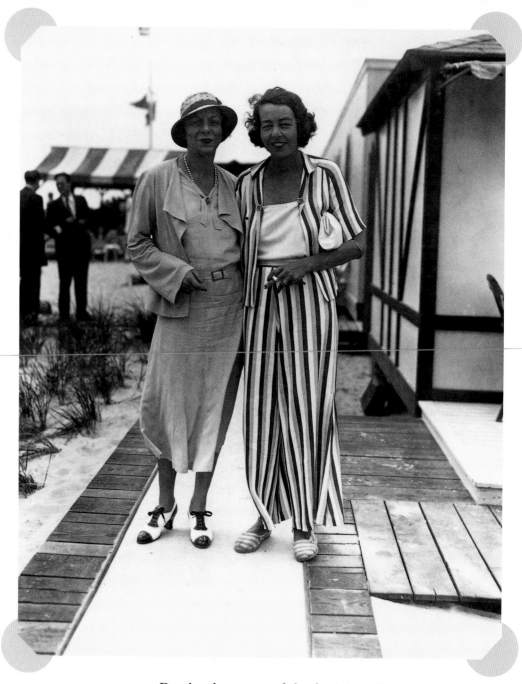

right: Leisurely resort wear for holiday makers in Rhode Island, 1934.

below: Beach beauties: *Vogue*, 1935/36.

Despite the return of the feminine silhouette, women elsewhere were trying to get thin. Diet and exercise were accepted as both enjoyable and necessary for the well-being of women, and the truly chic would go to resorts and health farms. In some respects they were another sort of private party; to take cures and undergo prescribed diet and exercise, just another game.

Tennis was finally played by women with bare legs, the famous and oft-cited Mrs. Fearnley-Whittingstall was the first to forge ahead playing at Forest Hills, New York. She wore socks instead and a pleated skirt and short sweater. It was immediately copied, because garters and corsets had been such a restriction. Shorts were soon introduced as a reaction against the fashions of the 20s, which were now considered tedious, and were taken up elsewhere with joy.

Resort wear was suitably sophisticated and relaxed. Huge wide trousers and backless tops with big hats and espadrilles were the designer answer to peasant clothes. Tennis whites and shorts were fun for cycling and general relaxation. Swimsuits were more formal

BATHING BREVITIES

to highlight the social aspect of leisurewear, and were the ideal dress for yachts. Costume jewelry was still lavish, worn with casual clothing, and the playsuit by American designers Claire McCardell and Tom Brigance bridged the gap perfectly between femininity and brevity, the casual aspect even more pronounced by the use of simple fabrics like gingham and cotton prints.

For the rich, exercise was both a passion and a necessity. Averell Harriman opened his new ski resort, Sun Valley, and it drew all sorts of film stars and famous people of the day. Everyone loved to be seen there, and not only could you ski, but the hot tubs and club lounge were great photo opportunity sites. In Europe, the Tyrol was a romantic notion, and the fashions of the late 30s were visibly influenced by Austrian national dress.

Flying became a great fun thing to do. After the success of Lindbergh and Amy Johnson (who flew to Australia solo with a thermos flask of tea and a round of sandwiches), everyone wanted to fly themselves, to ski resorts or just to Le Touquet, the French resort, for lunch. In some stores "real life" clothes sold better if they were billed as "the jacket worn by Amy Johnson" or whoever was in the news that month. Leather jackets became the thing for golf. Amelia Earhart was the first woman to fly across the Atlantic solo, so she had a very great influence on women's style, while Anne Morrow Lindbergh, people were thrilled to learn, wore a white canvas helmet and a double-breasted leather jacket.

One could be forgiven for thinking that the main sport for the lotus-eating society page–dwellers was lounging, but the concept of sport continued to widen. Women were taking up all sorts of sports in an effort to maintain their figure and get outdoors. Ice rinks opened, and fencing, cycling and tap-dancing were just a few of the other new things they tried. Track and field, polo and gymnasium exercises were also popular for those who were rather more serious about their sport.

Suntans were still obligatory, as were trips to the South of France, driving in open-top cars, sunbathing and generally being out in the open. Nivea did research into creams and Ambre Solaire promoted its distinctive oil as the ultimate in bronzing care.

People were going ever further afield, by train, plane and cruise ship. Manhattan, Jamaica, Kenya and Mexico were the really smart destinations. Safari and big game hunting were enjoyed by the elite, and the huge cruise liners were an extension of club-going, with people back and forth from Hollywood and Broadway, as well as between the salons and drawing rooms of Belgravia and the Upper East Side. It was the era of cruises, with deck sports and dressing for dinner, and a letter on ship's notepaper had a special cachet all its own. In all this, American slang was the new lingua franca.

Commercial flights took less time now and the aircraft were much more comfortable. They had beds and delicious food, and flying was enough of an event to warrant special smart traveling outfits, and a large number of trunks and suitcases. Wonderful photo opportunities were afforded on the steps of the plane or gangplank, big round vanity case in hand, a cunning hat, well-cut coat and a fur.

Trousers were a big feature of the 30s. Women wore them for sport, evening and casual wear, and soon they were being worn for work. Katharine Hepburn was known for her penchant for easy,

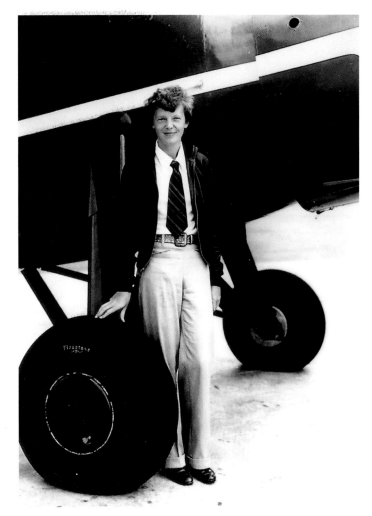

AMELIA EARHART
was the first woman to fly solo over the Atlantic, and was one of the inspirations for the fashionable girls-in-mens-clothes androgynous look, before she mysteriously disappeared over the Pacific during an around-the-world solo attempt in 1937.

plain fabrics in masculine styles. This was to be the foundation for American sportswear, which really just means casual clothing, from Clare McCardell right up to today. Jeans were beginning to be worn by Barbara Stanwyck among others in the westerns of the day, and were catching on for those who could risk a total lack of formality, although it has to be said the idea was still a little *de trop* for most people outside Texas or the film set.

Tampax was invented in the 30s, although in fact it was still not widely used even in the 50s, having the connotation of not really being suitable for nice girls, but it gave immense freedom to those whose dedication to sport or aesthetic appearance was uppermost.

The Concours d'Elegance was a very popular event in the 30s. Women would drive around in beautiful cars with white-walled tires and a small dog in tow, competing for points awarded for their style. Women's motor races were established in 1936, while further down the social ladder marathon dances for money were driven by economic need.

1990- 1980- 1970- 1960- 1950- 1940- **1930-** 1920- 1910- 1900- 1890-

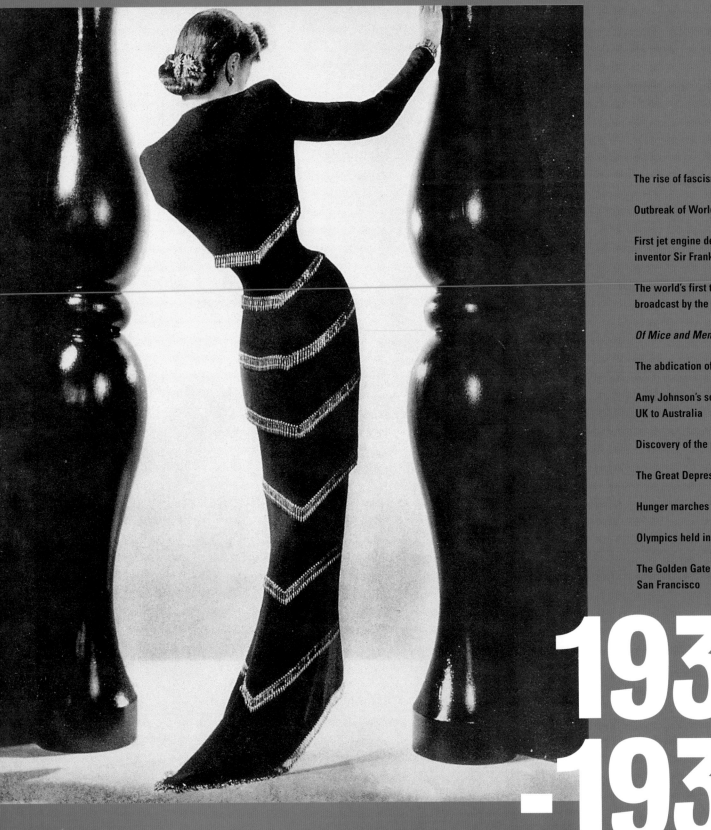

The rise of fascism and nazism

Outbreak of World War II

First jet engine developed by British inventor Sir Frank Whittle

The world's first television service is broadcast by the BBC in London

Of Mice and Men by John Steinbeck

The abdication of Edward VIII

Amy Johnson's solo flight from the UK to Australia

Discovery of the planet Pluto

The Great Depression hits America

Hunger marches in Britain

Olympics held in Berlin, Germany

The Golden Gate Bridge opened in San Francisco

1930 -1939

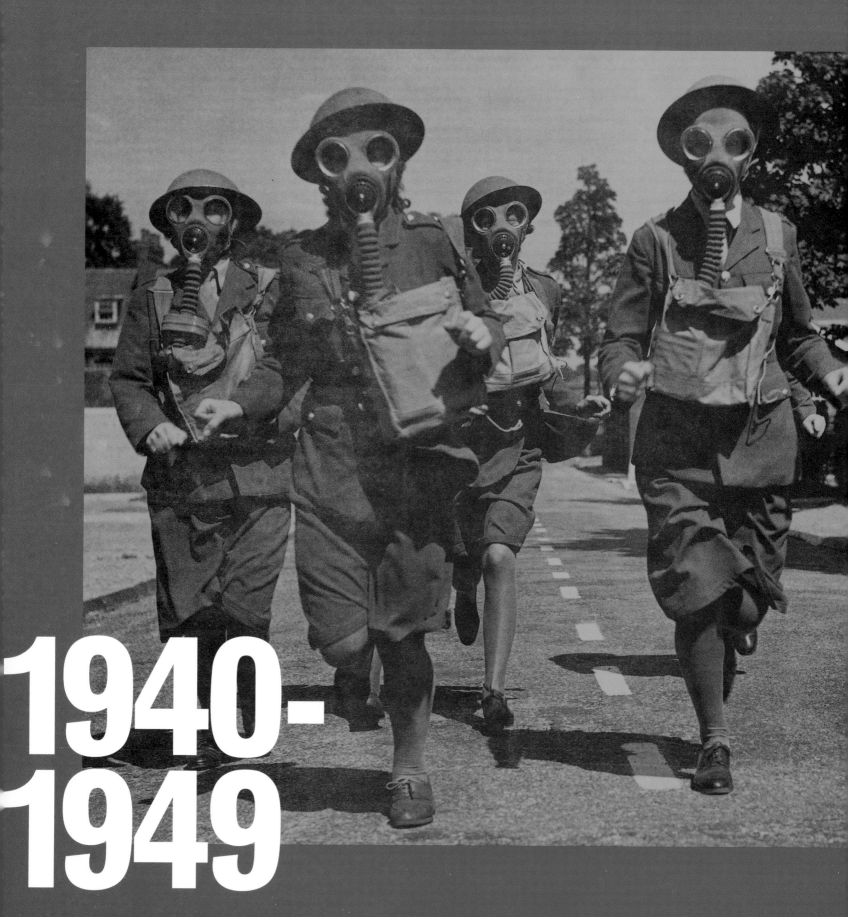

1940-
1949

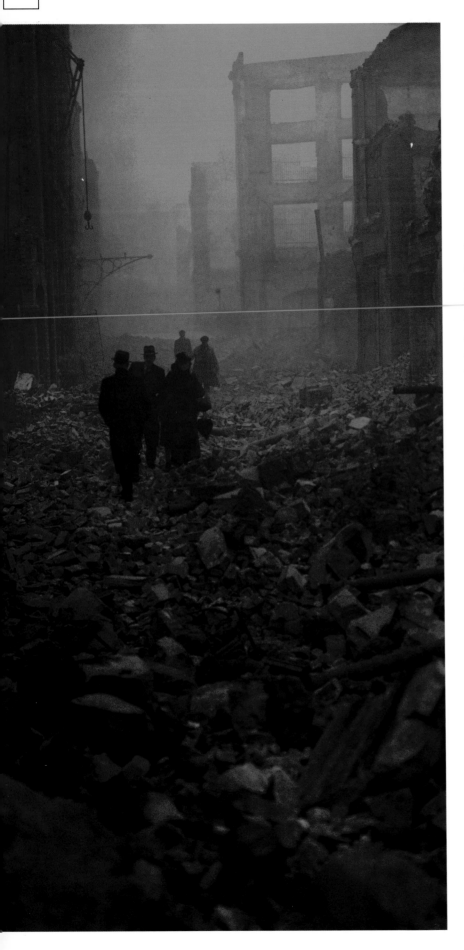

With the outbreak of World War II, things changed very quickly. There were immediate shortages of everything, including food, and one had to think twice whether any action or purchase was totally necessary. Metals traditionally used for jewelry were used for the war effort, and alternatives were found. Hooks and eyes and zippers became scarce, in fact the manufacture of anything except vitally needed products for the war was canceled as factories were turning out war supplies. A stiff upper lip was required, and duty overtook any other concern, at least in public. Weddings were held with simple ceremonies, and the whole country embraced *Vogue's* exhortation of "Make do and mend." Leading British fashion names Lady Diana Cooper and Norman Parkinson set an example, both going into pig farming and "digging for victory."

The war had a disastrous effect on the arts. As well as talented people losing their lives in the concentration camps and on the field of battle, most were drafted into the services. And in France, long the center of intellectual thought and discussion, there appeared severe rifts between those collaborating with the occupying Nazis and those supporting the Resistance.

Elsewhere it was easier to see things in black and white, simply in terms of right and wrong. For many in Britain, the war brought a change in attitude. It was no longer acceptable to be apathetic about the deprivation of others, and the former playboys and party girls of the 30s had to dress down, more often than not in uniform like everyone else. In many ways, this erosion of class barriers evolved naturally, since people were thrown together in most unexpected situations and saw each other in a different light. A new patriotism was all-encompassing, and was to persist long after the war.

In Europe the American influence, which had been steadily increasing via Hollywood and fashionable slang since the 20s, was in evidence with the presence of real life Americans GIs, who were introducing Britons and eventually the French to the finer points of American culture with nylon stockings and chewing gum, which gained them varying degrees of generous goodwill in return.

Women's roles were once more leading and supporting ones combined. They were called on to assist with everything from munitions and aircraft building to actual service. Congress, having passed laws after World War I that prohibited women's military service except as nurses, now passed legislation creating the Women's Army Corps (WACS), the Women's Reserves of the Navy (WAVES), the

far left: World War II left disaster and destruction in its wake.

left: Women in the Soviet Union making hand-grenades in a Moscow factory.

below: A changing role for women: these girls are members of a newly formed Rifle Club, November 1941.

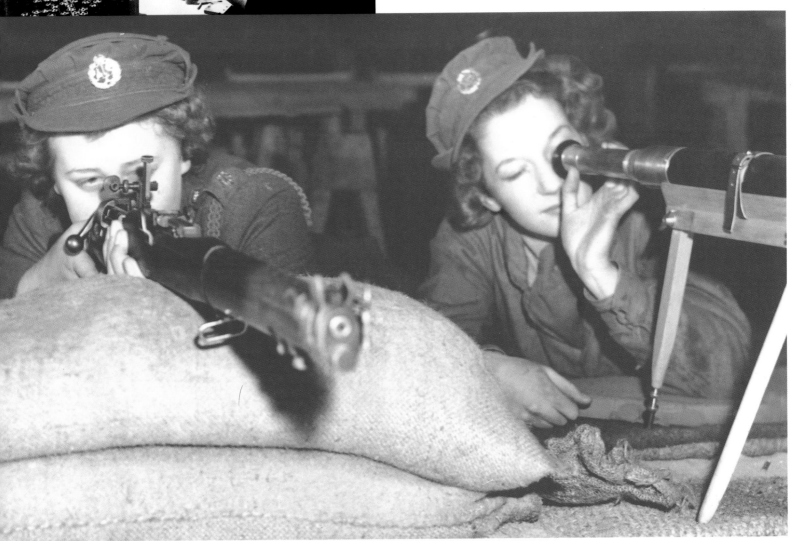

Coast Guard Women's Reserves (SPARS) and a women's reserve in the Marines. The women who served in these corps became clerical workers, parachute packers, pilot instructors, airplane mechanics, record keepers and more. One thousand female pilots flew US planes out of American air force bases in a paramilitary capacity during World War II. These members of the Women's Auxiliary Ferrying Squadron (WAFS) and the Women's Airforce Service Pilots (WASPS) flew military aircraft from factories to bases, tested and repaired planes, and taught flight and gunnery to male students.

After the war, there was a conscious desire to provide a better world for the de-mobbed millions. There was also a wider outlook with regard to long-distance traveling and communications, all of which benefited from developments and discoveries made in wartime. But there were more immediate social needs to be addressed first, and the price of this was a tightening, not expansion, of the financial belt.

COSMETICS BODY SHAPE & UNDERWEAR WORK & PLAY

1890- 1900- 1910- 1920- 1930- **1940-** 1950- 1960- 1970- 1980- 1990-

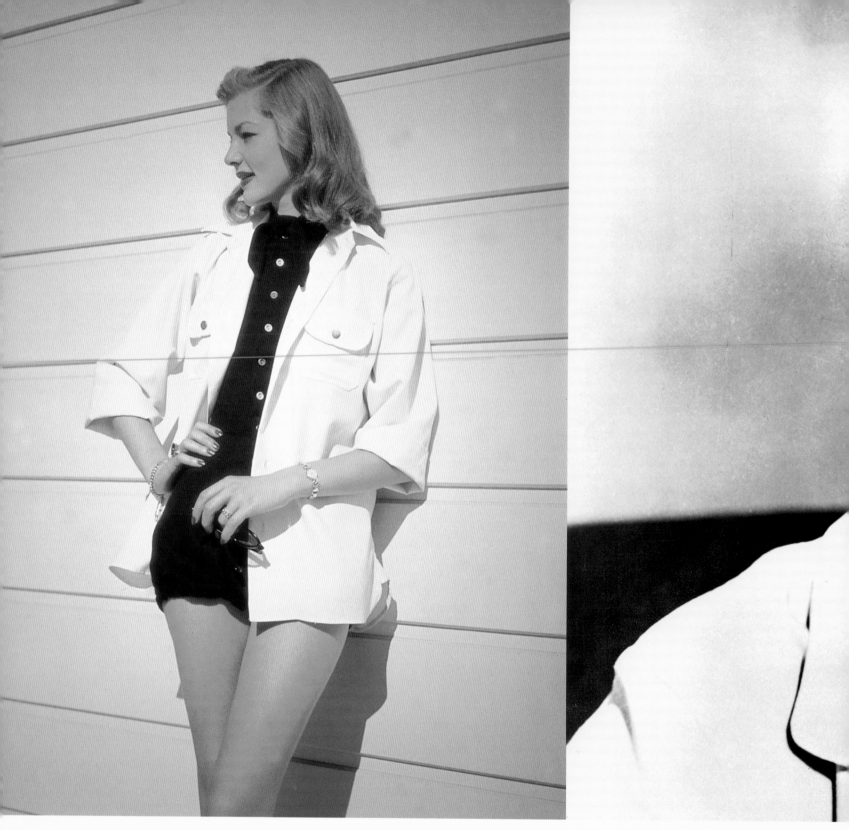

LAUREN BACALL

was discovered by Hollywood after a modeling job for the front cover of *Harper's Bazaar*. Eloquent good looks with an ambiguous suggestiveness led to many major roles, not least those with Humphrey Bogart, whom she married.

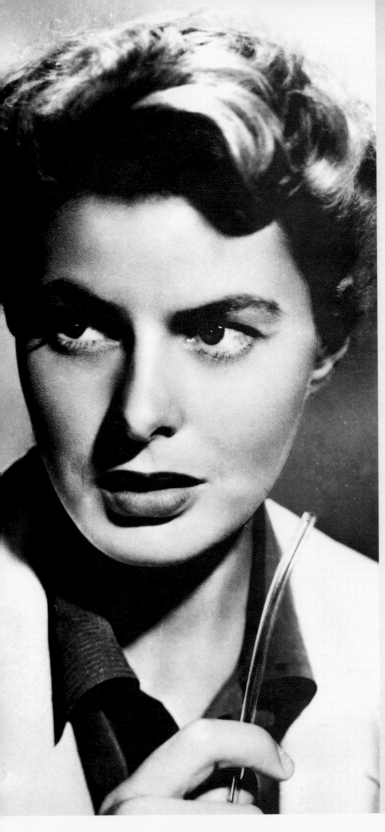

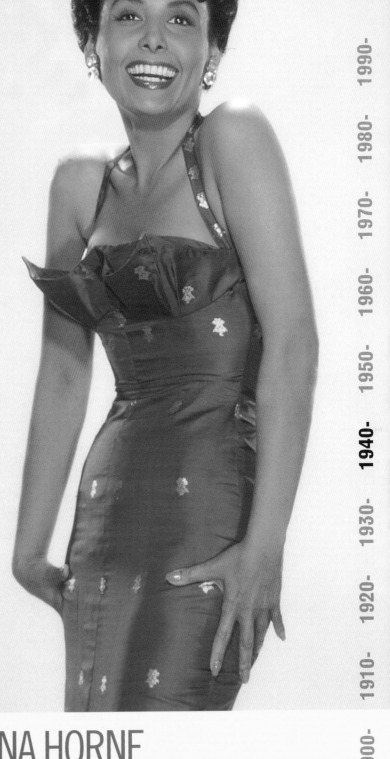

1990-
1980-
1970-
1960-
1950-
1940-
1930-
1920-
1910-
1900-
1890-

INGRID BERGMAN

had a romantic and heroic image in films like *Casablanca* and *For Whom the Bell Tolls*, and even a "saintly" one in *The Bells of St. Mary's* and *Joan of Arc*—and a stormy marital life, once being called a "free love cultist" in the US Senate.

LENA HORNE

was the first black performer to have a long-term contract with a Hollywood studio. A stunning beauty, she was already a star name as a jazz and blues singer when MGM signed her—only to cast her in cameo roles in musicals.

COSMETICS **BODY SHAPE & UNDERWEAR** **WORK & PLAY**

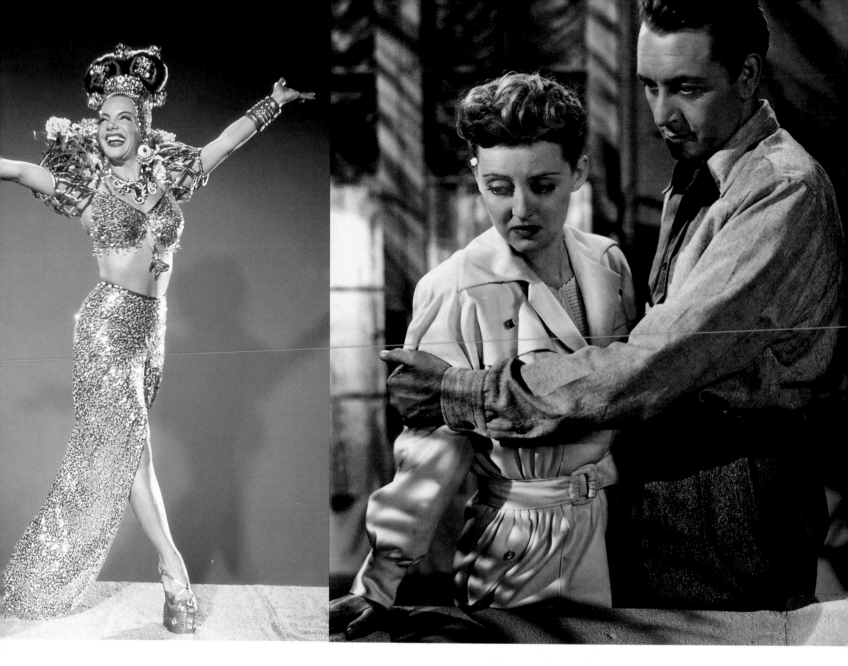

left: Carmen Miranda and her exotic dances were the perfect antidote to reality during the 40s.

center: Bette Davis—the indisputable queen of the "woman's" film.

right: Joan Crawford—with her full mouth and strict tailoring, she sums up 40s' glamour and drama.

Cinema was a sorely needed rallying force during the war, and a powerful means of propaganda. Films often featured plots that emphasized sacrifice, people giving up things for duty and loyalty. *In Which We Serve, The Best Years of Our Lives* and *Brief Encounter* are all typically English and rather stilted to us now, but were probably emotionally more powerful at the time because of these qualities. Postwar, between 1945 and 1950, 20 million people a week were going to the cinema in Britain.

And so-called woman's films provided brilliant, classic dramatic vehicles for stars like Joan Crawford and Bette Davis in *Mildred Pierce, The Women* and *Old Acquaintance.* In these movies much of the passion simmered under the surface of "normal lives," but the middle- and upper-class settings still gave the stars ample opportunity to be seen wearing high-fashion clothes.

Tense plots were, and still are, irresistible. Black-and-white film stock only serves to heighten the tension. Milestone films of the era such as *Citizen Kane, The Maltese Falcon, Casablanca,* and *Notorious* all have heightened dramatic images unimaginable in color.

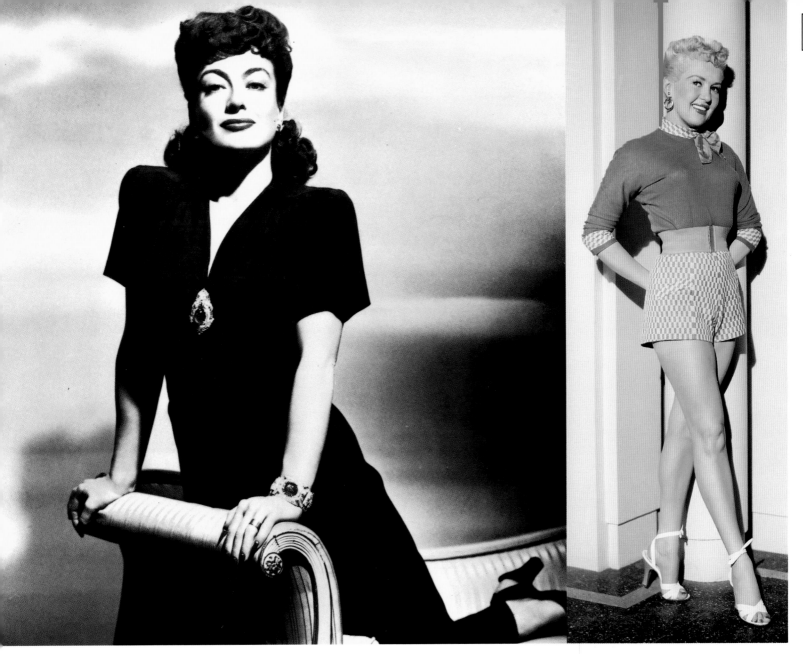

1990-
1980-
1970-
1960-
1950-
1940-
1930-
1920-
1910-
1900-
1890-

The *film noir* became a major genre in the cinema, with thrillers like *The Ashphalt Jungle* and *Kiss of Death* evoking a dark style with gloom-laden lighting and sinister camera angles. After the war, Neorealism emerged in Italy, an economic style utilizing authentic settings that said more by saying less in films like Roberto Rossellini's *Open City* and Vittorio De Sica's *Bicycle Thief.*

During the 40s the western took on a more significant approach to "goodies and baddies." An allegorical element began creeping in as people now had firsthand experience of communities uniting against evil, and the idea of women being the strength behind the men who were away fighting was no longer just a cliché.

It was not all doom and gloom, though, there were fabulous musicals, like *Cover Girl* with Rita Hayworth, and after the war, in a climate of balletomania, there was the painterly fable *The Red Shoes,* showing the tortured lives of the spoiled artists of the dance world and their opulent surroundings and clothes.

The Cannes Film Festival was inaugurated in 1947 and has made headlines ever since. Starlets padded along La Croisette, hoping for a big break. It became a huge event and starspotters and paparazzi alike cruised the length of the beach in the hope of a sighting.

Christian Bérard, René Bouche and Eric were the famous image-makers of the period, their lyrical and refined drawings of women perfectly in tune with the grace and nostalgic clothes of the 30s and later the continuation in the celebratory New Look.

Horst, Beaton, Blumenfeld, Parkinson and Hoyningen-Heune were the photographers who most influenced the style of the age, taking the models out into the open and staging less "occasional" pictures, and bringing a sense of life and poetry to the new fashion photography, with a formality befitting the clothes.

"SWEATER GIRLS" and other "pin-ups" were a tonic for the troops that lasted beyond the war and became a tradition in their own right. They went to war with the boys, wearing serviceman's hats tipped over one eye, and had a glamour all their own. The movie star Betty Grable (above) was the most popular of all, and her legs were insured for a million dollars!

COSMETICS **BODY SHAPE & UNDERWEAR** **WORK & PLAY**

ridiculously tall hats, some a foot and a half high, an explosion of bright color, long hairstyles and short skirts. This obstinate spirit was misinterpreted by women in England and America, who dressed in rayon and off-cuts while the French had silk.

Not all was gloom, though. Elizabeth Arden produced a water-proof white velvet gas mask for eveningwear and Schiaparelli and others delighted in the challenge of making clothes for the working woman. Togetherness was the keyword and the best known British designers tried to arrange new and enticing terms for export, and the French had to try hard to persuade the Nazis not to take Paris couture to Berlin.

After the fluidity of the fashions of the 30s, 40s clothes looked like they were cast in concrete, such was the desire for good tailoring and monumental, gravity-defying strapless evening dresses. For everyday wear, a certain sporty style grew out of utility dress styles, with their narrow revere collars, front buttons and shorter skirts and sleeves. The waist was nipped in, and every trick was used to economize on fabric. Peasant skirts were worn to infuse some color and exotic charm. Platform shoes were high fashion and also practical, as Ferragamo's gold leather cork-soled shoe shows—it saved on shoe leather. In Britain the ubiquitous CC41, the civilian utility label, was the universal symbol of government-approved quality that everyone looked for before buying anything.

With these highly austere and practical fashions in the street, Hollywood did its best to provide a little bit of frivolity and chic. Gilbert Adrian and Travis Banton were the most famous of all the studio fashion designers. Adrian made most of Joan Crawford's and Greta Garbo's clothes. He felt that he had invented the New Look before the war, because he, like many designers around the end of the 30s, made modern clothes with a Belle Époque feel. Banton's clothes were worn by Dietrich and he did wonderful, highly praised couture for top clients. He began his career at Lucile and his well-known signature look was wide shoulders and narrow hips, which became the shape of the 1940s.

During the war, fashions were polarized between the sporty and bright, informal peasant skirts versus high extravagance. It was no wonder that when the war ended women embraced the New Look wholeheartedly. Many designers felt it was the style we would have had all along, if it hadn't been for the war, since designers like Hartnell and Lachasse had anticipated it in the late 30s. The New Look was vital to Paris, which needed to regain its position as center of world fashion, and despite the initial violent reaction to the style, there was method in its madness. The women of Germany were given an ugly version of the platform wedge shoe in white plastic by the Allies, and even these became a sought-after fashionable item in a postwar atmosphere of desperation, where people were bartering to obtain even the basic necessities like soap.

Because metals went to the war effort, plastic and even cellophane were used to make costume jewelry. Some designers were tempted to try other metals, but it was out of step with the mood to wear it. Costume jewelry designers like Miriam Haskell did, however, rise to prominence in America, and her creations became highly prized later in the century.

The fashion experience was dreary during the war. In Britain, to buy clothes one needed both money and coupons. People with uniforms had to surrender their coupons to their employer as a contribution. The manufacture of parachutes used all the silk that would have been for stockings, and nylon was still not widespread. Everything was vitally weighed up according to priority. People were advised to treasure their old curtains, sheets and woolens, and schemes to cutdown and reuse them appeared everywhere in the press. American women were going without too, even though their shortages never actually became serious, they still reveled in the war effort.

Frenchwomen were still well dressed though, and in 1942, at the height of French defiance against the Occupation, fashion went to absurd lengths. Women paraded their hatred silently by wearing

Dior

Christian Dior gave the fashion world of 1947, in his New Look show, the tonic it needed. He gave women what they craved—femininity, opulence, and an entirely new approach to dressing up. The New Look required a handbag, cinched waist and huge quantities of fabric. The hat was of enormous importance, too. Dior not only changed the clothes, but he brought an air of anticipation. The runway show was born at this time, and the models and the clothes were newsworthy. For most people, the effort was impractical, but Edna Woolman Chase, editor of *Vogue*, wrote in praise: "His clothes, while wearable, gave women the feeling of being charmingly costumed, there was a saintly, romantic flavor about them." They were clothes that harked back to the Belle Époque with their gloves and petticoats and really needed a corset to achieve the shape.

James

Charles James is a figure who is receiving overdue recognition in today's fashion pages. His cult status with contemporary designers is due in part to his meticulous approach, his innovative mind and his very small oeuvre. His gowns were so distinctive and his designs so masterly that they fetch huge prices at auction on the rare occasions they come up for sale. His "taxi dress" has a spiral zipper, invented by James. This was the only solution to the construction of the dress and it is this attention to detail that makes his reputation. Always his own worst enemy in his personal life, and in his desire for uncompromising perfectionism, he died in New York's Chelsea Hotel in 1978.

above: A 1945 suit—despite the strict regulations people still maintained style.

left: Two new fashion items for women, to accompany their newly acquired lifestyles —trousers and platforms.

right: Dior's New Look brought a welcome elegance to the late 40s.

1990- 1980- 1970- 1960- 1950- **1940-** 1930- 1920- 1910- 1900- 1890-

COSMETICS **BODY SHAPE & UNDERWEAR** **WORK & PLAY**

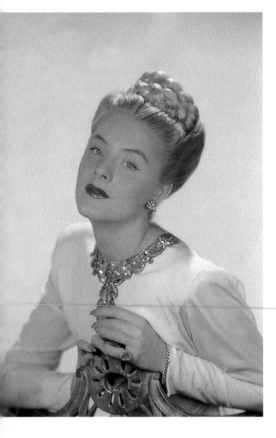

left: Hairpieces and wigs contributed to glamourous hairstyles.

right: Ingrid Bergman's "Joan of Arc" haircut influenced style into the 50s.

far right: Veronica Lake

It was Veronica Lake, a complete unknown, who was to bring archetypal 40s hair to the public. *Life* magazine ran a whole feature telling a drooling public how many hairs she had on her head, the length and how far down it started to wave. It was immediately copied by girls all over the world, and became the benchmark for 40s hair. It was, in reality, just a grown-out 30s page-boy cut, which suited the informal femininity of the war years. Lauren Bacall was to adopt the same style, to create a different look. It was versatile and easily put into more formal styles because it was long enough to roll.

Vogue magazine ran an article during wartime on how to set your own hair. The austerity was such that it was difficult to find help, but it also ran articles about how wonderful it would be to have a bath and be clean during the Blitz. Topknots started to be fashionable (and practical for war work) and, ever mindful of how appearance had to fit in, shorter hair or pathologically neat rolled styles came in to be compatible with the service uniforms. Some fun was to be allowed, however, since streaks and temporary evening colors were advocated in *The Queen* magazine. Some stayed with the tried and true, as marcel waves remained popular in Britain.

It was ultimately a time of individual choice, practicality and conservatism in hair. Needs was the guiding philosophy, and at the end of the war the New Look demanded first the formality of elaborate hair and then, when the need for novelty became irresistible (and influenced heavily by Ingrid Bergman in *Joan of Arc),* the big news was the "Joan of Arc" hairstyle, which remained in fashion into the 50s, when the style suited the gamine look so well.

Hairpieces were used frequently, to give some versatility, if one could not always be at the hairdresser. Hollywood, as usual, was a huge influence, and the wig manufacturers and makers of novelties, such as false braids, bangs on combs and falls of curls were doing a roaring trade. Curls were popular until 1947, and perms were hugely popular, particularly the new cold perm method.

The really popular style for working women and the fashion conscious mid-40s was the topknot or the doughnut. They put the hair up all the way around from the roots into a mass of curls at the top. This was very pretty, poking out of the homemade turbans made of scarves, and although they looked like washerwoman past and future, it was a jolly and becoming style.

Hats were worn all the time in the 40s, and they began to have more importance during the war, particularly in Occupied France, where any materials were used in such extraordinarily inventive ways as a tacit show of defiance. Hats suited the strictness of the new tailored suits; the smart look was never complete without a saucy hat and gloves to feminize the ensemble, which was completed with layers of lipstick. Turbans were ubiquitous at this time, often made in cellophane, old suit fabrics and anything that came to hand; they were a great morale-booster. Peaked cap styles for women came in also, under the influence of the "sweater girls." Mme Agnes was the grande dame of millinery in Europe, and Lilly Daché continued her own tremendous success.

After the war, hats were little, sloping down and dish shaped. Lilly Daché said in *Talking Through My Hats* "glamour is what makes a man ask for your telephone number. But it is also what makes a woman ask for the name of your dressmaker." She should know, she married the vice president of Coty, one of the biggest cosmetic companies, and her own business thrived for years.

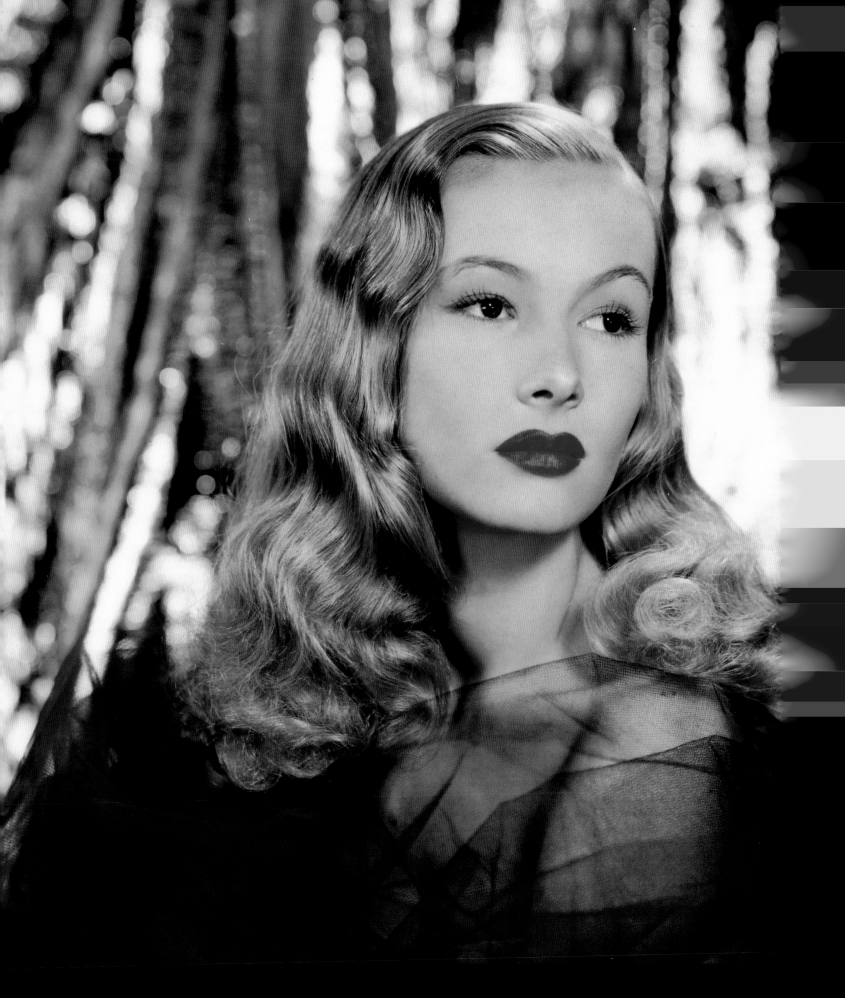

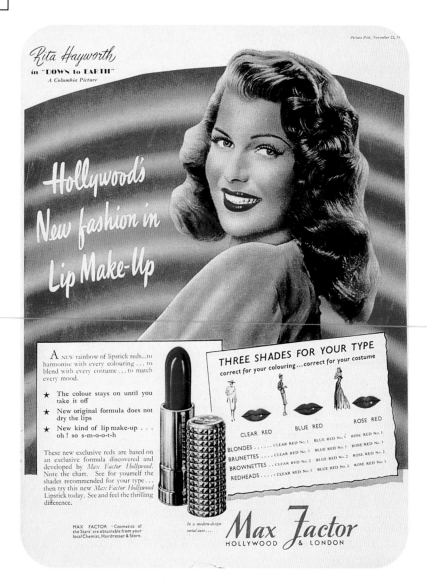

Picture Post, November 22, 19

Rita Hayworth
in "DOWN to EARTH"
A Columbia Picture

Hollywood's
New fashion in
Lip Make-Up

A NEW rainbow of lipstick reds...to harmonise with every colouring... to blend with every costume...to match every mood.

★ The colour stays on until you take it off

★ New original formula does not dry the lips

★ New kind of lip make-up ... oh! so s-m-o-o-t-h

These new exclusive reds are based on an exclusive formula discovered and developed by *Max Factor Hollywood*. Note the chart. See for yourself the shades recommended for your type ... then try this new *Max Factor Hollywood* Lipstick today. See and feel the thrilling difference.

MAX FACTOR · Cosmetics of the Stars' are obtainable from your local Chemist, Hairdresser & Store.

In a modern-design metal case ...

THREE SHADES FOR YOUR TYPE
correct for your colouring...correct for your costume

	CLEAR RED	BLUE RED	ROSE RED
BLONDES	CLEAR RED No. 1	BLUE RED No. 1	ROSE RED No. 1
BRUNETTES	CLEAR RED No. 3	BLUE RED No. 3	ROSE RED No. 3
BROWNETTES	CLEAR RED No. 2	BLUE RED No. 2	ROSE RED No. 2
REDHEADS	CLEAR RED No. 1	BLUE RED No. 2	ROSE RED No. 1

Max Factor
HOLLYWOOD & LONDON

above: Rita Hayworth promotes "Lip Make-up" for Max Factor.

right, above: The new eyelash curlers—a vital tool for making up the eyes.

below: Customers in a store in Croydon, England, having their legs painted to save clothing coupons they would otherwise spend on stockings.

With the outbreak of war things had to be prioritized, and among the first things to go was the manufacture of makeup; however, there was such an outcry that the government recognized the severe dent to morale (women's and men's) and it was reinstated. Sailors had their tobacco, and girls had to have their makeup, it was argued. However, the quality was nowhere near what women were used to, and there were fewer colors available, and the powder and lipstick was dry and flaky. Shortages of alcohol meant more perfume and less cologne, and shortages of fat and oils and the complete dearth of glycerine meant that products had no emollients, leaving manufacturers to find substitutes. As it was, they were already using film scrap instead of nitro-cellulose in nail polish. The trickiest thing was to find the metal for the packaging. Glass was impractical and expensive, but lots and lots was spent on advertising to keep the idea of romance alive, to keep the ideal of war workers looking great, and to maintain a foothold in the market place.

The importance of keeping one's man and the agony of divorce was emphasized over and over in fashion magazines, and many beauty writers decried pretty girls for thinking that they were exempt from making an effort. The case for cosmetics was never more forcefully made than in this decade, when glamour and effort in the area of beauty could almost be thought to have won the war.

After the war, though, many products were to benefit from the new technological developments, as many new companies joined the market. Pan-Cake by Max Factor was a favorite product during the war, not yet available in Europe, but people knew about it. It was available in "six lovely shades all compatible with Service uniforms" said the editor of *The Queen*. The company made special shades of it in large quantities for camouflage in the Pacific. In 1947, Pan-Stik made its appearance in Europe, it covered everything and created a clear, flawless appearance and was easy to apply, unlike the old prewar foundations, which were sticky and took ages to dry. It could be used for the theater and film studio, and now there was a version for the street.

Before and during the war, the face was simply made up; finely arched brows were penciled in, with powder and huge red cupid's bow lips being the hallmark of the age. Women loved to adjust their makeup in public, as they had seen countless film actresses do. Names like Revlon's Cherry Coke, Hot Dog, Mrs. Miniver and Raven Red were fun, and reflected the culture of the times. Toward the end of the decade, the emphasis changed to a younger, "fresh-young-natural look" with lighter lipstick shades and more emphasis on the eye, in anticipation of 50s' fashions.

Suddenly there was a plethora of new products: artificial eyelashes, which had been used in Hollywood but were not available commercially, fluid eyeliner and cake eyeliner, a new first. Also, eyeshadow sticks, more cream shadow, waterproof cream mascara, and eye makeup remover available in pads and assorted eyecreams. Eyelash curlers now appeared on the market, too. New lip pencils

were launched by Gala and Rimmel, and Yardley's new deeper colors were hot sellers. Coco Chanel introduced her range of lipsticks in the 40s, too.

During this decade, "beauty spot" patches were revived again, to coincide with the "painted look." With the new ultra-feminine clothes and with the introduction of the more "tawny" shades of lipstick, the dark, doe-eyed eyes made a comeback. Suddenly, shadow, eyebrow pencil and mascara were all essentials, and eyeliner made its debut as the new all-important cosmetic. By now, the look for the 50s was truly on the starting blocks.

Cosmetic company Lancaster, named after the Lancaster bomber, marketed hand cream, and, more interestingly, serum tissulaire and creme embryonnaire, a forerunner of today's approach to beauty, from its new Monaco factory. Other cosmetic brands mushroomed up from this point onward, to share in this exciting fast-growing business area. Many companies started with the advent of television, and provided specialist products for that market.

As in the First World War, huge advances were made in the world of cosmetic and plastic surgery. A special hospital was set up at East Grinstead in England, where the gifted and pioneering surgeon McIndoe did marvellous work on soldiers and civilians who had suffered burns and gradually, the science of reconstruction and skin donor projects were developed.

In the aftermath of the war, in 1946 Americans spent 30 million dollars on their cosmetics, a lot of which was valuable tax revenue for the government. Despite the immediate difficulty of obtaining the necessary ingredients, it was well worth the effort.

The use of deodorant was now widespread, although during the war years people more often used talcum powder. This was because of the usual shortages.

Christian Dior founded his lucrative perfume company, creating Miss Dior, which has remained a classic best-seller ever since.

LEG MAKEUP became quite the thing during the war, due to the shortage of stockings. Women wore socks for casual wear and washed out their stockings at night, but as time went on this ceased to be possible, and many women were reduced to making up their legs with makeup and drawing a line down the back of the calf to look like a seam. Step-by-step guides on these techniques appeared in the women's magazines and national press, with added tricks like using clothes pegs to keep one's garments out of harm's way. In Britain, some girls were even known to use gravy browning or tea bags to achieve the necessary tan—while others, of course, were spared these arduous chores because they were lucky enough to have met a generous American serviceman.

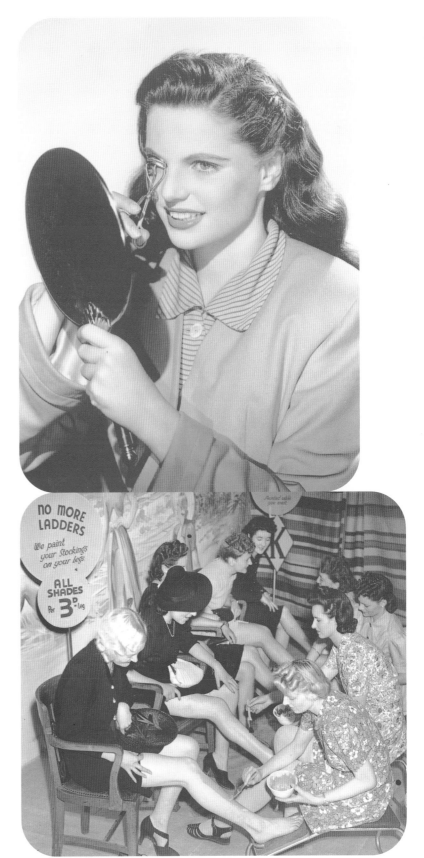

1990-
1980-
1970-
1960-
1950-
1940-
1930-
1920-
1910-
1900-
1890-

COSMETICS **BODY SHAPE & UNDERWEAR** **WORK & PLAY**

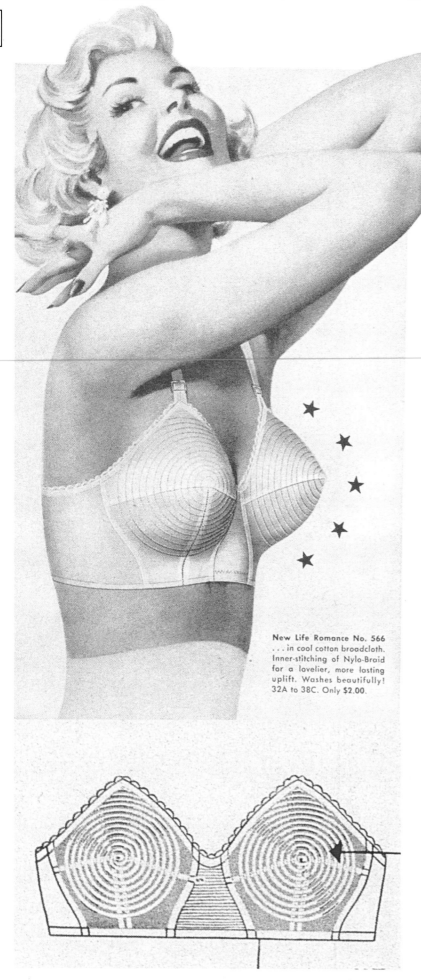

New Life Romance No. 566
... in cool cotton broadcloth.
Inner-stitching of Nylo-Braid
for a lovelier, more lasting
uplift. Washes beautifully!
32A to 38C. Only $2.00.

Wartime rationing made a huge impact on the physique of the average woman. The rationing of food and an increase in exercise meant that most people had never been fitter, and the wartime prescribed diet is praised today as ideal. Hard work and shortages led to more walking and cycling, and generally economizing and being more active made for a toned figure. Ironically, beauty in its simple form was very flattering.

Underwear was scarce during the war. Not because it wasn't worn, but, like cosmetics, it could not be made. Factories that were not making essential items for the war effort were requisitioned and so whatever you had, had to last. Women of all classes tried to make it themselves, from all sorts of materials. Parachute silk was an idea that occurred to many, and was tried by many, but by all accounts, it was very tough and chafed terribly, so it was worn infrequently and usually just for show.

In the United States, there was never really any serious danger of the country running out of anything, but the government felt that people should "go without to galvanize." It was felt that the lack of decent corsets and underwear could be a cause for fatigue and low morale, and therefore didn't help encourage women in working for the war effort. Miss Mary Anderson, the director of the Women's Bureau for Labour, insisted that good corsets should be made again. After the war, America went straight back to manufacturing in the proper quantities, whereas Britain and the rest of Europe really had to wait for the industry to get back to normal on account of a genuine dearth of materials.

During the war the rubber corset was introduced, but it was extremely unpopular. Girls also had to learn to go about in socks and shoes, and promote the fresh-air look due to the shortage of stockings. Articles appeared in all the magazines about methods of making stockings last. They included how to wash them, for those who had never had to before, and even how to dry them by whirling them around your head.

Women were very receptive to the new femininity, and when the New Look arrived at the end of the war, it was obvious that women were crying out not only for new outer clothes but really attractive underwear and foundation garments.

The New Look demanded suitably extravagant underclothes, for structural reasons as well as aesthetic. Christian Dior famously said "Without foundations there can be no fashion." Women must have felt so deliciously decadent using vast amounts of fabric with such abandon after all the rationing, and the petticoats and ruffles were extravagant while being necessary to the realization of the glamorous new shapes.

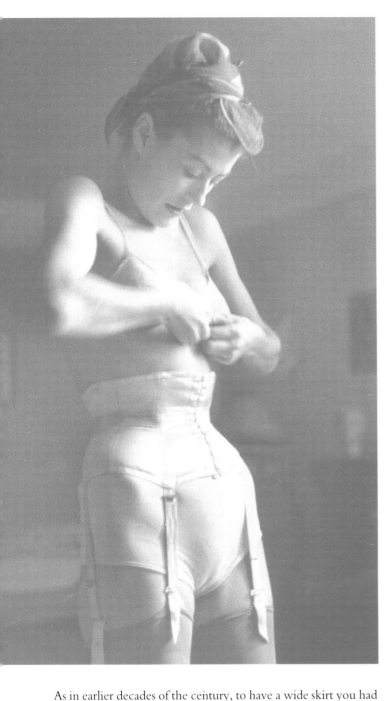

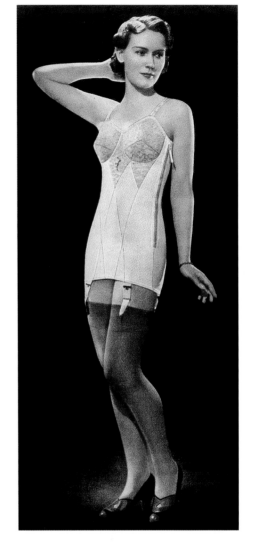

1990-
1980-
1970-
1960-
1950-
1940-
1930-
1920-
1910-
1900-
1890-

above: Corsets remained a part of female fashion throughout the 40s.

left: A "waspie"—the waist-only corset that gave the New Look its shape.

far left: Although a mark of the 50s, "missile" shaped bras started in the 40s.

As in earlier decades of the century, to have a wide skirt you had to have a narrow waist, and therefore a corset was needed to accentuate the contrast. Corsets were not as extreme as they had been, and a new type was introduced just for the waist. Called "waspies" they were still uncomfortable, made of boned material, sometimes laced up the back and were completely rigid with a little respite of elastic every so often. Those who tried it didn't much like it, and despite the very fetching photos showing the subtle sexiness of the idea of bondage, it was firmly rejected in favor of the less eye-catching roll-ons made in satin with padded hips and stitching instead of painful bones. Zippers were introduced instead of archaic eyes and hooks, but disappeared soon after because of the war.

Bras were also radical in the 40s, the strapless evening gown being the pride of that decade and the 50s. The bras were symbolic of the aggression of the era, with their bullet-like missile shapes and again, lots of stitching.

Nylon came into its own after the war, with other "de-mob" fabrics, and it was genuinely revolutionary. It had only been seen during the war in the United States, in stockings that came to Europe via friendly GIs, but after the war it was cheap and available—simply everybody wanted something made of it.

The need for relief from the tedium of wartime undies was never questioned, and novelty underwear came into its own in the late 40s. Frederick's of Hollywood came up with some bizarre ideas such as its "edible" underwear and underpants that played "When the Saints Go Marching In." The company has now achieved genuine cult status, and has enjoyed a reputation since the 40s for sexy, ornate and risqué bedroom wear that lives on and on.

above: An early bikini gets the cover-up treatment in this swimwear combination.

right: Lady Mountbatten—a member of one of Britain's richest prewar families, she had no qualms about having her uniform tailored on Savile Row.

The fresh, outdoor unspoiled look was ideal for most women throughout the 40s, partly due to the shortages and partly because of the change in their everyday lifestyle. Cycling was not just fun, it was also a convenient way to get around, walking being the other alternative.

Swimsuits adopted the new formality and dressed-up look, to get away from the mannish, tubular styles of prewar fashion. Swimwear resembled shortened evening wear, with ruching and, generally, lots of fabric. The bikini was invented just after the war in 1946, but many early examples could be quite generous with the material despite rationing favoring it being as skimpy as possible.

Jeans and the T-shirt as casual clothing started to appear during this period. Women were used to wearing tough work clothes, and those who didn't wanted to fit in. This ideal and the popularity of the western, meant that the American trend of wearing jeans in the cities, which started during the depression and the sport-conscious 30s, was more appropriate during the war.

Swing was the big thing musically, with star bandleaders like Benny Goodman, Artie Shaw, Harry James and Glenn Miller selling records by the million. The swing big bands played live for a dancing audience, and the dancehalls and ballrooms on both sides of the Atlantic boomed as never before.

Women got into male work clothes in the factories and in the forces. Their stamp was put on such attire by the little touches they might add to these usually dreary clothes, but often the basic change brought about by a female form in such rough and masculine attire needed no modification to the garments. Marilyn Monroe, looking back on her own wartime contribution during the time of her teenage marriage said "I wore overalls in the factory. I was surprised that they insisted on this. Putting a girl in overalls is like having her work in tights, particularly if a girl knows how to wear them. The men buzzed around me just as the high school boys had done. Maybe it was my fault that the men in the factory tried to date me and buy me drinks. I didn't feel like a married woman" (Anthony Summers, *Goddess: The Secret Lives of Marilyn Monroe*).

By and large uniforms were not nearly so provocative. In Britian the ATS (Auxiliary Training Service) started in 1938, and women were formally part of the army at last. During the First World War, women looked after the mail and nursed the sick, but were not admitted officially to the British Army. The ATS uniform consisting of a belted, pocketed army jacket, mid-calf khaki skirt, collar and tie and a soft-crown peaked cap was smart and practical. Officers had an updated version of the WWI uniform. Both were reasonable though unremarkable in appearance. *Vogue* counseled shorter neater hair to go with the businesslike nature of the uniform.

Women were always thinking of little things they could do to make themselves more attractive, while wearing the uniform for social functions. Few could better Lady Edwina Mountbatten, who having virtually limitless resources, had her entire ensemble re-created at a Savile Row tailor's, just that little bit shorter, and her shoes copied in a tiniest bit more delicate shape. As she was Colonel-in-Chief, there was no one to answer to.

Soon women in the forces entered the world of welders,

carpenters, draughtsmen, radiographers, mechanics, electricians and other tough trades. This went to the extremes of being sheetmetal workers and vulcanizers, and in civil defense manning antiaircraft guns and searchlights. Some even went to the Middle East while others had exotic duties in the intelligence units, taking phone calls and breaking codes. Altogether, nearly a third of all female soldiers had some trade, and special insignia were created for each.

For such a huge variety of activities there arose a great many new uniforms, dungarees, overalls, tin helmets, leather jerkins, and full battle dress with trousers as worn by men. Women were even formed into female-only military bands.

In France the Resistance could not wear actual uniforms, for obvious reasons. Nancy Wake, who parachuted into France and led men into action, was the leader of 7,000 Resistance fighters; when the Allies arrived to liberate her region, she appeared in pristine dress uniform. The rest of the time, the Resistance had to wear whatever met their needs, even if it meant dressing up in attractive, sexy clothes specifically to attract or distract German troops.

There were four female generals in the British Army after World War II, so (a few) women had finally made it to the top ranks and were involved in serious decision making.

CLAIRE MCCARDELL. It is scarcely possible now to open a book on the history of fashion sportswear, or an article about a new designer, that does not cite McCardell as the originator of American casual style. She is the forerunner of Calvin Klein, and many of Ralph Lauren's casual designs show her influence. Even Tom Ford of Gucci and Eric Bergère, who left Hermès in 1997 to go it alone, cite her as being a source of inspiration. Her clothes are said to have a timeless quality, making them appealing for years to come.

She was one of the most innovative fashion personalities to be working before, during and after the war, employing fabrics such as denim, gingham and jersey for a fresh, simple style that featured trousers and flat shoes during the day and simple elegant evening wear. She initiated this unusual look during the depression and during the war, and she employed hooks and eyes rather than zippers to save metal. Shoes, except ballet shoes, were strictly rationed, so McCardell persuaded ballet shoe manufacturer Capezio to add a heavier sole to their shoes. They immediately became high fashion. Devotees at the time included Slim Hayward (former wife of film director Howard Hawks and then-wife of theatrical impresario Leland Hayward; later, Lady Keith) and Lauren Bacall.

1890- 1900- 1910- 1920- 1930- **1940-** 1950- 1960- 1970- 1980- 1990-

COSMETICS BODY SHAPE & UNDERWEAR **WORK & PLAY**

Germany invades France

America enters the Second World War

Roosevelt is elected US President for a fourth term

World War II ended 1945

The first atomic bomb detonated near Alamogordo, New Mexico

London Airport opened

Independence from British rule of India and Pakistan

Jean-Paul Sartre publishes *Roads to Freedom* trilogy

The famine charity Oxfam is founded

Mohandas Gandhi assassinated

Broadway opening of Rogers and Hammerstein's *Oklahoma!*

Prehistoric cave paintings at Lascaux, France, discovered

Invention of the long-playing record

1940 -1949

1950-1959

AFTER THE UPHEAVALS OF THE WAR, WOMEN AGAIN HAD A STABILIZED ROLE AS PART OF THE IDEALIZED NUCLEAR FAMILY. BUT SOCIETY WAS CHANGING RAPIDLY AND THE NEW WOMAN WASN'T FAR BEHIND

The 50s were an aggressively positive decade. The triumph of democracy in World War II made for an optimistic mood that was accompanied by increasing prosperity. Peace-with-austerity that marked the latter half of the 40s gave way to a new affluence in the 50s that allowed for brave new worlds to be explored on both sides of the Atlantic. In America, Britain and other parts of the world this meant consumerism on an unprecedented level, with vastly improved standards of living being measured in both material goods and comprehensive social welfare programs. By the end of the decade British Prime Minister Harold Macmillan was able to claim "You've never had it so good," and in many ways he was right.

Technological progress triggered by the war now impacted on civilian life. Television, jet airliners, new synthetic materials and "streamlined" designs in everything from motor cars to furniture, all benefited from military research conducted during the war years. Full employment in the factories and farmlands meant more goods, more foodstuffs and more people able to afford them. Time payments put credit into the hands of ordinary people for the first time, supported by the burgeoning advertising industry, which aimed much of its message at the new goddess of consumerism, the modern housewife.

For women there was a whole new vista on the horizon. The nuclear family consisting of just parents and children, as opposed to the extended family of grandparents and other dependent relatives, became the norm. The ideal was to get married, have children and live in a nice house "happily ever after" with the same man for the rest of one's life. Marriage, like diamonds, was forever. And while it was now considered a good thing for a girl to go to college or even enjoy a brief career, a simple look at women's magazines of the 50s shows that the priorities were definitely homemaking—looking good and cooking good for your man. It was almost a reconstruction of the traditional role of women, after the radical nature of wartime occupations, albeit in a modern and certainly more affluent environment.

Women were cast in the role of professional homemakers, men the breadwinners. Cookbooks of the time have pictures of fully made-up women in cocktail dresses, stockings and high heels, with tiny aprons, striving to be great hostesses and good wives. Washing machines, labor-saving devices and washable fabrics meant there was lots to do looking after the family clothes, and comparisons of products and methods were the stuff of conversations and even magazine articles and radio programs.

Mass production of previously luxury goods put everything in the reach of ordinary people, and the new technology was also producing cheap, easily maintained artificial fabrics like Orlon, Rayon, Terylene, Courtelle and, of course, Nylon. They brought with them different colors, different textures and a different feel.

Also, there was another breed of woman being woven into the cultural fabric, the new Career Woman. She was confident, even unassailable, and she had a glamour so prestigious and hard that she seemed intimidating and efficient in the extreme. Characterized as cold and beautiful in photos and film, she was socially acceptable because it was understood that she'd give it all up for the right man.

A 1950s article in *Vogue* stated: "Thirty years ago college girls were told by various women's leaders that their first duty was to their sex. They had won the vote but the women's revolution was not complete. They must now fight their way into men's careers. To have a husband, home and children was treachery to the cause, a piece of self-indulgence. Now we find women in all careers and these women have homes and children. The young women not only accept the position—they choose it. Whereas 30 years ago the girl of social conscience would almost apologize for having a baby, the same girl now, more often than not, will be anxiously wondering how many babies she can afford, and if it is possible for her to do her duty by them and her husband while keeping her job."

And with the increased prosperity, a new youthful consumer was in evidence—the teenager. This new juvenile phenomenon had clout in the marketplace (even if they lacked it at home), and began to exert a powerful influence over manufacturers. And, as with women, it was the liberating influence of teenage affluence in the 50s that often led to liberation of a more radical kind in the 60s, as teenagers from the 50s became the twenty-somethings who led the 60s revolution—not least in the role of women.

All of this was against the uncertain background of the darkest days of the cold war, when the nuclear arms race and paranoia about communism encouraged a domestic and national insularity that further promoted the comforting idea of the stability and security represented by home and family. The cozy housewife of the Ideal Home of the 1950s wasn't just an advertiser's dream girl—she was a national propaganda asset.

LIFE & TIMES FACES IN VOGUE FILM & MEDIA FASHION HAIR & HATS

left: A housewife shows off her "new age" refrigerator.

far left: Teen talk—the teenager was an invention of the 1950s.

below: The model woman was perfectly groomed as well as a perfect wife.

1990-

1980-

1970-

1960-

1950-

1940-

1930-

1920-

1910-

1900-

1890-

COSMETICS BODY SHAPE & UNDERWEAR WORK & PLAY

MARILYN MONROE

remains, more than thirty years after her death, the ulti-
mate symbol of Hollywood glamour. The blonde hair,
hourglass figure, va-va-va-voom body language and hint
of breathless innocence was a potent mix.

AUDREY HEPBURN

represented the new chic of the 50s, the elfin beatnik in
couture clothes. Her impossibly perfect features set an
unattainable standard that was nevertheless aspired to
by fashion models and millions of other women as well.

1990-
1980-
1970-
1960-
1950-
1940-
1930-
1920-
1910-
1900-
1890-

ELIZABETH TAYLOR

has been described more than once as the most beautiful woman in the world. Striking looks, with violet eyes and raven-black hair, took her from 40s child stardom to the peak of Hollywood fame through the 50s, 60s and 70s.

COSMETICS BODY SHAPE & UNDERWEAR WORK & PLAY

while being talented and intelligent, were content to stay at home as perfect wives, but with a talent for getting into crazy situations.

Musicals like *Oklahoma*, *State Fair*, *The King and I* and *South Pacific* were colorful, had classic songs and old-fashioned heart-warming plots. Lots of musicals, such as *An American in Paris*, *Silk Stockings* and *Funny Face*, projected a vision of high society that somehow everyone could identify with. Films like *High Society* and *The Barefoot Contessa* exuded a new relaxed elegance, even Hitchcock thrillers like *To Catch a Thief* and *North by Northwest* celebrated a poised, effortlessly casual look that anyone could appreciate. And films like *How to Marry a Millionaire* and others suggested—in a lighthearted way—that it didn't matter if a girl's character might be questionable as long as she looked good.

Brigitte Bardot, in *And God Created Woman*, and Marilyn Monroe, in *The Seven Year Itch*, seemed the personification of a new amorality, the antithesis of the 50s' "straight" movie stereotype of no sex, even in the marital bedroom!

The emerging culture of (usually misunderstood) youth was apparent early in the decade with films like *A Place in the Sun* (with Montgomery Clift), *The Wild One* (Marlon Brando) and *East of Eden* (James Dean), that featured a new breed of teen-oriented male heroes that had its stylistic roots in Brando's character in *A Streetcar Named Desire* (1951). But new male leads needed new female co-stars, as names like Pier Angeli, Eva Marie Saint and Natalie Wood began to appear in screen credits.

And while westerns by and large continued to focus on the moralistic view of life, the triumph of good over evil, plots became more and more allegorical in films like *High Noon*, with the Western landscape coming to represent a mirror image of American society, and even America's idealized place in a far-from-ideal world.

In European cinema, films like *A Bout de Souffle* and *Hiroshima Mon Amour* were more realistic than most Hollywood films in showing the raw edge of relationships in the real world, while *La Dolce Vita* (1960) made a profound impact on the decade's view of itself. Meanwhile *Woman in a Dressing Gown* and *And God Created Woman* show two polarized views of womanly self-image.

Clothes became even more important in films. As a reflection of the style of a new prosperous society, they helped promote that style. The reasoning that decreed American superiority in the manufacture of material goods was reinforced in Hollywood films, but it was still Paris that claimed the genius for fashion and beauty.

Fashion shoots had a cool, hard edge to them in the 1950s. Perfectly composed models with vulpine features would be looking out at the Manhattan skyline or up at the Eiffel Tower, appearing as unanimated as possible, while signifying that they and the clothes they wear are from the culture that is on top of the world.

For Hollywood, the 50s were a rich and exciting time. Spectacle came into its own, and much use was made of color, which was rich and deep, perfectly showing off the vibrant hair tones and strong makeup fashionable at the time. Even when films were set in the past, they reflected current trends and images of 50s glamour.

Against a background of paranoia that stemmed from the McCarthy witch hunts of "communists," themes on screen were often lighthearted all-singing all-dancing celebrations of the good old days, or portrayals of a diamond-hard glamour that represented the ideal of the American dream.

Film, and television a little later, had a profound influence on the way people wanted to look, and one of the direct results of this was the diversity of "types" that began to appear. Refinement and tomboyishness were the two main female character types in film. The latter was represented by a new hearty, homey type of girl personified by Doris Day and Debbie Reynolds. There was a "kooky" side to this, which becomes pronounced in Doris Day's comedies from the late 50s, which featured archetypal women who,

1990-
1980-
1970-
1960-
1950-
1940-
1930-
1920-
1910-
1900-
1890-

These women with such poise and posture began to be known by name, and as the world of the magazine social columns opened up to them, even married into high society. Barbara Goalen, Gina and Fiona Campbell-Walter, Suzy Parker and Lisa Fonssagrives became personalities in their own right, some of them handling their own publicity. But gradually these ice maidens were replaced by younger, more casual-looking girls, characterized by "leaping realism" shots that were intended to be less formal, but in fact were no less contrived than the classic poses of the era.

The image-makers of the decade were people like Richard Avedon, Irving Penn, Erwin Blumenfeld and, later, Anthony Arm-strong-Jones (Snowdon). Their inventiveness in photographing models in and outside the studio, and their understanding of the clothes, made the 50s truly dynamic in terms of image-making. Gone were the static, characterless mannequins and in came super-elegant, yet interesting women in all sorts of guises. Many of these photographs, like Irving Penn's famous girls in the café, are now considered true works of art in their own right.

above: Glacial princess Grace Kelly with James Stewart in Alfred Hitchcock's *Rear Window*, 1954.

center: Doris Day, the shining example of natural, outdoor good looks, with Rock Hudson.

left: The quintessentially 50s Anita Ekberg in the influential *La Dolce Vita*.

TV was a different story. The characters were on their best behavior, as though they felt they might be refused admission to the living room if they misbehaved in any way. American shows like *Leave It to Beaver* and *Ossie and Harriet* were family-oriented and moralistic. Many people grew up thinking that was how life was; others felt that's how it at least should be.

Advertisers felt the same way. From detergents to cosmetics, a cosy domesticity was the safest "feel good" way to project their clients' products. There was plenty to be positive about in this brave new consumer-oriented world, and that was to be the emphasis in an advertising industry that had more influence than ever before.

COSMETICS **BODY SHAPE & UNDERWEAR** **WORK & PLAY**

above: The ubiquitous woolen twinset.

right: Fashions by Irena Roublon, 1951.

The main themes for fashion this decade were femininity and refinement. The runway became an important way of showing fashion, and the elegance of these events reflected the wealthy circumstance of those who would eventually buy the clothes. Hats and stiletto heels maintained this formality, in as much as wearing either required a very definite poise.

For the younger buyer, the market was full of alternatives: the "Beat look," with flat "pedal-pusher" shoes; and the "pumpkin skirt," a bouffant addition that ensured maximum mileage out of a plain dress, because you wore it over top and twinsets and pearls with the new longer, leaner skirt for young ladies.

CHANEL returned triumphantly in the 1950s with her cardigan-jacket suits, which are still worn today. With them came the gilt-chain quilted-leather handbag in 1957, which was an obligatory item once more in the 80s, and, in a reaction to the stiletto heel, her two-tone, low-heel sling-back pumps, which were the uniform of the "preppy" girl up to the late 80s. In an age when cheap copies and mass-production were in full swing, and American fashion finally gave the Europeans a run for their money, Chanel never minded imitation, saying one should be able to tell the difference.

Marcel Rochas, Nina Ricci and Pierre Balmain were all major names in this decade, and the American Norman Norell was an enormously influential designer, who later launched his own designer fragrance, a milestone in US fashion terms.

Givenchy

Fath

Hubert de Givenchy was a friend of Balenci-aga, and his designs were always elegant, refined and beautifully made. Ladylike always, they are best seen on his muse Audrey Hepburn. His clothes for *Funny Face*, starring Fred Astaire and Audrey Hepburn, were based on the life of photographer Richard Avedon, who acted as consultant for the picture, and the editor who sings "think pink" is reputedly Diana Vreeland. Hubert Givenchy and Audrey Hepburn kept up their special partnership, and she wore his clothes in *Sabrina* and *Love in the Afternoon* as well as in real life. Givenchy remains one of the major fashion houses in the world.

Jacques Fath, both a showman and shrewd businessman, was a very social couturier who designed a lot for masked balls, film, and for his principle client, Rita Hayworth, for whom he designed a trousseau and wedding dress. In 1939 his plunging necklines, tiny waists and full skirts anticipated what in 1947 became the New Look. Sexy—though never vulgar—sophisticated and young, he did an American collection for mass-production in the late 1940s. His main triumph in England was with actress Kay Kendall, who wore the most fabulously elegant clothes in *Genevieve*, featuring tweeds tailored like silk.

Balenciaga

Cristóbal Balenciaga was recognized as a genius and a true artist. He was not always understood by the public, but was admired by the fashion world for his discipline and his structure, which was always evident, even in flimsy fabrics. He invented the 3/4 length sleeve and the standaway collar, and turned conventional dimensions upside down. His hats were always huge or tiny, and he was the first to venture away from the New Look in favour of suits in the 50s. His jackets were the complete opposite, being "unshaped," and then he introduced the sack dress. His evening wear was absolute fantasy, but it never lacked in formality. And his Spanishness was always present; he used vivid, flame colors and strong reds, and cut them in totally simple ascetic shapes. Diana Vreeland was quoted as saying: "When a woman wearing Balenciaga entered a room, no other woman existed."

1890- 1900- 1910- 1920- 1930- 1940- **1950-** 1960- 1970- 1980- 1990-

During the 1950s, hair was constantly changed in just about every possible way. It was back-combed, dyed, teased, cut with razors, worn straggly and put up. In fact you could do just about anything with it except leave it alone.

Home dyeing was a hugely important market. In 1950, hair could be bleached, shampooed and dyed permanently in one step. Women began to use more and more outrageous colors and to streak their hair with all sorts of paints and products not meant for hair at all. Then spray colors came onto the market, making life much easier and more exciting, since they could be washed out and changed every other day. Gentlemen did prefer blondes, and three out of ten brunettes dyed their hair blonde to prove it.

Women began to expect to be able to change styles. When the chignon was reported to be back in fashion, those who had cut their hair simply bought hairpieces and experimented. When short Italian-influenced quite shaggy haircuts came in, which required constant clipping, it was chic to add a hairpiece and have snipped bangs, or to grow it out, to put a plastic band to pull the front hair smooth and let the back hair go fluffy. In any case, bobbed hair was in vogue throughout the 50s, either with bangs like Audrey Hepburn's famous hairstyle or, in the late 50s with the straggly hair of people like Juliette Greco—long and layered.

Short hair was popular throughout, in several different styles. The "butch" cut achieved with a razor, made popular by Shirley Jones, and the gamine cut, which lasted a long time, were very popular, largely due to the power of film. Ingrid Bergman's short *Joan of Arc* hairstyle was widely imitated, even with wigs.

Short bubble cuts done with pin curls were all very much the trend until suddenly, from nowhere seemingly, the bouffant look dictated the use of huge rollers, the hair being dried, puffed out at the sides and then lacquered in place. This type of hairstyle took over almost completely, and the bouffant and the beehive were defying gravity all over the world.

Hairspray and hairdressers became absolutely indispensable for almost every type of woman, and fashions came and went in such definite styles that one was either in or out of fashion with no in-between. Revlon came up with hairsprays formulated for different hair types in 1952, SatinSet and Silkinet. Hairdressers vied with each other to develop new and exciting styles, and a jealously guarded hierarchy developed in the profession.

Hair color was as harsh and artificial as the colors for makeup, and anyone who wanted Gene Tierney's red hair or Elizabeth Taylor's raven-black lustrous locks could have it for the price of a bottle of dye. The imitation game was still the one women were playing, but now it was possible to choose one's looks. Peroxide blondes were still very much in vogue, although there were more and more exciting silvery and honeyed shades to choose from.

The existential philosophy and "intellectual" type of look of the gamine was very influential at this time. Largely popularized by Audrey Hepburn in *Funny Face*, and, later, Juliette Greco, it gave rise to a whole generation of girls who went around in black, sporting these very effective but hard to wear styles of hair and clothing.

above: Tied back hair and short bangs were inspired by Audrey Hepburn and remained in fashion through the 1950s.

left: An example of the small, simple hats of the day, usually worn to go with suits.

Because hair was short or worn up so much of the time, earrings became a focal point during the 1950s. From the big hoops of Gloria Graham to the big buttons of the chicest fashion houses, they were as important an accessory as the enormous "waspie" belts also popular at the time.

Hats were simply not an option with either the bouffant or short hairdos, and as the 60s approached, the formality requiring hat, bag and gloves tailed off considerably. After the initial establishment of a need for refinement, with the continuation of the New Look, the dimensions of the hair became either too small or too big.

Hats that did survive were most successful if simple, like the coolie from Balenciaga, a simple beret or pillbox, or in the form of the merest sliver over the head, like a broken shell. At the end of the decade, the climate was simply too informal for hats, particularly the hideous shaped helmets and huge jockey caps certain designers tried to peddle to go with the sack dresses and coats. When worn, they generally looked ridiculous and ugly, and were more favored by fashion editors than anyone else.

1990- 1980- 1970- 1960- **1950-** 1940- 1930- 1920- 1910- 1900- 1890-

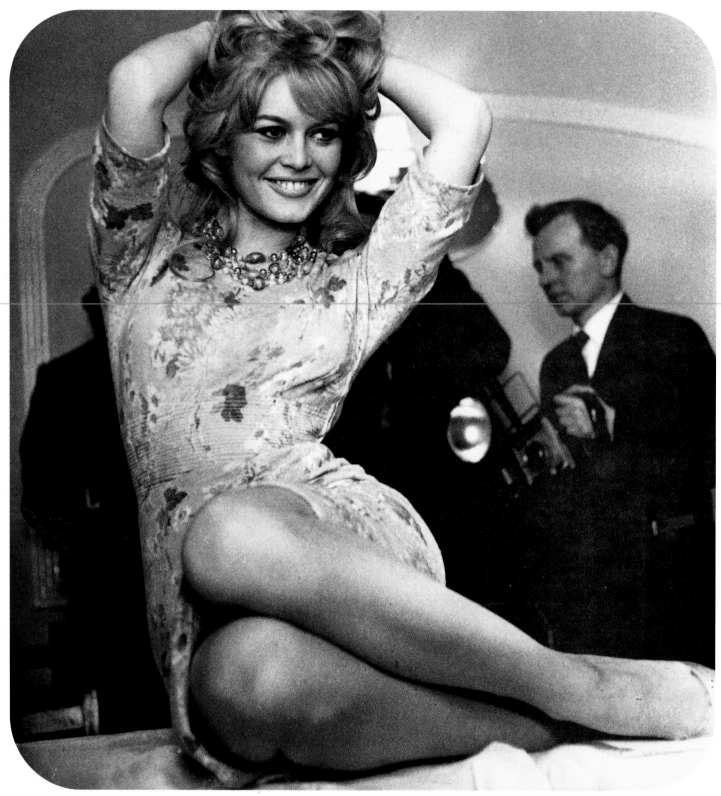

BRIGITTE BARDOT

Brigitte Bardot—the image of amoral sex-kitten was enhanced by tight-fitting clothes and the dark eyeliner and pale lips.

Hundreds of new names were to be established after the war. Cosmetics had been given such a push in the 40s, the technological improvements and changing attitudes all made a thrilling climate for the manufacturers and, increasingly importantly, the advertisers and image-makers. Now professional models were used rather than real people, and the industry took in all these new elements gladly.

The emphasis was now firmly on the eyes, with a new Egyptian shape defined by eyeliner and topped with the new wider, shallower eyebrows and a wider, shallower, lighter-colored mouth to go with it. The look was more harsh and slick than before, even though it was an era in which many women stayed at home, looking after children, full makeup on all occasions was promoted, and beauty was now almost a full-time occupation. As a wife, one was supposed to always look good, and if one had a career, as many women did, then it was inconceivable not to wear lipstick and powder at least. The first throwaway lipstick cases appeared, packaging becoming ever more sophisticated.

Women everywhere were in search of refinement, and Paris was its symbol. Scents of the day, even less expensive brands like Evening in Paris, sold in Woolworth's stores and saved up for by teenagers, had a little bit of that Parisian magic that hopefully would rub off on the ordinary consumer. It was relaunched unsuccessfully in the 90s—to most who bought it out of nostalgia, it didn't smell the way they remembered it.

Advertising became really inventive during this time, and the Revlon campaigns like Fire and Ice and Cherries in the Snow brought a little magic too. Madison Avenue ad men created classic campaigns for these brands. "Have you ever danced with your shoes off?" "Do you close your eyes when you're kissed?" It was a case of giving cosmetics "dignity, class and glamour" but also individuality, and possibilities beyond what was in the compact or on the face. White Shoulders scent and its advertising showed that even cheaper brands promoted refinement and feminine mystique. Beauty products started to have more and more romantic and exciting names, to make them appealing to women who bought the dreams attached to the ad campaigns, not just the goods.

Estée Lauder understood only too well the psychology of the desires of the American woman who would never visit Paris in her wildest dreams, yet looked to Europe for sophistication. She managed to sell Youth Dew to women in such a way that they would actually buy it themselves. In those days, it was unthinkable to buy flowers or scent oneself. All the initiatives were left to men. But, in creating the scent, and a highly provocative one at that, compared to the flowery girlie ones of the day, she got women to buy this exotic scent in a formula that went in the bath and in lotion. Its steady sales through the years, without advertising, are testimony to its success. Estée Lauder also understood the basic idea behind the modern woman's beauty regimen. She had always maintained that her products should be expensive, otherwise the buyer would not feel she was rewarding herself enough.

Eyeshadows were absolutely flooding the market with complementary mascaras, lining pencils and eyeliner liquids. The colors were often blatant and seem quite tacky to us today.

above: Cosmetics became a necessity for every woman during the 50s.

right: Estée Lauder's revolutionary scent, Youth Dew.

Violet mascara, blue eyeliner, and ice blue and silver shadow, or copper mascara with green frost shadow, were Revlon's idea of color coordination. Aziza, who just made eyeshadow, established a comfortable niche in the market purely on the basis of mascara.

Technological advances brought an ever-improving range of cosmetics with exciting new foundations like Touch and Glow and Love Pat, which brought the right dewy, moist look to skin with a depth of color that was absolutely right for then, but would be considered *de trop* today. The heavily penciled brows and bright hues of the 1950s would be completely unthinkable now in their original combinations, as would the feeling of wearing such a thick covering in the first place, but then it was considered exciting just to imagine that it was possible to buy the properties of glamorous womanhood so easily.

COSMETICS **BODY SHAPE & UNDERWEAR** **WORK & PLAY**

above; The babydoll look in shortie pajamas, 1959.

center: Her exotic beauty and curvaceous figure got Sophia Loren some choice film roles.

right: An advertisement by Maidenform for the popular strapless bra.

The body shape changed in the 50s and became more muscular, toned and womanly than the elongated rangy figures of the 40s. The padding of the New Look determined the shape of things to come, and the thing girls longed to be was either cute or refined. You had to be very womanly and curvy. The stiletto shoe and the eyes were all pointed and harsh, echoing the surroundings of the day, when modernity meant sharp corners and super-bright color—even cars were fashion conscious, and underwear, like the cars, was very streamlined. Bras, particularly, were pointed with stitching in circles to accentuate the mountainous aspect of what was under-neath. Breasts were becoming the focal point of the postwar years. There is a theory that says that man looks to the breast after any dis-aster (i.e., the war) like a hungry baby to its mother, but it could just be that fashion was looking to shift the erogenous zone. Whatever, Hollywood had a huge impact on underwear during this period, with Elizabeth Taylor in *Cat On a Hot Tin Roof* looking far too beautiful in her ivory slip, and Janet Leigh a cool thief in her black bra in the opening scenes of *Psycho*.

The strapless bra was a big number in the 50s, as the strapless evening dresses required something to hold the breast high and structured without showing. Wiring and stitching had to be tough and intricate. The cantilevered bra was reputedly invented by the tycoon Howard Hughes (based on his designs for an airliner!) and launched via the buxom Jane Russell in the 1941 film *The Outlaw*. Controversy surrounding Ms. Russell's cleavage led to the film's banning until 1950, so cantileverage came into its own in the 50s.

Layers of petticoats and special stiffened nylon skirts became commonplace. Several hundred yards of fabric could now be run off a bobbin, instead of the previous maybe 16 or 17. This meant that fabric could also be manufactured with a two-way stretch, so output was increased and ultimately meant the fabrics were cheaper. Petti-coats were huge even for day wear, almost like ballerina skirts made just for casual wear. Evening dresses often had several layers of sized canvas to make the skirt stick out to the maximum. The dresses worn by the very rich and fashionable, for Queen Elizabeth's coro-nation in 1953 for example, were heavy and coarse, and probably outlasted their wearers.

1990-
1980-
1970-
1960-
1950-
1940-
1930-
1920-
1910-
1900-
1890-

Girdles were heavy, despite the new advances in manufacturing processes, and corselettes and girdles still had garters attached, and stockings were worn as ritual by girls as soon as they were too old for their bobby sox. Pants on the other hand were, as yet, big and plain right up to the waist.

Nightwear was important too. The manufacturers realized there was a growing teenage market, with film stars like Sandra Dee popularizing the idea of slumber parties. Babydoll nightwear and girlie froufrou pajamas were worn, seemingly for the benefit of other girls rather than boys!

BATHING SUITS were seen frequently in the 50s for swimming, certainly, but also in beauty pageants, advertising and films. The movie star Esther Williams, in her swimming spectaculars, made swimwear the stuff of fashion fantasy. Most swimsuits of the era were like abbreviated evening gowns with boned support and frills and other ornaments; in fact it was hard to imagine the wearer wanting to get them wet. The bikini was introduced with huge publicity in 1946, named after an atomic bomb test site at the time, but it was only after French stars like Brigitte Bardot exploited it in the 50s that its popularity really exploded worldwide.

COSMETICS **BODY SHAPE & UNDERWEAR** **WORK & PLAY**

Leisure was something suddenly everyone enjoyed to some degree, not just a luxury for the few. Increased prosperity and the fostering of the nuclear family ideal led to a new concept, lifestyle. And as the idealized lifestyle was consolidated as a reality for more and more people, leisure activities became increasingly defined by age and peer pressure, with the attendant consumerism they attracted. For married people, there were activities like barbecues and other social interests that would take place around the home. Cocktails and dinner parties became part of more people's lives. Tennis, golf and other traditional sports of the well-off become the pursuits of the growing middle classes as well, while dancing and movie-going were the favorite pursuits of single people and not-yet-married couples.

Teenagers, as we know from songs during this period, agonized about being normal, being attractive and ever growing up. The pressures of being like one's peers were never greater, and with their new increased spending power the young were able to articulate it as their parents never could. Everywhere, young people were evolving their own looks and fashions, and the idea of identification through dress became the norm.

Music became a central part of the growing culture of youth, and the accompanying fashions for girls were casual—circular skirts, ponytails, pedal-pushers—and definitely "teen." Girls who tried to look adult before their time were very suspect indeed.

Once at college, though, the opposite was true. Students were either dressed up in ready-to-wear versions of their mother's clothes or, for those whose mothers had little or no control over them, decked out in the ballet-beatnik look (very Audrey Hepburn), as though they had just been working out a routine with Gene Kelly. But the look of youth was still generally clean-cut, the concept of youth revolution still a decade away.

Pastimes like bowling were on the increase, suitable for families and groups of kids alike, and this in turn encouraged the fashion for sportswear—baseball caps, Hawaiian shirts and, most universally, blue jeans. Within these teenage subgroups there was a definite mood to conform, to be like one's peers was paramount, being "in with the in crowd." Most important was to avoid any more than the minimum necessary contact with anyone considered a square.

It was the first era of television-led mass media, and new crazes popped up overnight like mushrooms, from the hula-hoop to flying saucers; so when some fundamental change occurred, be it method acting, rock'n'roll, the beat writers or whatever, it was usually dismissed as "just another craze." But despite its dismissal by the squares, youth culture proliferated across the US and Europe in coffee bars, jazz clubs, the soda-fountains of suburban America and Parisian pavement cafés.

High society, meanwhile, cruised abroad. The most fashionable destinations were Capri or Jamaica. Newport, Rhode Island; St. Moritz; South America; or the French Riviera were other magnets for the millionaire set, while the masked ball given by socialite-aesthete Carlos de Beistegui in Venice's Palazzo Labia in 1951 was the most spectacular social event of the decade.

above: With the arrival of rock'n'roll, music became part of the new lifestyle.

center: The beatnik look presented by top model Capucine.

right: Elvis, the greatest idol—teens were identified by who and what they liked.

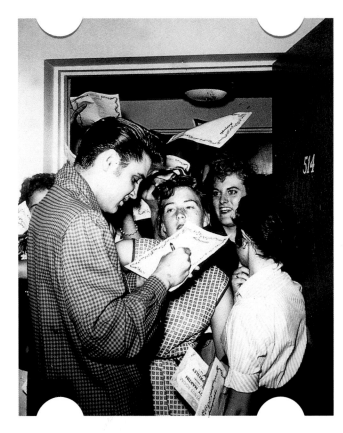

1990-
1980-
1970-
1960-
1950-
1940-
1930-
1920-
1910-
1900-
1890-

The film *The Barefoot Contessa* had a profound influence over the way celebrities and socialites were pictured. They wanted to be photographed in action, in their shirtsleeves and out in the fresh air. Karsh, Baron and Cecil Beaton were still taking the photographs of grand people in "posterity poses," but the style drifted more and more towards an informal and candid feeling, characterized in the Howard Conant series of pictures of Grace Kelly—the general feel was increasingly that of being caught unawares.

Grace Kelly epitomized this sort of style, seen first in Hitchcock's *Rear Window*, and throughout her life as princess of Monaco. Her unaffected, casual look based on the American sporting image, including the eponymous Hermès "Kelly" bag, is still very much the ideal for today's super-rich.

Dancing and dance music were very important in the 50s. Ballroom dancing, Latin American crazes like the mambo, and even country-based square dancing were all important trends prior to the advent of rock'n'roll, which seemed to overtake everything for a while. Although jiving went back through the bobbysoxers jitterbugging in the 40s to black American dance before the war, it became the universal dance of youth when Bill Haley, Elvis Presley and the rest burst onto an unsuspecting world. Youth was making its presence felt everywhere and in every facet of life. There was a predictable backlash from the moral majority, but things were changing very rapidly, and permanently. By the 1960s, it seemed like there was a permanent generation gap.

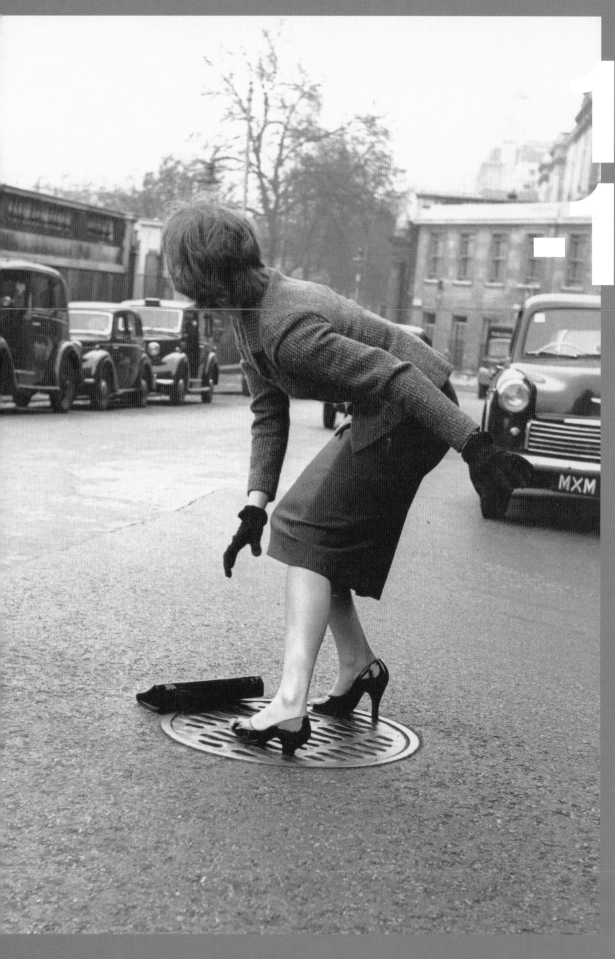

1950 -1959

The McCarthy hearings in the US

Alaska made 49th state of the United Sates

Jack Kerouac's *On The Road*

USSR tests an atomic bomb

US tests a hydrogen bomb

The coronation of Queen Elizabeth II

The first civilian jet airliner, the De Havilland Comet, goes into service

First transatlantic telephone service

The birth of rock'n'roll

Revolution led by Fidel Castro triumphs in Cuba

"Action painter" Jackson Pollock killed in car crash

1960-
1969

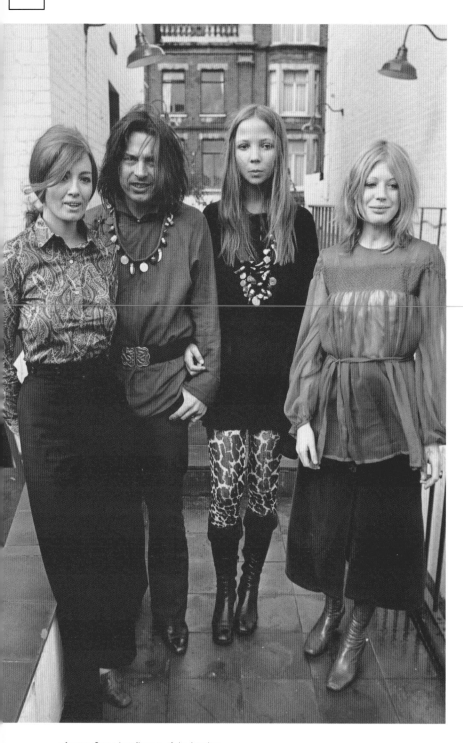

The values of the consumer society that had been so vigorously promoted were to be challenged all too soon, and from an unlikely source—from its young and from within. The 60s were a remarkable time in history, where the world seemed to come together and share its hopes for a free society and a more equal lot for everyone. There were astonishing changes taking place, particularly significant in the way that they were largely promoted and instituted by the young. Not literally by teenagers, but by that generation of 1950s teenagers who rejected the feel-good factor they were supposed to take for granted and who in their 20s became the movers and shakers, the anarchistic architects of the so-called "Swingin' Sixties."

It was an age of protest marches and direct action. From the marches against atomic weapons in the late 50s and early 60s to the international protests against the Vietnam War, it felt as though changes in attitude (if not in state policy) could be made because people shared the same ideals. The US civil rights movement was pledged to peaceful nonviolent action, and gained sympathy because of this dignified approach. Later in the decade a more violent, confrontational stance was adopted in the student protests of 1968, which were the turning point for many. Most importantly, liberal (and liberating) attitudes and opinions were becoming accepted as normal in the mass media, and significantly, women were equally active and involved in all this.

The personification of the cultural climate early in the decade was President Kennedy and, more particularly, his wife Jacqueline. Together they made a huge impact, and the administration, nicknamed Camelot, was one of the most romantic and oft-cited public images in history, which at the time not even rumors about sexual promiscuity and Mafia links could dim. In Britain, the final days of Macmillan's term seemed stuffy and old-fashioned by comparison, and there was considerable envy of the charismatic couple in the White House in governments all over the world.

The Macmillan government had its biggest crisis in the Profumo Affair, when the two young women at the center of the scandal (involving ministers, call girls and Russian spies), Christine Keeler and Mandy Rice Davies, almost brought the administration down.

Music exerted the single biggest cultural influence on this era. Rock music stars were the new poets, orators and philosophers, as everyone turned their attention away from the traditional channels of

above: Some key figures of the London scene, (left to right) Christine Keeler, David Bailey, Penelope Tree and Marianne Faithfull.

right: Argentine-born Cuban revolutionary leader Che Guevara at the United Nations, 1964.

far right: Known as the most stylish woman ever. Jacqueline Kennedy was more than a first lady; Paris, 1961.

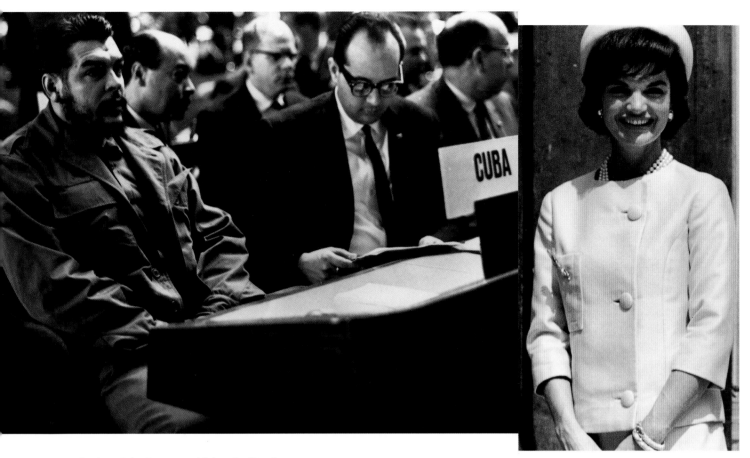

communication. John Lennon said that the Beatles were more popular than Jesus Christ, and the moral majority in the American South staged ceremonial burnings of records in response. Certainly the significance attached to the lyrics of songwriters like Bob Dylan, the way every new Beatles or Stones album sleeve was analyzed as an icon of the times, and the huge outdoor pop festivals at the Isle of Wight, Monterey and Woodstock that were gathering points for the faithful, all suggested that for youth, rock was like a new religion.

Art became a celebration of the banality of everyday consumer images, as Andy Warhol stated "Everyone will be famous for fifteen minutes." He reinforced his philosophy by giving everyday objects like soupcans sacred space on gallery walls in his silkscreens. Other promoters of this easily accessible pop art included Roy Lichtenstein, James Rosenquist, Tom Wesselmann and Claes Oldenburg. Op-art, geometric optical illusions, influenced the textile designs adopted by Mary Quant and other fashion designers at the time. Visual art had a place and position in society it had not occupied for some time.

Revolutionary figures like Mao Tse-tung and Che Guevara became icons among the young, as more and more people reacted against the Vietnam War; draft-dodging was seen by many people as an idealistic stance, an unthinkable prospect a decade earlier. The Berlin Wall had been erected at the beginning of the decade, but as television showed more and more horrific pictures of the war in Vietnam, to many in the West the cold war became a cultural cliché that propped up tired politicians on both sides of the Iron Curtain and provided plots for increasingly stylized spy films.

For the first time in the 20th century, sex was something to be discussed in the open, and virtually all taboos were challenged to some degree. For women, it was a time of liberation and legislation. The introduction of the contraceptive pill, followed by legalization of abortion in the United States in 1970, meant that for the young—and particularly young women—it was a golden era, where sexual activity took place for the first time without fear of unwanted pregnancy, and years before the threat of AIDS appeared.

Class mobility and meritocracy were the phenomena of the 60s, and widening education with more pupil power and an opening-up of the media to one and all challenged Western society irrevocably. Culture and counterculture lived side by side, with a media seemingly full of young idealists upsetting old establishment figures. The hippie movement that had its roots in San Francisco brought the notion of a drug-induced love philosophy into the mainstream of youth culture, but commercial exploitation and the realities of "bad tripping" soon saw flower power wilt.

The 60s, like the 20s that they are often compared to, were incredibly prosperous, and the young, spoiled children of the time had more leisure and spending power than any previous generation. Prices were relatively cheap, because of the huge volume of sales and technological advances in materials. In clothes, this meant that man-made fabrics and fashions could be inexpensively produced. Design-wise, the space programs exerted a huge influence, with the most modern materials and "space-age" looks reflected in the metallic and plastic styles on the runways.

COSMETICS **BODY SHAPE & UNDERWEAR** **WORK & PLAY**

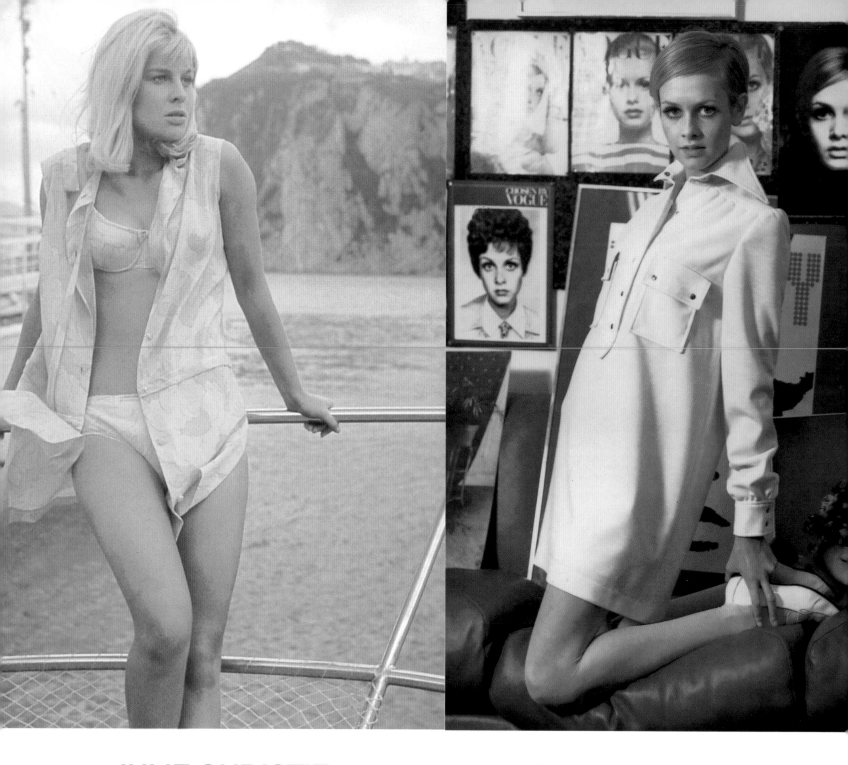

JULIE CHRISTIE

became one of the definitive icons of the period after her film debut in *Billy Liar* in 1962. Her striking facial beauty and enigmatic personality—typified in her Oscar-winning role in *Darling*—was the personification of the 60s woman.

TWIGGY

was, without doubt, the face of the decade. Her wide-eyed elfin features and slight build—hence her nickname—set a new girl-in-the-street standard for fashion models, and created almost overnight the look of the era.

1990-
1980-
1970-
1960-
1950-
1940-
1930-
1920-
1910-
1900-
1890-

THE SUPREMES

with their lead singer Diana Ross (right), the trio represented the new confident, sophisticated style of black America. They, along with Mary Wells, Aretha Franklin and others, made women an essential part of the soul music revolution.

01-27

Snowdon, Donovan, Duffy and Bailey helped express the expectations of the age, through their innovative and "spontaneous" styles of photography. Thought to be more natural-looking than previous fashion photography, the style was nevertheless just as contrived. However, its moods were different, the poses of the models had an off-guard accidental look to them, with the girls really looking as if they couldn't care less, rather than the intimidating long-held expressions of the 50s.

Fashion shoots had long been held in odd places since the 40s, influenced by photojournalism and war photography, but now there were shoots where the models participated in Batman cartoon strips or were draped over cars at the racetrack. They might even be falling into water, or rushing to some appointment in a panic.

Class barriers were well and truly down in the 60s, and the themes of couture were playfully re-invented in the media. The lady and the cheetah was one favourite in *Vogue*, and there were lots of exciting fashion ideas inspired by the "liberating" films of the day, movies like *Jules et Jim* and *Viva Maria*.

Partnerships were a favorite media theme, too. There was the Taylor and Burton saga, the Fonteyn-Nureyev chemistry and even the Warren Beatty and Vivien Leigh story, when they starred in *The Roman Spring of Mrs. Stone*. But Beatty was in a far more memorable team when he starred in *Bonnie and Clyde* with Faye Dunaway, the image of the devastatingly handsome couple of crooks inspiring a huge fad for 20s-style fashions that culminated in the "Biba" look.

Earlier, the *nouvelle vague* films of Claude Chabrol, Alain Resnais and Jean-Luc Godard made their presence felt. *The Servant,* by Joseph Losey, explored a sinister class dynamic with sexual overtones, while the landmark films *Lolita, Dr. Strangelove* and *2001: A Space Odyssey* guaranteed Stanley Kubrick an important place in film history.

The trend for working-class heroes in fiction was transferred to the big screen in Britain with *Saturday Night and Sunday Morning, A Kind of Loving* and *Alfie*, while in America, Steve McQueen was the American blue-collar equivalent in *Love with the Proper Stranger* with Natalie Wood. Meanwhile, married life took a turn for the better in *Barefoot in the Park* with Jane Fonda and Robert Redford.

The western went comic with *Cat Ballou* and more violent than ever before with Sam Peckinpah's *The Wild Bunch*, a foretaste of levels of screen violence to come. But the new western was the first "road movie," *Easy Rider*, where the heroes had motorbikes instead of horses and no real destination. They were "looking for America" said the posters—the frontiers were purely mental.

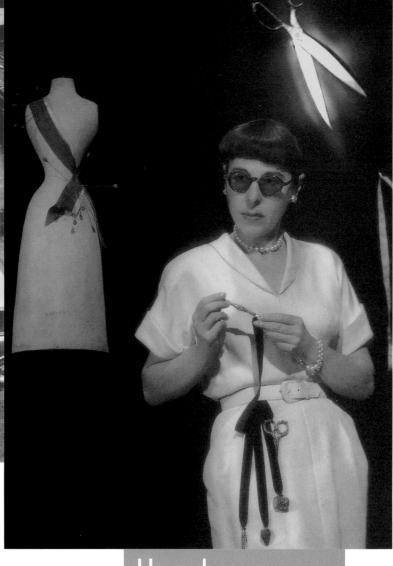

above: Model Jean Shrimpton posing with another icon of the 1960s, the Mini, in *Vogue*, 1962.

left: Warren Beatty and Faye Dunaway in *Bonnie And Clyde*, 1967.

The Pink Panther films were very popular and funny, and in Britain the seemingly sophisticated humor of the day was balanced by the runaway success of the Carry On series, where old-fashioned innuendo and belly-laugh humor still proved to be drawing the audiences. Then at the end of the decade, the surreal humor of Britain's Monty Python TV show became a surprise hit in other parts of the world, most significantly in the US.

Pop music had featured in films since the advent of talkies, and in the music-dominated 60s it was, perhaps predictably, the Beatles who made the biggest impression with *A Hard Day's Night*, its zany humor soon aped by others, most famously The Monkees. The other movie milestones music-wise were Robert Wise's epic screen version of the stage hit *West Side Story* and Don Pennebaker's documentary record of Bob Dylan's 1965 UK tour *Don't Look Back*.

1990-
1980-
1970-
1960-
1950-
1940-
1930-
1920-
1910-
1900-
1890-

Head

Edith Head dominated dress design in film from 1938, when she took the crown from Travis Banton, to the 1970s. She won eight Oscars for her work, designed for Vogue patterns and for Pan American airlines. Her film costumes included outfits for Marlene Deitrich, Mae West and Grace Kelly. A 1936 sarong for Dorothy Lamour was much copied, as was the evening dress worn by Elizabeth Taylor in *A Place in the Sun*.

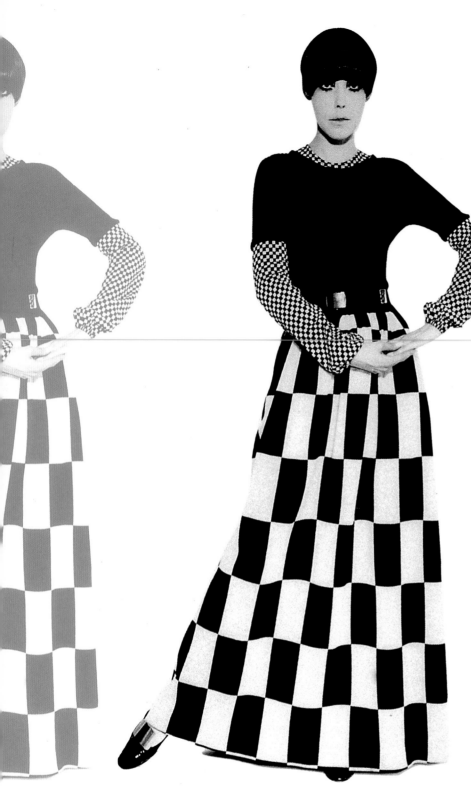

Space travel had a huge influence on the fashions of the time, too; the use of "modern" materials was felt to be terribly important. As the decade went on, the unisex aspect of the space age was the big experiment, and flared loon pants and boots replaced the mini and its kinky boots and kitten-heel slingbacks. Those who didn't want to surrender their femininity opted for the gogo skirts in leather and plastic and a cape.

Jewelry gained from the artistic climate and preoccupation with modern materials, Danish jewelry was fashionable and plastic and op-art inspired designs were ultra-modern.

British ready-to-wear dominated the fashion scene, the boutiques around Carnaby Street and the Kings Road were far more representative of the times than the couture houses.

The Italian fashion shows were established in the mid-60s, a while after their initial success in the 50s, but couture was not to be really successful again until the 80s, when conspicuous consumption came back into style. And status and power were not to have the same meaning ever again, although Italian fashion was much admired in the 70s in the ready-to-wear area.

PIERRE BALMAIN: His clothes were the embodiment of the early 60s—fresh and structured. His fashion house continues to turn out luxe clothes under the direction of Oscar de la Renta.

DIANA VREELAND: Few people have made such a contribution to fashion history from such a privileged position. Her "why don't you" column in the 30s asked "why don't you . . . wash your baby's hair in champagne." She was editor of *Harper's Bazaar* for more than 20 years and of *Vogue* in the 60s, her epigrams still being quoted widely—"Pink is the navy blue of India" was a favorite. She was personally responsible for the Metropolitan Museum of New York's collection of couture, and ran its board after her career in fashion journalism ended. She had a great love of lacquer red, and knew everyone who was anyone of remote interest in the world of fashion.

The main fashion breakthrough was, of course, the mini. The variations on the theme were numerous, and went from the sublime to the ridiculous. The cautious office mini pinafore dress by Foale and Tuffin, the Courrèges mini with the hole in the middle, the two piece held together with a huge plastic ring, the ubiquitous "Lilly" dresses by Lily Pulitzer in their wash-and-wear colored cotton prints—in all its seemingly endless variety, the mini was worn by everyone from the Kennedy clan to the trendiest models to the average woman at the beach and on the street, its almost home-made simplicity was the apogee of chic.

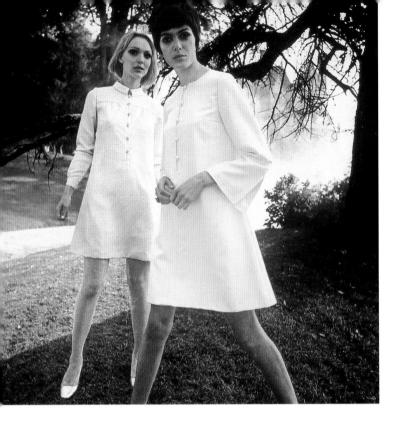

above: Variations on the mini were seen everywhere in the 60s.

left: A wool knit maxi-dress by designer Rudi Gernreich.

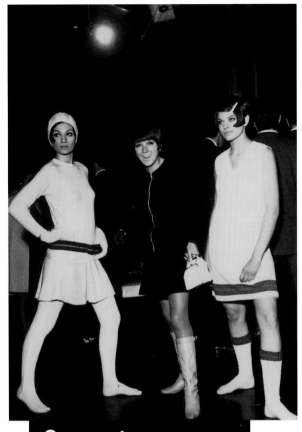

Quant

Mary Quant revolutionized not only the face of British fashion but the faces of the fashionable. False eyelashes and crazy frosted colors were a fundamental part of the 60s' image, and she had them first. At the forefront of the revolution, she opened the first boutique in the Kings Road in 1955. She popularized miniskirts, skinny rib sweaters, hip-slung belts and colored tights. Today she heads a thriving makeup business that includes a string of retail outlets in Japan, where the young have given her makeup cult status. There was no particular look for her clothes other than the mini and boots, but with her huge doe eyes, symmetrical mouth, painted nails and Vidal Sassoon bob, she—like her models—really was the personification of the London look of the 60s. She once made a much more hip Kings Road version of the Barbie doll, called Daisy, after her logo, the daisy flower, which can also be found on a range of bed linen, bags and sweaters. When awarded the OBE, she went to Buckingham Palace to receive it from the Queen in a miniskirt!

Cardin

Pierre Cardin, intellectual and polymath, studied architecture before joining Paquin, Schiaparelli and then Dior. He also designed costumes for Cocteau. Always avant garde, he was pleased to be known as the space age couturier because of his use of interesting, modern fabrics. He loved the idea of unisex fashion, and he was the first designer to seriously invest in licensing deals.

Pucci

Emilio Pucci was an Italian aristocrat who started in sportswear in America, developing boldly patterned clothes based on medieval heraldic banners. His use of brilliant, acid color made his reputation. His designs were archetypal of the 1960s, and he enjoyed a renaissance in the 80s. All his clothes were signed like works of art, and now can fetch enormous prices.

Courrèges

André Courrèges was the top designer of his era, the mid-60s. His creations were meant to be sexless uniforms for living in space, and his use of strange materials reflects his background in civil engineering. His work was plagiarized mercilessly during the peak of its fame; critics now say that the shock value was taken for granted in his time, although there were constantly articles in *Vogue* and *Queen* asking "Can one really wear Courrèges?"

Rabanne

Paco Rabanne trained as an architect. With an intense interest in pop art, he worked in plastic and metal, combining different textures. Sculptural and industrial looking, his designs suited 60s self-conscious modernism, but were not truly classic. He soon got himself into a corner from which he seemed unable to escape, with dress designs that were simply not practical. In retrospect, some critics said he only ever had one idea.

1990-
1980-
1970-
1960-
1950-
1940-
1930-
1920-
1910-
1900-
1890-

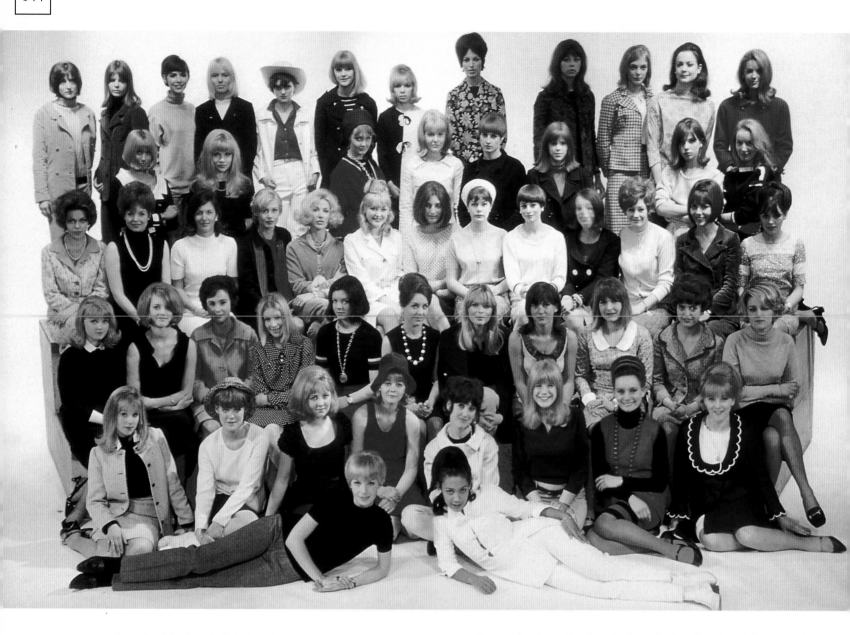

above: A variety of popular looks from the decade. This picture, "The Classiest Class of 1965" consists of a number of up-and-coming British females of the time, including Francesca Annis, Lulu and Nico.

right: Jean Shrimpton, known as "the Shrimp," checks her appearance.

The enthusiasm for false hair peaked in the 60s—girls wore wigs to change personality; according to an article by Polly Devlin in the London *Evening Standard*, "you could be different people if you had different hairstyles," but there was no mention of how shallow these personae might be. Lilly Daché advocated a whole wardrobe of wigs, instead of hats, and Elizabeth Arden sold bows with hair attached. You could even get wigs on the National Health.

Dyes were still very obvious, and as if to highlight this, they had names like Just Peachy, Honey Doux, Tickled Pink and Frivolous Fawn. Shampoos were changing—Flex was the first corrective protein treatment for hair, and the first approved anti-dandruff shampoo ZP11 came on the market in 1963.

Twiggy popularized the short urchin cut. It was perfect for the ragamuffin Oliver Twist look, and the fine-boned looked stunning and even ethereal in it. Teenage girls loved short hair, and as the fashion spread in America, the *New York Times* ran a piece that featured six pictures and asked which were girls and which were boys, followed by a commentary.

Long, straight hair was equally popular. For the first time the same styles worn by the models, singers and fashionable people could just as easily be worn by schoolgirls or the very young. Girls had the money to look like stars and the stars wanted to look like the girls. That was where the inspiration was coming from! Long hair went from straggly with little bangs like Brigitte Bardot in the 50s to the straight Jean Shrimpton style. Finally, towards the 70s and the introduction of unisex fashions, the now well-worn cultural joke of not being able to tell the boys from the girls was repeated yet again, only this time the hair in question was long and straggly.

Sassoon

Vidal Sassoon was an archetypal figure of the 60s, from London's East End like many of his contemporaries, he was the hairdresser who completely reinvented the bob. Taking it down the neck in layers and heightening it at the top, it had exactly the right dimensions for the 60s and the almost amateurishly simple symmetry of the clothes. Mary Quant (above, with Sassoon) was one of the first to acquire it, and the rest of the world followed suit soon afterwards.

COSMETICS BODY SHAPE & UNDERWEAR WORK & PLAY

Cosmetics were of utmost importance throughout the 60s. In stark contrast to the ultra-sophisticated faces of the 50s, the 60s look put the accent on looking young, childlike even, with the eyes almost permanently agog. Huge wide painted eyes, pale skin and big pale lips were the ideal, and the use of false eyelashes and color—and strange frosted colors—was especially encouraged. Custom beauty counters were "the next big thing," where customers could go and play around with makeup and try out new ideas in situ.

The very early 60s saw the "pale" look, which by the end of the decade had given way to the riot of color and exotic looks that came with psychedelia and culminated in the cult of body painting.

From the charcoaled upper lid and eyeliner look to the wide-eyed doe image, and from the pale, pale, brown lipsticks to the pink and peach shades—the choice was endless.

Huge, dark eyes were the ideal, and the contour of the eye socket was defined in a totally new way, in contrast to the eyeliner on the lid in the late 50s and early 60s. Lipstick shades were peach and pink, with names like Beach Peach, Swinging Pink and Little Red red. Red lipstick had to be very bright, but paler lips were more common, to contrast with the dark, dark eye makeup.

Rouge made its comeback in the 60s, now called blusher, it was deemed indispensable in creating the face shape that became so important. Fabergé Rosy Glow, Germaine Monteil liquid blusher and Hazel Bishop Fresh'n'Bright arrived in about 1963 and were popular through to the 1980s.

False eyelashes were news from about 1964. First mascara was the new big thing, which got progressively wilder and heavier, with different colors added to black. Then lash-lengtheners were introduced, and finally false lashes took over. They were applied lash by lash, lasted a week and some were even made of mink, sable or human hair. All sorts of color combinations were available, tweed and gold, for example. Eventually, they were mass-produced in rows, requiring some customizing to fit. In the late 60s they could be cut away at the corners, made of foil or glitter and, because they were glued on, resulted in all manner of humorous situations, from ending up being swatted in salads to giving wearers a fit of blinking.

Cover Girl makeup was introduced in the United States to great interest. It featured real, well-known people who endorsed its quality. It epitomized the new, young glamour, clean, fresh and young and really wearable. It was not the only brand, however. Cutex had made a huge impact, and in England, Mary Quant was to introduce her range of unusual colors with crazy names like Posh Prune and In Clover and was getting more and more outrageous by the moment. Eyeshadows by Mary Quant came in a set called Jeepers Peepers; mascara was made in colors; her foundation was called Starkers; and she introduced Face Shapers "for doing all those face modelling things." Her half-and-half lipstick called Skitso and PVC White nail polish were some of the must-haves of the times.

Makeup was getting more and more adventurous with glittery false eyeshadows, sequins along the eyelid and Pablo, the makeup artist for Elizabeth Arden, would create butterfly wings around the eyeline or paint colors that continued over the whole face.

Leg makeup was back. With the miniskirt the last thing to be alluring was flaccid white flesh. Estée Lauder made a whole range, just for legs, with lubricator, cream, powder and rouge for knees. Others were less fussy and less subtle, the early body makeups, actually up to the 90s, always went orange and concentrated in dry areas, like feet and knees.

Colors were sold in duos or trios as well as singles in small mirrored compacts and eyeshadow sticks struck a chord with the childlike fascination for color. This all helped to encourage experimentation. Cream shadows in throwaway plastic tubes were another novelty for the artistic, naive chick. Bronze, gold and silver or any metallic shades were popular and new. Aziza made all sorts of colors with gold highlights, which would, of course, look fab with your Paco Rabanne.

The subject of plastic surgery was more openly discussed, and the Catholic church or its spokespeople seemed to concur that in cases of extreme ugliness, and maybe for certain jobs, cosmetic surgery could be excused.

Elizabeth Arden concentrated on arctic looks for blue-eyed blondes, and her Swedish collection of skincare seemed to be aimed at the fair-skinned. The blue-eyed blonde was the ideal of the time, despite the tendency to flirt with other types, and the lip-service paid to the global village.

The civil rights movement heralded a new black consciousness, and black beauty matters began to get serious attention with the launch of *Ebony* magazine in 1966. One of their first articles was "Are black girls getting prettier?", while the presence of an African-American contestant in the Miss America pageant made headlines.

Revlon produced its revolutionary new age-oriented cream, Eterna 27, for the over-35 market, and were the first to sell and develop an anti-wrinkle night cream of the same name. They were also quick off the mark to come up with the first department store range of hypo-allergenic cosmetics, called Etherea.

Scent continued to be a feature of the big-name designers, and Yves Saint-Laurent launched his Rive Gauche in its bright, new, striped blue and silver packaging in 1968.

1990-
1980-
1970-
1960-
1950-
1940-
1930-
1920-
1910-
1900-
1890-

top: "Mary Quant will give you a lovely pair of shiners"—an ad for eye shadow.

above and left: Face and body painting was a huge craze.

COSMETICS BODY SHAPE & UNDERWEAR WORK & PLAY

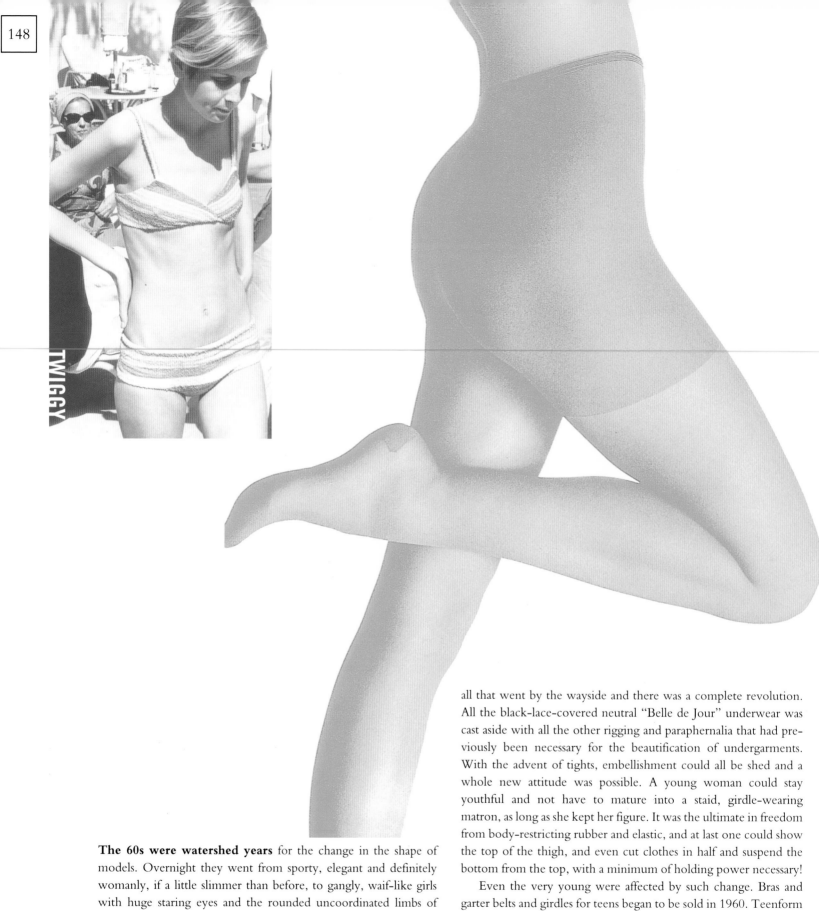

148

TWIGGY

The 60s were watershed years for the change in the shape of models. Overnight they went from sporty, elegant and definitely womanly, if a little slimmer than before, to gangly, waif-like girls with huge staring eyes and the rounded uncoordinated limbs of children. The gauche, untrained poses of the models, sometimes with the head bent over, accentuate this innocence.

Underwear started in the 60s by being a continuation of the roll-on girdle and the perky structured bra, but quite without warning, all that went by the wayside and there was a complete revolution. All the black-lace-covered neutral "Belle de Jour" underwear was cast aside with all the other rigging and paraphernalia that had previously been necessary for the beautification of undergarments. With the advent of tights, embellishment could all be shed and a whole new attitude was possible. A young woman could stay youthful and not have to mature into a staid, girdle-wearing matron, as long as she kept her figure. It was the ultimate in freedom from body-restricting rubber and elastic, and at last one could show the top of the thigh, and even cut clothes in half and suspend the bottom from the top, with a minimum of holding power necessary!

Even the very young were affected by such change. Bras and garter belts and girdles for teens began to be sold in 1960. Teenform was a huge success.

Teenage and childrens' foundation wear influenced all underwear trends for the next 20 years. This was due to the invention of Spandex and Lycra in 1958. They had long been used in test gar-

ments only. They contained no rubber and resisted perspiration. Oils and lotions and detergents didn't harm them, and they could also be dyed, thus changing the image of underwear overnight. Warner used the new synthetics in their Little Godiva, Birthday Suit and Merry Widow. Both Lycra and Spandex would become big news in the 80s when applied to wool and outerwear cloth.

Trousers could now be tight and not have to be worn with socks or betray the presence of garters. The choices were incredible, and the first thing manufacturers did was to come up with the idea of the trouser girdle and the panty girdle for those who could not maintain the required scrawniness. These were extremely popular right into the 70s, and it was a condition that air hostesses wear them when working until about 1975.

The miniskirt was the culmination of the search for the holy grail for womankind, freedom of movement. Finishing and model schools held classes in how to get in and out of low sportscars when wearing a mini and, as they reached ridiculously small proportions, panties were plainly and proudly visible.

Underpants were getting smaller too. Nylon fabrics were more and more brightly colored, often with garish patterns and designs instead of plain white briefs. Bikini pants were getting smaller all the time until the half brief in the 70s. They were virtually seamless too, which meant they were less visible when worn.

The bra could not have been more different from that of the 1950s. At the beginning of the 60s, they were usually very structured and they invariably contained foam-lined cups. The body stocking was the next development, to have seamless and invisible undergarment was the natural progression, but, those who could wear it were the ones who invariably didn't need to be wearing it at all. Like the no-bra bra, it was superfluous.

Tights were being made from 1960 onwards. Ballet dancers' styles had been around longer, of course. First appearing in the 50s, stockings and long pants were made to overlap and were then only available in wool. They were really meant for sportswear. The new tights did not come in overnight, and many poor fashion victims tried to wear stockings with minis. But by 1969 more than 160 million pairs of tights of a combined total of 460 million stockings and tights were sold.

However, old habits die hard, and older women kept wearing what they were used to, until in 1976 manufacturers finally stopped making removable garters from pantie corselettes. Then, of course, once removed from the market, everyone wanted them as a novelty in the 70s.

above: Ursula Andress from *Dr. No*, 1962, in the archetypal 60s' bikini.

left: The new tights made wearing minis much easier.

1990-
1980-
1970-
1960-
1950-
1940-
1930-
1920-
1910-
1900-
1890-

COSMETICS **BODY SHAPE & UNDERWEAR** **WORK & PLAY**

right: With human's first step on the moon came many attempts at space age fashion. Dress by Paco Rabanne, 1967.

below: The flowery shirts, sandals and beads of flower power fashion were in part inspired by The Beatles and their guru, the Maharishi Mahesh Yogi.

For many, Xanadu, Nirvana or wherever was a boutique in London's SW3 zip code or Carnaby Street. Street fashion was beginning to take off, and what was going on in trendy boutiques like Granny Takes A Trip and I Was Lord Kitchener's Valet was of far more significance than what was parading on the runway.

These were years of protest. Civil rights was the most important campaign through the first years of the 60s, culminating in the great March on Washington in 1963. Then the Vietnam War became the focus of protest movements, especially among the young of America, the males of whom faced the prospect of being drafted. Later in the decade, there were demonstrations for the legalization of soft drugs, women's liberation and gay rights—all areas that were almost taboo in the 50s. Finally the student turmoil of 1968–69 brought near chaos to the streets of London, Berlin and Rome, while the French government was almost toppled, and in the US twelve students were shot dead by the National Guard during a demonstration at Kent State University, Ohio.

The biggest step in historical terms was human's journey into space and the first walk on the moon. Neil Armstrong and his colleagues made the "giant leap" in 1969, and the world never looked the same again. The first woman in space, the Russian Valentina Tereshkova, had already gone into orbit in 1963. No one seemed to mind that a monkey got there before all of them.

Travel and cars featured strongly in the media of the day, often at a motor trade show with a female model on top. The relationship between man and car had stayed pretty much steady through the century, with cars as status symbols and totems of modernity, and sometimes supposed sex symbols. But now the car was small and peppy, minis all made their impact as junior-sized, easy to park and cheap to run.

Youth had its own styles in personal transport. The Vespa scooter pioneered by young Italians early in the 60s became the symbol of the British Mods, "dedicated followers of fashion" who staged some famous pitched battles with their arch rivals the leather-jacketed motorbike-riding Rockers in the mid-60s.

"Tune in, turn on and drop out," said Timothy Leary and that's what millions of young people did, but, amazingly, it was this same generation of "drop outs" who initiated most of the changes of the decade. The dividing lines between work and play were less distinct than they had been before, especially for the young people coming out of universities and art colleges and entering the increasingly youth-oriented industries of fashion, photography and music.

It was a time for journeys of all kinds. The Beatles visited the Maharishi in 1968, so it became briefly fashionable to make a pilgrimage to India, commune with nature and feel the vibes. All you needed was love, as they said.

WOODSTOCK (right) was the cultural milestone of the age. Like Live Aid in the 80s it would be engraved on the hearts of those who were there and intrigue those born afterward. In 1969, billed as "three days of peace and music," it stopped traffic throughout New York State, when nearly a million fans turned up from all over America. Sewerage, electricity and water supplies broke down almost immediately as the site became a mud-bath in heavy rain storms, but the event, with stars like Jimi Hendrix, Janis Joplin and the Who, came to define the whole generation.

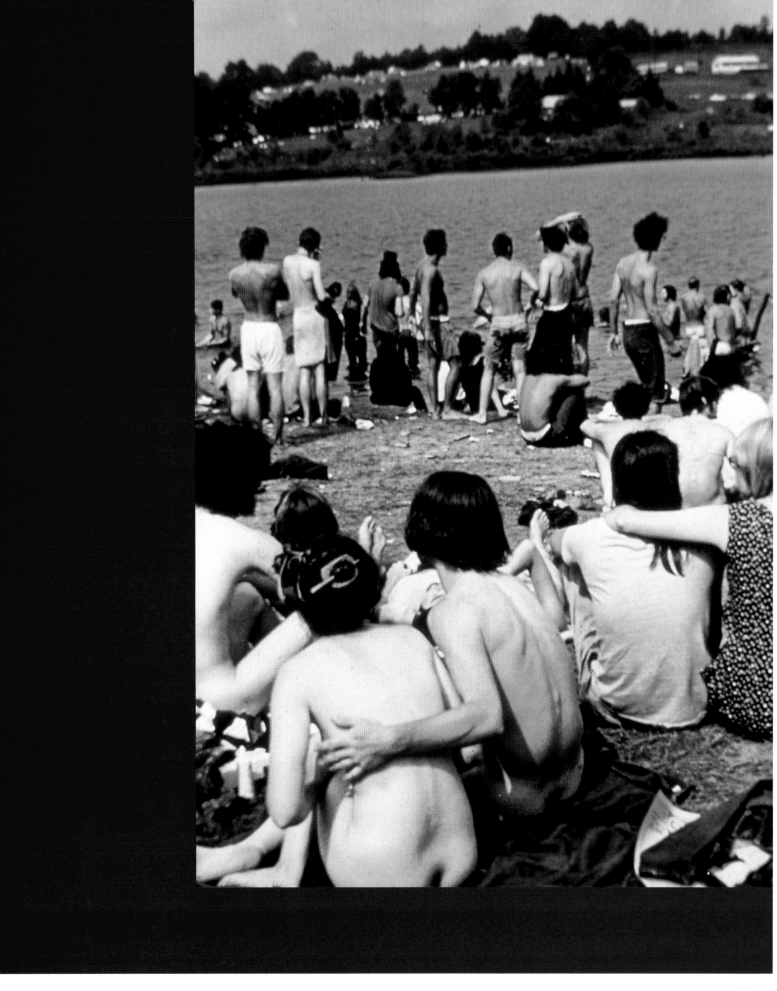

COSMETICS BODY SHAPE & UNDERWEAR **WORK & PLAY**

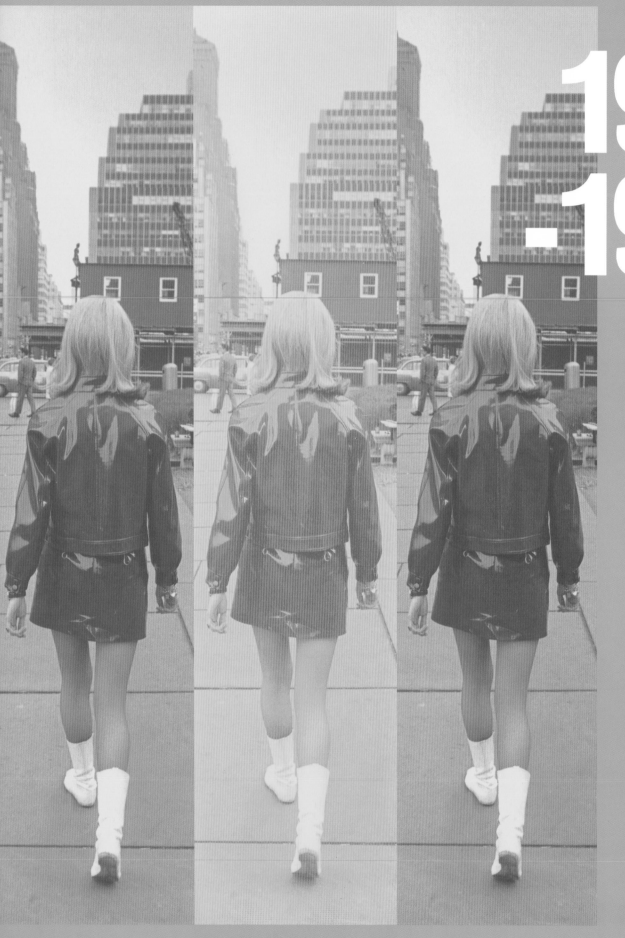

1960
-1969

The Cuban missile crisis

John F. Kennedy assassinated

The Beatles conquer America

Civil Rights bill passes in the US

The Berlin Wall is built

The war in Vietnam

Introduction of the contraceptive pill

The pop art explosion

The Cultural Revolution in China

Assassination of Martin Luther King, Jr.

Woodstock pop festival

The US lands a man on the moon

Student riots in Paris

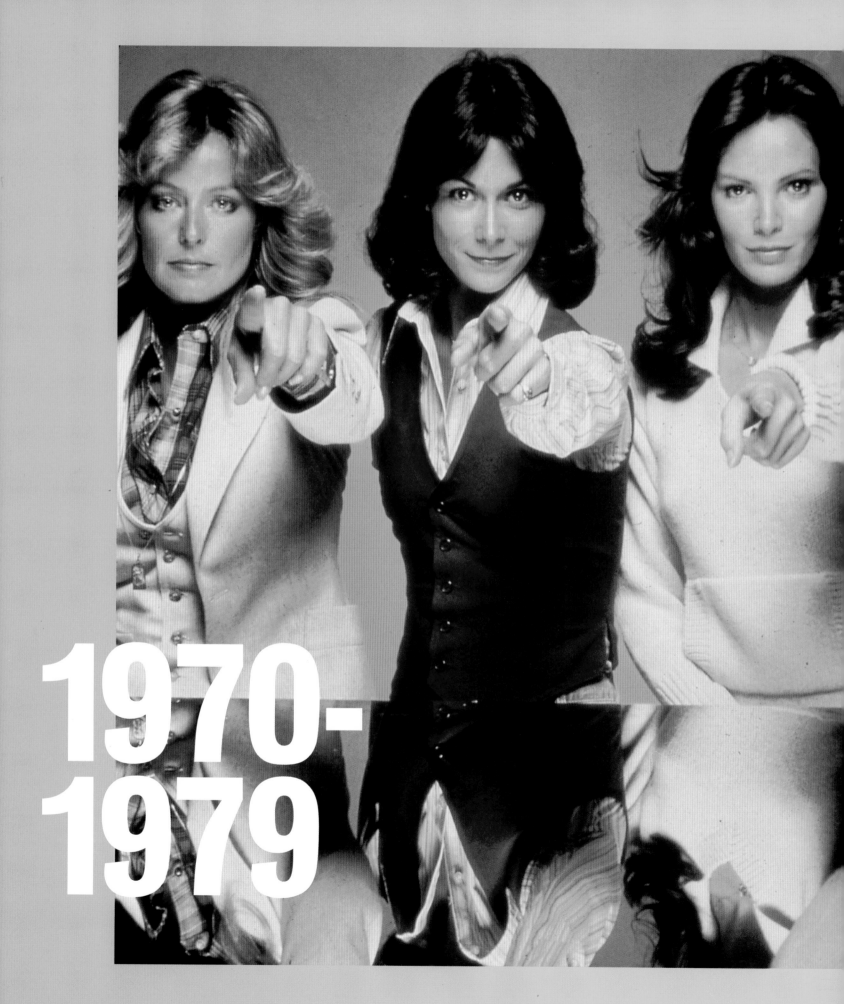

1970–1979

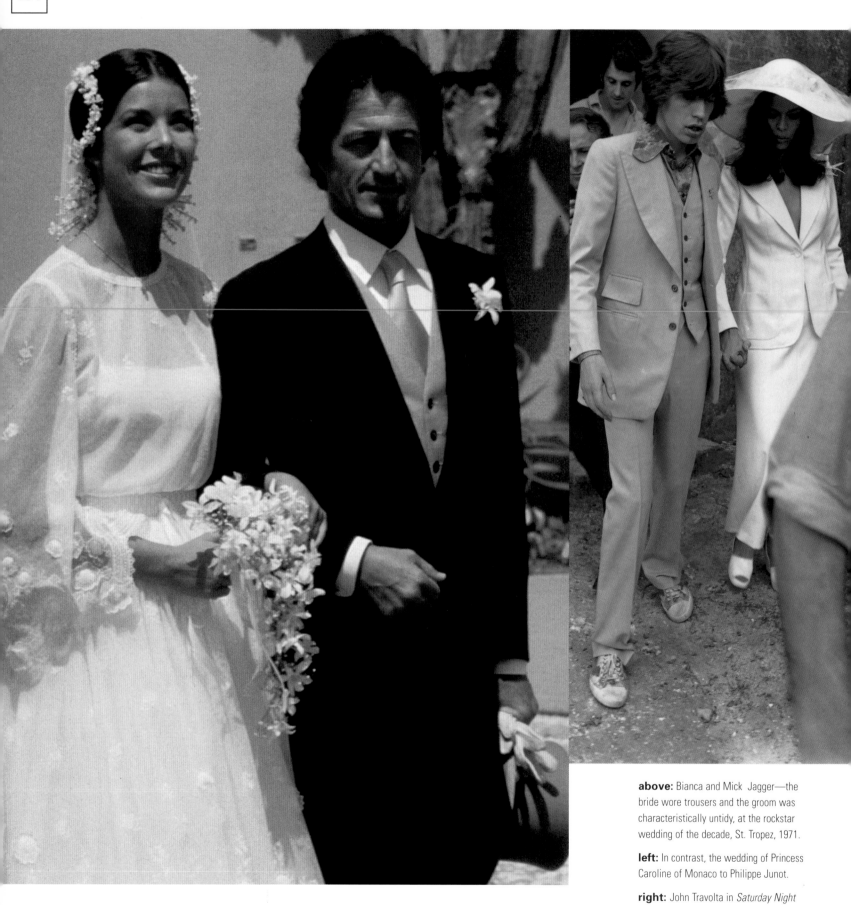

above: Bianca and Mick Jagger—the bride wore trousers and the groom was characteristically untidy, at the rockstar wedding of the decade, St. Tropez, 1971.

left: In contrast, the wedding of Princess Caroline of Monaco to Philippe Junot.

right: John Travolta in *Saturday Night Fever*, the disco-dancing film that became a symbol of one style of the 1970s.

LIFE & TIMES FACES IN VOGUE FILM & MEDIA FASHION HAIR & HATS

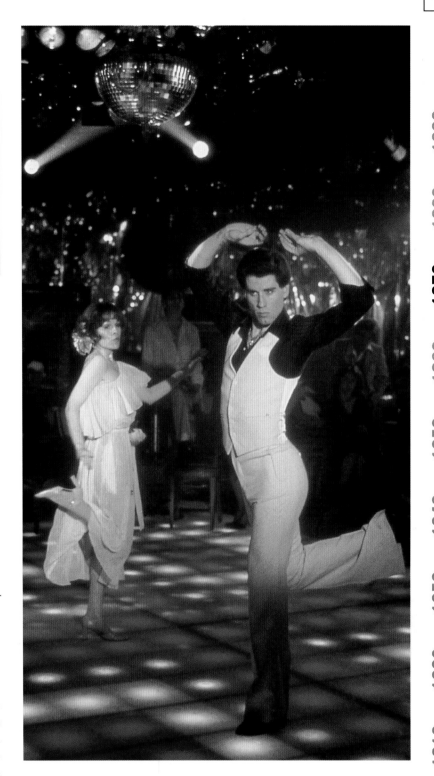

THE SEVENTIES ARE OFTEN CITED AS THE DECADE OF DECADENCE, BUT DESPITE THE EXTREMES OF GLAM AND PUNK THIS WAS THE TIME WHEN WOMEN REALLY LOOKED AT THEIR PLACE IN MODERN SOCIETY FOR THE FIRST TIME

After the idealistic, ebullient and often blurred utopia of the 60s, came the faltering, cynical 70s. The bubble had seemingly burst with the daily news diet of Vietnam, Watergate and the failed *Apollo 16* mission. The late 60s had brought a creeping distrust of authorities and government in America and Europe; the student riots in Paris, the *Oz* trial in England, the US's radical Minutemen, Yippies and Black Panthers all challenged the old guard, but not long into the 70s, disillusion rather than idealism set in. In addition to this, there were severe financial constraints, with higher taxes and higher prices brought on by the Middle East oil crisis.

Aesthetically, the depressing scene was compounded by the folksy and relatively unglamorous Carter administration. The 70s have become a byword for bad taste because they spawned trends that had a habit of starting and stopping like breakers, in contrast to the jubilant tidal wave that carried everyone with it in the 60s. Looking back, glam rock, platform shoes and disco have all become the stuff of smug jokes, but there was experiment, and in the case of punk, a real expression of the times.

The tendency to examine every aspect of life inside and out is manifested in Richard Rogers' Pompidou Center in Paris, with the plumbing and air conditioning pipes on the outside of the structure. There was endless speculation about the relationship of skirt lengths and economics; sociological theorizing was rife; and deadly serious questioning about every matter was the order of the day. "What does it all mean?" might have been the refrain as sociology and politics were discussed in endless permutations. Freudian and the more contemporary Langian psychology were much discussed, as well as astrology and mystical eastern cults—all uncomfortable signs that politics appeared to offer no solutions.

Feminism was taken up in earnest during the 70s. While some women were dreaming of baking their own bread at a scrubbed pine table, others would have been more likely to be carrying a paperback copy of the pioneering feminist polemic by Germain Greer, *The Female Eunuch*.

Were they having it all or doing it all? Many women on the front line of motherhood took to wearing a uniform of short hair, dungarees and carrying a plumber's bag as if to underline all that was required of them as women. "You've come a long way, baby," said the popular Virginia Slims cigarette advertising campaigns, with more than a touch of irony.

1990- 1980- 1970- 1960- 1950- 1940- 1930- 1920- 1910- 1900- 1890-

COSMETICS **BODY SHAPE & UNDERWEAR** **WORK & PLAY**

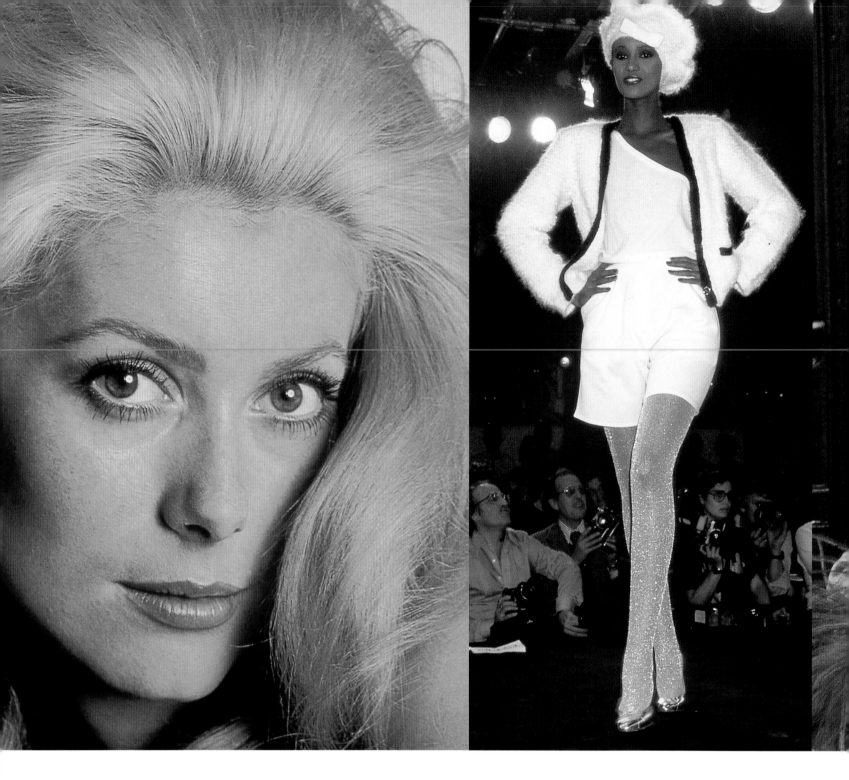

CATHERINE DENEUVE

who was a protégée of star-maker Roger Vadim, was a cool, fragile beauty who became France's leading screen actress. She had children by Vadim and Marcello Mastroianni, and married and divorced British photographer David Bailey.

IMAN

the Somalian-born supermodel, was reputedly discovered as a tribeswoman in Kenya, but in fact was the daughter of a wealthy diplomat. Her exotic good looks made her one of the highest paid runway models of the 1970s.

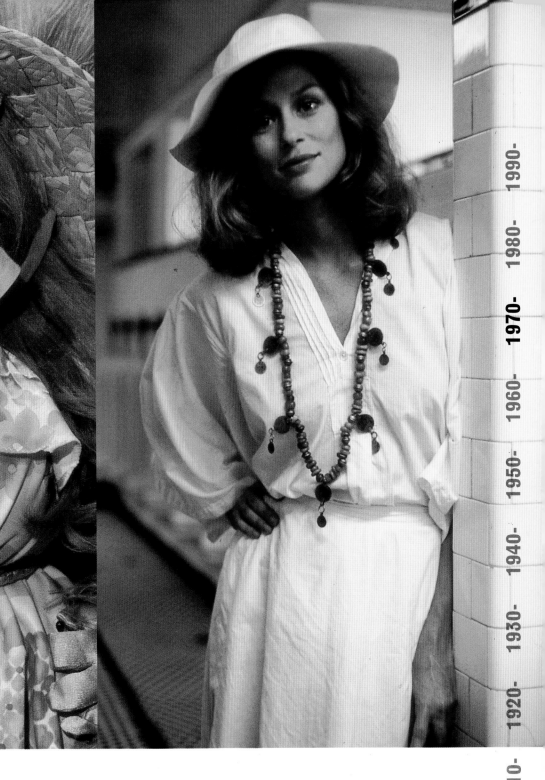

1990-
1980-
1970-
1960-
1950-
1940-
1930-
1920-
1910-
1900-
1890-

MISS PIGGY

was *the* TV personality of the 1970s that simply everyone who was anyone wanted to appear on screen with. Grace, poise and a beguiling personal charm made the star of *The Muppet Show* a true icon, as well as idol, of the era.

LAUREN HUTTON

used to describe her looks as "Gap-teeth and nose like a banana," but they served her well as a Playboy bunny and then glamour model, before she broke into movies in 70s films that included *Welcome to LA* and *American Gigolo*.

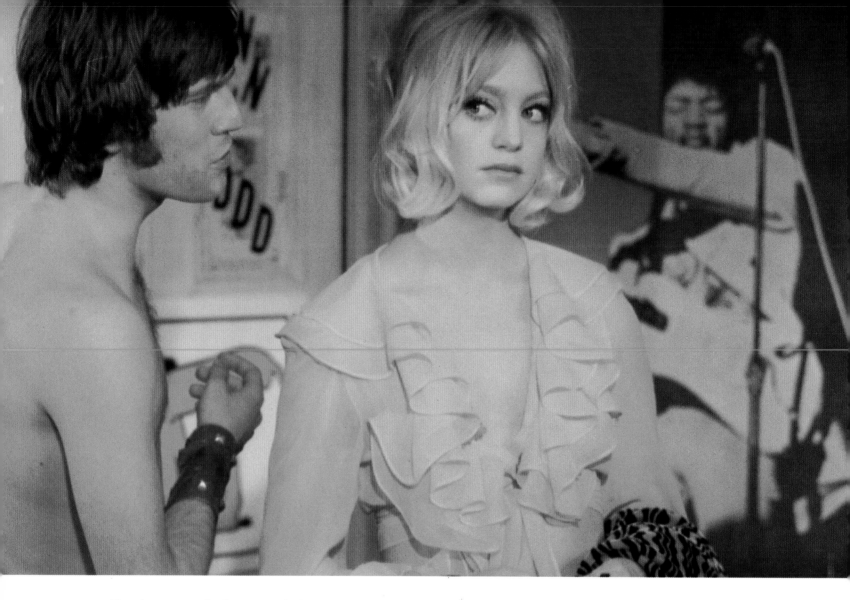

Despite, or maybe because of, the militant feminism and the grim cultural scene, 1970s' imagery was, on the whole, nostalgic, wistful and romantic. Lots of advertisements featured girls with flowing locks, leading white horses through wooded glades, or couples enjoying picnics in the summer. Usually, these people were wearing clothes from the Belle Époque, the turn of the century, when things had been simpler, rosier and feminine beauty was all. Products went "back to nature," it seemed there was lemon, avocado and green apples in everything. The nostalgia was like a common fantasy of reliving the most attractive times with the advantages of labor-saving devices, social enlightenment and technology. It captured the imagination, and adverts for products as diverse as Dubonnet and Cadbury's Chocolate Flake benefited greatly from this atmospheric escapism. Many of the older cosmetic companies like Yardley, Houbigant and Goya capitalized on this emphasis on their heyday, and often used reproductions of the original packaging and the work of artists such as Mucha and Klimt. Films like *Barry Lyndon* inspired a fresh appraisal of historical style and fashion, and the hallmark imagery for the period is full of this.

Nostalgia was rife in film. *Butch Cassidy and the Sundance Kid* was hugely influential in that it showed an idealized vision of earlier times, and what made it all the more appealing was that Etta, the character played by Katharine Ross, rides with the guys and is romantically, if not physically, involved with the two men. The western was suddenly giving its women something to do!

Star Wars, the ultimate space movie, was strangely inegalitarian, Princess Leia was part fairy-tale princess, part wise-cracking broad. James Bond films featured Roger Moore wrestling with males and females, and establishing the incorrect sexual politics that proliferated movies of the decade.

Not only were Butch and Sundance New Age men, but they were on the wrong side of the law. It was a completely new approach, particularly for the western, which was traditionally the cathedral of American cultural issues. Other retro films, like *Paper Moon* experimented with sympathizing with the bad guy, and others with rewriting history. The best example of the latter was Ken Russell, who managed to upset everyone, even the avant garde.

The film the public loved all decade was *Love Story*. And sexual politics were everywhere, it seemed; *The Stepford Wives* was a chilling polemic on the matter, whereas the master of the genre, Woody Allen, discussed it endearingly and with vulnerability in virtually all his films. His hit of the 70s, *Annie Hall,* even has his girlfriend (played by Diane Keaton) wearing the trousers! *Shampoo* was a risqué study in advanced sexual relations, while television series

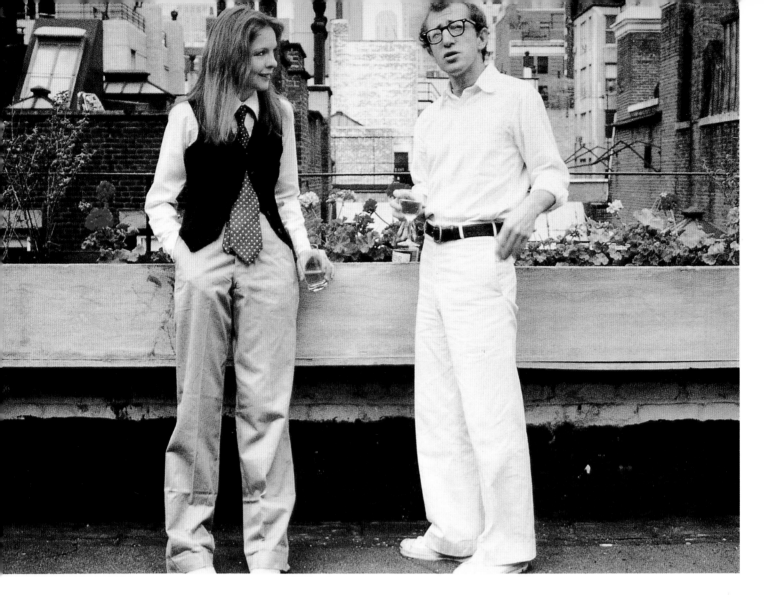

1990-
1980-
1970-
1960-
1950-
1940-
1930-
1920-
1910-
1900-
1890-

like public television's *Upstairs, Downstairs* reminded us how it all used to be, in case anyone had forgotten already. *Roots* was a breakthrough series on the African background of black Americans, and had a profound effect. The parameters of taste were shifted again in the 70s with films like *Last Tango in Paris* and *Deliverance*. There were a number of films, including *The Last Picture Show* and *American Graffiti,* that used nostalgia to show a less-than-perfect side of the American dream. Films like *One Flew Over the Cuckoo's Nest, Looking for Mr. Goodbar* and *American Gigolo* were indicative, too, of the commercial risks being taken in film, in terms of controversial subject matter.

The craze for attending dance lessons for a quick workout with chorus-line professionals was born partly out of the success of dance-oriented films like *Saturday Night Fever, Grease* and *Fame. Grease,* with its 50s retro theme, gave women more problems; trying to look good wearing Lycra trousers with mules.

Television also brought us such classics as *Charlie's Angels* and *Wonder Woman.* The Angels were just the 70s ticket in their pin-stripe suits and influential haircuts, but, in reality, the Angels were on remote control, carrying out the whims of the creepy Charlie, who's never seen, but always seemed to be around enjoying seeing the girls in such close proximity to danger. One of the later Angels,

Shelley Hack, was the model in the ads for the scent of the 70s, Revlon's Charlie (no relation). *Wonder Woman* was just a straight swap for the man in tights, so self-sufficient that she didn't even get the option of a male version of Lois Lane.

Photographic images were just as divided in what was a highly creative climate, free from many of the commercial dictates that are apparent in the 1990s. In the 70s, the stance of the models had gone beyond the childlike posture of the 60s, and was either very aggressively upright or ultra feminine, with an embryonic womanly quality. From the gentle, soft-focus pictures and posters by Sarah Moon, and the disturbing voyeurism spying on the youth and innocence of the subjects of David Hamilton, to the aggressive, hard-edged and predatory sexuality of Helmut Newton and the fetishistic nature of Guy Bourdin's work for Charles Jourdan, the polarity of images denotes a war in the process of being waged.

left: Goldie Hawn exemplifies the wide-eyed face of the decade in *There's a Girl in My Soup,* 1970.

above: Diane Keaton and Woody Allen in the warmly regarded *Annie Hall,* 1977.

even for the tall Texan models who were arriving in London by the drove. Designer Jean-Charles de Castelbajac was most keen on this look in sports fabrics.

Halston, Gucci, Fiorucci . . . the disco look came in the final part of the decade, with Studio 54 pictures of Bianca Jagger and Jerry Hall in Halston's slinky dresses with spaghetti straps, little evening bags and torque jewelry. Other disco favorites were satin boxer shorts with high heels, harem pants, and leotards, with tiny little Hollywood hats and veils and leather trousers worn with high necked lace blouses and flat shoes.

US fashion crossed the Atlantic with exports like Ralph Lauren in the late 70s, and found its niche immediately. Italian designers Gianfranco Ferre and Missoni also found a dedicated following. British designers such as Jean Muir showed a discipline and ability to design clothes in a style which remains today a distillation of the principles of modern clothing design. Jasper Conran, a recent graduate from Parsons School of Design in New York, attempted the same ideal. Others who stand out from the period are Yuki, the modern Grès, with his draped jersey evening creations, and Bill Gibb and Thea Porter, who each in their own way invented a sort of "hippie princess" look. At the end of the 70s, there was a trend towards the fantasy fashion of Thierry Mugler, where space meets Hollywood, in the angular, screen goddess suits that were toned down by others to form the basis of the 80s power suit. The pantsuit died a natural death, because despite their chic, such outfits could not be worn at work, and by the end of the decade, slinky, sexy clothes had taken over as a backlash against the baggy look.

PUNK was one of the biggest stories in fashion in the 1970s. Born out of a relatively short-lived anti-fashion street cult, it ended up representing some of the most pivotal ideas of its time through its notoriety, its similarity to tribal intimidation techniques, and its political stance. In 1977, Derek Jarman made the film *Jubilee* and it portrayed an England viewed by Queen Elizabeth I, running through the inner city streets with the disaffected youth, the unemployed and the bleak-hearted. At the same time Malcolm McLaren launched his group the Sex Pistols, and he and Vivienne Westwood opened their shop Sex on the Kings Road, selling bondage trousers, kilts, T-shirts with offensive slogans and mohair sweaters in Spiderman weave. Worn with huge jack boots, chains and spiked leather jackets, the only possibility for hair was crazy colors, gelled into impossible shapes like horns and spikes, or the Mohican. Body piercing and safety pins set off the total image. Its influence filtered through not only to new wave street styles but also to designers such as Zandra Rhodes in the 70s, and later Jean-Paul Gaultier.

The 70s will always be fondly remembered for the platform shoe. It came in hundreds of different versions, from the 1940s open toe to be worn with flowery retro summer dresses, to the ridiculous popstar spangled wedgies that are totally of their time. There had of course been prototypes from the 40s and even medieval days, but never were they so outrageous or exaggerated. Covered in glitter or appliqué leather stripes, made as boots, sandals and hideous Bay City Rollers lace ups, they brought out all the humor of glam rock music to the world of fashion.

The layered look was one of the uglier aspects of the 70s. Despite a hostile reaction from the press, it, together with smock dresses, was adopted with the nagging suspicion that the designers really did hate women. The dirndl skirt with the garment based on a sailing windbreaker over baggy boots was terribly difficult to wear,

above: Early 70s style from an Estée Lauder advertisement (left) and a Lanvin model.

left: Typical early 70s Biba girl.

Saint Laurent

Yves Saint-Laurent started his career with Christian Dior, and was a prodigy in the fashion world. His cossack-inspired outfits were a high point of 70s fashion, and he smartened up the idea of cross-dressing with "le Smoking," the superbly tailored classic black tuxedo for women. He also created safari looks and other trouser suits, dressed-up-adult looks, and sumptuous brocade creations to complement his outrageous scent, Opium.

Biba

Biba was started by Barbara Hulanicki as a boutique in London's Kensington, and at the height of its success it came to be a world of its own, occupying an entire department store. It sold makeup, clothes based on Hollywood of the 30s and 40s, hot pants and slinky evening wear, all in outrageous color combinations and at affordable prices. The store also had the famous dominatrix room, selling Theda Bara–type brass breast cups and naughty underwear, and ice cream sundaes in the art deco Rainbow Room. The shop was very laid back regarding security, and was plagued with shoplifters. It closed in the late 70s though the name survived as a designer label for some time after. It has returned in the 90s with the same palette of eggplant and bottle green, if not the metallic turbans and exoticism that made it a legend.

Ossie Clark

Ossie Clark died in distressed circumstances in1996 but was very successful in his time. His tailoring was magically in keeping with the taste for larger-than-life details, big buttons, revere collars, and yet he always achieved just the right dimensions. He used stretch fabrics for abbreviated Edwardian clothes with leg- of-mutton sleeves, pintucked effects down the front with a huge number of tiny buttons, and utilized the dreamy intricately detailed fabrics designed by his collaborator, Celia Birtwell. He made beautiful, feminine clothes that are wholly characteristic of the 70s.

1990-
1980-
1970-
1960-
1950-
1940-
1930-
1920-
1910-
1900-
1890-

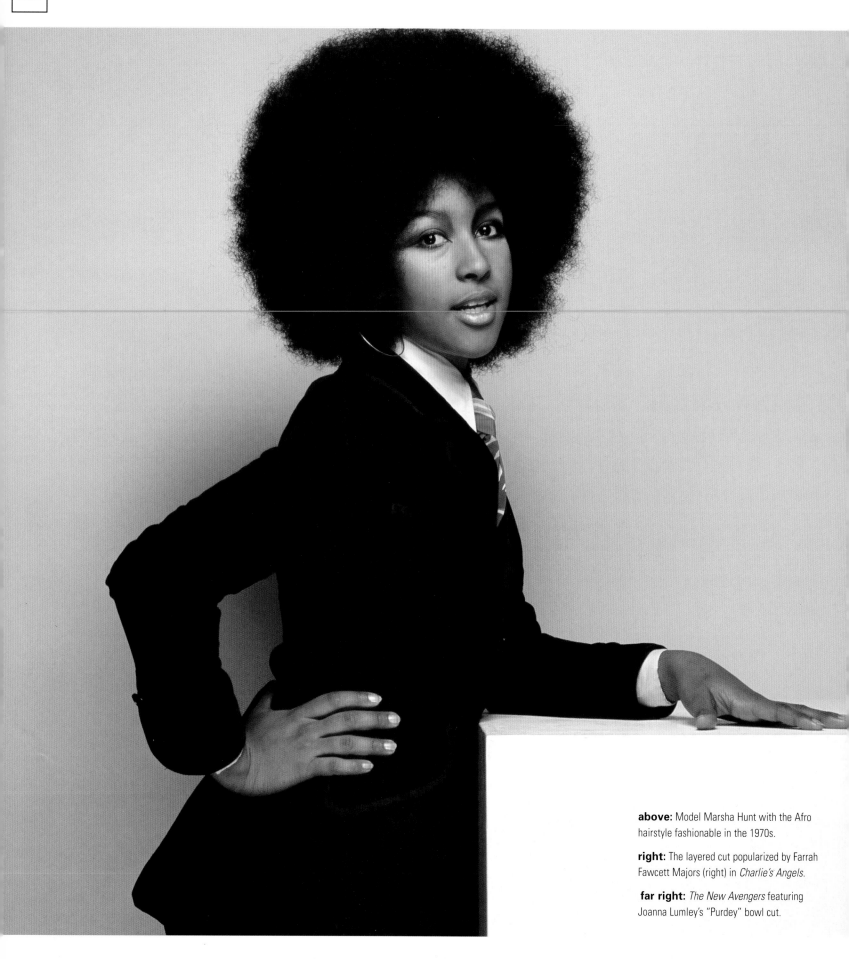

above: Model Marsha Hunt with the Afro hairstyle fashionable in the 1970s.

right: The layered cut popularized by Farrah Fawcett Majors (right) in *Charlie's Angels*.

far right: *The New Avengers* featuring Joanna Lumley's "Purdey" bowl cut.

70s hair was just as innovative as its makeup and brought a variety of styles and techniques to the fore. Perms were once again the fashionable thing, and difficult feats were attempted with geometric cuts combined with tight perms. The stack perm was very popular, and the 40s were echoed with frothy loose perms put up into wartime topknots, most often seen in a lurid wartime red. The preoccupation with retro that started in the early 70s with films set in the 20s and 30s led to the popularity of the bob.

The craze for nostalgia in advertising and packaging found its way into hair products, and there arose a trend for commercially produced shampoos based on traditional cures like lemon shampoo for greasy locks, beer shampoo for dull hair and chamomile for blondes. Packaging changed to produce sachets of shampoo, conditioner and wash-in and wash-out dyes.

Crimping was a consistent feature of 70s hair, because it was perfectly in keeping with the pre-Raphaelite clothes in ethereal and painted chiffons with floating ruffles that straddled the hippie and high-fashion images of the day. Tiny braids were also popular and were echoed or even mixed with braided fabric trimmings. Ethnic styles were the rage, from the Afro to the dreadlock imitations of little braids worn by Bo Derek in *10*.

It was also a colorful decade for hair; red tints were popular. Especially bright, very artificial colors and henna made a comeback. Highlights were first seen this decade, although mostly in bleach, so it looked as though a comb with icing sugar had been dragged through the hair, most unlike the subtle use of foil and several colors used later on. In 1978, the first ammonia-free hair colorant appeared—Colorsilk—and changed the options for home colorists vastly.

Layered haircuts came in all sorts of guises, from the famous Klute haircut invented for Jane Fonda, to the very long layers found on men and women and characterized by Bonnie Tyler, and layers in varying degrees were ubiquitous throughout the 70s. Often they looked like two haircuts: a short full cut on top of long hair, or later the layers were stretched to the maximum degree, with the shag. Farrah Fawcett Majors was owner of one the most popular haircuts of all time. The style was widely imitated and adapted. It combined glamour with sporty practicality and made its wearer a household name.

Huge long beehive styles were popular at the turn of the 60s and 70s and many styles required painstaking blow drying or tongs. Before the decade was over though, with the ethnic influence and sophistication of the perm, wash and wear was the order of the day, and scrunch drying was the trend to last indefinitely through the next two decades.

The Mia Farrow crop was immediately popular and the bubble cut returned. Other short styles were the "Purdey" haircut created for Joanna Lumley in the TV series *The New Avengers,* a sort of ultra chic bowl cut popularized further the female version of the quiff. Rock music popularized many styles, and the use of Krazy Kolor.

The question as far as styling products went was, is she or isn't she? The advertising for Harmony hairspray always featured a girl walking slowly through a public place with all manner of men debating the matter. Once Punk and New Wave were established, gels were popular for mainstream haircare. The young used KY jelly to create 20s men's evening styles and woodpecker styles, until the market caught up with the gels and mousses which were so characteristic of the 80s.

Scarves, skull caps and turbans were very popular, and ranged from the gypsy scarf with escaping hair and huge earrings, the purpose-made scarves with built-in braided fabrics, worn with plaited hair, to silky turbans to wear with swimwear. The Hermès scarf was worn pre-Sloane by their rivals, the Mayfair Mercenaries, with huge paparazzi-evading sunglasses. Knitted skull caps with locks of angelic curls framing the face were the retro ideal, with the crochet cloche with silk, or crochet flower, and the pillbox with small veil, which was later the commonest hat for attending weddings and events of the season. The imaginary Hollywood look demanded its own flying saucer—like *"Now Voyager"* hats.

Long straight hair with a center part was in, but long hair soon traded in the bouffant Bobby Gentry look for something more refined when Roxy Music came up with their glamorous album covers, heralding a new Hollywood-pastiche ideal.

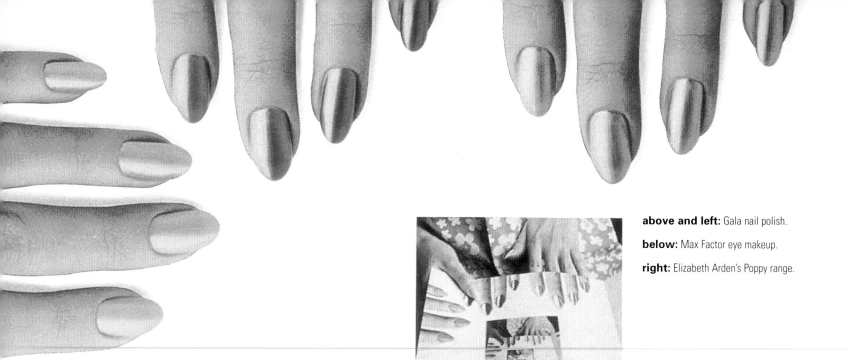

above and left: Gala nail polish.

below: Max Factor eye makeup.

right: Elizabeth Arden's Poppy range.

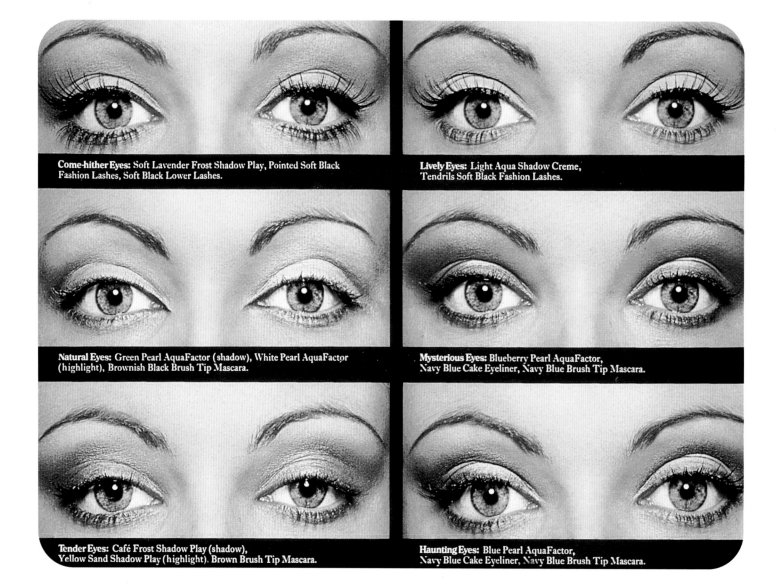

Come-hither Eyes: Soft Lavender Frost Shadow Play, Pointed Soft Black Fashion Lashes, Soft Black Lower Lashes.

Lively Eyes: Light Aqua Shadow Creme, Tendrils Soft Black Fashion Lashes.

Natural Eyes: Green Pearl AquaFactor (shadow), White Pearl AquaFactor (highlight), Brownish Black Brush Tip Mascara.

Mysterious Eyes: Blueberry Pearl AquaFactor, Navy Blue Cake Eyeliner, Navy Blue Brush Tip Mascara.

Tender Eyes: Café Frost Shadow Play (shadow), Yellow Sand Shadow Play (highlight), Brown Brush Tip Mascara.

Haunting Eyes: Blue Pearl AquaFactor, Navy Blue Cake Eyeliner, Navy Blue Brush Tip Mascara.

Around this time a very few gifted makeup artists were creating their own characteristic looks and gaining recognition. Way Bandy had a magical gift for color and an ability to present a soft dewy look to the complexion, quite specific to him. A book outlining his techniques was published before his untimely death.

Nail polish was made in virtually every color from the dark to the glittery and the day-glo to the very popular pale pinks and apricots with a pearlized finished. Long nails were very highly prized, and false nails, colored and natural, were sold along with special decals in assorted designs, including the *Playboy* bunny logo and seasonal Christmas greetings.

Skin care for the young was promoted heavily and the new Estée Lauder brand, Clinique, was created as a younger sister to her existing brand. The approach was prescriptive, the familiar mantle of doctorly mystique brought out again and it was immediately successful. Soap and water, lotion and moisturizer was a discipline requirement, and the complex analysis of the customer through a series of questions logged on a sliding board. This system would come up with skin type. It was and still is a great gimmick. Elsewhere the cheaper brands were coming up triumphantly with the idea of combination skin, and marketing accordingly.

At the top of the pile, Dr. Erno Laszlo, whose products were so exclusive that you had to pay a membership fee to be introduced to them, was mentioned in *Annie Hall*; Woody says, "I'm going out with a girl who uses black soap for God's sake!" when he is in the initial stages of infatuation. Dr. Lazslo established his "clinic" in the 30s, but truly attained cult status in the 70s when the many screen star devotees went public and attested to its miracle properties.

Cosmetic surgery was viewed much in the same light as psychoanalysis; it was something Americans were doing as part of the philosophy and lifestyle of the "me generation." Developments were reported in women's magazines, rumors of filmstars having surgery abounded, but there was as yet a gulf between what was acceptable for them and what ordinary people would do for themselves. That was all to change very shortly however. Soon anybody who felt they deserved it was having a facelift or liposuction. And all the ladies who lunch seemed to be training as counsellors and psychotherapists in the 80s and 90s too!

Animal testing became more of an issue now, the company Beauty Without Cruelty receiving massive publicity. Although they distributed the products mainly through health shops, they found a loyal following and, perhaps more importantly, there was a gradually increasing pressure for the larger companies to question their own methods.

Charlie was the groundbreaking scent of the 70s. Charlie was presented as a real character, personifying a lifestyle for young women to identify with. She was sporty, international, fun and embodied the philosophy as the new woman who was confident and sexy.

The 70s brought some outrageous trends in makeup, and some interesting products, as well as some interesting ways of selling the goods. Face painting was popularized by David Bowie, Kiss and the other glam rockers and the Pierrot look was frequently seen on the beauty pages, models with wildly colored faces in clown garb and dunce hats and pom-poms. Makeup was often natural, but more frequently it was very colorful, with very heavily emphasized features and thin, thin eyebrows. Colors were often very dramatic, with lips very red or dark, almost black. Eyes were made up with the new pencils, and the eye shadow was applied to be seen right into the socket.

Makeup and beauty pages advocated the "contour" look for makeup, with lots of shading to "create bone structure." In the late 70s there was always a white streak of highlighter below the brow bone, extremely popular throughout the decade, and *the* success story was lip gloss for people of all ages. The cheaper brands of cosmetics were offering a better selection of products than ever. Even teenagers with meager allowances could achieve the latest looks.

The "California look" was the other most current image. Glowing tan skin and bright lips, or for career women, clear lipgloss and nail polish. Other new products included face glossers, blusher sticks and kohl pencils. Musk extract started to appear in scents and skin products. Moisturizer sales boomed and, due to cheap travel deals and the fact that everyone across the class spectrum now took vacation, the time had come to promote suncreams. The desire for a deep mahogany tan in two weeks led companies like Lancaster and Bergasol to do extensive research into self-tanning creams and skincare products for tanning.

The disco craze brought its own range of iridescent colors and effects—Madeleine Mono in New York produced a range called Arabian Lights, with dramatic jewel-like colors with special built-in pots of iridescent highlighters to glow in the dark. On the whole makeup was very intricate, with lots of detail and often lots of color.

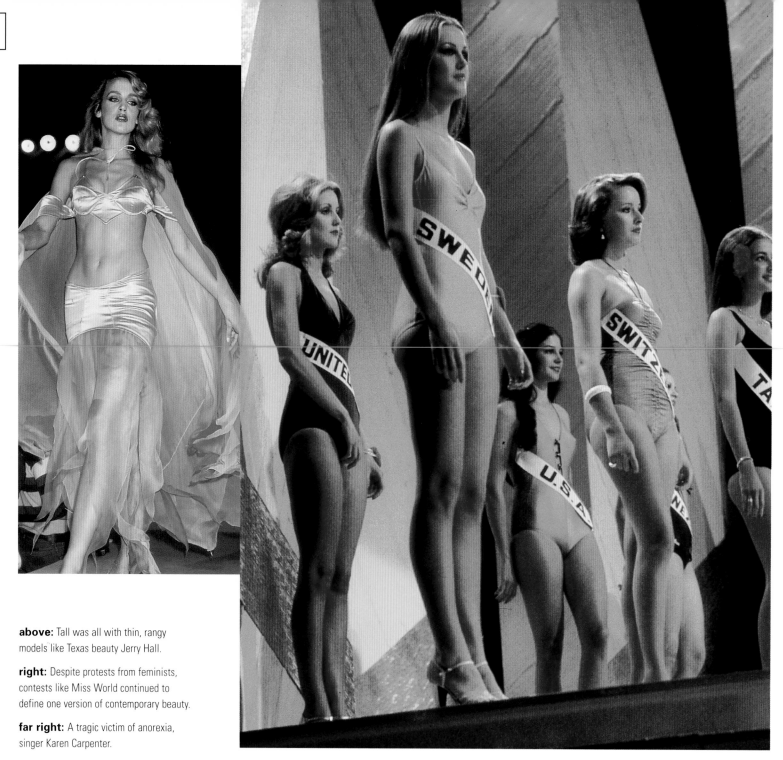

above: Tall was all with thin, rangy models like Texas beauty Jerry Hall.

right: Despite protests from feminists, contests like Miss World continued to define one version of contemporary beauty.

far right: A tragic victim of anorexia, singer Karen Carpenter.

The 70s, like the 60s, continued to idealize a very thin figure. Whereas the 60s silhouette had been quite childlike with rounded limbs, the 70s woman was elongated and stick-like. Suddenly, there was an awareness of anorexia and Susie Orbach published *Fat Is a Feminist Issue*. There was immense pressure to stay thin, and many people, especially young girls, came near to death in their efforts to maintain a pre-pubescent body shape. The singer Karen Carpenter actually did die as a result of her obsession with staying thin. The cause of her death was kept secret for a long time, until rumors of drug-taking made it necessary to reveal her eating disorder to protect her wholesome image. Thereafter, anorexia got a lot of publicity, and as a result was better understood.

Another, less serious, preoccupation of the 70s was cellulite. Elancyl sold kits in department stores to "scrub" away the cellulite with their strange-looking beauty tool. There was a huge plastic hedgehog with a handle, and friction bumps and soap to put on it. Afterwards a special cream would be applied, and it was all supposed to miraculously disappear. Later, drainage diets and treatments were advocated, and in the 80s liposuction was heralded as the permanent way to keep it at bay.

The 60s had given women good reason to dispense with fussy foundation garments, but in reality, there were still enormous sales of girdles and bras. In the 70s there really was no reason to wear a bra, but even women who didn't need to were afraid not to. Rudi

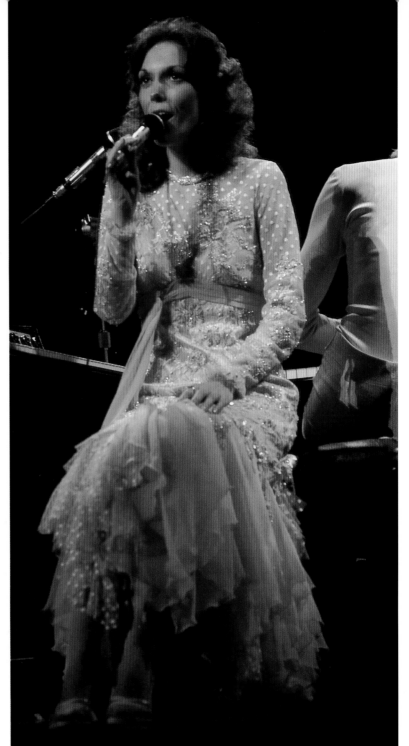

Gernreich, dead on as usual, came up with the no-bra bra for just such customers, tongue in cheek, of course, but manufacturers spent the rest of the decade catering to these individuals, and the overendowed were stuck with very little support as a result.

Due to the craze for antique clothes and Edwardiana, camisoles were worn as clothing, and antique or retro underwear was displayed as often as possible, peeking out under gathered skirts, and even bloomers were worn for fun.

Janet Reger established her own company in London in 1967 and became an immediate success with her frilly feminine and naughty 90s-inspired bustiers and garters. Rather than burn these bras, women received them gratefully as gifts from men; they were definitely popular with both parties. The Reger business lasted a good ten years, into the mid-80s.

The retro nostalgic trend demanded matching underwear, and other companies tried more structured underwear with garters and such. There were also the stretch cotton sets of bra and panties without real size or support, but attractive nevertheless for their fashionable coordinated colors.

Seamless underwear and tights had a huge impact on the fashions of the day. The thermo-produced "Glossies" underwear and its imitations making a "natural" shape the ultimate, and toward the end of the decade when clingy, slinky fashion was the in-thing, presumably as a backlash against the heinous "layered look," these transparent, skin color confections were indispensable.

The cleverest invention was the Glossies-type nude bra. Made of thermo-plastic stocking type material, they were totally see-through in varying shades of tan. Some were boned, some were one-piece, they were phenomenally successful, because they looked natural while doing an important job.

The seamlessness of underwear was an enormously important development in its day, the usual stripy tights were even imitated by bras and pants to show the latest technology, and the appeal of funky coordinating tights and lingerie was very novel. Then, it was all passé and the appeal of seamed tights and old-fashioned sexy underwear was too much to resist, since it was being worn just for effect.

Like so many 70s' inventions these did the rounds again in the 1990s after a long retirement. Bandeau bras and halter tops were pervasive fashion items offering little support. Both were difficult for those over the age of 11 and yet they were an attractive idea. The Wonderbra, which first appeared around this time, had various arrangements for halter necks and backless or crossover back tops and dresses, but they came adrift frequently, so there could be a lot of tugging and pulling going on.

The standard for the ideal body shape was reinforced by the beauty pageant. The swimsuit and high heels perfection of the girls was flaunted while they confided their less than lofty ambitions through Vaselined teeth (it helps the lips glide into a wider smile). Then in their evening wear, the camera would go behind the scenes while the runners-up had to try to look happy for the three finalists chosen by a celebrity panel.

The half brief was the dominant underwear shape of the 1970s.

It was mass-produced in cotton and Nylon, as well as by the major underwear companies in up-market versions, and it was ubiquitous throughout the era. Towards the 1980s it took on a new role as the minimalist string bikini and, through the spreading influence of travel brochures and articles picturing the beaches of Rio de Janeiro, the even more revealing thong.

American flesh-colored tights were the joke of the late 70s, so popular had they been, worn with socks or even patent wet-look socks, to wear with the same color pumps to look like boots. And Lurex and stripy tights, and all sorts of sheer, colored tights were on sale throughout the decade.

1990-
1980-
1970-
1960-
1950-
1940-
1930-
1920-
1910-
1900-
1890-

167

COSMETICS **BODY SHAPE & UNDERWEAR** WORK & PLAY

Jeans

The designer jean was born in the 70s when Gloria Vanderbilt, Fiorucci and Calvin Klein all launched new shapes and colors, and for a while superseded the popularity of traditional brands. Denim jeans had been through many incarnations, including loon jeans, leather jeans and hip-huggers in the 60s and into the 70s. Now they were appearing in velvet, leopard print and plastic, worn with short boots or cowboy boots, and maybe a leather jacket with the collar up. There were more than 30 companies in the 70s making jeans, all taking larger sales than ever before. And jeans were tighter than ever, since the new skimpy underwear made it possible to wear trousers without cramming in a whole lot of unwanted extra swagging.

above: A bearded Mick Jagger and his then girlfriend Jerry Hall, both jeans-clad as they go roller skating in New York.

The fitness-conscious woman of the 70s was quite likely to be a practitioner of yoga, or maybe she owned an exercise bicycle on which she wore a velour toweling tracksuit. Jogging was another popular method of exercise—many people were ill-prepared for it, and knew nothing of warm-up exercises or the damage caused by running on city streets in thin-soled sneakers. Then, the only way to look after your feet was to wear Scholl "exercise" sandals.

Later in the decade, the opening of the dance centers and health clubs induced a fad for professional dancer-style classes as exercise. They also sold the clothes, the leotards and the leg warmers, which were taken up by the fashion mainstream. Little cardigans, thick tights and cheerleader type skirts also formed the basis of many looks of the 70s and 80s and, more importantly, greatly influenced the underwear and tights to the present day. And the gymnastics of young Olga Korbut captured everybody's imagination. New fabrics influenced sportswear design immeasurably. Few women would have adopted a really serious active exercise regimen unless they had been a sports star at school, and even then, only the truly dedicated took it seriously. But, at the end of the 70s and, of course into the 80's, jogging stop-watches and proper shoes started to be promoted, and stamina was discussed. This, and the growing popularity of wholefoods and health foods, ushered in a new awareness of proper fitness and real sport.

Jane Fonda brought out her first exercise videos and, for those without VCRs, books on fitness. "Feel the burn" was a catchphrase that rapidly entered the venacular as participants in aerobics developed into something more strenuous than jazzercise. Fonda's studios in Beverly Hills brought a hard-edged splendor to something previously practiced in school gyms and living rooms with closed curtains. The smart, airy studios and the promise of a jacuzzi after the torture was a shrewd formula that bred a million imitators and an industry that is still growing fast. Fonda, always one to throw herself wholeheartedly into anything she does, declared that her body was better at 50 than when she starred in *Barbarella*. Most of us don't approach that kind of perfection in a whole lifetime, but it is the promise and the self-reliance that keeps us going and it's changed women's expectations significantly in a relatively short space of time. In the 80s this very positive mental attitude toward exercise was almost obligatory.

Tennis was inspirational, as a younger breed of tennis stars such as Chris Evert, Andrea Jaeger and Tracey Austin didn't just improve the women's game, their fresh, crisp cotton tennis dresses with trendy embroidery or tight shorts were the perfect foil for tanned legs and a toned physique.

1890- 1900- 1910- 1920- 1930- 1940- 1950- 1960- **1970-** 1980- 1990-

T-shirts

The T-shirt was standard 1970s leisure wear. For a while the ultimate in unisex garments, it had come a long way from the plain white US naval undergarment introduced during World War II. After the tie-dye shirts of the late 60s, the 70s saw long, short and cap-sleeved versions with scoop neck, V-neck and ribbed crewneck, and with embroidery, appliqué and, of course, the message. The message could be a corny joke, a picture of Donny Osmond or Che Guevara, or even the sloganeering of the famous antiwar series launched by Katharine Hamnett in the 1980s.

COSMETICS BODY SHAPE & UNDERWEAR **WORK & PLAY**

The Vietnam war ends

Revolution in Iran puts Ayatollah Khomeini in power

Watergate scandal leads to resignation of President Nixon

Margaret Thatcher becomes Britain's first woman prime minister

World's first test-tube baby born in UK

Jimmy Carter elected US president

The OPEC rise in oil prices hits economies worldwide

Coco Chanel dies

Pop legend Jimi Hendrix dies

Civil war erupts in Pakistan

Mao Tse-tung dies

1970 -1979

1980-1989

The 80s represented boomtime. The "big bang," or the greater accessibility to the stock markets, symbolized a return to the values of laissez faire capitalism and a free market economy, and a new breed of individual developed—the yuppie. Originally an acronym for "young urban professional," these city whizzkids with the huge salaries "worked hard and played hard," to use their terminology, and rewarded themselves with only the best in clothing, cars and other consumer goods. Expense accounts pushed prices up for the rest of us, and a whole generation was drawn into the look and the attitude, whatever their real job. The smart accoutrements were Porsche cars, Filofaxes, Psion organizers and any kind of mobile phone or laptop computer. So pervasive was the new business ethos, that women's magazines were full of articles on networking, power breakfasting and the glass ceiling.

AIDS had a devastating impact on the beauty and fashion industry, and safe sex became a preoccupation. Women began to buy and carry condoms and dental dams themselves. Consenting single adults were confronted by a new dilemma. Sexual freedom was taken for granted, now there was a bigger price to pay than ever imagined.

Feminism per se was considered outmoded, though factions kept the faith in various ways. Most women turned their attention to making decent amounts of money rather than moaning about who done them wrong. Everyone, it seemed, wanted to be a material girl like Madonna, even if they didn't actually work. Naomi Wolf wrote *The Beauty Myth*, about how unrealistic standards of female beauty were a form of social control mitigating women's increasing status in business and the professions. Idealized images of female beauty were the new weapons of the anti-feminist backlash.

In Germany the Berlin Wall came down, signaling to all that the "evil empire" of communism was no more, and the Eastern bloc countries were intent on joining in the capitalist conspiracy without rancor or regret. This was the decade that exploited the traditional "special relationship" between the US and Britain, the time of Reagan and Thatcher. In Britain, the government fostered a new mentality, basing the wealth of the country on house ownership, while in the US the Reagan administration will be remembered primarily for its "trickle-down," supply-side approach to economics: don't tax the rich and they'll reinvest in America. When the money supply was tightened to bring inflation under control, recession

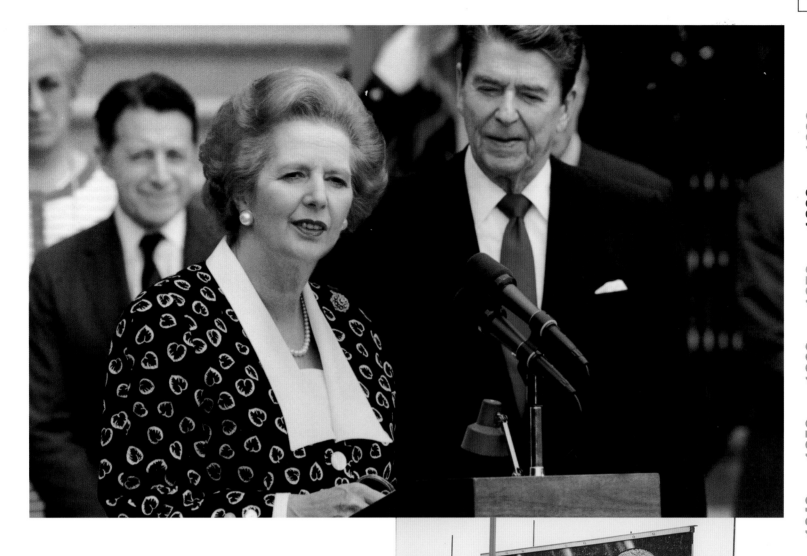

1990-
1980-
1970-
1960-
1950-
1940-
1930-
1920-
1910-
1900-
1890-

ensued; unemployment rose to its highest levels since the Great Depression.

At the same time as there was great prosperity for some, there were social problems like homelessness and disaffected inner-city populations. This desolate landscape was in stark contrast to the small numbers of people who found themselves better off. The environment was another cause for concern, and the conduct of multinational conglomerates was increasingly under scrutiny. Consumers brought up on protest and idealism began to use their power to boycott companies thought ideologically unsound, and ethical considerations began to be made in product advertising, to harmonize with the views of younger buyers.

A whole new generation of huge fortunes were made, notably in the media and the new computer industries. There was a feeling of prosperity and hope, and the new growth areas were the service industries, where women, particularly, could profit. public relations, journalism and business and finance were open to women as never before. If you weren't a businesswoman, then you had to be one of the ladies who lunch; either way, conspicuous consumption was the order of the day—and the more conspicuous the better.

above: AIDS posters warned of a unique threat to humanity and the need for "safer sex."

top: Thatcher and Reagan—female power and Marlboro-man credibility combined in a new version of the "special relationship."

left: A whole look and lifestyle went with the antiestablishment punk attitude.

COSMETICS **BODY SHAPE & UNDERWEAR** **WORK & PLAY**

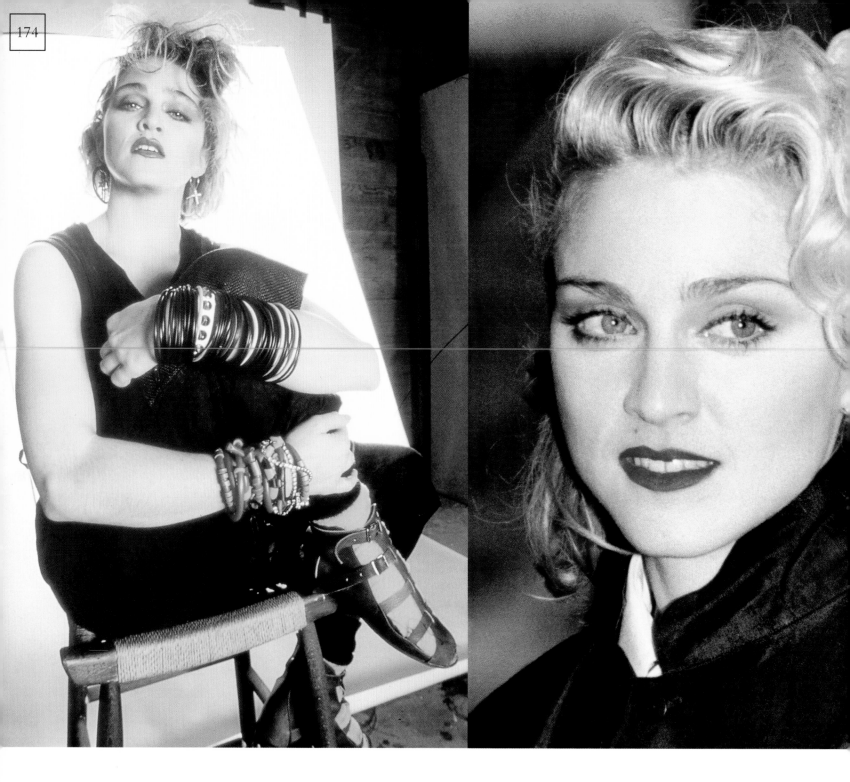

MADONNA

was the ultimate fashion chameleon, recreating herself in a variety of roles that ranged from the streetwise punkette in *Desperately Seeking Susan*, Marilyn Monroe clone, soft-core porn queen and Gaultier-clad disco diva.

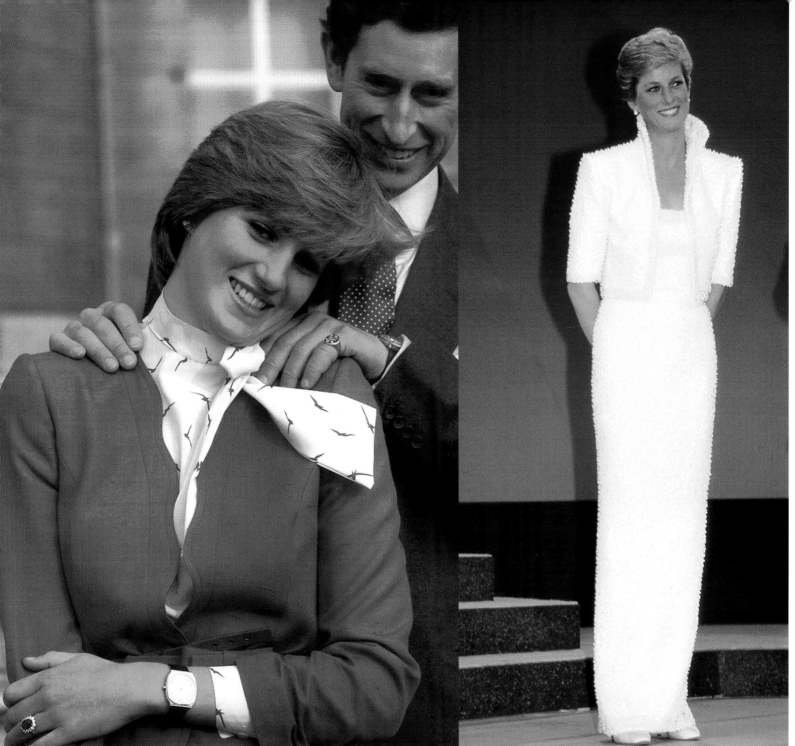

1990-
1980-
1970-
1960-
1950-
1940-
1930-
1920-
1910-
1900-
1890-

PRINCESS DIANA

as Lady Diana Spencer was a typical well-to-do single young woman. As princess of Wales, after a fairy tale wedding—and wedding dress—that captivated the world, she was to emerge as the celebrity clothes horse of the decade.

The lifestyles of the wearers of investment jewelry and real fur coats were increasingly a preoccupation of the magazine reading public; this was the heyday of celebrity-obsessed glossies that pictured the rich outside their estancias, with helicopters and yachts in the background, confiding the names of their pet poodles and showing their artwork and other possessions. There was also *Lifestyles of the Rich and Famous*, led by the garrulous Robin Leach, plus fantasy soap operas like *Dallas* and *Dynasty*, more akin to comic strips than serious drama, all adding up to a preoccupation with the high life. The fashions therein, particularly lingerie, were influential on what people wanted to look like in the 80s.

This, coupled with the increasing emphasis on consumerism and the continuation of the label consciousness of the late 70s, meant that products even found their way into the narrative of the literature of the time in the novels of Jay McInerney and Brett Easton Ellis, and into the fabric of film and television. *Miami Vice*, *LA Law* and even films like *Fatal Attraction* fetishistically present a seamlessly perfect materialistic world and its dubious morality.

The spate of brat-pack films and shows for baby boomers increased. Many who identified with the characters from *The Big Chill* loved *Thirtysomething*. Films like *Desperately Seeking Susan*, *Diva* and *Betty Blue*, on the other hand, were popular precisely because they deliberately set out to resist this bland homogeneous sense of identity, and presented a foretaste of 90s values. But very much the embodiment of 80s values was *Wall Street*.

The western took a cue from the 70s success *Blazing Saddles,* and satirized itself with *Silverado*, with John Cleese as a suburban type of sheriff, and attempted a more realistic and balanced view of Native Americans in *Dances With Wolves*.

Fashion photographic shoots became more lifestyle-oriented and elaborate and, in contrast to the studio-bound 70s, the shoot was again liberated to the outside world, as it had been during the 50s and 60s. A new breed of fashion editors encouraged innovative stylists that made a series of exciting narrative-type images—in graveyards, Chinatown or anywhere, and created a hard-edged look with often very expensive clothes from the couture houses, and exclusive accessories like Manolo Blahnik shoes. At the other end of the spectrum, Bruce Weber, working for Ralph Lauren, gave a glimpse of a sort of elitist *Saturday Evening Post* vision of the past, in his advertising and promotional brochures.

The celebrated Levi's commercials, including the famous Nick Kamen laundromat advertisement, made a big impression on the decade, and advertising became a far more sophisticated game than ever before. At the same time, it was more appreciated than ever and is still one of the more self-referential areas of media today. Audiences were becoming more sophisticated, and more aware of the games being played.

The chicest fashion accessory anyone could have was, peculiarly, a child. Score five for a woman holding a baby, ten for a man. Of course the baby had to be perfectly pretty, clean and beautifully dressed. The other criterion was that you must be able to leave it somewhere when something more interesting came up. Infants appeared everywhere, though in the film *Baby Boom*, which satirized the lives of yuppies, the heroine dropped out for a real man. A controversial Benetton advertisement showed the gritty and meaningful reality of birth, while on television there was a new generation of family comedies, like *The Cosby Show* and, later in the decade, *Roseanne*.

above: Michael Roberts, the influential fashion editor at *Tatler.*

right: Huge shoulder pads and decadent lifestyles that millions aspired to, epitomized in the long-running *Dynasty.*

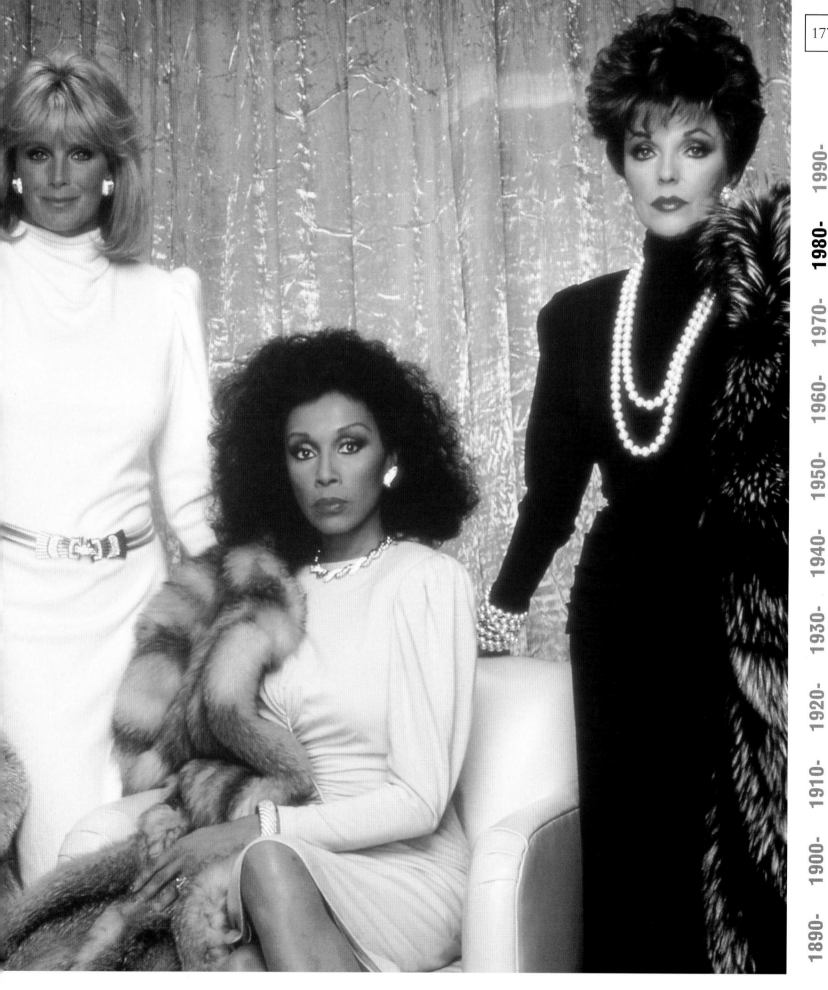

1890- 1900- 1910- 1920- 1930- 1940- 1950- 1960- 1970- **1980-** 1990-

COSMETICS BODY SHAPE & UNDERWEAR WORK & PLAY

With new-found prosperity and the label consciousness of the late 70s, businesswomen and trophy wives began "aspiration" dressing and power dressing. But it wasn't just money they were flaunting, it was the body too. DuPont's new fabric, Lycra, meant one thing—and that was cling. Well, if you were earning six-figure salaries, working out in the gym and spending huge amounts on your clothes, clothes had to show your best assets!

The places to flaunt it were the expensive restaurants and at corporate entertainments. Increasingly, society was besieged by a new group of meritocrats. The key to the 80s was tailoring, and for daywear, people lived in suits. If you didn't have one, you couldn't go anywhere. The shift from the Victorian jacket and gathered skirt with the pussycat bow to padded shoulders and narrow skirt was finite. The huge shoulder pads accentuated the narrowness of the hips, and this mannish silhouette differed from the one of the 40s because the skirt was short and tight, frequently in stretch fabric, it was pert and cute. It was the ultimate carry-through outfit, overtaking even the little black dress in versatility. It was worn to the office, to weddings and on dates

Tailoring was all-important. The best at it were Moschino, who played Schiaparelli-style visual jokes, with bath tap buttons, obvious stitching and mismatched tweeds, and Valentino, who made the snappy little suit into the ultimate in femininity. Valentino's suits, cocktail dresses and gowns were somehow smarter, sexier and smaller than everyone else's. The Chanel suit was re-done over and over again by Karl Lagerfeld, worn with biker boots and huge ear-buckles.

When you couldn't wear the power suit, it was time to get out the ballgown. Ballgowns gave expression to our most romantic dreams, and came back very much in fashion after the publicity surrounding the Princess of Wales's wedding dress created by the Emanuels, the classic little girl's ideal of a dress.

American fashion featured a classic continuation of the look brought by Claire McCardell to casual wear in the 40s. Anne Klein, Perry Ellis and even Isaac Mizrahi brought a spareness to provide relief from the fussy, almost Victorian ideas in British fashion at the time. The peplum jackets and little details for formal wear were over-detailed compared to the distillation of the preppy look by Ralph Lauren, which gave an old-fashioned gentility to his clothes and his shops. His clothes gave us a look at fashion history through rose colored glasses, when his peers were looking through X-ray specs. (Stephen Sprouse has never taken his off!) Conversely the phenomenally successful minimalism of Calvin Klein was ideally suited to the image of the new women with money. Not wanting to look like anyone's property, or part of any time but her own, the wearer of Klein could be assured of premium quality materials, sexy cut and subtle colors adaptable to any lifestyle.

New wealth required new parading and aspirations. Three of the great companies from earlier in fashion history enjoyed a new popularity. Louis Vuitton, Hermès and Chanel were the makers of the three most sought-after bags of the 80s. Vuitton luggage, Hermès Kelly bags ($4,800 to order) and the quilted Chanel bags littered the first-class travel venues of the world and spawned mil-lions of copies. The Chanel suit enjoyed a revival, worn by everyone from the Princess of Wales to "B" list celebrities. Worn with everything, including jeans, it was the smart item to have. Other status symbols were the Prada nylon bag, Psion organizers, laptop computers, Rolex "oyster" watches and a Filofax. The obsession of the 80s was to have the best you could buy.

For women who want to make statements, there is nothing more arresting than Japanese fashion. Designers like Issey Miyake, Rei Kawakubo of Comme des Garçons, and Kenzo were much more appreciated in Europe than they ever would be in Japan, where European clothes represented modernity and sophistication. More akin to this statement-making clothing than the others, Romeo Gigli, the new Fortuny, whose arrival coincided with the New Romantic trend, took his place among the great and good—including the British-originated Callaghan, label which achieved and maintained cult status with its whimsical creations in Milan. Christian Lacroix is another one of these romantic couturiers and designers who has created an empire from the nostalgia for his past. He mixes the color and drama of the bullfight and the femininity of his prematurely gray muse, Marie, to create clothes the timid would not contemplate.

Real Italian ready-to-wear arrived in America and made an immediate hit with the moneyed youths on the trading floors, and was even mentioned in the scripts of *LA Law* and *Miami Vice*. Giorgio Armani was one of the first really expensive designers to launch a diffusion range, which still bears the trademark cut and simplicity of his main collections, and the tailored ethnic touches that are so exciting.

British fashion reached the pinnacle of recognition once more as Vivienne Westwood delighted the press with outlandish collections with names like "Britain must go Pagan." Her ideas were always shocking at first and imitated later. Rifat Ozbek also had a romantic, story-like approach to his collections, drawing on African breastplates and Native American medicine bowl imagery, and thé dansant themes. Street fashion was elevated to the runways too, and British fashion produced Richmond Cornejo, Body Map and Workers for Freedom, whose roots were in what was going on in "real life." Margaret Howell was a seasoned survivor from the late 1970s, producing tailored and mannish, traditional styles with a twist, like cavalry twill trousers worn with a sized floral silk roll collar shirt or a complete "Captain Birdseye" outfit for girls. Her understated, alternative chic was a welcome relief from the tedious formality of the clone dressing chosen by most women during this period.

It was also at this time that the anti-fur Animal Liberation Front, People for the Ethical Treatment of Animals, and other pressure groups made their presence felt. Fur wearers were attacked in the street with cans of paint to show in the most graphic way the protester's disapproval. The lurid shades of 70s fake furs were replaced by the most tasteful "natural" colors, but still fake enough to be distinguishable from the real thing; some were even clever enough to have Mickey and Minnie Mouse in the pile. The pressure group Lynx ran an all-star poster campaign, with the famous slogan; "It takes 20 dumb animals to make a fur coat and only one dumb bitch to wear it."

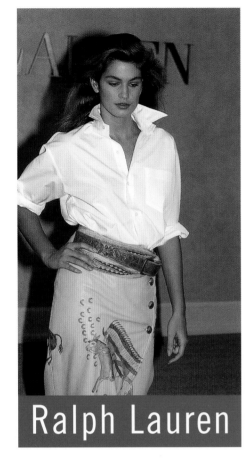

Ralph Lauren

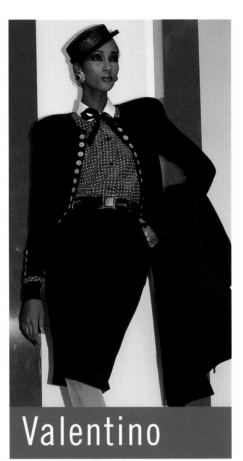

Valentino

Donna Karan

Donna Karan designs clothes for women like Karan. Her advertisements are deliberately ambiguous; always in salubrious settings, there are clothes, scents and accessories for every occasion. A strong, sexy model pictured with a child in a model kitchen in cheap jeans and expensive boots, at the airport surrounded by body guards, or in a limousine looking at the Manhattan skyline. Whether she is meant to be the wife or the president, she does not waste her time pleasing the conventional. She is clearly an intellectual, smart enough for the boardroom, but not too busy to make cookies with the child, and sexy to boot. The question is not "How does she do it?" but "How can I do it?"

Alaia

Azzedine Alaia was king of cling. Born in Tunisia, he went to Paris in the 50s to work for Dior, but quickly went independent. He was originally interested in sculpture, but soon discovered Dior, Balenciaga and Vionnet, who is his true inspiration. He spent hours poring over the Vionnet archive, and has been known to take her dresses apart to understand her technique. A keen collector of vintage couture, including the oeuvre of Vionnet herself and cult figure Charles James, his output is minimal, and he describes himself as "between machine and the hand." He makes the sexiest clothes, using a skillful technique of inventive seaming.

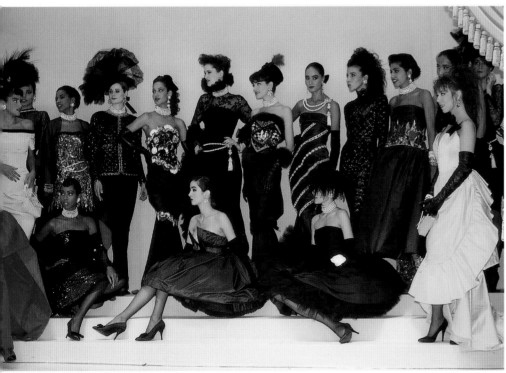

above: The ultimate luxury—top models display Chanel couture, 1986-87.

1990-
1980-
1970-
1960-
1950-
1940-
1930-
1920-
1910-
1900-
1890-

COSMETICS BODY SHAPE & UNDERWEAR WORK & PLAY

During the 80s, hair followed the corporate rule and had to look soigné and expensively coifed. This generally meant high maintenance. Back-combing, blow-drying, and perms were essential to attain these styles, and quite often the bouffant head was forced to make an about-face for a severe but sleek ponytail. Mostly, though, for the young, hair was worn long and loose and preferably any shade of blonde.

This was the era of the trophy wife, who spent long hours in the beauty parlor and hairdresser to look right for the many social and business events she attended with her husband. Blonde highlights were *de rigueur* for these women, who were often so similar that they were indistinguishable from each other. Highlights became more sophisticated since their inception in the 70s. Several shades of color were alternated to give a richer, deeper overall effect. Some streaks were as thick as tiger stripes; others were fine and painstaking. And as with everything else, there were definite trends in highlighted streaks, while lowlights were another technique of enriching any color of hair.

The legacy of punk was the number of spiky, gelled hairstyles that stood up over the head, or the short, vertical styles popular in continental Europe. The accent was most definitely on the up and up, and often short punky styles were worn to great effect with romantic ballgowns and couture, to accentuate the fledgling youth of those who bought the clothes.

The 80s heralded the return of the hat. With all the social events to go to, the hat was indispensable. The pillbox with the veil became almost a joke, it was imitated so widely and cheaply that it became completely undesirable. There were, however, a huge number of styles to choose from. The other most popular styles were the massive feathered marshmallow, feathers all over and no brim, and the large Edwardian picture hat. The man's Panama was extremely popular with girls at outdoor sports events, going well with the understated casual fashions usually worn on such occasions. And flying in the face of the politically correct, individualists everywhere loved fur hats for extreme cold in the city.

Finally, anyone with any pretence of looking remotely sporty had to wear designer sunglasses in their hair. There was no season for this, but since the 70s, dark glasses were obligatory for driving the BMW or the Mercedes, for sitting outside the swank joint on a warm day or for shopping along Fifth Avenue.

left: Model Iman shows off the latest coiffed, "big" hairstyle.

right: Ivana Trump with husband Donald—the bigger the hair, the bigger the bank balance on the New York social scene.

below: Punk hair was full of attitude, the antithesis of the 70s fashion for "hairdos."

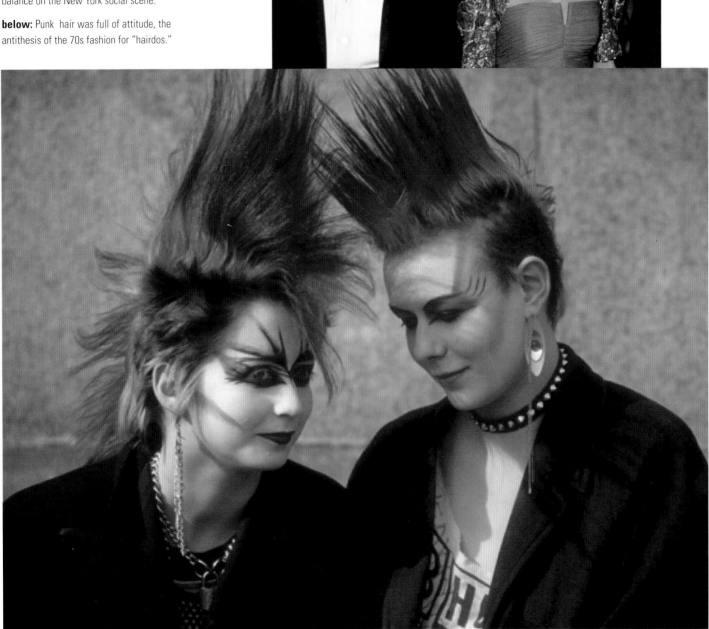

1890- 1900- 1910- 1920- 1930- 1940- 1950- 1960- 1970- **1980-** 1990-

above: Vichy's ad campaign for skincare promoted the idea that women could be beautiful and intelligent.

right: Revlon's Charlie took on a new lease of life – a distinctly 80s image.

With the dominance of the corporate culture, makeup became less girlie and more matt, with strong and spare use of color. A natural looking skin was desirable, often gently tanned, or even freckled, with strong definition of eyes and mouth. Eyebrows were thick under the influence of Brooke Shields, and lipstick was often power red or shocking pink and eye pencils were out for everyone except the Princess of Wales. Eyeliner became very voguish, and eyeshadows were more usually in natural colors.

The use of good tools was greatly emphasized in the beauty press, and blending became the skill of the moment. The contours and shading and highlighting of the 70s were now thought to be derisory and unnatural, and the personalized approach to foundation was a great new selling angle. The prospect of a foundation made to match your skin tone was too good to be true. A new company called Prescriptives made its name on the force of this trend.

Looking at the rows of faces of women commuting to work every day, you might have felt you were in a museum of ancient terra-cotta pots, such was the popularity and range of brown gradations around.

The neutral makeup look was all-important though, and Ultima II was the leader in this trend. A smooth no-makeup finish was the most desirable beauty feature. The new silicone-based foundations became much lighter, and powder was increasingly translucent.

1990-
1980-
1970-
1960-
1950-
1940-
1930-
1920-
1910-
1900-
1890-

Powder was a must for any serious contender in the beauty stakes, but, again, new developments meant that they had changed beyond recognition.

Following the success of Clinique's soap-and-water philosophy, the 80s brought a new style product in the form of face washes. "Cleanse, tone and moisturize," the mantra of 70s manufacturers and gurus alike, went out with the bathwater. Clarins spent a lot of money on publicity and hedged its bets; it gave a choice of wash or traditional products all bathed in a quasi-aromatherapy philosophy, with their belief that plant extracts can do much for the psyche and the skin. With this in mind, they launched their Eau Dynamisante, the "energizing" spray that could be worn with or without other scent.

Liposomes were very important in skincare in the 80s. Anti-aging was a frequently repeated beauty promise. Suddenly, capsules and special creams were launched that were incredibly expensive, but promised results that were quite priceless. We were introduced to ceramides and liposome technology in the usual diagrams of the skin's surface, and suddenly it was another necessity to "manage" our aging processes. Collagen was another important age-management product.

In view of the importance of careers and corporate ladders this decade, lots of women played up the "brainy" image and wore glasses. The more professorial the better, and financial districts the world over were full of beautiful sirens wearing heavy horn rims and taking them off to great appreciation in the wine bars and smart restaurants of the day. Forget contact lenses, unless they were lapis lazuli or a deep shade of violet, let it be a great surprise to all that one was beautiful as well as terrifically gifted at closing a lucrative deal; the money came first and the seduction outside working hours!

Giorgio was *the* scent of the 80s. Brash and strong, it was banned from lots of the best restaurants of the time. In fact it was a publicity coup that notices could be seen all over the major cities banning it by name!

Anita Roddick

Anita Roddick was one of the larger-than-life personalities of the 1980s. Second-generation Italian immigrant, as a poor student married to a hippie poet she borrowed £4,000 to start the Body Shop, and is now one of the richest idealists in Britain. Through the flotation of the shares she became an overnight millionaire, but it is her vision of the world as the "global village" that separates her from the multinational conglomerates. Any beauty recipe is of interest—whether it be thousands of years old or a tribal old wives tale. Well known for her benevolence, she founded the Big Issue project for the homeless and ensures that the company's workers abroad are well looked after in the many projects she has set up, particularly for women. She has made a substantial difference to the marketing of cosmetics and the choice of those products. After the huge press coverage of Princess Diana's wedding makeup, she and Barbara Daly launched the Colourings range of goods, which encouraged the new practice of crediting makeup artists for their work.

Throughout the 20th century, women have adopted and adapted menswear and made it their own. The combination of women's underwear with key pieces of menswear that symbolize authority were seen to be potentially explosive in the 20s and 30s, and was potently revived in the 70s film *Cabaret* by Liza Minelli. In the 1970s, underwear was worn to great effect as outerwear. In the 80s, the concept was taken further by Jean-Paul Gaultier; in his 1983 collection, underwear was clearly visible, or even part of the ensemble, and developed into the incredibly reactionary clothes with the 50s "missile" bra worn outside a man's pinstripe suit. When worn by Madonna on her world tour, in the "western saloon" showgirl outfits with the conical breasts, the statement

turned into polemic, and was widely imitated by clubgoers and girl singers alike. Not to leave out the boys—he dressed them in skirts—it was an even exchange! Gaultier scent is the distillation, quite literally, of these ideas, and the bottle is clad in a very Gaultier outfit with bondage connotations. Uncork and set free.

Swimwear, like everything else, was an excuse to flaunt the body beautiful. Bikinis were a boned bra and high cut pants, while, influenced by the Brazilian beaches, thongs were worn by the brave. Underwear was often the same shape, with manufacturers like Victoria's Secret and La Perla realizing that under the pinstripes, many women would want to wear very feminine lingerie. But the most successful underwear sales in the 80s were the Y-front jock

left: Jean-Paul Gaultier was a key exponent in turning underwear into outlandish outerwear.

far left: Sport and diet gained increasing importance through the 80s.

below: Power dressing extended to the beach with high-cut costumes, spiky hair and jewelry.

1990-
1980-
1970-
1960-
1950-
1940-
1930-
1920-
1910-
1900-
1890-

underwear for women by Calvin Klein. The more masculine the better. Heather-gray cotton, sensible, big and comfortable, worn with a tank-style undershirt, they were the ultimate aphrodisiac for the preppy yuppies and, what's more, they felt good too. Finally women had made it to sensible, no-nonsense healthy underwear. Comfort had finally become a fashionable commodity, even in underwear—which by definition, because of its proximity to the body, is the last bastion of emancipation and intimacy.

The body as cult was so strong that Lycra cycling shorts, leotards and leggings were worn as clothing on the street, with the bra showing artfully from the shirt; likewise ripped jeans were very chic, but ideally had to show a perfectly honed buttock.

Underwear was either very much on show outside the clothes or very opulent and "for your eyes only" in the 80s. The return to seams and basques was all very well, but it didn't sit very well over the $3,500 Lycra-and-wool suit. The heather-gray cotton briefs by Calvin Klein didn't do much for it either, and it was impossible to wear a shirt tucked in or any kind of top. So Donna Karan invented the bodysuit. The bodysuit, for those who don't know, is an all-in-one undershirt and pants, with snaps between the legs for the obvious purpose. There is hardly any line, and the top is joined to the pants, often in different cotton or fabric, or maybe all in the same Lycra fabric, with or without sleeves, and it is the ultimate in modern clothing.

COSMETICS **BODY SHAPE & UNDERWEAR** WORK & PLAY

People came to know a lot about fitness and diet in the 80s. Whereas starvation diets had been the rage in the 70s, it was now recognized that these were self-defeating, and with the craze for cross-training, the body needed to be fueled regularly. Women were taking part in marathons and other events without anyone being surprised, and fads like low sodium and dietary requirements were more widespread. Sport seemed to be part of everyone's life.

The gym was a social place rather than a locker-room boy's club. An antidote to stress, weight-based exercises and circuit training became popular for women, as well as the traditional dance and music-based routines. Aerobics were heavily promoted, and a proper understanding of warming up, minor injuries and so on was accepted as essential. Other perks of the gym, like jacuzzis, sunbeds and health-drink bars, added to the social environment created.

With the new figure-hugging sports clothes worn in the street to show off the hard work, jeans took on a new significance. They were either much more conservative and worn with velvet slippers or a blazer and white shirt, or they were worn ripped or customized into something more meaningful and individual. Either way, their status in fashion terms was much different to the student image of the 60s and 70s, it was time to make as much of an effort with them as one would with anything else.

Many career women started to wear sneakers to work in the 80s, changing into their office shoes after a good long walk from the subway or whatever. Sports shoe companies began taking these women, and the whole female market, and collecting data and analysis of what women wanted from sports clothes. Through this approach, the "step" aerobics were born and a multimillion dollar industry was found to be out there waiting to happen.

The big news in 80s fitness was the sports bra. After "jogger's nipple" and the problems felt by the well-endowed taking any form of exercise, there was a huge range of sports underwear to be found. The Calvin Klein look found its way into the women's locker room, along with the tank-top-style bras and the specialized, usually white, fitted bras with cup sizes.

Shopping malls, the new temples to modern lifestyle fashion, featured all the casualwear manufacturers and sold version after version of jeans, loafers, sneakers and sweaters, all the classic sports styles from the history of 20th-century sportswear, so people not only spent their leisure time playing sports, but thinking how they would look when they did! It is not hard to see why the retro sports looks of the 20s and 30s surged in popularity.

Spectator sports were also of paramount importance, as they had been at the beginning of the century: polo, racing, tennis and motor racing all had associations with glitz, and in Britain even dog-track racing became extremely chic for a while, as the new stadiums had cafés, bars and other glamorous facilities. How one would be seen while watching others was as difficult a choice as it had ever been.

When the 80s are due to be the next decade for rediscovery, it will be interesting to see which elements appeal to people, and why.

1990-
1980-
1970-
1960-
1950-
1940-
1930-
1920-
1910-
1900-
1890-

above: A spectator at Ascot keen to be seen in shocking pink.

left, top: The new craze for fitness was no longer confined to the gym.

left, bottom: Ripped jeans with strategically placed tears.

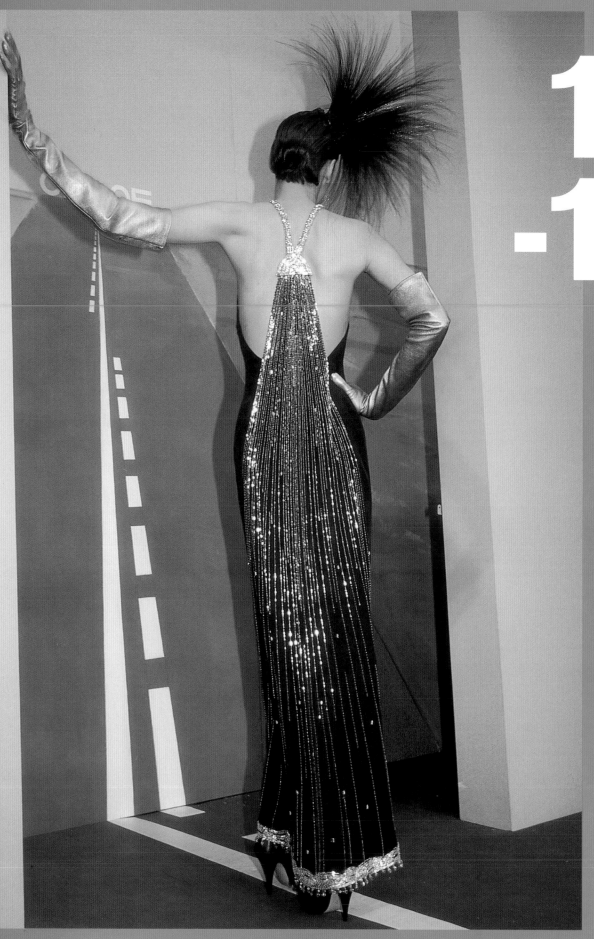

1980
-1989

The Iran–Iraq War

Prince Charles weds Lady
Diana Spencer

Earthquake in Mexico claims
20,000 lives

Britain and Argentina war over
the Falklands

Bob Geldof organizes the Live Aid
concert for famine relief

John Lennon is murdered in
New York City

Chinese students are massacred in
Tianamen Square

The *Challenger* space shuttle
explodes, killing seven astronauts

Major conferences are held
addressing the threat of AIDS

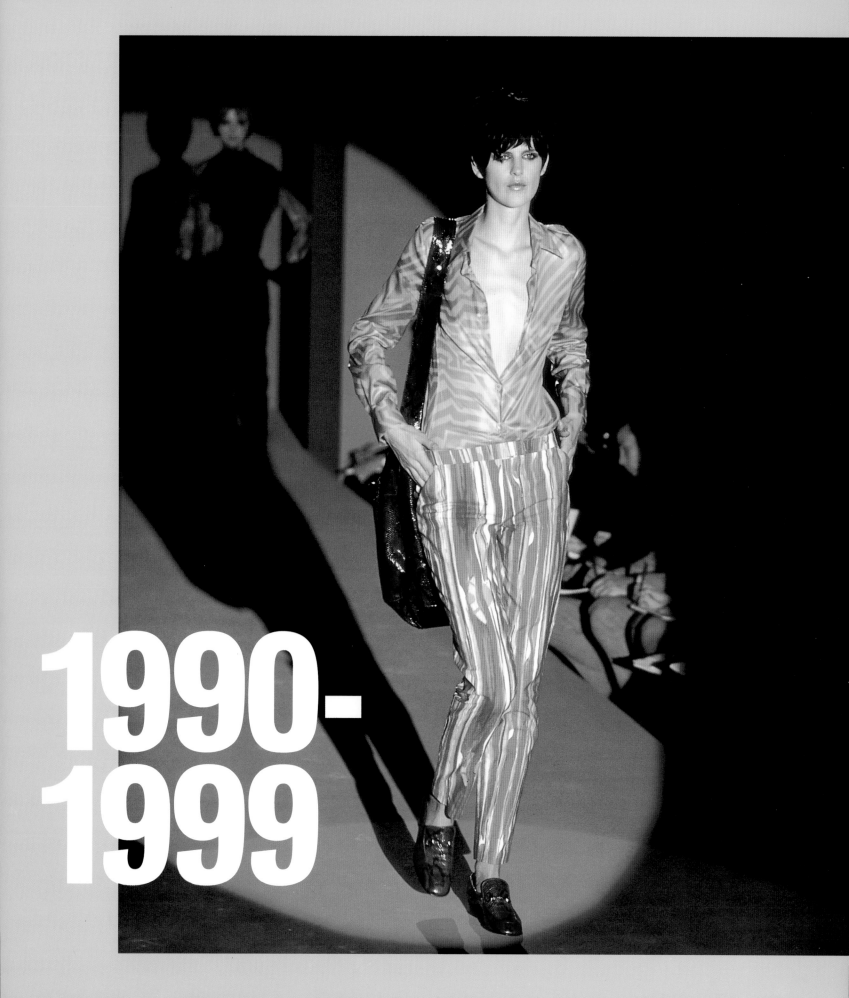

1990-
1999

THE NINETIES SAW AN ENORMOUS BACKLASH AGAINST MANY OF THE VALUES PROMOTED IN THE EIGHTIES. CYNICISM GAVE WAY TO OPTIMISM, AND THE FUTURE WAS NO LONGER A THING OF THE PAST AS THE MILLENNIUM NEARED

During the 90s, there has been an enormous backlash against the values promoted in the 80s. Those in the media like to portray them as vulgar and uncaring days, when social problems like homelessness and poverty grew while vast fortunes were made on a get-rich-quick ethic. If that is the case, then the 90s are therefore seen as healing, restorative and hopeful. As we are on the eve of not only a new century but a new millennium, it would seem even more vital that we get things right.

Many of the ways in which it was thought we could do that are less credible than was originally imagined. Political correctness (PC) has been discarded in exasperation, and a more plain-speaking mien has taken over. The majority of former taboos have been broken in the media—we celebrate lesbianism in chic fashion shoots, flip through the new women's erotica, watch films about cannibalism and deplore bimbos and himbos. Wearing their red AIDS ribbons, women debate date rape, PC and dead white males, and whether any are valid concepts outside academia and campus politics. Medical research has dwelt increasingly on genetics, and many faults hitherto accepted as character faults or incurable illnesses are now potentially just bad programming.

Feminism, while not dead, is certainly less conspicuous, many of its ambitions now achieved and part of the social landscape we take for granted. Looking at today's cultural imagery of *G. I. Jane* and *The First Wives Club* it is hard to believe that there was ever a time when women's identity was unacknowledged. The feminist movement as such became so associated with fragmentation and factionalism that fewer and fewer women could identify with it.

The new big thing is girls, like boys, behaving badly and getting away with it. Having fun is much higher on the agenda these days. There is a rash of new publications for young women with attitude. If the 70s were all about thinking about it, the 80s were about doing it, and now, in the 90s, we're laughing about it.

A huge growth in the media coupled with more sophisticated audiences mean that our society can afford to take a rather endearing, often self-deprecating look at itself, and examples of this can be as easily found in advertising as much as in television shows and magazines. TV sitcoms like *Friends* have been hugely influential in fashion terms, as well as in articulating the idiosyncrasies of success-

1990-
1980-
1970-
1960-
1950-
1940-
1930-
1920-
1910-
1900-
1890-

ful post-modern sons and daughters of baby boomers. To watch it is to wish we could live that life and look that cool when we go through those familiar dilemmas ourselves.

Culturally speaking, the 90s are concerned with the cross-fertilization of the arts and sciences in literature and art, and there is a huge environmental idealism at work in the advertising for big corporations and consumer products. These inputs are heavy on philosophy, and appeal to the young in such a way that a product is often not even pictured. The once-infamous Benetton campaigns, for instance, show images to provoke thought, not to order us to buy goods. Others, like the many new cosmetics companies, do not advertise but rely on PR and word of mouth. MAC, for example, uses the audacious figurehead RuPaul as its "face," but you will rarely see it in any magazine. Also, exclusivity deals with the big department stores for a specified period of time are typical of the more subtle marketing techniques used now.

Recycling is a reality, and it can be commercial suicide to be selling anything not environmentally friendly. Farming is constantly being challenged about its methods regarding both crops and live-stock, and the recently agreed rules for human embryology have been shown to be flawed by anomaly. There is a yearning for simplicity and a definite and consistent ideology. At the same time the public has an insatiable appetite for novelty, a healthy irreverence towards many of our cultural values, and continued fascination with technological innovation.

There have been scars that are only beginning to heal. AIDS has taken its toll among many talented individuals in the fashion and artistic world, but this has heightened attitudes to the need for fund-raising and awareness campaigns, not just in the cause of AIDS research but other equally urgent areas. Diana, Princess of Wales, killed tragically in 1997, supported AIDS research, a ban on land mines and other causes, with a fashionable image that was clearly an asset to the campaigns concerned. Even former icons of youthful rebellion like Rolling Stone Keith Richards and other survivors, are now part of a benign rock aristocracy, often playing for charity while they read about their offsprings' antics in the gossip columns.

SUPERMODELS

The supermodel elite: (top, left–right) Christy Turlington, Naomi Campbell, Claudia Schiffer, (center, left–right) Cindy Crawford, Linda Evangelista, Tatjana Patitz, Niki Taylor, Yasmeen Ghauri, (bottom, left–right) Karen Mulder, Elaine Irwin Mellencamp.

left: Lara Croft, the computerized hero-ine—here dressed by Alexander McQueen—of the *Tomb Raider* PlayStation game, who represents a 90s ideal, that of the (virtual) sexy-but-smart supergirl.

SHARON STONE

became a 90s sex symbol after her erotically charged role as the icy *femme fatale* of *Basic Instinct*. Later films like *Casino* have revealed more than just her body—a more mature acting style as well as undoubted good looks.

UMA THURMAN

achieved cult status after her performance in *Pulp Fiction* (above), but the tall, usually blonde, ex-model has become part of the 90s Hollywood mainstream in films as varied as *Henry & June* (as June Miller) and *Batman and Robin*.

1990-

1980-

1970-

1960-

1950-

1940-

1930-

1920-

1910-

1900-

1890-

KATE MOSS

spearheaded the 90s reaction to the supermodel look, with a waiflike image that combined an unfashionably skinny 5-foot-7-inch frame with a stunning beauty, which—with or without makeup—came to personify the times.

JEMIMA KHAN

with a flawless beauty that some would say is straight from the pages of a magazine, helped popularize the *shalwar khameez*, the traditional two-piece dress of the women of Pakistan, home of her handsome cricket-star husband, Imran Khan.

COSMETICS BODY SHAPE & UNDERWEAR WORK & PLAY

above: Ellen DeGeneres with partner Anne Heche at a 1997 film premier.

right: Kate Moss in Calvin Klein looks out on the streets of New York.

far right: British pop icons The Spice Girls took their feisty "girl power" worldwide, reflecting teen street-style of the mid-90s.

below: Susan Sarandon (left) and Geena Davis as road rebels *Thelma and Louise*.

The demand for new and exciting images continues to grow as it has since the beginning of the mass-market. The ideal is no longer single or even dual, it now proliferates faster than it can be described. The search for novelty and artistic freedom has provoked hostile reaction as the last bastions of our taboos are toppled; there are some potent and tough images all around us. Particularly in the lion's den at the moment are the fashion editors who use extremely young models. This contentious subject is summed up and satirized by the advertising campaign for Calvin Klein's Obsession, in which the models are deliberately seen as underage victims of sleazy old photographers whose presence is felt by off-camera whispers imploring them to bare their bodies. The underwear fashion shoot of Kate Moss by Corinne Day in *Vogue* in February 1993, at the height of grunge, was also felt to be suggestive and unsuitable due to its "underage" feel. Young models continue to be controversial, not just because we feel that society must protect the young from being exploited but also because within about two weeks of work, many can buy their parents out many times over. In a business where, in theory at least, it's all over by the age of 30, good luck to them!

Androgyny has been an important feature in 90s imagery, Jenny Shimizu, Ellen DeGeneres and kd lang being prime examples of

sexually ambiguous celebrities who embody something potent in image making. The March 1997 edition of *Vogue* featured a panel discussion transcribed on the subject of thin models and anorexia. The "fat" lobby increasingly resents the way fashion dictates that only pencil thin models represent beauty in our cultural imagery.

Fashion photographers like Herb Ritts and Arthur Elgort are consciously artistic in a sort of *Rolling Stone*-meets-documentary way. There is also an amount of narrative in many successful image series. From the white trash Guess campaigns to Levi's mermaids and even the pseudo-Sloane characters in the UK Gold Blend series, they invite involvement as well as belief. Even the UK "indie" magazine *Dazed and Confused*, in deliberately trying to nudge the parameters of acceptability with their "stabbed house-wife" fashion shoot, chose a narrative approach.

Ageism is another obsession. Levi's went the whole nine yards and their latest advertising campaign features models in their 80s as real and interesting people and not just tokens. The same goes for Calvin Klien's CK One, which features people of all sizes and dress sense as if to say "hey we can be like you" not "you can be like us." The fat lobby are missing the point that CK is making, the images are not and should not be uniform. There is an increasing number of professional middle-aged models making a fortune on the run-way, and making major names for themselves.

Hollywood, on the other hand, is an ivory tower of conservatism compared to the cutting edge of fashion. The decisions taken in Hollywood are less artistic now and more business-oriented. Michelle Pfeiffer, ostensibly one of the most feminine film actresses, made this indictment on her industry at a ceremony recently: "What a great year! Demi Moore was sold to Robert Redford for a million dollars, and Richard Gere bought Julia Roberts for two

thousand." Even though there are now lots of female directors and big players, genuinely feminist (with a small "f") movies are still thin on the ground. One of the few that broke through big was *Thelma and Louise*, a winning double-hander of a road movie, with Geena Davis and Susan Sarandon, in which two women confront male redneck chauvinism at its worst and achieve immortality in the process. And as *Variety* pointed out at the time, it's not about women vs. men, it's about freedom.

Prada

The buzzword in fashion in the 90s is individuality. That goes for length, style, trousers or dresses—it is the wearer's choice not only what to wear but how to wear it and what with. Those in the know realize that whatever it is will be loaded with a significance that the cognoscenti will not miss, but it is still a liberating factor overall. Masai with Victorian, retro and tattoos, and Suzi Wong in feathers and cowboy boots—there are no limits to the playful re-invention of themes.

The big designers play a bigger role than ever before in the lives of everyday people, because you'd have to be a hermit not to be aware of them, with the amount of media exposure they receive both on the runway and on the backs of the celebrities who buy their clothes. Events like the announcement of new designers for Dior and Givenchy, Galliano and McQueen respectively, and Stella McCartney's inheritance of Karl Lagerfeld's crown at Chloe garner enormous interest. Likewise the many fashion awards, on-the-spot interviews with the supermodels backstage at shows and increasing television shows devoted to the subject all keep the megastars constantly in the news.

We've had waif and grunge, the inevitable antidote to the "dress for success" and corporate images of the 80s, and now we have the invention and reinvention of retro styles from Anna Sui and Prada; the wit and historical knowledge of Vivienne Westwood, Alexander McQueen and Galliano; the alternative formality of Armani and Donna Karan; and the statement-making of Comme des Garçons and the late Gianni Versace. These designers, and the renovated ones like Gucci are superb technicians as well as being able to anticipate and interpret the general fashion mood. The looks that appear on the runway are less realistic in the 90s, in a sense, because the fashion show is such a huge media circus, such a huge arena compared to real life. So much anticipation surrounds the shows that a lot depends on instinct and the actual interpretation of fashion.

In the 90s there is a huge choice of fashion, and the couture looks are translated immediately to the mall, so the looks appear at virtually the same time. There is a huge awareness of the characters and the happenings on the runways, and many people are interested in it as entertainment thanks to TV programs and magazines, and the personality status of the models.

Designers are also higher profile today in that they secure licensing deals and participate in lifestyles that portray them as Renaissance men and women, industrialists with artistic genius who entertain "A" list celebrities, have muses and control empires of clothing, perfume and makeup. None of this is particularly new, but the PR machines make sure to remind us more often and the scale of it all is mind-blowing. Designers, not content with licensing, have created diffusion lines in the 90s, which bring a new class of customer. But, it is increasingly rare to find anyone dressed from head to toe in one designer.

There is a new sensitivity to goods and the way to wear them. Attitude and not status determines the way we look. What goes around comes around, and couture is as popular today in the press as it ever was, plus there is also a renewed respect for workmanship and recherché objects as there was at the end of the last century. There is less elitism in a certain sense, because everyone borrows from everyone else, rich or poor, young or old, and all it requires is an eye and an instinct.

D & G

Stefano Gabbana from Milan and Domenico Dolce, a Sicilian, first made their name in the late 80s. Taking their inspiration from Italian neo-realist films and the sartorial style of the southern Italian matriarch, their look was a welcome antidote to the ubiquitous 1980s "inverted triangle" shape of the power suit, with its huge macho shoulder pads and minimized hips. The image they promoted heralded the current focus on the bosom, through the strong use of the corset and waspie. Their aim was to create fashion for woman as heroine rather than workhorse. Their advertising promotes a character with a tough exterior, but with a new resonance. This return to femininity with its distinct cultural twist helped pave the way for the retro role-playing runway shows of the 90s and their influence has been far-reaching in couture and prêt-à-porter.

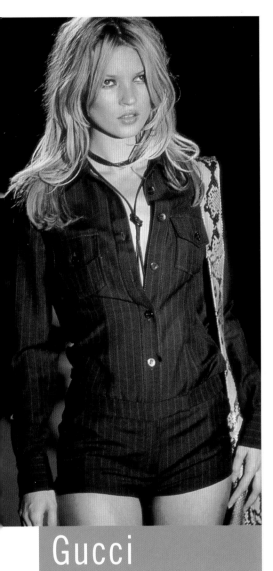

Gucci

above: Kate Moss in Gucci, Spring/Summer '96.

right: Iris Palmer models Molinari, Spring/Summer '97.

left: Shalom Harlow walks for Prada, Autumn/Winter 1997.

Molinari

1990-
1980-
1970-
1960-
1950-
1940-
1930-
1920-
1910-
1900-
1890-

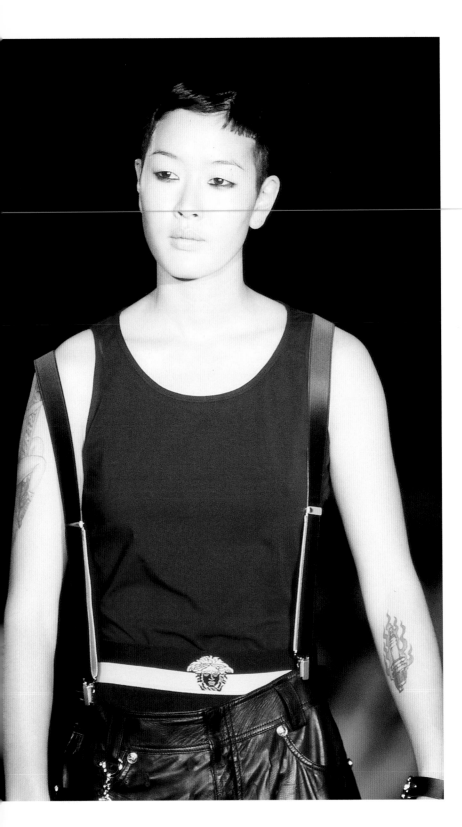

Hair this decade follows the individuality rule. Specific hairstyles for a look have not been obligatory since the 70s, except perhaps for TV anchorwomen. The diversity of influences is exciting, and because of the range of hairpieces and extension techniques, even if you cut your hair, you can have long hair the next day for a change in any color. The hit hairstyles of the decade without a doubt are the Meg Ryan mop-top and the super-popular Jennifer Aniston pseudo-70s long short-layer cut (with or without the frosted coloring).

In the color department, the blonde is supposedly out and the redhead was voted the most popular character with men on the grounds that she is fiery and individual—there's that word again—and dark is more popular with women because it is more in keeping with the contemplative mood of the age.

Actually, it's become acceptable to have no hair at all in the 90s. Princess Caroline of Monaco, who rarely if ever puts a wrong foot forward in the fashion and beauty stakes, had temporary alopecia from stress but nevertheless looked quite stunning; she came up with interesting ways to enhance her natural good looks with scarves and hats. Demi Moore, shorn for *G.I. Jane,* has really flaunted her baldness, as did singer Sinead O'Connor, and Sigourney Weaver in *Alien,* in the 80s—and it has long been a feature on the runways.

For those whose bone structure couldn't take it, dressed hair has been a big thing. Messy ponytails and 60s French braids have been popular for work and evening. Very formal looks have become accessorized with tiaras, from the beautiful craftsmanship of Slim Barrett, crowns in filigree metals including silver and gold with intricate patterns with or without semiprecious stones, to the kitsch department store Miss Universe type. Some very lucky people can even wear the heirloom type.

Products are generally less visible. Gone is the gel and mousse look, and the accent is on condition and silkiness. Shampoos and conditioners are making greater claims for repair and nourishment in a more laid-back style of salesmanship. Two-in-ones have received a rather bad press, and humor has entered the world of shampoos. Celebrity hairdressers have increasingly marketed their own ranges of products, like the makeup artists. And the braids and intense colors from the fashion shows are being increasingly adopted in the quest for novelty.

1990-
1980-
1970-
1960-
1950-
1940-
1930-
1920-
1910-
1900-
1890-

above: Linda Evangelista (here with Karl Lagerfeld) often changed her image and her hair color, here bright red in the early 90s.

right: Jennifer Aniston with the famous "Rachael" cut from *Friends*.

left: Model Jenny Shimizu's androgynous short'n'shorn look on a '94 Versace runway.

controversial, since they have been known to burn, and several have been withdrawn from the market because the concentration was thought to be too high. The fruit acids, salicylic or others, can be very irritating and actually cause sun allergy or even bizarre pigmentation in the odd extreme case. In fact several premier houses, including Christian Dior, delayed the launch of their AHAs despite having the go-ahead. In the end, they did what many other companies have done and confined AHAs to a low concentration in body moisturizers. The first AHA product was introduced in 1992 when La Prairie launched its Age Management Serum, which sold exceptionally well. Avon mass-marketed a miraculously cheap version and Revlon followed suit. Clinique went all out to promote its own AHA product around the same time, and customers loved the feeling of having "new skin" every day. Now, they are slightly out of date and risky, due to the reported reaction to the sun. They have been overtaken by Retinol and Vitamin A products, while Revlon has been promoting its new Age Defying Makeup as the gentler alternative.

Direct marketing has changed from the days of a local neighbor on commission to wacky, humorous marketing strategies. Humor abounds in the mail-order market, which, surprisingly, thrives without the customer being able to try before she buys. The unique presentation and fun names make it worth the effort and the wait to order products by mail.

The cellulite obsessed got good news this decade, since it is now said to be possible to banish the condition for good through the use of lotions like Dior's Svelte and Clarins' Lift-minceur—these have received sensational press, and the results are guaranteed.

Education about global warming and holes in the ozone layer mean that beauty's biggest enemy in the 90s is the sun. Products increasingly have sunscreen as standard and the look in the beauty pages is paler and more "interesting." Skincare for everyone is of more importance and suncare for everyone is gradually being seen as of paramount importance.

The problem of the variety of skin tones and oiliness have still not been overcome sufficiently to make a proper mainstream range of cosmetics for black skins a viable proposition. However, January 1998 saw the launch of several ranges from the UK chain Marks and Spencer, among others. The "gray" market, those over 40, is also a new area of interest in cosmetics for the future.

The problems concerning the environment are of an overriding consideration in this decade, and the manufacturing companies, however large or small, have realized that customers are not only interested in the look of the products and the reputation for their own safety, but for the good of the planet. Recyclable packaging is another important marketing element in both makeup and hair products. Likewise, animal rights are another important issue of our times. No longer is it just the concern of minority groups; there is a fierce debate going on regarding animals being used for testing and experimentation in the cosmetics industry. It is an issue that is about to affect the whole manufacturing and marketing strategy.

Women are not only prepared to spend money on themselves, but increasingly those affluent enough to afford it are trying cos-

After the standardization of the groomed look in the 80s came the relief of experimentation and individuality. There was also the continuation of a trend started in the previous decade, that of the professional makeup artist receiving recognition for his or her work. Like many hairdressers and designers, they have established their own brands. Bobbi Brown and Shu Uemura are now quite recognizable names. Makeup artists often published books and even founded schools in the 80s, now it is normal practice for the rich to hire a well-known artist for a special occasion. The rest of us can only hope to go on one of the many "make-over" programs on TV or follow the steps in magazines and books.

The consumer is now usually quite educated in the techniques from the plethora of advice given in magazines, and enjoys using the best tools available. She expects high-performance products, for example anti-shine, indelible foundations and lipstick, AHA creams, light refracting foundation and ever-improving tools.

One of the most high-profile and innovative of these artists is François Nars, who has worked with Madonna and all the hippest photographers, including Patrick Demarchelier, Steven Meisel, Herb Ritts and Bruce Weber, as well as Avedon and Irving Penn. Nars asserts: "Truly modern makeup should enhance a woman's natural look without ever dominating or masking her own beauty or personality." This is the story of the 90s: if you have confidence in yourself and your judgment, you are beautiful.

It goes without saying that technological advances have meant that creams, anti-aging products and sun creams are constantly making more promises. Alpha hydroxy acid, or AHA, creams have made their debut this decade. They have been more than a little

metic surgery as a more enduring morale booster. Having bought their own scent and even jewelry for years, it is the last taboo. In the 80s, many women became more used to higher earnings and independent spending, and it is now commonplace to correct serious or irritating defects surgically with little stigma. In the early years of the 90s, an important discovery was made in plastic surgery. A real smile had been impossible to reconstruct without tightness and an unnatural stiff look, until surgeons found that the vital muscles were not straight, but J-shaped.

Other advances like liposuction and laser treatment, as well as safer implants, have popularized the science, and there is much debate in the media on whether to admit to having had it done or not. According to many top hairdressers, women are more willing to attribute their scars to brain surgery than the cosmetic variety. The face-lifts of today are not just done by pulling the facial flesh back, but by repositioning the muscles on top of the bones, so they don't get really tight as they used to, and therefore shouldn't fall and have to be redone later.

Some people are addicted to cosmetic surgery, others, like Cindy Jackson, who modeled herself on Barbie, make a living out of their experiences. It helps to know what you're in for, but women wanting surgery find that the very discretion they require can get in the way of gaining information and, more importantly, any recourse if it all goes wrong.

Another permanent beauty feature, the tattoo, has grown in popularity, as it is so effective in the game of mix and match, tattoos looking good with the primmest clothes. Originally a 19th-century innovation popular with sailors, traditionally it has been regarded as something indulged in by the likes of fairground barkers, 50s greasers, 70s punks and other "ne'r do wells" on society's fringe— it was generally thought that most, being there for life, were eventually regretted. They can now be removed, and there are now also body decals, which make the permanence of tatoos seem unnecessary

The makeup market is increasingly youth-led. Very young girls have great spending power and know all the hip brands, and the majority of the 70s revival comes from the club scene. Companies like Urban Decay and Philosophy market with humor. Names like Ooh la lift, Cockroach and Hope in a Jar and Pigment of Your Imagination charm the intellect, and the colors excite the eye. Some of the proprietors of these companies are young too; Claudia Mojave is in her early twenties; she was at college when she started Hard Candy, which trades on the image of "trailer trash" and now sells T-shirts to further promote the image.

Press interest around formerly risqué scents like Mitsouko, Fracas, Cuir de Russie and Shocking has grown enormously, as it has around recherché "boutique" scents such as Antonia's Flowers or anything by Annick Goutal. Ralph Lauren has taken the fashion and beauty story full circle and launched a range of fragrances and associated products to complement his new range of sports clothes. Like Patou and Poiret before him, he is changing the way we dress and enhancing the effect with aromatics.

above: Famous makeup artist Kevin Aucoin preparing Cindy Crawford for a Revlon ad campaign.

left: Calvin Klein's unisex scent CK One.

far left: Advertising image for the Dior Svelte range of perfumes and cosmetics.

below: Voluptuous actress Pamela Anderson Lee must have had the most publicized plastic surgery in history.

1990-
1980-
1970-
1960-
1950-
1940-
1930-
1920-
1910-
1900-
1890-

COSMETICS **BODY SHAPE & UNDERWEAR** **WORK & PLAY**

above: Liz Hurley in the notorious "safety pin" dress by Gianni Versace.

right: Caprice Boulet, successor to Eva Hertzigova as the Wonderbra girl.

far right: Chanel goes minimal in a 1996 micro bikini, modeled by the aristocratic English beauty Stella Tennant.

Body shape is under intense scrutiny at the moment. First, we had the reaction to the super muscular figure of the ever more fanatic aerobics enthusiasts. The waif look was by no means original. Its roots lie in the 19th century, when women used to stay up all night drinking black coffee to look fragile and undernourished. The reaction to it this decade, though, was surprisingly moralistic. Body shape has changed, and the controversy over the thinness of models in the press has made the fashion press paranoid about the extreme. We are now seeing a wider range of body shapes from different racial groups, and for the first time in the last 500 years or so the foundations do not dictate the dimensions of the fashion look.

That is not to say that there are no trends in underwear, in fact quite the contrary is true. The spending analyses show that women take great pleasure in buying luxurious underwear for their own pleasure and are prepared to pay lots more for something that rarely gets seen. The three-pack from a chain store is definitely reserved for the most ascetic among us these days, and has been seen off by the selection of styles available in every section of the market.

The breast is also more pronounced, so, despite the general interest in the 70s, things are definitely less "burn your bra" and more "hello Wonderbra!" The Wonderbra is a cultural icon recognized by both sexes, and is synonomous with the in-your-face attitude of new women. Due to diet and genetic reasons, there are more women today who look like Jessica Rabbit than Twiggy, and teenagers have adopted the Wonderbra as essential gear. It captures in a sort of Olive Oyl way their burgeoning sexual allure, coupled with their other trademark, the clumpy shoe. Their other trick, copied by the super-chic with washboard stomachs, is the pierced navel to complement the trend for hip huggers.

The long lean and lace combination is persistent, particularly with the new knitwear. Like the Versace safety pin dress, these filigree cobwebs of fairy workmanship pose the problem of what to wear underneath. A body stocking is the best option, but for real fashion victims, big underpants have still been ubiquitous at the shows, proving that some trends really are for eight-year-olds only. Vivienne Westwood wore nothing underneath when she went to collect her decoration at Buckingham Palace. The press had a field day and now her son, Joe Corre, is the forerunner on the underwear scene. His company, Agent Provocateur, shows in raunchy retro style that underwear is always best when it has an audience.

1990-
1980-
1970-
1960-
1950-
1940-
1930-
1920-
1910-
1900-
1890-

COSMETICS **BODY SHAPE & UNDERWEAR** WORK & PLAY

There can hardly be a person left who is seriously interested in beauty who does not do some form of exercise. The accent is no longer on particular forms of fitness, but there is a growing interest in a holistic approach, the rediscovery of alternative therapy, in preventive medicine, gentler forms of exercise that have benefits for the mental state, and stress remedies. There has also been a rise in popularity in health resorts, spas and alternative clinics.

This decade has produced a generation to whom ideological choices mean a great deal. It is a continuation of the opening of the mind that occurred in the 60s. As Teresa Hale, director of the fashionable Hale clinic says, "Alternative health was one of the success stories of the 60s, like the music, it was a seed that was planted and one of the few that flowered. Although it was embraced by the flower power culture it has flourished and grown and become mainstream."

The 90s has followed an extremely aggressive and stressful decade and so the holistic approach has never looked so attractive or commercially sophisticated. We are all more aware of looks, health and lifestyle, all traceable to a revolutionary self-awareness that led in the 60s to a certain social responsibility. In other words it is

almost an obligation to maintain health by diet and exercise for a more enjoyable life, and also a way of having more control of our lives and our health. The integrated nature of alternative health is attractive, and a large part of it is the feel-good factor, the rewarding of the self and an *amour propre* in every sense.

Governments have shown increased interest in it because with dwindling resources and increased expectations of medicine, the idea of fewer prescribed drugs and intrusive surgical procedures is obviously of enormous value. To the individual, who has never been better educated about health, it means more control over her body and the chance to achieve a balance in her life.

The benefits of flotation tanks, flower remedies, cooling irrigation and homeopathy have all been investigated more thoroughly recently, as have Eastern mind and body disciplines such as yoga, t'ai chi and, most interestingly, tantric sex, to give more choice for a better life. Communication and an integrated approach is generally considered to be advantageous, too. Breast cancer and osteoporosis among female problems have been greatly publicized through fund-raising and in women's magazines. Breasts, though more pneumatic these days, are not necessarily more healthy.

1990-
1980-
1970-
1960-
1950-
1940-
1930-
1920-
1910-
1900-
1890-

Advertising, particularly for sports shoes, promotes an ideal image of a quest for ever-improving goals and personal best in a tough urban jungle. Whatever your sport, whatever the level, even if your personal best is the circuit from the sofa to the fridge, a professional approach and dedication is seen as desirable for the modern athlete on the front line. Fitness videos in exotic locations help to inspire the homebody to action and increased effort. Reebok does enormous amounts of research on what women want from sports goods and exercise. Sportswear increasingly borrows from the vocabulary of children's clothing, using ever more durable, high-performance fabrics. Bright colors, big stripes and loose fitting styles, less influenced by gender than purpose—how far we have come from the beginning of this story.

Clothes for sport have their own trends; skiwear is increasingly retro, with improved fabrics, designers like Sam de Teran have taken skiwear out of the realms of tired and into trendy *Avengers*-type high fashion. Participants in other sports like rollerblading and working out in the gym have shed the purpose-made leotards and thongs and become more relaxed in what they wear. Tennis has returned to traditional outfits.

above: Naomi Campbell, Claudia Schiffer and Karen Mulder pose with their lookalike dolls launched in March 1996.

left: Linda Evangelista opens a New York store, in aid of breast cancer research.

BARBIE is the number-one toy in the world at the moment. The apparent inspiration for the world's most prestigious designers, architects and who knows how many people since her birth in 1959. She has had many top careers, several image changes and a whole host of little friends, not to mention serious adult collectors and admirers. She is one of the most potent cultural icons of the 20th century, all the more powerful, since being a doll, she knows no barriers of race, class or age.

In a way, she is the opposite of the 90s' ideal of plurality of beauty, and yet she still remains the embodiment of what we prize. She will shape and wear the dreams and aspirations of millions of little girls; from her, they will learn femininity, and their choice of role, and from them will come the ideas for her new roles and appearance. Like her clothes, it's a two-way stretch. To find out what happens next, watch that pink box.

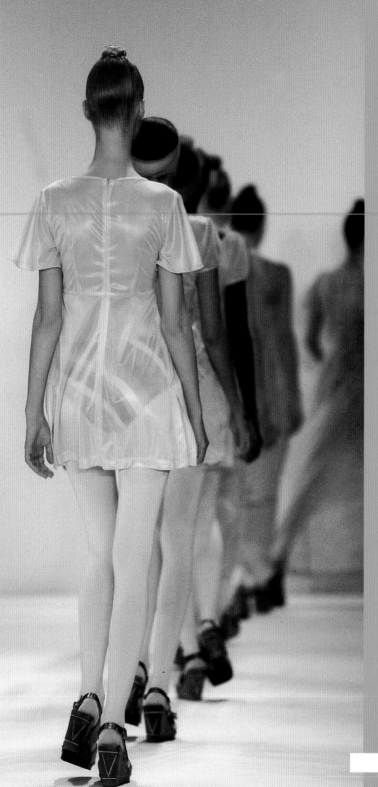

The Berlin Wall dismantled

The Gulf War

Bill Clinton twice elected US president

Nelson Mandela becomes president of South Africa

Hubble space telescope reveals outer fringes of the universe at the beginning of time

British Labour Party wins landslide election victory after 18 years in opposition

Designer Gianni Versace murdered in Miami

The Internet established, revolutionizing worldwide information communication

A living sheep cloned

Hong Kong returned to mainland China

Diana, Princess of Wales, killed in car accident in Paris

The world prepares to greet the millennium

1990 -1999

"What is beauty anyway?
There's no such thing."
Pablo Picasso

"You're the most beautiful woman
I've ever seen, which doesn't say
much for you." Groucho Marx

"There are no ugly women,
only lazy ones."
Helena Rubinstein

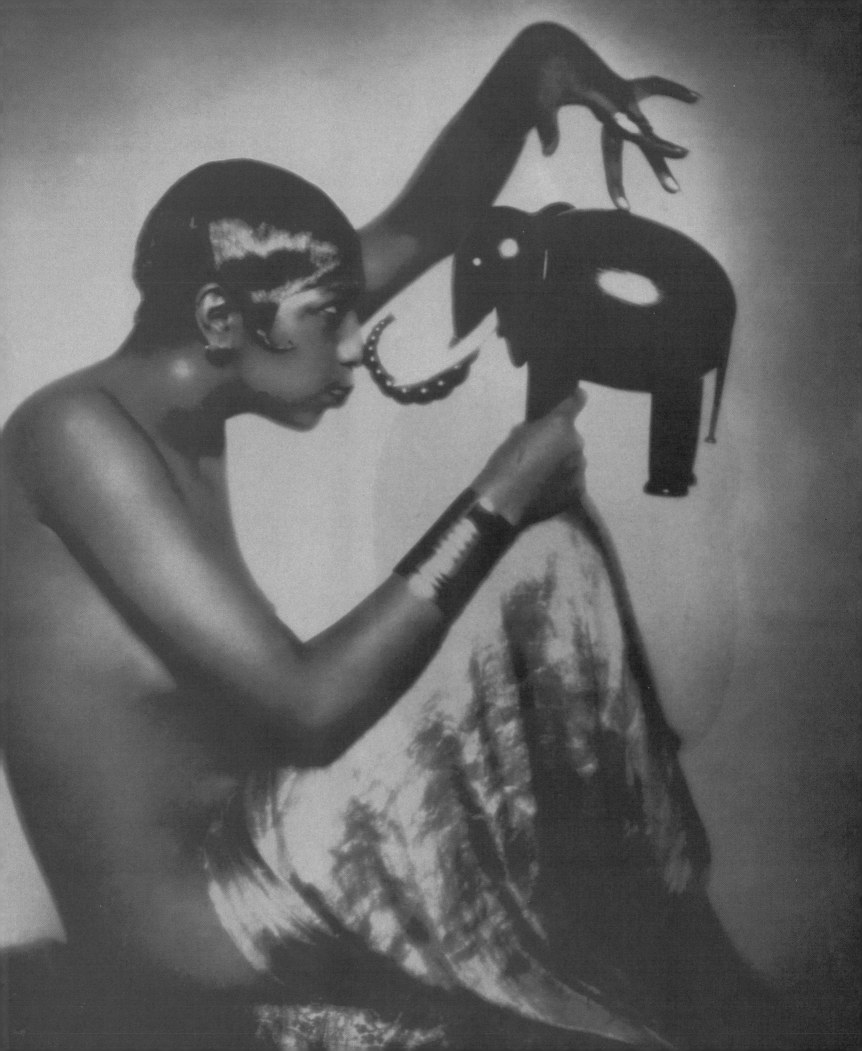